2004

CY TWOMBLY

DIE SKULPTUR THE SCULPTURE

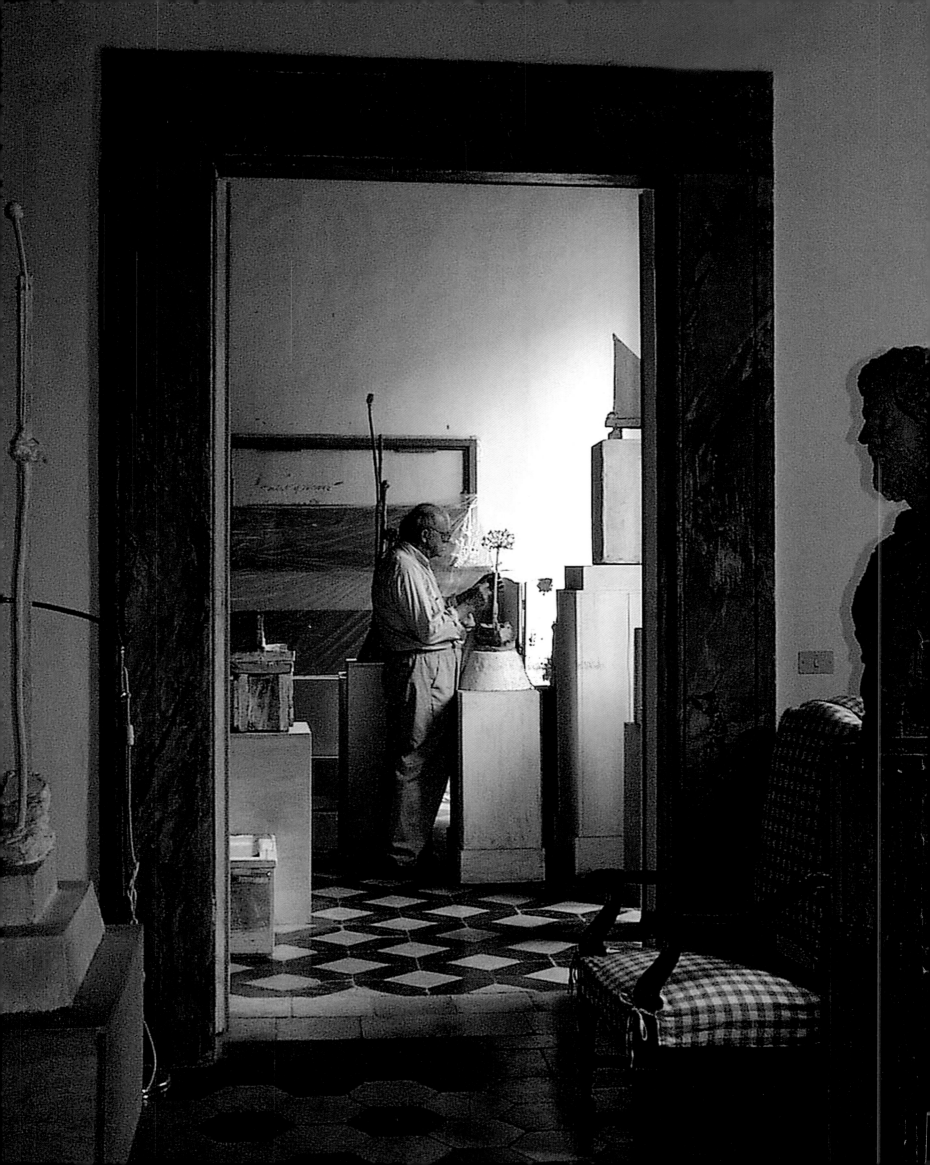

CY TWOMBLY

DIE SKULPTUR THE SCULPTURE

Katharina Schmidt

Kunstmuseum Basel

The Menil Collection, Houston

Hatje Cantz Verlag

Leihgeber
Lenders to the Exhibition

Kunstmuseum Basel
15. April bis 30. Juli 2000

The Menil Collection, Houston
September 20, 2000 – January 7, 2001

CREDIT | PRIVATE
SUISSE | BANKING

Ein Kultur-Engagement

Mit dankenswerter Unterstützung
der Avina Stiftung aufgrund
der Vermittlung von Alesco AG

Cy Twombly machte durch seine großzügigen Leihgaben, für die wir ihm zu außerordentlichem Dank verpflichtet sind, diese Ausstellung möglich. Ohne die reiche Unterstützung durch das Kunsthaus Zürich und die Menil Collection, Houston, wäre sie unvollständig geblieben. Allen, die uns ihre kostbaren Werke zur Verfügung stellten, fühlen wir uns sehr verbunden. Unser Dank schließt auch jene ein, die es vorziehen, ungenannt zu bleiben.

It is only through Cy Twombly's generous loans, for which we are immensely grateful, that this exhibition has been possible at all—and it would not have been complete without the forthcoming support of the Kunsthaus Zürich and The Menil Collection. We owe a deep debt of gratitude to all those who have put their precious works at our disposal, and our gratitude goes equally to those lenders who prefer to remain anonymous.

Houston	The Menil Collection
	Dr. Ned Rifkin, Director
New York	Mr. Robert Rauschenberg
	Mr. David White, Curator
Roma	Mr. Cy Twombly
Zürich	Kunsthaus Zürich
	Herr Dr. Felix Baumann, Direktor
	Herr Dr. Christian Klemm, Vizedirektor
	Daros-Sammlung Schweiz
	Herr Dr. Stephan Schmidheiny
	Herr Dr. Jacques Kaegi
	Herr lic. phil. Peter Fischer

Inhalt
Contents

Dank

Cy Twombly hat die Ausstellung in Basel und Houston in allen Phasen der Vorbereitung auf ebenso liebenswürdige wie konstruktive Weise begleitet. Für seine außerordentliche Großzügigkeit und die gute Zusammenarbeit sind wir ihm zu großem Dank verpflichtet, in den wir auch Frau Tatia Franchetti Twombly einschließen.

In allen Stadien und auf allen Ebenen der Vorbereitung war uns die unermüdliche, freundschaftliche Unterstützung durch Herrn Nicola Del Roscio ganz besonders wertvoll. Für seine Begleitung der Ausstellung danken wir ihm auf das Herzlichste.

Auf vielfältige Weise hat Frau Doris Ammann, Zürich, die Vorbereitungen der Ausstellung unterstützt; Herr George Frei war uns immer wieder spontan behilflich.

Herrn Dr. Christian Klemm sind wir für seine Mitwirkung als Autor sehr verbunden. Die Übersetzung ins Englische besorgten Herr David Britt, Frau Dr. Fiona Elliott, Frau Eileen Walliser und Herr Roger Harmon. Die Exponate wurden in Rom, Zürich und Houston neu fotografiert; für besondere Bemühung danken wir Herrn Mimmo Capone, Rom; Frau Cécile Brunner, Kunsthaus Zürich; Ammann Fine Art, Zürich, sowie The Menil Collection, Houston. Außerordentlich entgegenkommend reagierten auf unsere Fotowünsche Herr Robert Rauschenberg, Herr Nicola Del Roscio, Herr Plinio de Martiis und das Archivio Mulas, Mailand. Zahlreiche Institutionen und Persönlichkeiten halfen uns mit Informationen, stellten uns Fotomaterial und wertvolle Dokumente aus ihren Archiven zur Verfügung. Ihnen allen, auch jenen, die hier ungenannt bleiben, sei für ihre Unterstützung gedankt: Galerie Karsten Greve, Köln; Herrn Prof. Dr. Reinhold Hohl, Magden; Herrn Dr. Harald Szeemann, Tegna; Ammann Fine Art, Zürich.

Wir danken allen Mitarbeitern der beiden Museen in Basel und Houston für ihr besonderes Engagement bei der Vorbereitung und Durchführung dieser Ausstellung. Wissenschaftliche Assistenz: Dr. Hartwig Fischer, lic. phil., Birgit Gudat (B), Susan Davidson (H); Verwaltung: Urs Reimann (B); Restaurierung: Hanspeter Marty, Zürich, Carol Mancusi-Ungaro, Pia Gottschaller, Brad Epley, William Steen (H); Registrars: Charlotte Gutzwiller (B), Julie Bakke (H); Public Relations: Christian Selz (B), Vance Muse (H); Dokumentation: Barbara Kunz (B), Mary Kadish (H); Sicherheitskonzept: Pierre Jean Lauter (B) mit Hans G. Winkler und Sigrid Benz, Rode Melder GmbH, Hamburg; Technischer Museumsdienst: Ernst Rieder, Dieter Marti, Markus Spinnler, Urs Nachbur (B); Buck Bakke, Gary Parham, Doug Laguarta (H).

Wir danken dem Hatje Cantz Verlag, namentlich Frau Annette Kulenkampff, Verlegerin, Frau Christine Traber, deutsches Lektorat, sowie Frau Gabriele Sabolewski für die einfühlsame Gestaltung.

Die Möglichkeit zu dieser Sonderausstellung in der Schweiz verdanken wir dem Kanton Basel-Stadt, Träger der Öffentlichen Kunstsammlung Basel, sowie der Crédit Suisse, Private Banking; namentlich haben uns einmal mehr Frau Anne-Christina Keller und Frau Monika Baumann, Zürich, Herr Werner Rüegg und Herr Mark Kunz, Basel, ihr begeistertes Engagement gezeigt. In Houston danken wir Herrn Dr. Ned Rifkin, Direktor, The Menil Collection, und Frau Louisa Stude Sarofim, Präsidentin, The Menil Foundation. Für dankenswerte Unterstützung der Avina Stiftung aufgrund der Vermittlung von Alesco AG fühlen wir uns Herrn Dr. Stephan Schmidheiny und Herrn Dr. Jacques Kaegi besonders verpflichtet.

Acknowledgments

Cy Twombly participated in every phase of the preparation of this project in the kindest, most constructive way. We owe him an immense debt of gratitude for his outstanding generosity and for working with us as he did; we should like also to extend our warmest gratitude to Tatia Franchetti Twombly.

At every stage and on every level of the preparations the tireless, friendly support we received from Nicola Del Roscio was particularly valuable. We thank him most sincerely for all his help with the exhibition.

Doris Ammann, Zurich, supported the preparations for the exhibition in a number of different ways; George Frei was always ready with help the moment it was needed.

We would like to thank Christian Klemm for contributing his essential essay to this publication. For the translation we wish to acknowledge: David Britt, Fiona Elliott, Eileen Walliser, and Roger Harmon. New photographs of the artworks were taken in Rome, Zurich, and Houston by Mimmo Capone, Rome; Cécile Brunner, Kunsthaus Zürich; Ammann Fine Art, Zurich, and The Menil Collection, Houston. Grateful acknowledgment for generous support with photographs is due to Robert Rauschenberg, Nicola Del Roscio, Plinio de Martiis, and Archivio Mulas, Milan.

Important additional information, materials, and documents have been provided by Galerie Karsten Greve, Cologne; Prof. Reinhold Hohl, Magden; Dr. Harald Szeemann, Tegna; and Ammann Fine Art, Zurich.

The teams of both institutions in Basel and Houston showed enormous commitment in a variety of ways. Assistant Curators: Hartwig Fischer, Birgit Gudat (B), Susan Davidson (H); Administration: Urs Reimann (B); Conservation: Hanspeter Marty, Zurich, Carol Mancusi-Ungaro, Pia Gottschaller, Brad Epley, William Steen (H); Registrars: Charlotte Gutzwiller (B), Julie Bakke (H); Public Relations: Christian Selz (B), Vance Muse (H); Documentation: Barbara Kunz (B), Mary Kadish (H); Security System: Pierre Jean Lauter (B) with Hans G. Winkler and Sigrid Benz, Rode Melder GmbH, Hamburg; Technical Service: Ernst Rieder, Dieter Marti, Markus Spinnler, and Urs Nachbur (B), Buck Bakke, Gary Parham, and Doug Laguarta (H).

We thank Hatje Cantz Publishers, specifically Annette Kulenkampff, Publisher, Christine Traber, Editing Director, and Gabriele Sabolewski for her sensitive graphic design.

For the opportunity to mount this special exhibition in Switzerland we should like to express our gratitude to the Canton of the City of Basel, and Crédit Suisse, Private Banking; Anne-Christina Keller and Monika Baumann, Zurich, and Werner Rüegg and Mark Kunz, Basel, have once again demonstrated the enthusiasm of their involvement. In Houston we wish to thank Ned Rifkin, Director, The Menil Collection, and Louisa Stude Sarofim, President, The Menil Foundation.

For invaluable support from the Avina Stiftung through the mediation of Alesco AG, we should particularly like to thank Dr. Stephan Schmidheiny and Dr. Jacques Kaegi.

Vorwort

Wer im Frühjahr 1979 die Einladung zu einer Ausstellung Cy Twomblys in der Galerie von Lucio Amelio in Neapel erhielt, konnte die weiße Panflöte, dieses stille leuchtende Objekt, kaum je wieder vergessen. Zwanzig Jahre zuvor entstanden, wirkte es faszinierend aktuell und machte auf die Doppelbegabung des Künstlers neugierig. Nur Wenigen mag damals in Erinnerung gewesen sein, dass der bekannte Maler, der nun elf Skulpturen zeigte, 1955 in seine erste New Yorker Einzelausstellung auch Plastiken einbezogen hatte, die allerdings ohne Beachtung blieben. So entstanden in den fünfziger Jahren vor einer langen, einschneidenden Pause nur noch wenige Arbeiten und erst seit 1976 wuchs in größerer Dichte und Kontinuität der heutige Bestand. In Krefeld, wo Paul Wember Cy Twombly schon 1965 vorgestellt hatte, zeigten Gerhard Storck und Marianne Stockebrand 1981 im Haus Lange mit 23 Skulpturen erstmals eine breitere Auswahl. Seither fand sich immer wieder Gelegenheit, kleine Gruppen von Originalplastiken oder einzelne Bronze- und Kunststoffgüsse zu sehen, integriert in Einzelausstellungen des Künstlers, in großen internationalen Manifestationen oder im Rahmen thematisch ausgerichteter Projekte. So wies Harald Szeemann 1987 in seiner Züricher Twombly-Retrospektive, die durch vier weitere europäische Länder reiste, mit 20 Werken erstmals auch der Skulptur innerhalb des Gesamtschaffens eine bedeutende Stellung zu. Anschließend überließ Twombly dem Kunsthaus Zürich als Depositum ein Ensemble von neun Originalskulpturen, die er 1994 schenkte. Kirk Varnedoe nahm im gleichen Jahr in seine Retrospektive auch einige der wenigen erhaltenen frühen Plastiken auf und verwies beispielhaft auf Parallelen innerhalb der verschiedenen Gattungen. In die eigens für sein Werk errichtete Cy Twombly Gallery der Menil Collection in Houston, die im Februar 1995 eingeweiht wurde, nahm der Künstler ebenfalls eine Gruppe von Skulpturen auf. Im Frühjahr 1999 präsentierte die American Academy in Rom eine eindrückliche Auswahl von zehn Plastiken der achtziger und neunziger Jahre und im Herbst zeigte Larry Gagosian in New York mit großem Erfolg zehn Bronzen.

Erstmals ist es nun möglich, Twomblys skulpturales Œuvre in einer umfassenden Auswahl und mit vielen, nie öffentlich gezeigten Arbeiten darzustellen. Langjährige Auseinandersetzung mit seinem Schaffen und der Kontakt zu dem Künstler führten unabhängig voneinander im Kunstmuseum Basel und in der Menil Collection in Houston zu dem Wunsch eines solchen Projektes. Gemeinsam mit Cy Twombly konnten wir im Juli 1999 eine Exponatenliste erstellen, in der alle Werkphasen in repräsentativer Weise berücksichtigt sind und alle Themen und Motive zur Geltung kommen. Haben die weißen Originale innerhalb der Skulpturen den Vorrang, so sind die Bronzen da einbezogen, wo die Gipse nicht erhalten blieben oder die Güsse andere künstlerische Aspekte einbringen. Von der ursprünglichen Idee, Beispiele der Malerei und Zeichnung hinzuzufügen, nahmen wir im Dialog mit dem Künstler Abstand zugunsten einer umfassenden Präsentation der Skulpturen.

Mit großem Enthusiasmus haben wir die Ausstellung von Cy Twomblys Plastiken erarbeitet, überzeugt von der bedeutenden Stellung, die sie in der Skulptur unserer Zeit einnehmen.

Katharina Schmidt
Direktorin der Öffentlichen Kunstsammlung Basel

Paul Winkler
The Menil Collection, Houston

Preface

No one attending the exhibition of Cy Twombly's sculptures at Lucio Amelio's gallery in Naples early in 1979 is likely ever to forget the radiant tranquillity of the white panpipes. Made twenty years earlier, this work managed to look entirely contemporary even as it whet the appetite for further revelation of the artist's dual talent. At the time, few would have remembered that this celebrated painter, who was now showing eleven sculptures, had included sculptural objects in his very first solo exhibition in New York in 1955. These passed unnoticed, and during the rest of the 1950s Twombly made only a few sculptures. A long hiatus then followed. It was only in 1976 that a new sculptural œuvre began to emerge, increasing both in volume and in continuity of production. In 1981 in Krefeld, where Paul Wember had first presented Twombly's work in 1965, Gerhard Storck and Marianne Stockebrand organized the first representative showing of twenty-three selected sculptures at Haus Lange. Since that time, there have been a number of opportunities to see small groups of Twombly's original sculptures, or individual bronze and resin casts—as part of one-man shows, at large international exhibitions, or in the context of thematic projects. The first curator to give sculpture a degree of prominence within the artist's work as a whole was Harald Szeemann: he included twenty sculptures in his Twombly retrospective in Zurich in 1987, which toured to four other European countries. Twombly subsequently loaned an ensemble of nine original sculptures to the Kunsthaus in Zurich, donating the works in 1994. Also in 1994, Kirk Varnedoe organized a retrospective in which he included some of Twombly's few surviving early sculptures and drew some exemplary parallels between different art forms. The artist himself selected a group of sculptures for inclusion in the specially built Cy Twombly Gallery at The Menil Collection in Houston, which was inaugurated in February 1995. Early in 1999, the American Academy in Rome presented an impressive exhibition of eight sculptures of the 1980s and 1990s, and in New York, in the autumn of the same year, Larry Gagosian organized a successful show of ten bronzes. Now, it is possible for the first time to see a comprehensive selection of Twombly's sculptural œuvre, including many pieces never before shown in public. The idea for such a project emerged independently at the Kunstmuseum Basel and at The Menil Collection in Houston, following years of engagement with the work and dialogue with the artist. In July 1999, working in collaboration with Cy Twombly, we succeeded in drawing up a list of sculptures representative of every period of his career, and touching on all his recurrent themes and motifs. Among the sculptures, the white originals take pride of place; bronzes are included in those cases in which either the plaster has not survived or the cast makes an additional artistic point. In the course of our discussions with the artist, we abandoned our initial idea of also including examples of Twombly's paintings and drawings in favor of a comprehensive presentation of the sculptures.

In preparing this exhibition, our enthusiasm has all along been sustained by the conviction that this body of work is of major importance in the sculpture of our time.

Katharina Schmidt
Director, Öffentliche Kunstsammlung Basel

Paul Winkler
The Menil Collection, Houston

Vorbemerkung

Die Entstehungs- und Ausstellungsgeschichte von Cy Twomblys Skulptur macht verständlich, warum dieser Teil seines Werkes bisher in der umfangreichen Literatur weitgehend fehlt. Der frühe Krefelder Katalog beschränkte sich auf knappe Angaben; die Rezensionen gehen wenig über ein allgemein wohlwollendes Interesse hinaus, wobei die elementaren Formen und das Weiß die meiste Aufmerksamkeit erregten. Aus Harald Szeemanns Katalog der Züricher Retrospektive sprach sein einfühlsames Verständnis für das Unverwechselbare und für die hohe Qualität dieser Werke. Ihre poetische Dimension suchte der griechische Dichter Demosthenes Davvetas in mehreren Texten zu erfassen. Besitzt Robert Rauschenberg eine der wenigen erhaltenen Arbeiten von 1953 und erinnert sich Twombly daran, dass einzig der Freund Jasper Johns seine Plastiken von Anfang an schätzte, in einem Künstlergespräch »Cy Twombly. An Artist's Artist« im Oktober 1994 holte Kirk Varnedoe die Meinung jüngerer Künstlerkollegen zu Twomblys Skulpturen ein. Im selben Jahr publizierte Christian Klemm aus Anlass der Schenkung an das Kunsthaus Zürich im Jahresbericht des Museums einen Essay, in dem er auf die Nähe zum Werk von Alberto Giacometti aufmerksam machte und damit an eine der wesentlichen Affinitäten des Plastikers Twombly rührte. Nicola Del Roscio hat verdienstvoller Weise 1997 in dem Catalogue raisonné den bis dahin nur in Ausschnitten bekannten Korpus vollständig veröffentlicht. Die Einführung von Arthur Danto sowie David Sylvesters Essay im letztjährigen Katalog von Gagosian ergänzen die vorhandene Literatur. Mit der eingehenden Unterstützung des Künstlers und Nicola Del Roscios verfasste Achim Hochdörfer eine informationsreiche weiterführende Magisterarbeit zum Thema an der Wiener Universität. Dieses Gesamtbild bewog mich schließlich dazu, den eingehenderen Vergleich zwischen Twomblys Malerei und seiner Plastik in einer späteren Publikation zu behandeln und mich im hier gegebenen Rahmen ganz auf das plastische Werk zu konzentrieren.

Nach früheren Ausstellungen zu Twomblys Malerei und seinen Serien auf Papier konnte ich den langjährigen Dialog mit dem Künstler fortsetzen. Nun führte die Hinwendung zur Skulptur an die Orte ihrer Entstehung, im Winter 1998 nach Rom in die American Academy auf dem Gianicolo, im Frühling nach Gaeta, im Sommer zu seinem römischen Wohnsitz und im Herbst in seine amerikanische Heimatstadt Lexington, Virginia. Einem wachsenden Bedürfnis nach möglichst detailgetreuem Erfassen der Werke kam Twombly entgegen, indem er mir erlaubte, digitale Arbeitsaufnahmen zu machen – fotografische Notizen, Gedächtnishilfen. So entstanden Bilddokumente, die ohne den Dialog mit Cy Twombly niemals meinen Schreibtisch verlassen hätten. Wenn sie nun in diese Publikation einfließen, verstehe ich sie als Einladung zum genauen Sehen.

Katharina Schmidt

Introductory Note

History—that of the making of Cy Twombly's sculpture and that of the exhibitions in which it has been shown—goes some way to explain the comparative neglect that this body of work has hitherto suffered in the sizeable critical literature on the artist. The early Krefeld catalogue confined itself to bare facts, and the press notices of the exhibition convey little beyond a well-meaning but unspecific interest, largely confined to the artist's use of white. Harald Szeemann, however, in the catalogue of Twombly's 1987 Zurich retrospective, expressed an empathetic understanding of the distinctive identity and high quality of these works, and the Greek poet Demosthenes Davvetas has sought to capture their essence in a number of essays. Of Twombly's fellow artists, Robert Rauschenberg owns one of the few works of 1953 still in existence, and Twombly remembers that his friend Jasper Johns thought highly of his sculptures from the first. Greater attention was paid in the 1990s. In October 1994, in an article called "Cy Twombly: An Artist's Artist," Kirk Varnedoe brought together the views of a number of artists of a younger generation on Twombly's sculptures. In that same year, to mark the artist's donation to the Kunsthaus Zürich, Christian Klemm published an essay in the museum's yearbook in which he called attention to similarities between Twombly's works and those of Alberto Giacometti, thus revealing one of Twombly's most vital sculptural affinities. In 1997, Nicola Del Roscio performed a valuable service by publishing the whole corpus of Twombly's sculpture, hitherto known only in fragments, in a *catalogue raisonné*. Arthur Danto's introduction to that work and David Sylvester's essay in the 1997 Gagosian catalogue complete the published literature on the subject. With active support from the artist and from Nicola Del Roscio, Achim Hochdörfer has produced an informative master's thesis on the sculpture at Vienna University. For the purposes of the present catalogue, my reading of the literature persuaded me to postpone a detailed comparison of Twombly's painting and sculpture, and to concentrate entirely on the sculptural work. In the past, I have worked on exhibitions of Twombly's paintings and of his serial works on paper; the present exhibition has enabled me to continue a long-standing dialogue with the artist. In the course of 1998, I was able to visit the places where the sculpture was made: the American Academy on the Gianicolo in Rome in the winter, Gaeta in the spring, Twombly's Roman residence in the summer, and his American hometown of Lexington, Virginia, in the fall. Twombly has responded to my growing need for a close and detailed engagement with the work by allowing me to record it with a digital camera. Intended only as aids to memory, the photographic jottings would never have traveled beyond my own desktop were it not for the dialogue with Twombly. Their appearance in this publication is intended as an invitation to look more closely.

Katharina Schmidt

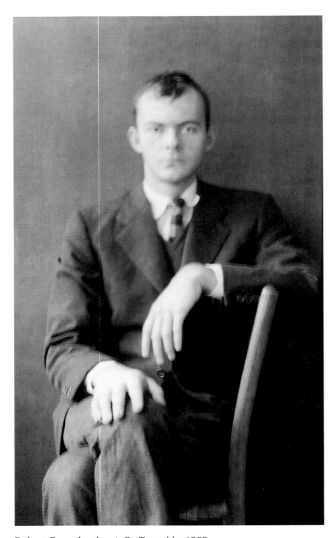

Robert Rauschenberg, *Cy Twombly, 1952,*
Black Mountain College, North Carolina
Langzeitaufnahme · Long exposure photo

Cy Twombly, Roma 1970

Cy Twombly, Bolsena 1968

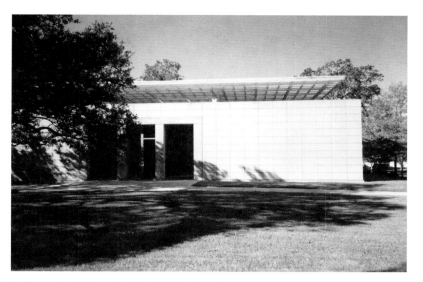

Cy Twombly Gallery, The Menil Collection, Houston

Cy Twombly bei der Arbeit an Skulpturen
Cy Twombly working on sculptures
Gaeta 1985

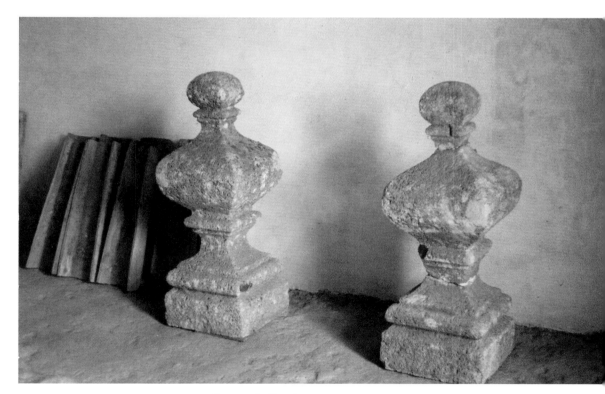

Bassano in Teverina
»Stilleben« mit römischen Dachziegeln
"Still life" with Roman tiles

Gaeta

Cy Twomblys Skulptur sehen

Katharina Schmidt

1 Cy Twombly mit einer Assemblage,
nicht erhalten
Cy Twombly with assemblage,
non extant
Groveland, Massachusetts 1946

Cy Twombly, Schöpfer eines umfangreichen malerischen Œuvres, dessen persönlicher Stil sich einprägt, unverwechselbar subtil und leidenschaftlich, ist als Plastiker wenig bekannt. Dass von Mitte der vierziger Jahre bis heute mit Unterbrechungen und an verschiedenen Orten ein Korpus von 148 Skulpturen entstanden war, vermittelte erst der Catalogue raisonné, den Nicola Del Roscio 1997 publizierte.

Die meisten Originale der in geringer Auflage in Bronze oder einem synthetischen Material gegossenen Skulpturen behielt Twombly in seiner Nähe. Sie sind ihm kostbar. Nach Jahren vermag er ihnen mit einem Handgriff einen anderen Akzent zu verleihen, eine leise Korrektur anzubringen. Wenn er sie von den historischen Möbeln, den Tischen, Konsolen, Säulen nimmt und jenen Dialog unterbricht, in den sie verstrickt sind, mit dem marmornen Bildnis eines Marc Aurel, einer Domitilla oder eines Apoll, um sie auf einem Museumssockel auszustellen, wirken diese anscheinend so einfachen Gegenstände von mittlerer Größe unvermittelt nah, gegenwärtig. Und doch bleiben sie distanziert, monumental, entrückt. Ihre nachhaltige Faszination irritiert, ihre Stille beruhigt. In selbstverständlicher Weise beziehen sie sich auf die Tradition skulpturaler Gestaltungen, verfügen aber souverän über die Autonomie einer aus Handwerklichkeit und Auftragswesen entlassenen Kunst, die sich offen neu definiert. Ihre eingehende Betrachtung mag am Beginn einer vertieften Auseinandersetzung stehen.

Früher noch als die ersten dokumentierten, aber meist verschollenen vollplastischen Arbeiten entstanden 1946 in Groveland, Massachusetts, jene Fotografien, auf denen der achtzehnjährige Cy Twombly eigene Werke präsentiert. Die beiden Materialbilder sind nicht nur wegen formaler Verwandtschaft zu seiner frühen Malerei aufschlussreich, sondern auch in Bezug auf seine Skulptur. Bei dem größeren der beiden Querformate (Abb. 1) erkennt man vor einem weißen Fond eine rechteckige, in etwa den Rahmenproportionen entsprechende dunklere Collage. Über die ganze Mitte liegt als breites Band ein grobmaschiger weißer Spitzenläufer, offenbar eine ausrangierte Handarbeit. Dass auf ihr ein weißer Teller mit hohem Rand befestigt ist, setzt nicht nur eine Kreisform auf das Rechteck darunter, sondern suggeriert auch die Aufsicht auf einen gedeckten Tisch.

Wesentlich abstrakter mutet das kleinere Objekt an. (Abb. 2) Auf einem querformatigen Brett, ein Fundstück mit alten Bemalungen, sitzen an beiden Enden runde Scheiben mit zentralen Knöpfen. Denkt man vielleicht an einen weiblichen Torso,[1] so vermittelt die breite Verbindungsachse, die ein Blechstück in der Mitte herstellt, den Eindruck von einem Mechanismus, einem Räderwerk; möglicher-

Looking at Cy Twombly's Sculpture

Katharina Schmidt

Cy Twombly, creator of an extensive œuvre of paintings memorable for their personal style and unmistakable in their subtlety and passion, is little known as a sculptor. Not until Nicola Del Roscio published the *catalogue raisonné* in 1997 did it emerge that Twombly had made as many as 148 sculptures in a variety of locations, starting in the mid 1940s and continuing sporadically to this day. The artist has kept most of the originals of the small editions cast either in bronze or in some synthetic material. They are precious to him. Even years later, he may still put his hand to them, altering an accent or making a minor correction. When he separates them from the furniture that is their customary surroundings—the tables, consoles, and pillars—and interrupts their engrossing dialogue with the marble bust of a Marcus Aurelius, a Domitilla, or an Apollo in order to place them on a museum base, these apparently simple, medium-sized objects gain enormous immediacy and presence. And yet they also remain distanced, monumental, detached. Their enduring fascination is disturbing, their stillness soothing. Effortlessly they relate to the traditions of sculptural form, at the same time enjoying the autonomy of art that has transcended the strictures of craft and commissions. But perhaps the works should be subjected to closer scrutiny before moving to a deeper reflection.

Even before the earliest documented fully three-dimensional works—now mostly lost—there were the photographs made in Groveland, Massachusetts, in 1946 in which the eighteen-year-old Twombly presented his own works. These two assemblages are significant not only for their formal affinity with his early paintings but also in terms of his sculptures.

In the larger of the two (fig. 1), both of which are in landscape format, a darker rectangular collage is set against a white ground, more or less corresponding to the proportions of the frame of the picture. Along the center, from top to bottom, runs the broad band of a coarse white lace runner, obviously a piece of discarded handwork. The fact that a high-rimmed white plate is fixed to it not only introduces a circular form combined with a rectangle but also suggests that one might be looking at a set table.

The smaller object (fig. 2) seems considerably more abstract. At either end of a rectangular board, an *objet trouvé* with remnants of paint, are circular discs with central buttons. While it might initially strike one as a female torso,[1] the broad connective axis, a piece of tin in the center, suggests that this might be some kind of mechanism, a wheelwork; possibly this is one of the first depictions of the chariots found later on in Twombly's œuvre. Both works bespeak the artist's early interest in found objects taken from his immediate surroundings, objects bearing

2 Cy Twombly mit einer Assemblage,
nicht erhalten
Cy Twombly with assemblage, non extant
Groveland, Massachusetts 1946

weise handelt es sich um eine der ersten Wagen-Darstellungen, wie man ihnen
später in Twomblys Œuvre wieder begegnet. Beide Arbeiten belegen sein frühes
Interesse an Fundstücken aus der nahen Umgebung, die Spuren des alltäglichen
Gebrauchs aufweisen. Mehr als alle anderen Anregungen und Einflüsse, die der
angehende Künstler noch vor seiner eigentlichen Ausbildung verarbeitete, scheint
hier die Begegnung mit dem Werk von Kurt Schwitters wirksam, dessen Verwen-
dung antiästhetischer Materialien, die er collagiert und assembliert. Ihre Herkunft
aus der banalen Alltagswelt, in der sie zur Unbrauchbarkeit verschlissen, dafür
aber mit Erinnerung und Emotionen aufgeladen wurden, prädestiniert sie für
einen künstlerischen Zusammenhang. In ihn überführt, erlangen sie eine andere
Bedeutung, erscheinen nobilitiert. Die Auseinandersetzung Twomblys mit dem
Werk von Schwitters klingt in seinen späteren Collagen nach; eine von Schwitters'
»Kathedralen« in seiner eigenen Sammlung bestätigt diese Affinität auf das Schönste.

Mit kleinen vollplastischen Arbeiten von 1946 beginnt der Catalogue raisonné der
Skulptur: ein winziger Terracotta-Torso auf pyramidalem Holzsockel, mehrstufig
aufgebaut; ihm folgen zwei schlanke Figürchen von anthropomorpher Allüre.
Aus demselben Jahr datiert auch die zierliche Plastik *Ohne Titel* (Lexington 1946,
Kat. 1, S. 17). Von einem schwarzbraunen, kompakten Holzquader ragt zentral
ein Vierkantstab, aus dem wiederum ein runder Metallstiel wächst, dessen obere
Krümmung in einen kleinen Trichter mündet.[2] Sie hält an einem flachen Metall-
band eine kleine Zahnradscheibe. Dass ein zweiter, ganz dünner Doppelstab das
Rädchen von hinten stützt und im Vierkantständer erdet, unterstreicht seine fron-
tale Ausrichtung und lässt es rührend still wie eine runde Blüte verharren. Oder
sprießt diese auf dünnem Stängel und wird von dem herabpendelnden Metallteil
davor bewahrt, nach vorne zu kippen? Die Spannung zwischen Hängen und
Stehen, Stützen und Halten, die hier spielt, entspricht dem Umkippeffekt in der
Wahrnehmung: Bald sieht man das stillgelegte verfremdete Zahnrädchen, bald
die magische Rosette, die ihre kreisenden Impulse aussendet.

Eine auffallende Neuerung bringt die Skulptur *Ohne Titel* (Lexington 1948, Kat. 2,
S. 19). Auf einem Plateau sind zwei weitere Sockel platziert: etwas zurückgesetzt
vom vorderen Rand, zentral und parallel zur Vorderkante ein flaches Klötzchen.
Auf ihm sprießen zwei Knollen. Kurz vor der Hinterkante ragt, ebenfalls mittig
postiert, ein anderer schlanker Sockel empor, Basis für den Stängel einer runden,
nach oben geöffneten Korbblüte. Wiederum verwendet Twombly Fundstücke,
organisches Material, Holz mit den sichtbaren Spuren seiner Maserung und Jahres-
ringen, aber auch den Zeichen früherer Nutzung wie Nagellöcher, Absplitterungen,
Risse. Ein umgedrehtes Kästchen dient als Plattform, sodass die Fläche, auf der
einst sein Inhalt lastete, nun von außen belastet wird. Den zweiten kleineren So-
ckel bildet ein massives Holzstück. Seine Seitenkanten sind mit einem feinen Ge-
webe geglättet, als sollten die Schnittflächen verbunden werden; ein rohes, dickes
Kantholz bildet den dritten Sockel. Zu dem hieratisch in Tiefe und Höhe gestaffel-
ten Konzept gehört wesentlich die leichte Aufsicht, da sich in ihr die Blüte ver-

the marks of daily use. More than all the other stimuli and influences that the young artist was coming to grips with even before beginning his formal training, it seems that his encounter with the work of Kurt Schwitters was the most crucial: specifically Schwitters' use of anti-aesthetic materials in collages and assemblages. By virtue of their origins in banal, everyday life, where wear and tear have rendered them virtually useless but also left them all the more highly charged with memories and emotions, these materials were predestined for an artistic context. As soon as they entered that context, they took on a different meaning; they appeared ennobled. The artist's involvement with Schwitters' work still echoes in his later collages; the presence of one of Schwitters' *Cathedrals* in Twombly's own collection confirms this kinship beautifully.

The *catalogue raisonné* of Twombly's sculptures begins with the small fully three-dimensional works of 1946: a tiny terra-cotta torso on a pyramidal wooden plinth, followed by two small, slim figures of anthropomorphic character. From the same year, there is also the delicate sculpture Untitled (Lexington 1946, cat. no. 1, p. 17). A piece of slender, squared timber rises from a black-brown,

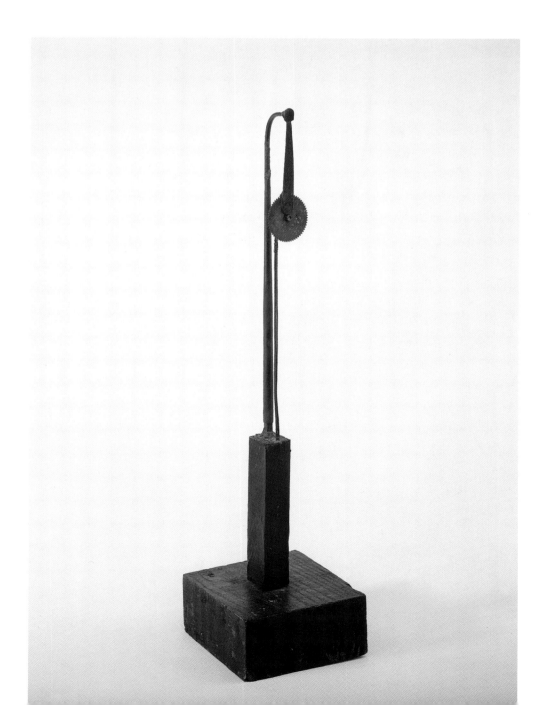

1 *Untitled*, Lexington 1946

17

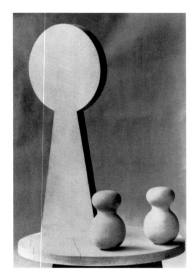

3 Hans Arp,
Un grand et deux petits, 1931
Fondation Arp, Clamart

deutlicht, sodass die Knollen, vielleicht auch Knospen, und ihr geöffneter Teller simultan zur Geltung kommen.

Das Ensemble biomorpher Elemente auf einer Platte kann seine Verwandtschaft zu frühen Werken von Hans Arp (Abb. 3) ebenso wenig leugnen wie die Nähe zu Giacomettis Konstruktionen, wobei Twombly selbst die besondere Faszination erwähnt, die *Der Palast um vier Uhr früh* von 1932 auf ihn ausübte; die Arbeit befand sich seit 1936 in der Sammlung des Museum of Modern Art.[3] (Abb. S. 173) Twombly lässt die Figuren nicht aus einer Ebene aufwachsen, sondern baut aus kubischen Formen eine profilierte Landschaft, und auf dem Grund des Holzes wachsen Gebilde aus anorganischem Material: bodennah, glatt, mit kurzem dicken Stiel die Knollen, Pilze oder eher Knospen; schlank, elegant, zum Zenit geöffnet, die Blume. Dieses kontrastreiche Spiel ist wesentlich durch einen Kunstgriff gemildert. Die einheitliche Übermalung mit weißer Tünche verdeckt die Unterschiede und fasst die ganze Komposition in homogenisierend lichtem Ton zusammen, wie es bald zum Charakteristikum seiner plastischen Arbeit werden sollte. Der Farbauftrag erfolgt locker, unregelmäßig, mit Rinnsalen. Verwendet Twombly antiästhetische Materialien, so überführt er sie in sein ästhetisches Konzept, in das sie ihre ursprüngliche Bedeutung einbringen, auch wenn sie eine Umdeutung erfahren. Wie die Schichten der Farbe und das zugekleisterte Gewebe verweisen die Jahresringe des Holzes auf organisches Wachstum, Alterung, auf das Phänomen der Zeit. Lässt diese frühe Skulptur bereits verschiedene Aspekte erkennen, die aus Twomblys malerischem Werk, den Collagen und Zeichnungen vertraut sind, macht sie gleichzeitig deutlich, dass seine Plastik aus einer anderen Grundhaltung entsteht als die Gemälde und dass in den allerersten skulpturalen Werken vieles angelegt ist, was sich später weiterentwickelt. Außer einer im Charakter gröberen, in der Thematik verwandten Arbeit von 1951 – ein ebenfalls aus häuslichen Fundstücken komponiertes, weiß gefasstes Objekt[4] (Abb. 4) – kennt man erst wieder Plastiken des Künstlers von 1953.

Die fünf Jahre zwischen 1948 und 1953 brachten in Twomblys Leben reiche Veränderungen. 1947/48 hatte er die Museum School in Boston besucht, ein Jahr später wechselte er an das neu eingerichtete Department of Arts der Washington and Lee University in Lexington. 1950 erhielt er ein Stipendium, das ihm erlaubte, an der Art Students League in New York bei Will Barnet, Morris Kantor und Vaclav Vytlacil zu studieren. In seinem zweiten Semester begegnete er dort dem gleichgesinnten Robert Rauschenberg. Der Aufenthalt in New York ermöglichte ihm den Kontakt mit der Avantgarde; er sah die Ausstellungen von Jackson Pollock, Mark Rothko, Barnett Newman, Clyfford Still, Robert Motherwell in den Galerien von Betty Parsons und Samuel Kootz und die Werke von Willem de Kooning und Franz Kline bei Charles Egan. 1951 verbrachte er das Sommer- und Wintersemester am Black Mountain College; Ben Shahn und Robert Motherwell wirkten dort im Sommer als Artists-in-Residence. Im November konnte er in der Seven Stairs Gallery in Chicago Bilder ausstellen, die er am Black Mountain College vollendet hatte; Robert Motherwell ermöglichte ihm gegen Jahresende eine Ausstellung in

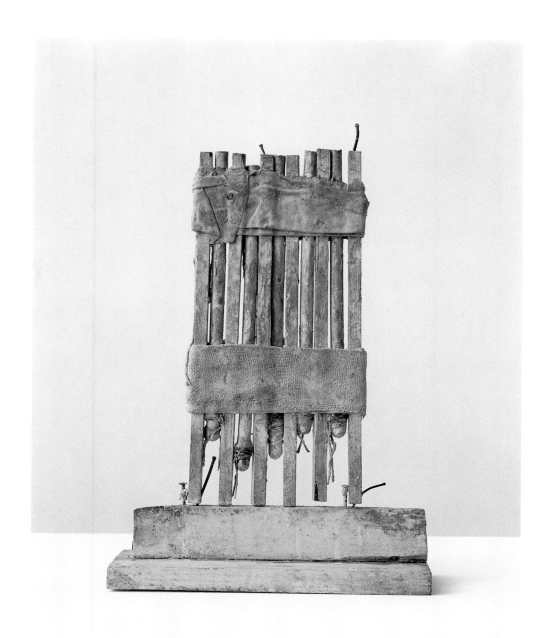

3 *Untitled*, New York 1953

compact wooden block. Out of the vertical piece grows a round metal stem, curved at the top with a small ball on the end.[2] Hanging from it by a flat ribbon of metal is a small cogwheel. The fact that the disc is supported from behind by a second, very fine double rod planted in the four-sided vertical element underlines the frontal orientation of the disc and keeps it touchingly still, like a round blossom. Or is it growing out of the fine stem and being prevented from tipping forward by the metal ribbon hanging down from above? The tension between hanging and standing, supporting and holding, that is at play here corresponds to the shifts in our perception: now one sees a cogwheel, and suddenly it seems to transform into a magic rosette sending out circling impulses.

The sculpture Untitled (Lexington 1948, cat. no. 2, p. 19) brings a striking innovation. On a plateau rest two plinths. Set back a little from the front edge, centered

6 Robert Rauschenberg,
 Feticci personali,
 Giardino del Pincio, Roma 1953

wie sie hier umgerüstet wurden. Holzstäbe, Stoffreste, Kordel, Nägel, Umwick-
lung, Verschnürung, Verknotung, betonte Frontalität steigern sich gegenseitig
und erzeugen so eine Wirkung von starker psychischer Energie. Die Ähnlichkeit
des zweiseitigen Objektes mit der Panflöte, der Syrinx,[6] die über den Eindruck
eines Zaunstückes obsiegt, wird dennoch überlagert von der symbolischen
Bedeutung der Grenzmarke und von der magischen Ausstrahlung der Knoten
und steht für ein raues, ein klagendes Lied. Twombly wird es einige Jahre später
neu komponieren.

In seinem Gesuch für das Reisestipendium hatte Twombly sein Interesse an den
traditionellen Wurzeln der modernen Kunst betont und neben dem klassischen
Formengut Fetische und rituelle Gegenstände erwähnt;[7] sicher spielte dabei der
Dialog mit Rauschenberg eine wesentliche Rolle. Dies erhellt vor allem aus den
Fotografien von dessen nicht erhaltenen hängenden Fetischen, den *Feticci
personali*, aus Wolle, Schnüren, Fell, Perlen, Spiegel, Textilien, wie er sie im Pincio-
Park in Rom einen Tag lang ausstellte. (Abb. 6) Trotz gemeinsamer Ziele und der
Nähe der beiden Künstler bleibt ihre Individualität immer klar erkennbar. Viele
von Rauschenbergs Arbeiten aus den frühen fünfziger Jahren sind zerstört oder
verschollen; über eine Gruppe früher Skulpturen Twomblys geben heute nur ei-
nige wenige Dokumente Auskunft. Rauschenberg fotografierte 1954 in seinem
Atelier den Freund mit Bildern und Plastiken, von denen eine einzige Skulptur in
überarbeiteter Form erhalten blieb. (Kat. 5, S. 30) Auf einem der Fotos unter-
scheidet man fünf Plastiken (Abb. 7): Eine etwa zwei Meter hohe Stele ragt empor,
bis zur Hälfte mit Papier umhüllt und verschnürt; eine flache Bodenplatte dient

and parallel to the short side, is a small, flat block. Two knobs grow out of it. Close to the other short edge, again positioned in the center, is another tall, slender plinth, from which rises the stem of a round, open composite blossom facing upward. Again Twombly has used found objects and organic material: wood with a visible grain and annual rings as well as signs of previous use, like splinters, cracks, and nail holes. An upturned box serves as a platform, so that the surface on which its contents once rested now bears its load from outside. The second, smaller plinth is formed from a solid piece of wood. Its side edges are smoothed out with a piece of fine material, as though the cut edges had been bandaged. The third upended element is a rough, squared timber. An important part of this hieratic, layered concept with its depths and heights is the way the gaze is drawn lightly downward, focusing on the rosette of blossoms, so that the nodules, or perhaps buds, and the open blooms all come into their own simultaneously.

This ensemble of biomorphic elements on a base can no more deny its kinship with early works by Hans Arp (fig. 3) than it can with constructions by Alberto

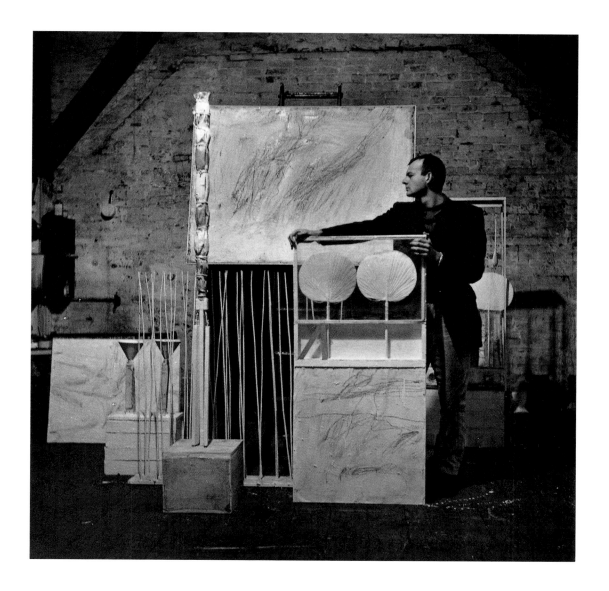

7 Robert Rauschenberg,
Cy Twombly mit Skulpturen und einem nicht erhaltenen Gemälde in Robert Rauschenbergs Atelier
Cy Twombly with sculptures and a painting (non extant) in Robert Rauschenberg's studio Fulton Street, New York 1954

dünnen, wie Halme hoch stehenden Holzruten als Basis; zwei Trichter sprießen als Blütenkelche auf kräftigen Stängeln aus einer groben, weiß getünchten Bretterkiste; zwei weitere Plastiken wiederholen dieses Prinzip der Anordnung. Twombly steht zwischen den seltsamen Objekten: flachen »Schränken«, Kästen mit hohen Sockeln, aus denen auf langen Stielen Fächerpaare ragen, von einem frei stehenden Rahmen überhöht. Die niedrigere der beiden Plastiken, die der Künstler umfasst, ist auf der Vorderseite des Sockels mit locker ausfahrenden Grafismen im Stil seiner Bilder bedeckt.

Eine Plastik aus dieser Zeit blieb unverändert erhalten: *Ohne Titel* (New York 1954, Kat. 4, S. 26 und 27), heute in der Menil Collection in Houston. Hochschlank die Form der Stele auf niedrigem Fuß, der Aufbau zweiteilig. Die weitaus größere untere Partie, durch vier dünne Stabpendel gegliedert, erhält im oberen Drittel einen besonderen Schmuck durch drei Reihen symmetrisch angebrachter kleiner Spiegel; ihre Reflexion löst die Fläche weiter auf, bezieht die nächste Umgebung in die Plastik ein, bannt den Blick und gibt ihn zurück. Wie zwei verschiedene Arten von Licht – das der weißen Farbe des Sockels und das der Spiegel – konfrontiert Twombly auch zwei Arten von Linien: die vertikalen Geraden, die der Schatten der herabhängenden Stäbe auf die Innenwand zeichnet, und die ausfahrend freien Grafismen, die er in Schreibrichtung in einem kleinen Kompartiment quer darüber ausführt. Das merkwürdige Pendel, das an dünnen Stängchen darüber baumelt, scheint dem Reich des Zaubers und der rituellen Handlungen entnommen. Mit Drähten provisorisch befestigte Löffelstiele halten zwischen ihren flachen Kellen ein verschnürtes dunkles Knäuel aus Stoff. Auf wen es verweist, wessen Lebensspuren es trägt, bleibt verborgen; in dem strengen geometrischen Gesamtaufbau bildet es zusammen mit den heftigen Schraffen ein magisch-geheimnisvolles Konzentrat vitaler Energie. Knüpft Twombly – wie Rauschenberg in einigen *Elemental Sculptures* von 1953[8] – an die Form der hängenden Plastik zum Beispiel eines Giacometti, eines Alexander Calder an, so faszinierte ihn damals offenbar die Ausdrucksintensität magischer Objekte besonders.

Eine andere Aufnahme von Rauschenberg (Abb. 8) zeigt eine jener Plastiken mit zwei Palmwedeln, die in stark veränderter Form als *Ohne Titel* (New York 1954, Kat. 5, S. 30)[9] erhalten blieb. Twombly entfernte den Rahmen von etwa doppelter Höhe des Sockels und mit ihm fünf Holzlöffel, die daran herabhingen. Auch die vier umwickelten und verschnürten Stäbe, die die Palmstängel flankierten, entfielen, ebenso die runden Spiegel auf der Frontseite.[10] Diese präsentiert sich jetzt als klares Rechteck, nur im oberen Viertel durch eine kräftige Zierleiste, Reststück des früheren Rahmens, gegliedert. Ein feines, kaschiertes Textil mit alten Nähten, Säumen, kleinen Fältchen zeichnet eine leicht bewegte Oberfläche. Vom Sockel steigen die beiden hohen Stiele auf bis zu ihrem majestätischen Abschluss in eleganten Kronen aus Fächerblättern. Von alters her nutzt man in heißen Ländern für diese leichten Utensilien die radiale Blattstruktur der Palme, beschneidet den Rand, sodass sich ein handliches, die Herzform andeutendes Blatt ergibt, gesäumt mit einer Zierkante. Der weiße Anstrich ändert nichts an dem formal wie

Giacometti, and Twombly himself has talked of his fascination with Giacometti's *Palace at 4 a.m.* of 1932, part of the collection of The Museum of Modern Art since 1936 (illus. p. 173).[3] Twombly did not have his figures emerge from a flat surface but built a distinctive landscape of cubic forms. Out of the wooden base grow shapes made from inorganic materials: smooth knobs with short chunky stems close to the ground, mushrooms or buds perhaps. The flower, slim and elegant, is opened to the zenith. This game of bold contrasts is significantly softened at a single stroke, for the object is painted entirely in white house paint, disguising differences and drawing the whole composition together in a homogeneously light tone that soon became a characteristic trait of Twombly's three-dimensional works. The paint is applied loosely, irregularly, and allowed to run in places. Twombly may have been using anti-aesthetic materials, but he transposed them into his aesthetic concept where the materials retain their original meaning though in transmuted form. Like the layers of house paint and the pasted-over fabric, the rings in the wood tell of organic growth, ageing, and the phenomenon of time.

While this early sculpture displays certain features familiar from Twombly's paintings, collages, and drawings, it is nevertheless clear that his three-dimensional work derives from a different inner stance and that much of what will evolve later on was already inchoate in these first sculptural works. Apart from a related, although coarser work from 1951—also made from domestic *objets trouvés* and painted entirely white (fig. 4)[4]—the next surviving sculptures date from 1953.

The five years between 1948 and 1953 saw a wealth of changes in Twombly's life. In 1947–48 he attended the Museum School in Boston. A year later he transferred to the newly established Department of Arts at Washington and Lee University in Lexington, Virginia. In 1950 he was awarded a grant that allowed him to study at the Art Students League in New York with Will Barnet, Morris Kantor, and Vaclav Vytlacil. In his second semester there, he met the like-minded Robert Rauschenberg. His time in New York brought him into contact with the avant-garde: he saw exhibitions by Jackson Pollock, Mark Rothko, Barnett Newman, Clyfford Still, and Robert Motherwell at Betty Parsons' and Samuel Kootz's galleries, and works by Willem de Kooning and Franz Kline at Egan Gallery. In 1951 he spent the summer and winter semesters at Black Mountain College, where Ben Shahn and Motherwell were artists-in-residence in the summer. In November he showed pictures he had made at Black Mountain College at the Seven Stairs Gallery in Chicago; Motherwell used his influence to secure a joint exhibition for him and Gandy Brodie at the Kootz Gallery toward the end of the year. In 1952 Twombly and Rauschenberg traveled south together as far as Key West, Florida, and Cuba; back at Black Mountain College, Twombly met Franz Kline, Jack Tworkov, and John Cage all in the same year. With a grant from the Virginia Museum of Fine Arts in Richmond, which he shared with Rauschenberg, Twombly set off on a trip to Europe and North Africa in the autumn. From Naples he went to Rome, then later

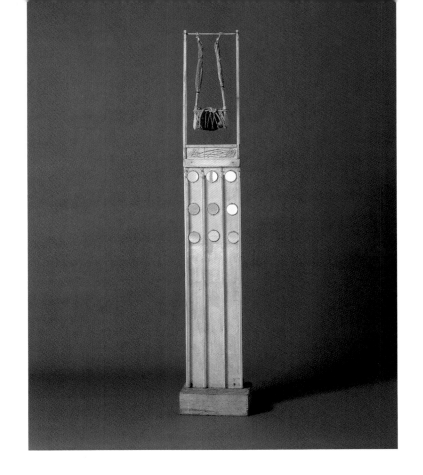

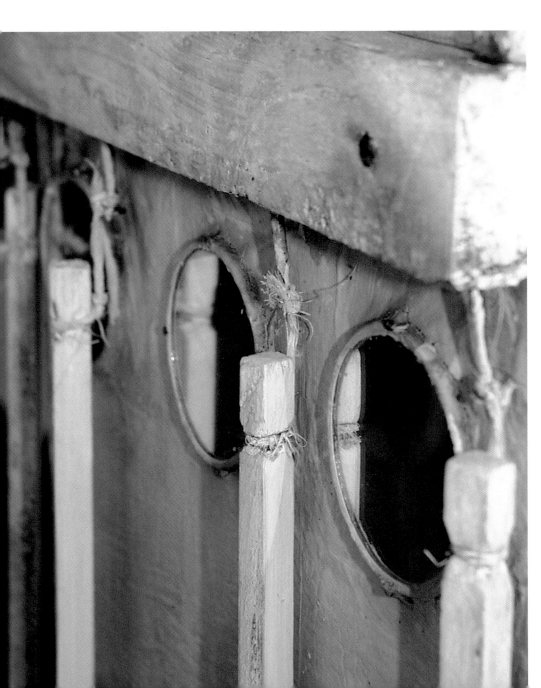

4 *Untitled*, New York 1954

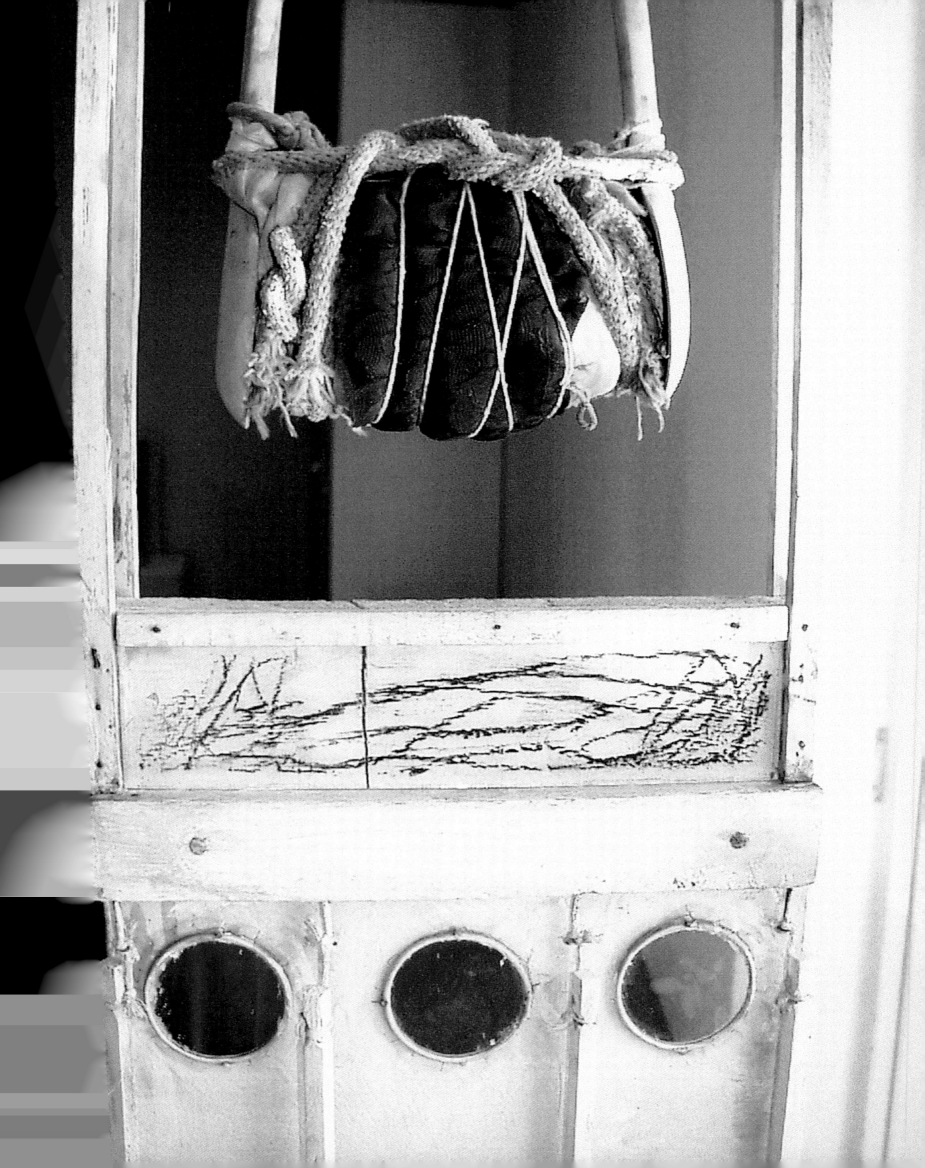

inhaltlich vorherrschenden Prinzip der Dualität: Die klare geometrische Figur des Sockels überhöhen stilisierte Naturformen. Allseits strahlend, doch präzise konturiert, erscheinen die symmetrischen Fächer wie ein wohlgestaltetes Paar junger Bäume; dem schreinartigen Sockel, Requisit des Totenkultes, entwächst die Palme, Symbol ewigen Lebens. Kirk Varnedoe beobachtete, dass Twombly in seinem 1954 ebenfalls in der Fulton Street entstandenen monumentalen Gemälde *Panorama* in der rechten oberen Ecke diese Plastik eingezeichnet hat (Abb. 9), wie vom Duktus seiner Handbewegung mitgerissen und verformt.[11]

Als Twombly nach der Entlassung aus dem Militärdienst seine erste Einzel-ausstellung in der Stable Gallery im Januar 1955 zeigte, bezog er auch Skulpturen ein, von denen heute nur eine erhalten scheint. Sie wurden so gut wie nicht beachtet, nur der Kritiker und Dichter Frank O'Hara nannte sie »geistreich und gespenstisch«, sprach von großen, weißen Kästen mit schwingenden Stäben und Spiegeln;[12] er vertrat überhaupt die Ansicht, dass es diesem Künstler zugute komme, »... allein nach seinen eigenen Maßstäben gesehen zu werden«.[13]

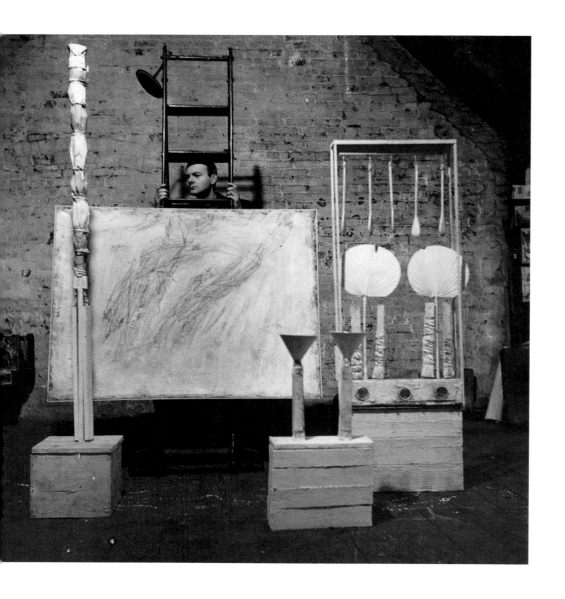

8 Robert Rauschenberg, *Cy Twombly mit Skulpturen und einem nicht erhaltenen Gemälde in Robert Rauschenbergs Atelier · Cy Twombly with sculptures and a painting (non extant) in Robert Rauschenberg's studio, Fulton Street, New York 1954*

traveled on to Morocco. There his path converged with Rauschenberg's again, and the two spent the winter in Casablanca, Marrakesh, the Atlas Mountains, and Tangiers. In Tétuan they met the writer Paul Bowles, with whom they made day trips into the surrounding country. They returned to Rome via Spain; at the Galleria Via della Croce 71, Twombly had his first exhibition in Italy; his second opened on March 14 in Florence at the Galleria d'arte contemporanea with wall hangings he had produced in Tétuan. Made of dress materials, these simple geo-metric-abstract compositions have not survived (fig. 11). In late spring 1953, Twombly returned to New York and worked in Rauschenberg's studio in Fulton Street on paintings, sculptures, and monotypes. In the autumn, he showed a selection of his paintings, sculptures, and drawings at Eleanor Ward's Stable Gallery and in Princeton before being drafted into the army.

The first sculpture he made that year in New York reflects the transition he had undergone and is visibly connected with the drawings he made during his travels with Rauschenberg (fig. 5) and with a subsequent group of pictures (illus. p. 155) that came to terms with his experiences after the event.[5] In the large, powerful drawings and in the paintings marked by black-and-white contrasts, we find dense vertical shapes in sharp, wild, aggressively prickly rows, like a barrier blocking our view into the pictorial depths. Translated into three dimensions, namely, the repetetive vertical shapes, these take on a different accent. No longer does the format of the pictorial medium determine a particular excerpt from a series of similar elements. Instead the little section of fence, improvised from eleven uprights, that we see on a plinth in Untitled (New York 1953, cat. no. 3, p. 21) seems relatively unstable. Six of the elements, including those at either end, are four-sided; all of them reach from the plinth to the irregular top edge. The five remaining rounded uprights are pinned in between; they are shorter and lumpily wrapped with material at the bottom. The ends of the twine used to tie the material hang down into the gaps below them, where we also see the bent nails that hold the rickety structure together. Both here and on the top edge, the nails sprout like thin shoots straining toward the light even as their bent shape reminds us of the hefty blow used to plant them there. Two broad, loosely woven jute bandages, carefully wound round the uprights, emphasize the flat frontality of the object. More or less smooth with a trace of white, these bindings contain the overall form and create a sense of calm that contrasts with the segmental rods and obsessive ties and knots. Although these anti-aesthetic materials bear traces of previous use, our attention is drawn more to how they have been reused here. Pieces of wood, remnants of material, twine, nails, wrapping, ties, knots, emphatic frontality—these different elements intensify each other, creating a sense of powerful psychic energy. The similarity of this two-sided object to panpipes, or the syrinx,[6] overmasters the notion of a fence and is itself overlaid by the symbolic meaning of a boundary marker and by the magic aura of the knots. The whole becomes a raw, plaintive lament. A few years later, Twombly would return to the theme and compose it over again.

9 Cy Twombly, *Panorama*, 1954. Detail
Daros-Sammlung, Schweiz

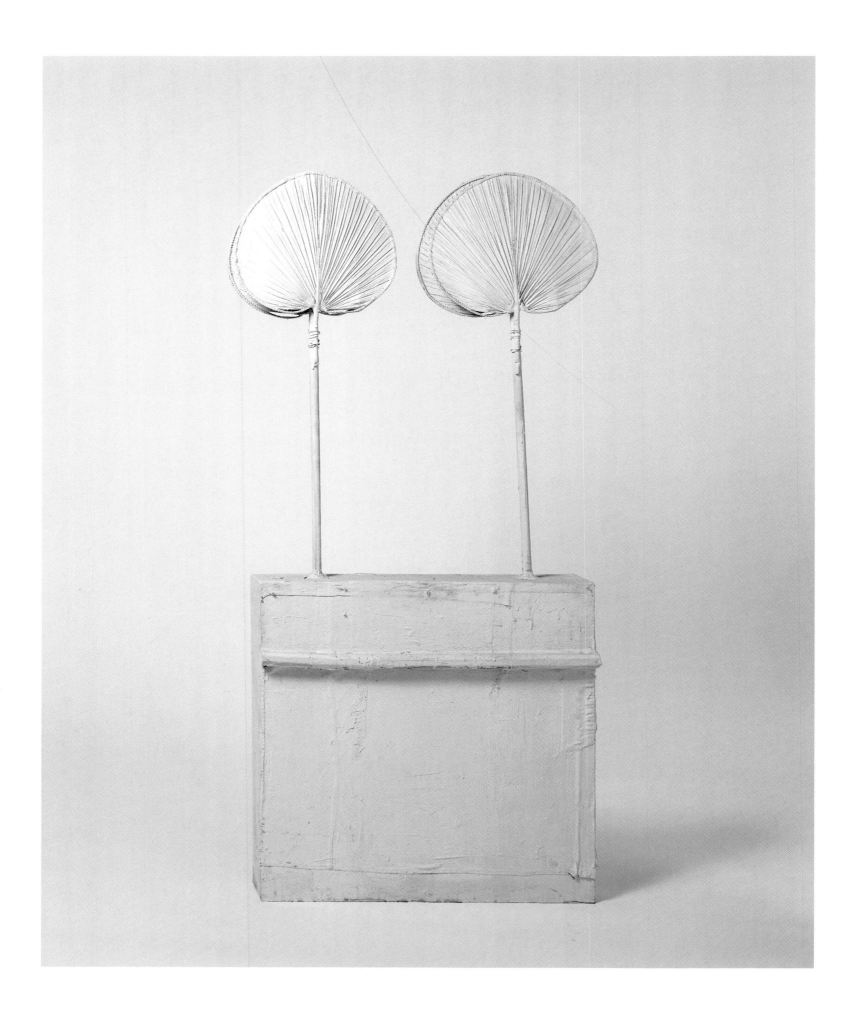

In his application for a travel scholarship, Twombly made particular mention of his interest in the traditional roots of modern art, listing fetishes and ritual objects as well as classical forms.[7] Certainly his conversations with Rauschenberg must have had a decisive influence in this respect. This becomes evident above all in the photographs of Rauschenberg's hanging fetishes (now lost), his *Feticci Personali* made from wool, cords, fur, pearls, mirrors, and textiles, which he exhibited for a day in the Pincio Garden in Rome (fig. 6). Despite their shared aims and close proximity, the two artists always remained clearly distinguishable as individuals. Many of Rauschenberg's works from the early 1950s have been destroyed or lost, and the information we have on a group of Twombly's early sculptures, is recorded only in a handful of documents.

In his studio in 1954, Rauschenberg photographed his friend with a number of sculptures, of which only one has survived in a reworked form (cat. no. 5, p. 30). In one of the photographs, five works are visible (fig. 7): a two-meter stele, half of it wrapped with paper and tied; a flat base on the floor with thin, strawlike wooden rods growing straight up out of it; two funnels sprouting like blooms, their sturdy stems rising from a coarse, whitewashed crate; and two more sculptures echoing this arrangement. Twombly stands among the strange objects, including flat "storage units," and boxes with high plinths, towered over by pairs of fans on tall stalks, the whole impression reinforced by a freestanding frame. The front of the lower of the two works grasped by the artist is covered with the same loosely flowing *graphismes* one finds in his paintings.

One sculpture from this period has survived unaltered: Untitled (New York 1954, cat. no. 4, pp. 26–27), today in The Menil Collection in Houston. The structure, in which a tall, slim stele stands on a low base, is in two sections. The top third of the much larger lower section, which is divided by four thin stick pendulums, is specially decorated with three rows of small symmetrically placed mirrors; their reflectivity dissolves the surface and incorporates the immediate surroundings into the sculpture, capturing one's gaze and returning it. Just as he used two different kinds of light—from the white paint of the plinth and from the mirrors—Twombly also contrasted two different kinds of lines: the vertical shadows cast on the back wall by the suspended pendulums and the free-flowing *graphismes* that he executed like handwriting in the small compartment across the top of this section. The strange pendulum directly above this, hanging from thin rods, seems to be taken from the realm of magic and ritual. A dark wad of material is held between the bowls of two flat wooden spoons flimsily tied together. To whom it may refer, and whose life it echoes, remains a secret; with its strictly geometrical overall structure and its strong cross-hatchings, the work generates a magically mysterious concentration of vital energy.

While Twombly—like Rauschenberg in some of his *Elemental Sculptures* of 1953[8]—adopted the notion of hanging three-dimensional forms in the manner of Giacometti or Alexander Calder, he seems to have been especially fascinated at the time by the expressive intensity of magical objects. Another of Rauschenberg's photographs (fig. 8) shows the one surviving sculpture with two palm fronds; in

5 *Untitled*, New York 1954

6 *Untitled*, New York 1955

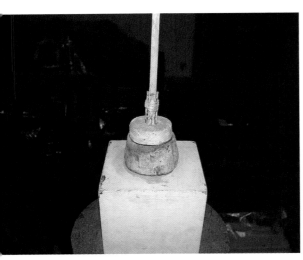

6 *Untitled*, New York 1955

Im selben Jahr 1959 entstehen drei weitere Skulpturen, die an Fetische oder rituelle Gegenstände gemahnen. Alle verarbeiten Fundstücke aus Holz, Stoff, Schnur, Kordel kommen in der Verbindung ihrer Einzelteile ohne zusätzliche Hilfsmittel aus: stecken, schnüren, keilen, klemmen, umwinden, verhüllen. Die Akribie und Konzentration, mit der die einfachen Elemente präpariert und zu ihrer endgültigen Gestalt zusammengefügt werden, teilen sich in den geheimnisvollen Objekten mit. Die schlanke Stele (*Ohne Titel*, New York 1955, Kat. 6, S. 32 und 33), die mit Giacomettis Frauenfiguren verglichen wurde, lässt eine Dreiteilung erkennen, die tatsächlich anthropomorphe Assoziationen weckt. Der zylindrische Fuß, dessen runde Form sich absetzt von einem kubischen Sockel, bietet der fest in einer kleinen Rosette verkeilten Stele Fügung. So kann sie den seltsam glatten Beutel tragen, der über ihr oberes Ende wie ein kleiner, praller Leib herabhängt und das Zentrum bildet. Rechts und links davon streben zwei dünne Stäbe auf, klemmen ein kürzeres Holzteil zwischen sich und enden stumpf, von einer Stoffbandage straff umwickelt. Obwohl das Säckchen die Schauseite beherrscht, spart Twombly darüber eine Leerstelle aus, zwingt den verhüllten, mysteriösen Kern mit der einfachen Durchsicht zusammen. Die eleganten Proportionen, die subtil ausponderierten Kräfteverhältnisse zwischen Halten, Tragen und Ziehen, zwischen Steigen und Hängen, bilden den Reiz dieses Objektes, bei dem sich alles auf den Gegensatz von Transparenz und Verhüllung konzentriert.

Bei *Ohne Titel* (New York 1955, Kat. 7, S. 33) handelt es sich nicht um eine stehende Figur, sondern eine Art modellhafter Anlage von kubischer Gesamtform, die sich in der Aufsicht erschließt. Wieder spielen Symmetrie, Parallelität und Dualität eine entscheidende Rolle. Auf einem kompakten Sockel sind zwei T-Träger aus Holz befestigt, an der Innenseite nochmals durch kleine Vierkantleisten verstärkt. Der eine dieser beiden Stege zeigt in der Oberkante zwei Einkerbungen. In sie geklemmt, zusätzlich mit Nägeln fixiert, steckt das gezwirbelte feine Tuch, das zungenartige Formen umhüllt und ihnen eine schmiegsame Befestigung bietet, wobei das Leinen mit der geometrisch starren Trägerkonstruktion kontrastiert. Wie ovale Brückchen überspannen sie die Unterkonstruktion, die Spitzen knapp aufgestützt. Das enigmatische Objekt erinnert nicht nur an Architekturmodelle und einfache Demonstrationen statischer Probleme, aus der Erinnerung taucht eines jener altägyptischen Schemelchen auf, die den Füßen des Pharaos eine formgerechte Stütze boten; an flache Boote denkt man auch, die, nur ein wenig angelehnt, zwischen Liegen und Treiben, zwischen Wasser und Land verharren. Folgte man dieser Assoziation, klänge hier schon ein Motiv an, das Twombly später intensiv beschäftigen wird.

Ohne Titel (New York 1955, Kat. 8, S. 34), wieder eine kleine Standfigur, betont das krude Fabrikat. Eine flache, quadratische Platte hält einen in der Mitte aufragenden Vierkantstab, Ständer für fünf aus seinem oberen Ende ragende Latten. Während das etwas kürzere mittlere Holz blank belassen blieb, sind die übrigen in alte Textilien mit Nähten und Verschleißspuren eingeschlagen, der überstehende Teil umgelegt und verschnürt. Alles kantige Rohmaterial ist unter der

6 *Untitled*, New York 1955

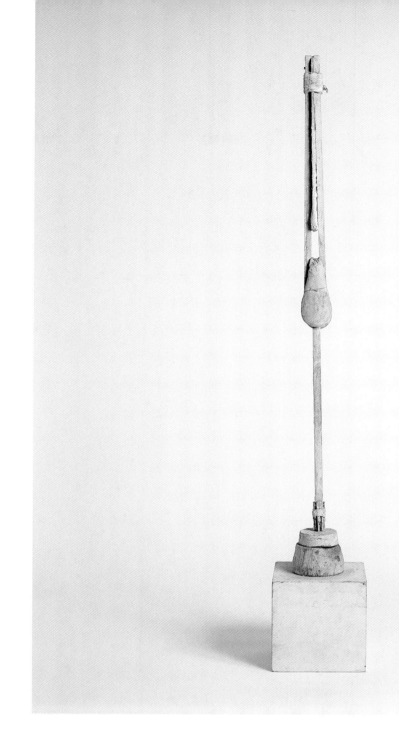

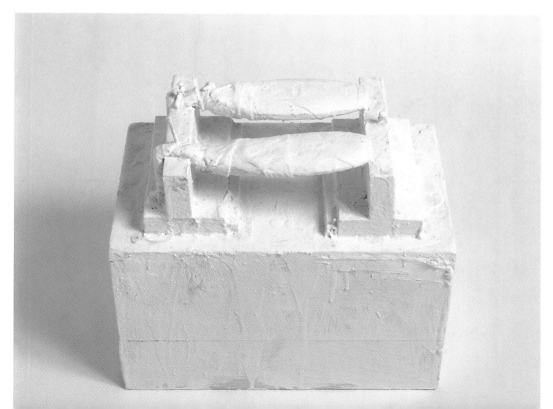

7 *Untitled*, New York 1955

33

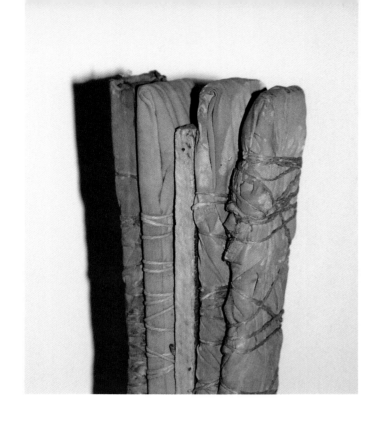

8 *Untitled*, New York 1955

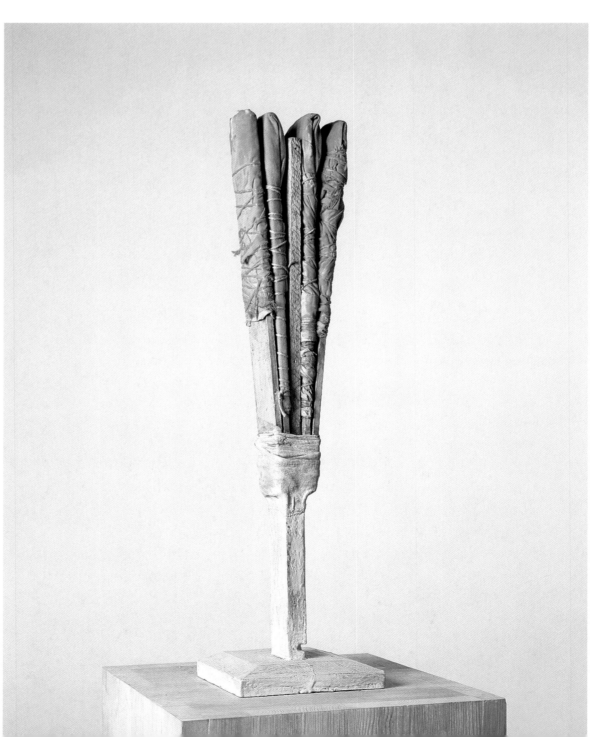

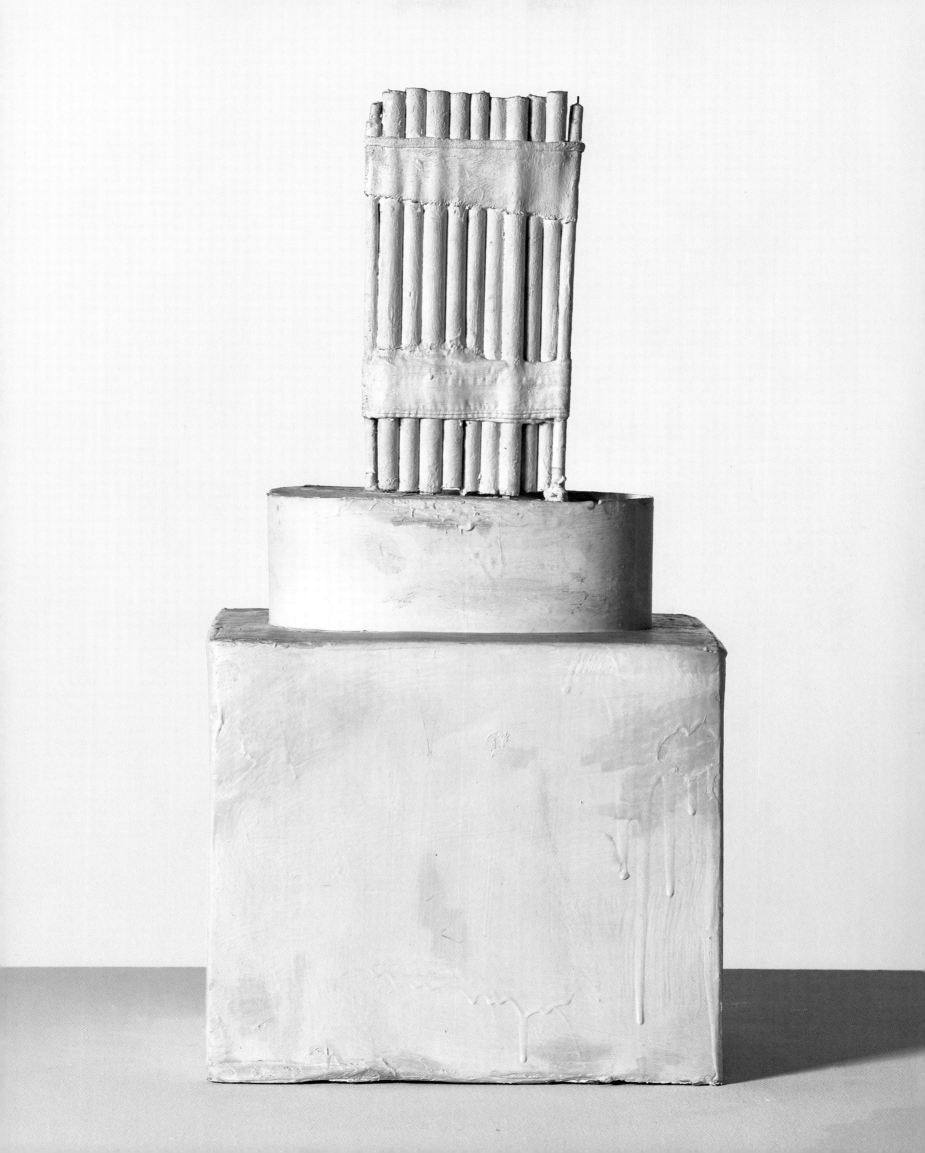

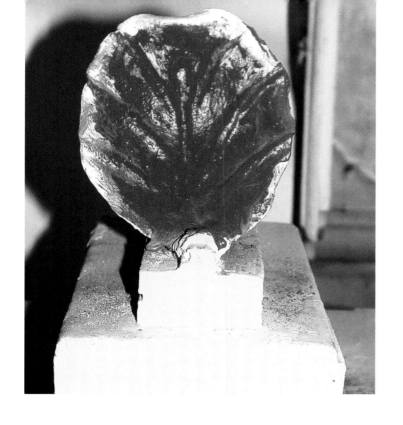

10 *Untitled*, New York 1959

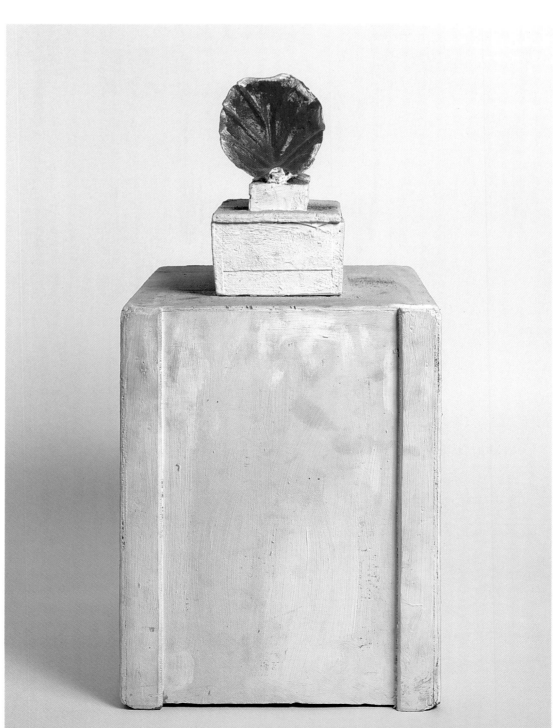

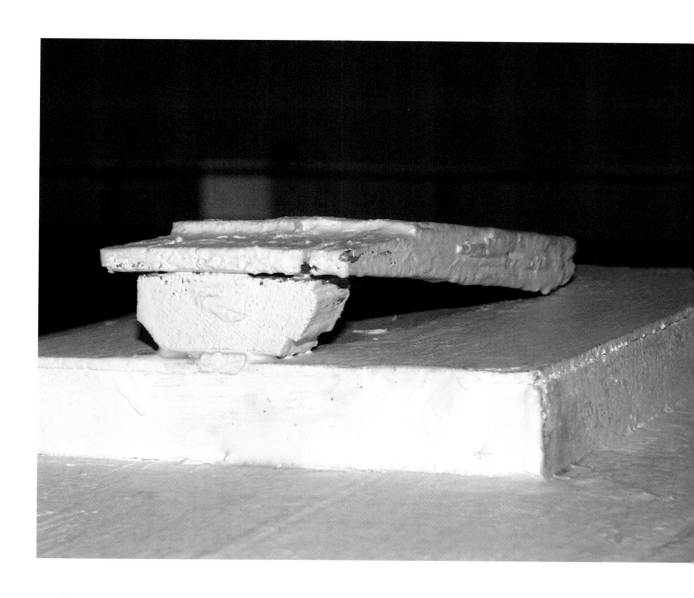

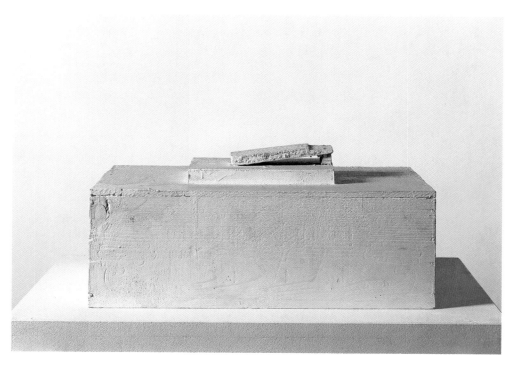

12 *Untitled*, Rome 1978

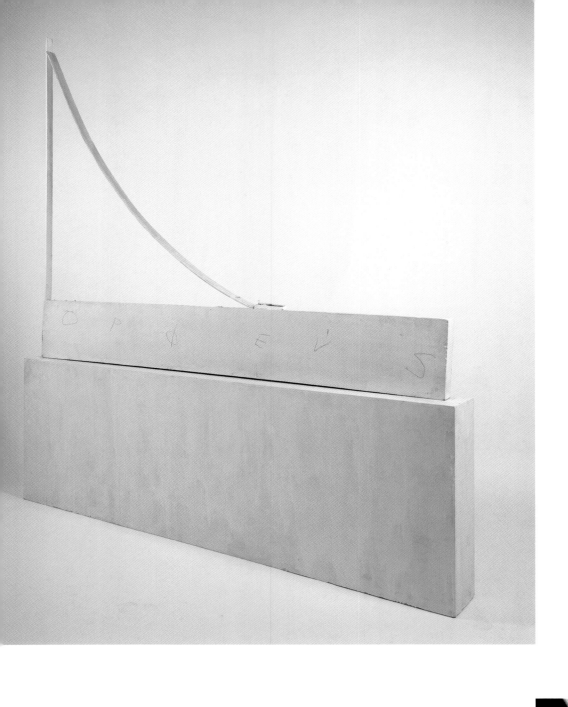

15 *Orpheus (Du unendliche Spur)*, Rome 1979

15 Cy Twombly, *Veil of Orpheus*, 1968
Private collection

materials used to make this assemblage are still perfectly simple and bring their own history with them, everything seems softer, smoother. Set on a high cuboid plinth made from a corrugated cardboard box, a smaller oval base forms a little plateau. On this altar, we see the icon itself: again eleven rods bound with cloth into a rank, rather like a set of panpipes. There are no gaps between them; only a slight unevenness upsets the straight row, providing rhythmic energy. Strips of soft white linen cover the twine that holds the rods together. Twombly did not angle the lower edge of the instrument but retained its rectangular, archaic form and its fencelike character, which—like the flute itself—may evoke associations with the "great Pan" (fig. 13), for his realm lay beyond civilization in Arcadia, the free natural world.[18] The three-fold horizontal articulation of the overall sculpture, which is repeated in the "flute," the extremely carefully balanced proportions, and the luminescent white paint underlining the unity of the figure and its setting combine to give the work its classic beauty.

"White paint," Twombly remarked in a conversation in 1999, "is my marble. I have thought of adding colors like Picasso did with his *Glass of Absinthe*, but I didn't succeed."[19] Apart from the restrained colors of some found objects (mostly pieces of wood left unpainted), isolated traces of colored chalks, the patina on his bronze casts, and various whitewashes, Twombly has worked only twice with intense pigments. Untitled (New York 1959, cat. no. 10, pp. 42–43) is the first known example of a three-dimensional work where Twombly used a glowing red. Again the overall composition consists of a number of stages. On a cube—a crate strengthened at the front with two strips of wood—lies a box topped by a third long, low box that serves as a plinth for a shell standing upright at the front edge. Growing out of a soft rosette, it confronts the viewer with the red of its inner oval. Powdery traces of the pigment are scattered on the plinth, radiating an aura all their own. The shell—which Twombly made from a spatula-shaped leaf[20]—may be read as a symbol for Venus, just as the flute may be read as a symbol for Pan. Red, the color of love, which Twombly also uses in his drawings when he writes the name of the goddess, dominates the little altar like those cult figures to whom the faithful bring their libations. The powder, growing paler from step to step,

Pan wird abermals ein mythischer Hirte und Sänger zitiert, dem man auch sonst in Twomblys Gemälden und Zeichnungen begegnet. Twombly greift aber nicht auf die reiche Orpheus-Ikonografie zurück, sondern auf Rilkes *Sonette an Orpheus*,[29] jenem 1922 auf Schloss Muzot entstandenen zweiteiligen Zyklus von 26 und 29 Gedichten. Der späte Rilke wählte den tragischen Sänger stellvertretend für den Dichter, dem einzig er noch eine Sinn stiftende Kraft zutraut. Sein »Lied überm Land / heiligt und feiert«.[30] Peter Pfaff spricht von einem der letzten bedeutenden Versuche, eine ästhetische Metaphysik zu begründen.[31] Liebe zu anderen Künsten, ganz besonders zur Dichtung,[32] lässt Twombly Themen und Motive wählen, die, in Sprachbildern formuliert, sich übersetzen lassen in sein Medium. (Abb. S. 179) Die Metapher von der Spur der Kunst findet hier ihre Analogie in der Linie, die von einer seltsam kleinteiligen, sperrig-aggressiv vernagelten Stütze »unendlich« aufsteigt. Auch sie lässt sich, wie der Name des Dichters, in zwei Richtungen lesen. Ob sie aufsteigt oder herabschwingt, bleibt offen. Damit klingt ein Thema an, das Twombly in weiteren auf Rilke Bezug nehmenden Skulpturen behandelt, das Steigen und Fallen ineins.

Das zweite Thema, das der Künstler seit 1977 in der Skulptur behandelt, ist der Wagen. Zu Weihnachten schenkte er seiner Frau einen »Blumenstrauß auf Rädern«. (Abb. S. 168) Dabei variiert er in plastischer Form eine bildliche Vorstellung, die er im Februar/März 1974 auf Captiva Island und anschließend im Mai in Rom mit den Sesostris II.[33] gewidmeten Papierarbeiten entwickelt hatte. Drei blaue Lotoskelche recken sich auf einem hölzernen Stängel, der auf einem fahrbaren Untersatz wie aus einer anderen Welt ankommt. Die Inschrift »CAR NYMPHAEA CAERULEA« lässt an einen Festwagen zu Ehren der Nymphe denken. Der blaue Lotos galt im alten Ägypten als heilige Blume. Drei Blüten bildeten zusammen die Hieroglyphe für »Pflanze«, Vergangenheit, Gegenwart, Zukunft und Ewiges Leben symbolisierend. Seine Darstellungen, einzeln, in bestimmter Zahl, zu Sträußen gebündelt, durchziehen als charakteristischer Schmuck die altägyptische Kunst; Lotos diente auch als Grabbeigabe.[34] Yvon Lambert erwähnt noch weitere Bedeutungsnuancen im Zusammenhang mit den Sesostris-Arbeiten.[35] Statt der Blüten als symbolträchtige Fracht tritt mit *Ohne Titel* (Rom 1978, Kat. 13, S. 51) das Fahrzeug selber mehr in den Vordergrund. Dabei wählt Twombly wieder primitive Vorbilder; an etruskische Beispiele (Abb. 16), ja an antikes Kinderspielzeug lässt sich denken bei dem niedrigen, gestreckten Zweirad, das man am besten von der Seite, mit der ganzen Länge seiner niedergelegten Deichsel betrachtet. Als langes, schmales Brett auf die kurze Achse zweier hölzerner Radscheiben genagelt und mit einer Auflage verstärkt, ragt sie weit vor, als liefen die Pferde an überlangen Zügeln; nun aber, ohne Gespann, zeichnet eine weitere dünne Latte die sanfte Linie ihrer Leinen nach. Festgemacht ist sie oben an einem Brettchen, das, senkrecht auf der Radachse errichtet, einem Lenker knappen Stand gewährte. Ist alles äußerst strikt, klar und minimal gestaltet, hier auf der Oberkante dieser kleinen Brüstung knäult es sich: Um Ringschrauben gewickelt, durch Ösen gezogen, mit Klemmen versehen, gedreht, gebogen, ver-

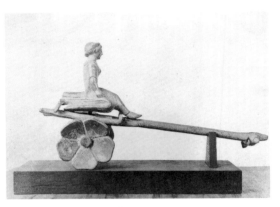

16 Demeter auf einem Wagen, etruskisch, 4. Jh. v.u.Z.
Demeter on a chariot, Etruscan, fourth century B.C.
The British Museum, London

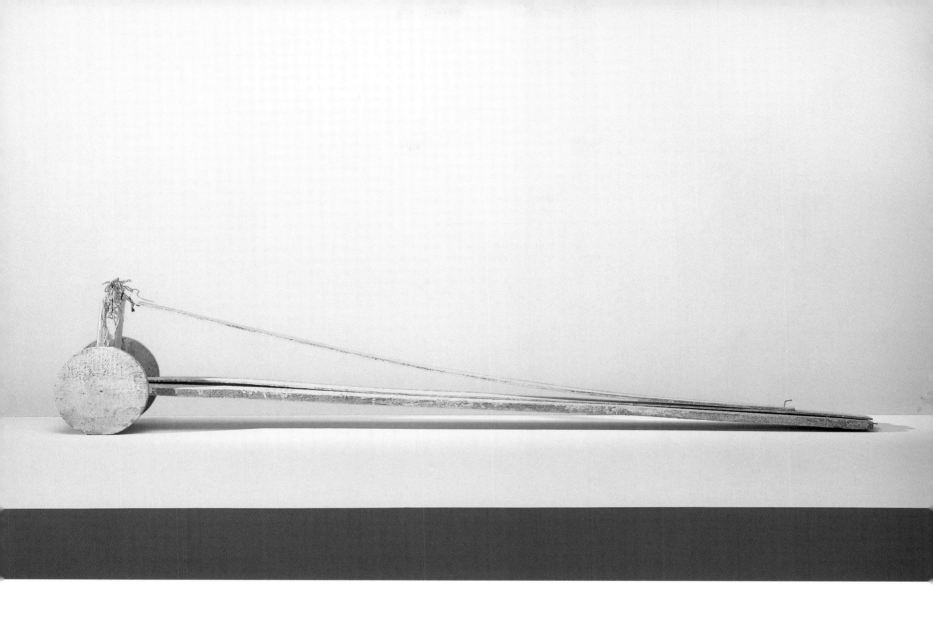

13 *Untitled*, Rome 1978

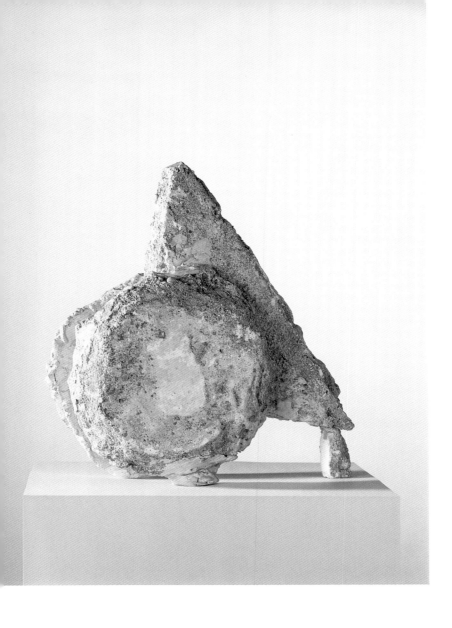

16 *Untitled*, Bassano in Teverina 1979

52

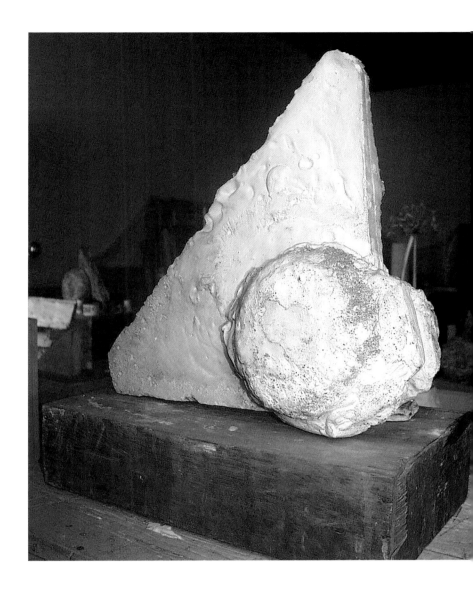

17 *Untitled*, Bassano in Teverina 1979
 Bronze, Rome 1979
18 *Untitled*, Bassano in Teverina 1979

18 *Untitled*, Bassano in Teverina 1979

strikt – ein ganzes krauses Drahtgewirr ist aufgeboten für dieses eine schwingende Teil, das nur ein krummer Nagel an seinem vorderen Ende sichert. Bedingt die niedrige Achse die Bodennähe des Gefährts, so weckt die kompakte Rundform der kleinen Räder die Vorstellung von kurzen Bewegungsimpulsen, während die überlange Deichsel, überhaupt die ganze lange, flache Konstruktion an schnelles Fortkommen, an weite Strecken, an riesige Distanzen und Räume denken lässt. Archaisches Relikt, Modell, Spielzeug – von schlichter Eleganz und fast rührend in seiner Simplizität – entfaltet dieses Gefährt in Ruhestellung das ganze Faszinosum einer genialen Erfindung und ihrer erstaunlichen Effizienz.

Andere Skulpturen mit Wagendarstellungen entstehen 1979 und 1980 in Bassano, allerdings nun mit neuen Mitteln. *Ohne Titel* (Bassano in Teverina 1979, Kat. 16, S. 52) ist die erste bekannte Arbeit, für die Twombly ein Gips-Sand-Gemisch verwendete und die einzelnen Elemente goss.[36] Das ergab ein raues, grau-weißes Gebilde mit unregelmäßiger Oberfläche, bröselig an Rändern und Kanten, dazwischen unvermutet glatte Partien. Die Komposition ist denkbar einfach und so angelegt, dass die Hauptansicht das Gefährt von der Seite zeigt: zwei plumpe Radscheiben, dazwischen, auf der Höhe der Naben, ein gleichseitiges Dreieck als Wagenkorb wie bei antiken Streitwagen. Hinten hält eine kurze Stütze die Standfläche waagrecht wie im Einsatz; von vorn wird deutlich, dass der Wagenkasten nicht dreidimensional konzipiert ist, sondern nur aus einer Scheibe besteht, deren aufragende Schmalseite sich mit den Radkugeln zum Anblick eines Phallussymbols verbindet. Der Streitwagen, Attribut des Kriegsgottes Ares, spielt als Dreieck stilisiert in Twomblys 1977/78 in Bassano entstandenem zehnteiligem Gemäldezyklus *Fifty Days at Iliam*[37] eine beherrschende Rolle. Kreise, Dreiecke bestimmen die Kampfformationen der Götter, der Helden, und die phallische Form drückt die tödliche Aggression des Angriffs aus. Diesen dynamischen Eindruck nimmt die Ruhestellung des Vehikels etwas zurück, ohne die starke emotionale Besetzung zu mindern. Die Deutung des Wagens wirkt offener, umfasst sie das alltägliche urtümliche Fortbewegungsmittel sowie das gloriose Triumphgefährt für Menschen und Götter. Dies gilt sehr ähnlich für die im gleichen Verfahren hergestellte Skulptur *Ohne Titel* (Bassano in Teverina 1979, Kat. 18, S. 53 und 55). Die Komposition lässt kaum einen Unterschied erkennen. Einzig die beiden Radscheiben sind etwas kleiner; das Dreieck, entsprechend niedriger, liegt mit dem hinteren Winkel auf dem verwitterten, dunkelbraunen Sockelkistchen auf, die Abstraktion wirkt weiter getrieben. Die beiden Hauptansichten sind unterschiedlich behandelt: Während die eine rau blieb, wie der Guss es ergab, bedeckt die andere eine dicke, weiß-sämige Gipsschicht. Die auffallende Dualität, schon mit den beiden Materialien gegeben, kommt auch im Kontrast der Vorderansicht des Wagens, einer Phallos-Statue,[38] mit dem seitlich betrachteten Wagenkorb, einem Dreieck, zum Ausdruck. Dies zeigt, wie sehr das spannungsvoll-intensive Objekt mit symbolischen Details aufgeladen ist, die sich elementar auf die Geschlechterproblematik beziehen. Der ganze Stapel von reizvoll verwitterten Kisten, die Twombly auftürmt und mit dieser Figur krönt, liefert einen wie in Generationen gewachsenen Unterbau, von den »Linien des Lebens« gezeichnet.

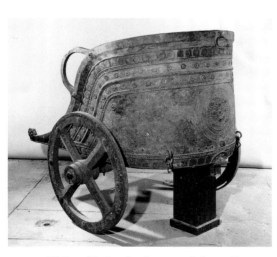

17 Etruskischer Streitwagen, 4. Jh. v.u.Z.
Chariot, Etruscan, fourth century B.C.
The British Museum, London

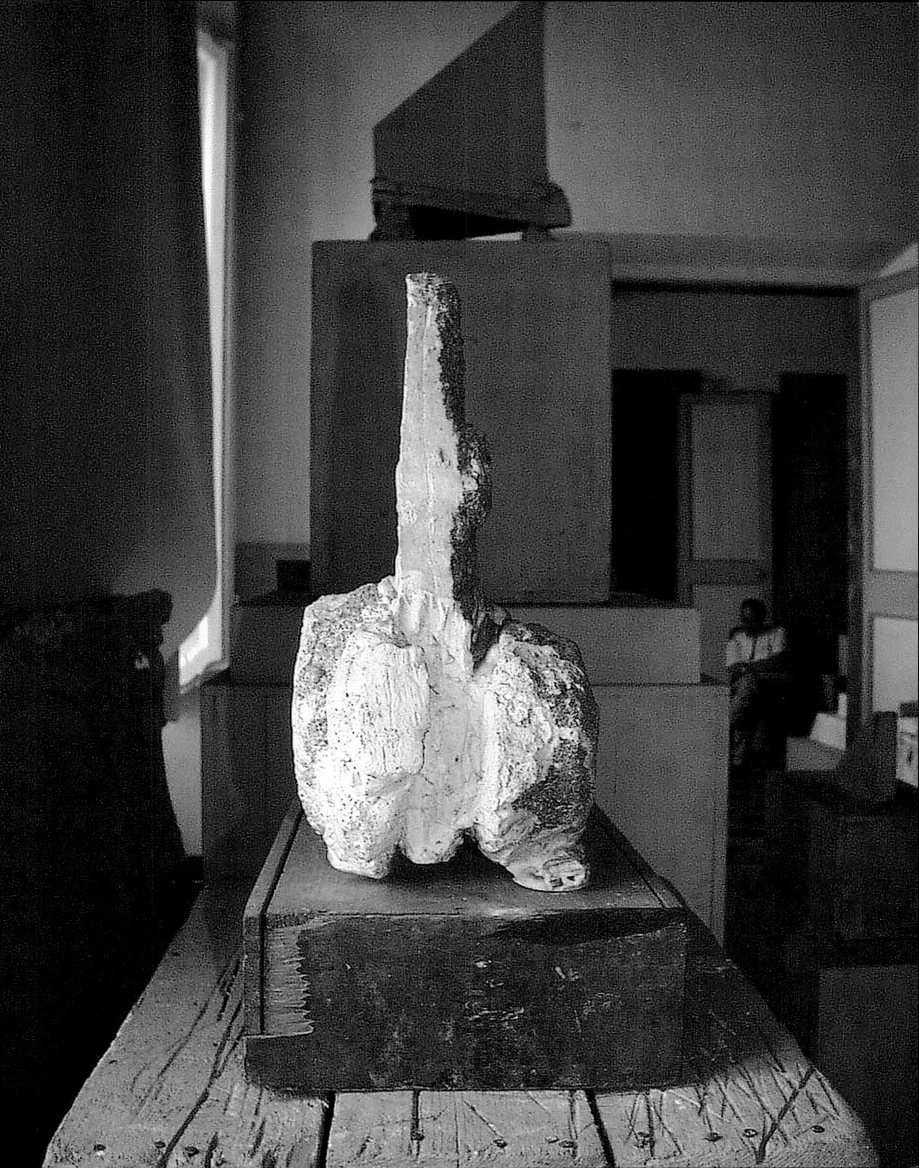

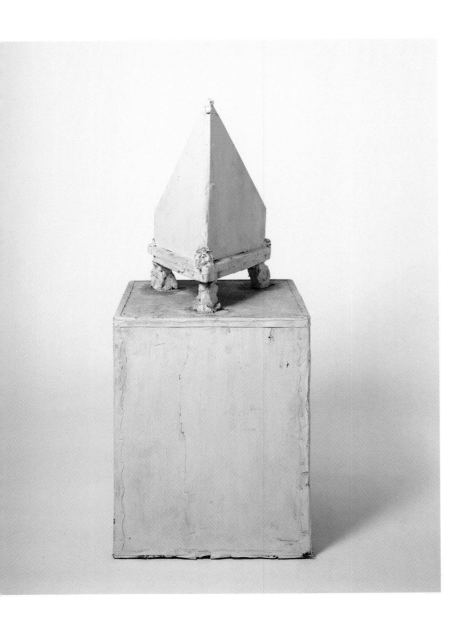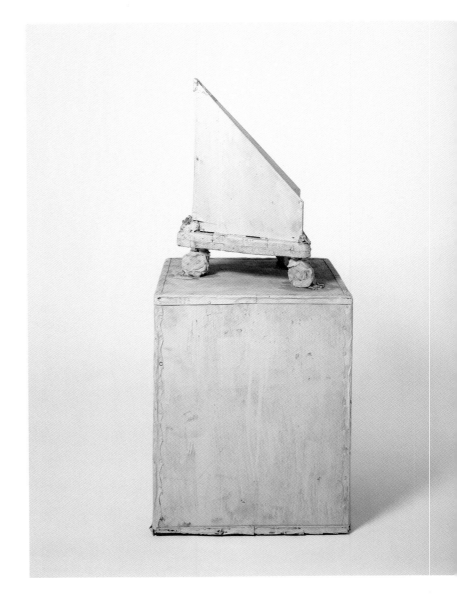

23 *Anabasis*, Bassano in Teverina 1980

echoes the gesture of supplication; its gradual disappearance symbolizes the transience of feeling.

In keeping with its altarlike character and the hieratic quality of the shell, the frontal aspect of this sculpture absorbs all our attention. Beneath the shell, we discover a kind of disc, flat like an unopened bud; since both forms spring from the same stem, they could be seen as different stages of a single process of development. The overall concept might be taken as an image of the blossoming and wavering of emotion, but there is no knowing for certain. One thing we may be sure of is that this theme would have had particular significance for Twombly in a year of momentous events in his personal life. This "altar to love" was to be the last sculpture that he produced for many years.[21]

As a painter, Twombly produced substantial groups of works in response to his new surroundings, both the natural environment and the hot summer climate. The coastline, the atmosphere of the sea, shifting clouds, the seasons—all are reflected in his pictures and in the airy poetry of his drawings. In these expanses of space and time, his protagonists are Sappho, Plato, and Catullus, and as in the tragedies of antiquity, the gods and heroes that Twombly invoked by name leave behind bloody traces, above which hovers Thanatos, the winged god of death. When Twombly returned to sculpture in 1976, the change in his style was readily apparent. He reacted to the theories of Minimal Art, with its reduction of form and its material concretization, by creating groups of paintings and drawings that reflect on themes such as movement, space and time, and numbers and proportions. The first of these sculptures, such as Untitled (Rome 1976, cat. no. 11, p. 44), are of the utmost simplicity and clarity. In choosing cardboard tubes of the kind used for sending rolled-up drawings, Twombly called on utilitarian items close at hand in his own studio. He then set the thinner tube on top of the slightly thicker one. The natural brown color of the cardboard tubes is hidden by white paint, which has been allowed to run and drip; the paint ennobles the form, underlining the tubes' original purpose of protecting works of art and yet obscuring it as well, bringing the two individual objects together in a single two-part structure. Twombly did not put the top cover in position, one can see into the empty interior and take in the correspondence between outer and inner form. Twombly made four of these stele constructions, playing with different proportions, returning to the larger formats he had tested in 1954. While the unusual dimensions determined by the use of prefabricated materials might awaken associations of stylized human figures (fig. 14), these works also resonate with the artist's interest in the general nature of human existence and with his special capacity of abstraction, which led his fascination with all things organic, and the many forms they may take, back to the fundamentals of being.

In 1975 Twombly began to restore a fifteenth-century house in the medieval town of Bassano, north of Rome, and to build an adjoining studio. This task occupied him for the next three years.[22] Bassano, not far from Bomarzo, was to be his place

19 *Untitled*, Bassano in Teverina 1980

Anabasis (Bassano in Teverina 1980, Kat. 23, S. 56) verweist durch den Titel direkt auf den martialischen Aspekt,[39] formuliert das Wagenthema aber anders. Was dem Betrachter hier auf hohem Sockel wie ein leuchtend weißer Schiffsbug entgegenkommt, entfaltet die Aura von Sieg, von Triumph. Twombly verwendet wieder Fundstücke, Strandgut des Alltäglichen. Diesmal bildet er den Wagenkasten dreidimensional aus, arbeitet mit einer Mehransichtigkeit der Skulptur. Eine hohe glattwandige Kiste, entlang den Kanten mit Blechbändern beschlagen, die Längsseite für die Vorderansicht bestimmt, trägt das Wägelchen. Als seine Bodenplatte dient ein ehemaliger fahrbarer Untersatz für große Topfpflanzen. Seine Rollen sind durch dicke weiße Knetmasse arretiert und so verpackt, dass ihre funktionale Form fast ganz unter der weichen Modellierung verschwindet. Zwei deckungsgleiche Sperrholz-Trapeze bilden den spitzwinklig aufragenden Korb. Keine Kenntnis jener etruskischen Streitwagen (Abb. 17), die die Villa Giulia aufbewahrt, keine Lektüre antiker Schriften vermag Twombly in historisierende oder philologische Bahnen zu lenken. Sein Umgang bleibt frei, schöpferisch. So kann er immer wieder mit elementaren Formen und Figuren von monumentaler Wirkung eine Brücke schlagen. Sie verbindet die Erinnerung an die Simplizität fundamentaler kultureller Entdeckungen, an ihre Entwicklung in Mythos und Geschichte, mit der gewachsenen aktuellen Bedeutung seines Gegenstandes.

Die Faszination des stillgelegten dreirädrigen Vehikels geht nicht allein von der Höhe und Helligkeit seiner Erscheinung aus. Immer heben die gewählten, die umgedeuteten Alltagsgegenstände im neuen, künstlerischen Zusammenhang die formgebende Qualität ihrer geometrischen Struktur hervor, nun aber nicht mehr funktional, sondern ästhetisch relevant, scheint sie als das höhere Prinzip in ihnen enthalten und korrespondiert mit dem Anspruch, den der Akt der Symbolbildung stellt. Erst auf dieser Ebene wird verständlich, warum sich Twombly nicht einfach für primäre Formen der Kunst interessiert, sondern seine Bezugsfelder – wenn nicht Natur, Landschaft, Fauna – in Zonen hochentwickelter Kulturen liegen. *Anabasis*, der kleine Triumphwagen, steht vor uns: Startbereit, siegessicher und rührend zugleich auf seinen fixierten Rädern, feiert er die Schönheit der Geometrie, die Metamorphose der Dinge, die Einfachheit des Sublimen.

Seit 1981 nimmt Twomblys Arbeit mit Skulptur zu, ein Großteil des plastischen Œuvres stammt aus den letzten zwanzig Jahren. Da er nicht gleichzeitig malt oder zeichnet, lässt dies Rückschlüsse auf die anderen Medien zu. Im Wechsel zwischen glatteren, feineren und raueren, gröberen Arbeiten, entstehen immer wieder solche, die ähnliche Themen und Fragestellungen umkreisen: Bewegung und Stille, Raum und Zeit.

Was kann es mit einem so herben Objekt wie *Ohne Titel* (Bassano in Teverina 1980, Kat. 19, S. 59) auf sich haben? Grob die Holzkiste, fast ein Würfel, grob die drei hoch gestellten Bretter, eines hinten in der Mitte hochkant bündig an die Kistenwand genagelt, die anderen beiden, etwas schmäleren von vorn dagegengelehnt und mit Ton gehalten, auf eine Schauseite hin nachlässig weiß gestrichen, mit Rinnsalen, »Nasen«, ungedeckten Stellen; wulstig verkrustet, verklebt.

19 *Untitled,* Bassano in Teverina 1980

the work of Rainer Maria Rilke.[27] A flat lath rises to a height of almost two and a half meters from the narrow end of a long, shallow two-part plinth. Running upward from the plinth to the top of the lath, fixed by nails and small pieces of wood, a second thin lath describes a gentle curve, inviting the viewer to imagine it continuing into infinity in both directions. The composition of the work reflects formal opposites: surface–line and closed–transparent. In widely spaced Greek letters, the name "Orpheus" runs in opposite directions on either side of the plinth; in the title this is complemented by the Rilke quote, "Thou unending trace." The relationship to the painting of the same name made in Bassano in summer 1979 is evident (fig. 15).[28] Orpheus—like Pan, a mythical shepherd and singer—is encountered in other paintings and drawings by Twombly as well. But Twombly did not go back to the rich iconography of the Orpheus myth, turning instead to Rilke's "Sonnets to Orpheus,"[29] a two-part cycle of twenty-six and twenty-nine poems written at Schloss Muzot in 1922. Rilke, in his late period, chose the tragic singer to represent the poet, who alone retains the power to give meaning to the world: his "song alone circles the land / hallowing and hailing."[30] Peter Pfaff described this as one of the last meaningful attempts to found an aesthetic metaphysics.[31] Twombly's love of the other arts, especially poetry, led him to choose themes and motifs that—having originated as word-pictures—lent themselves to translation into his own medium (fig. 26, p. 179).[32] The metaphor of the traces left by art finds an analogy in the line that curves up "unendingly" from a strangely small, clumsily aggressive base. This, too, like the name of the poet, may be read in two directions. Whether it is rising upward or curving downward remains an open question. And this in itself touches on a theme that Twombly addressed in other sculptures alluding to Rilke: the phenomenon of rising and falling in one.

The second theme the artist took up in 1977 is that of the chariot. For Christmas he gave his wife a "bouquet of flowers on wheels" (fig. 16, p. 168). This was, in effect, a three-dimensional variation on an idea he had developed in the works on paper dedicated to Sesostris II, that he made on Captiva Island during February–March 1974 and again in Rome in May.[33] Three blue lotus blossoms strain upward from a wooden stem set on a mobile base apparently arriving from another world. The inscription "CAR NYMPHEA CAERULEA" brings to mind thoughts of a processional chariot in honor of the nymph. In ancient Egypt, the blue lotus was revered as a holy flower. Three conjoined blossoms form the hieroglyph for "plant," symbolizing past, present, and future, and eternal life. They regularly crop up, singly or in bouquets, as a characteristic decorative form in ancient Egyptian art. Lotus flowers also served as burial offerings.[34] Yvon Lambert mentions yet more nuances of meaning of lotuses in connection with the Sesostris works.[35] In Untitled (Rome 1978, cat. no. 13, p. 51), the chariot itself moves into the foreground, in effect replacing the deeply symbolic blossoms. Once again, Twombly chose primitive models; one might well be reminded of the Etruscan chariot (fig. 16)—or even of ancient children's toys—at the sight of the low,

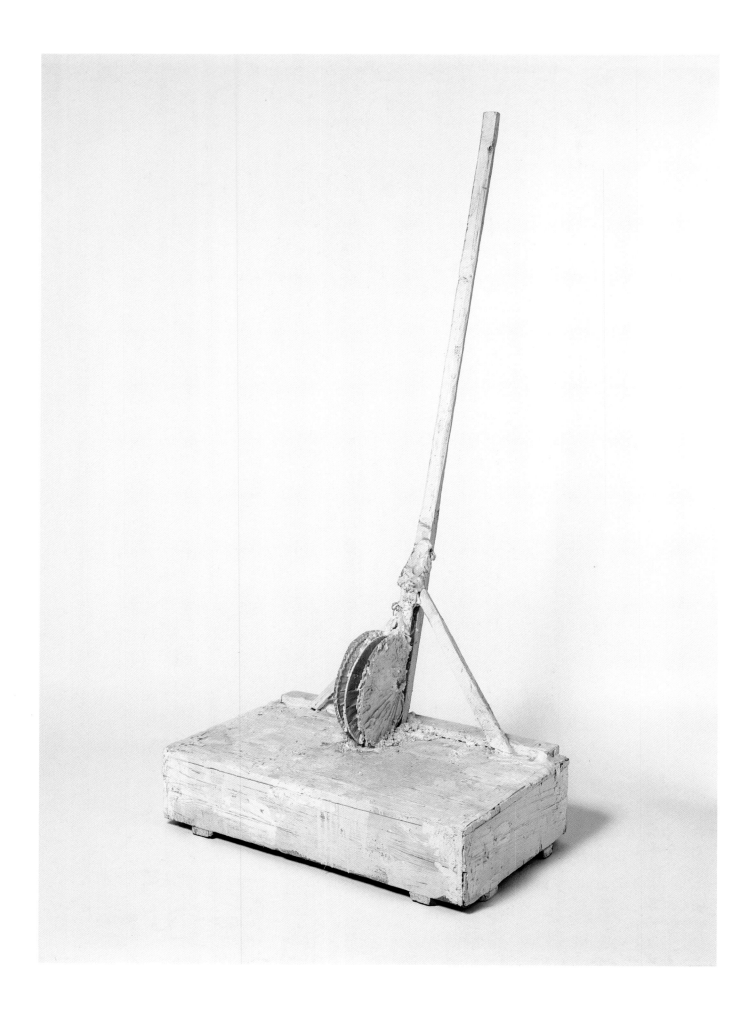

elongated two-wheeler, best viewed from the side, with the full length of its extended shaft resting on the ground. The long, narrow piece of wood nailed to the short axle between two wooden wheel-discs and reinforced with a strut stretches far forward, as though the horses were running on overly long reins; there are, however, no horses, but rather another fine lath that echoes the soft line of the reins. It is secured at the top to a little board that is placed vertically on the axle and would have given a driver a bit of room to stand on. While everything else is rigorous, clear, and minimal, here at the top edge of the little upright, a tangled confusion reigns: wound round ring screws, drawn through eyelets, pinned down, turned, bent, and entwined—a maze of wire is recruited for this mobile part, which is fixed with only one bent nail at the front end. While the low axle keeps the vehicle close to the ground, the compact circles of the little wheels create the impression of short surges of movement, whereas the extended shaft, indeed the whole long, flat construction, speaks of rapid progress, long distances, and vast expanses and spaces. Archaic relic, model, toy—almost touching in its elegant simplicity, this vehicle at rest has the galvanizing effect of an inspired, astonishingly efficient invention.

Other chariot sculptures were produced in 1979 and 1980 in Bassano, albeit made of different materials. Untitled (Bassano in Teverina 1979, cat. no. 16, p. 52) is the first known work where Twombly used a mixture of plaster and sand to cast the individual elements.[36] The result is a rough gray-white structure with an irregular surface, and crumbly edges and corners, the roughness interspersed with unexpectedly smooth sections. The composition is relatively simple and constructed so that the main view of the work shows the vehicle from the side: two ungainly wheel-discs with between them, at the same height as the hubs, an equilateral triangle forming the body of the chariot in the manner of ancient battle chariots. At the back, a small support holds the floor horizontal, as though in use; from the front, it becomes clear that the body of the chariot is not conceived three-dimensionally, but consists of a flat plate whose narrow front edge, rising up between the two rounded wheels, is distinctly phallic. The battle chariot, an attribute of Ares, the god of war, plays a major role—stylized as a triangle—in the ten-part cycle of paintings *Fifty Days at Iliam*, which Twombly made in Bassano in 1977–78.[37] Circles and triangles dominate the battle formations of the gods and heroes, while the phallic form stands for the fatal aggression of attack. The stasis of the chariot somewhat diminishes the impression of dynamic energy without, however, lessening the powerful emotional charge of the work. The meaning of the chariot becomes more open, embracing everyday methods of locomotion as well as the glorious triumphal carriage favored by men and gods alike. Much the same may be said of another similar sculpture, Untitled (Bassano in Teverina 1979, cat. no. 18, pp. 53 and 55). There is scarcely any difference in composition. The wheel-discs in the second are slightly smaller, and the triangle, correspondingly lower, rests at the rear on a weather-beaten, dark brown box-plinth; the abstraction thus seems to have been taken further. The two sides of the object are also treated differently: while one is left in its original raw state,

24 *The Keeper of Sheep*, Bassano in Teverina 1980

des schräg emporragenden Hirtenstabes. Twombly gibt diesem nicht die vertraute uralte Würdeform mit gekrümmter Spitze wie Joseph Beuys. Ein kräftiger Stecken passt für ein robustes Werkzeug. Doch die »Schippe«, in Bastelmanier mit Draht, mit Schnur an den Stiel gebunden, bilden drei Palmfächer, wie Twombly sie schon früher benutzte. Radial angebracht, stellt ihre Repetition die Schwenkbewegung der Schaufel in mehreren Phasen dar; ein Prinzip, das den Künstler in der Auseinandersetzung mit Edweard Muybridge, Marcel Duchamp, Giacomo Balla zeitweilig auch in anderen Medien beschäftigte.[42] Das seltsame Gerät mit der Fächerschaufel aus Palmblättern, für die das Wedeln charakteristisch ist, erinnert an die locker schwingende Geste, mit der die Herde vor der Zerstreuung bewahrt, dirigiert wird: an das Hüten. Zugleich verweisen die Palmblätter, Symbole des Lebens, auf das, was hier bewacht, gelenkt und gerettet werden muss. Der Hirte, dessen Instrument wir sehen, leistet harte Arbeit, agiert nahe am Grund; so ist sein Werkzeug mit Tonklumpen bespritzt, mit roher Materie verklebt. Ohne das Weiß, hier Synonym für sein Epitheton, die Güte, aber auch die grobe Machart mildernd, bliebe die spirituelle Botschaft versteckter. So aber strahlt das von zwei kräftigen Streben gehaltene Gerät auf einer wenig vertrauenerweckenden Kiste, dem dubiosen Grund, hell wie die reine Symbolfigur, für die es steht.

Die Skulptur *(Für F. P.) Der Hüter der Herden* (Jupiter Island 1992, Kat. 55, S. 68)[43] ist dem portugiesischen Dichter Fernando Pessoa gewidmet, der unter einem seiner Pseudonyme, Alberto Caeiro, 1911/12 das so betitelte Buch mit 49 Gedichten schrieb. Ähnlichkeit mit der Skulptur von 1980 besteht insofern, als man wieder eine Art charakteristisches Gerät, diesmal eine Hacke, in der dünnen, aufgerichteten Figur auf einem Sockel erkennt. An einem Rundstab mit eigener kleiner quadratischer Plinthe lehnt das kürzere vorgestellte Werkzeug. Sein Stiel ist kräftig und setzt sich am Boden rechtwinklig in einem breiten Blatt fort, als müsse ein großer Fuß Stab und Stiel soliden Stand bieten. Nimmt der Betrachter die Figur von vorn als eine nach oben verjüngte Gerade wahr, so differenzieren sich erst von der Seite gesehen die wenigen Elemente, und in der Aufsicht von rechts liest man die Inschrift auf dem Blatt der Hacke, entdeckt aber auch das Laub, die Blätter, die sich wie Schößlinge um das Gelenk schmiegen. Dedikationen an Dichter, Maler, Philosophen hat Twombly in Malerei und Zeichnung immer wieder vorgenommen, um über die Zeiten hinweg mit Bewunderung seine Rezeption ihrer Werke zu dokumentieren und zugleich ihre Wirkungsgeschichte fortzuschreiben. Der Titel *Der Hüter der Herden* entsprach seiner Affinität zur Gestalt des Hirten, der bei Pessoa nicht Schafe, sondern Empfindungen hütet. Der höhere Rundstab, die radikale Stilisierung der menschlichen Figur und seit prähistorischer Zeit ihre einfachste Darstellungsweise, repräsentiert hier die aufrechte Haltung des Einsamen, der nur so den Überblick, die Weitsicht behält; an ihn gelehnt sein Insignium, Stütze und Arbeitsgerät. Einer höchst abstrakten Komposition verleiht es einen konkreten Bezug, der seinerseits einen weiten Bedeutungshorizont eröffnet.

Unter den Skulpturen von 1981 nimmt *Ohne Titel* (Formia 1981, Kat. 27, S. 71) eine Sonderstellung ein. Behandelt ist ein Thema, das zu Beginn des 20. Jahr-

the other is covered with a thick, grainy-white layer of plaster. This striking duality, already inherent in the different materials, is also evident in the contrast between the front view of the chariot, a statue to Phallos,[38] and the side view of the triangular body. This demonstrates the extent to which the forcefully intense object is charged with symbolic details referring to the problem of gender. The stack of attractively weathered boxes that Twombly piled up and crowned with this figure forms a substructure that has seemingly grown over generations and is now marked by its own "life lines."

The very title of *Anabasis* (Bassano in Teverina 1980, cat. no. 23, p. 56) speaks of its martial nature, although now the chariot theme is formulated differently.[39] The shape on a high plinth, approaching the viewer like the gleaming white bow of a ship, emanates an aura of victory and triumph. Again Twombly has used found objects, the flotsam and jetsam of everyday life. But this time he has constructed the body of the chariot in three dimensions, creating a sculpture that may be viewed from different angles. A high, smooth-sided box bordered with sheet metal, its long side facing the front, bears the little chariot. The base of the chariot was originally a trolley for large potted plants. Its casters have been immobilized by thick, white clay, gently modulated, that almost entirely obscures their form and function. Two identical plywood trapezoids form the sharply angled superstructure. Neither his awareness of the Etruscan battle chariots preserved in the Villa Giulia (fig. 17) nor his knowledge of classical literature lured Twombly into a historicizing or philological mode. He handles his materials freely and creatively, repeatedly using elemental forms and figures of monumental import to build a bridge linking the remembered simplicity of fundamental cultural discoveries and their evolution in myth and history to the meaning these things have arrived at today.

The fascination of this immobilized three-wheeled vehicle does not derive alone from its height and brightness. The formal quality of the geometric structure of these selected everyday objects reinterpreted in their new artistic context is accentuated: now equipped with an aesthetic rather than a functional relevance, this formal quality appears in the objects as a higher principle and thus fulfills the demands made by the act of creating a symbol. Only on this level does it become clear why Twombly was not simply interested in indigenous art and why his points of reference—when they are not nature, the landscape, and its fauna— lie in the realms of highly evolved cultures. *Anabasis*, the little triumphal chariot, stands before us ready to set off, certain of victory and yet resting on its small, fixed wheels. It celebrates the beauty of geometry, the metamorphosis of objects, and the simplicity of the sublime.

In 1981 Twombly started to devote greater attention to sculpture; much of his plastic œuvre dates from the last twenty years. The fact that he did not paint or draw at the same time allows us to come to certain conclusions about these other media. In the alternation between smoother and finer, rougher and coarser

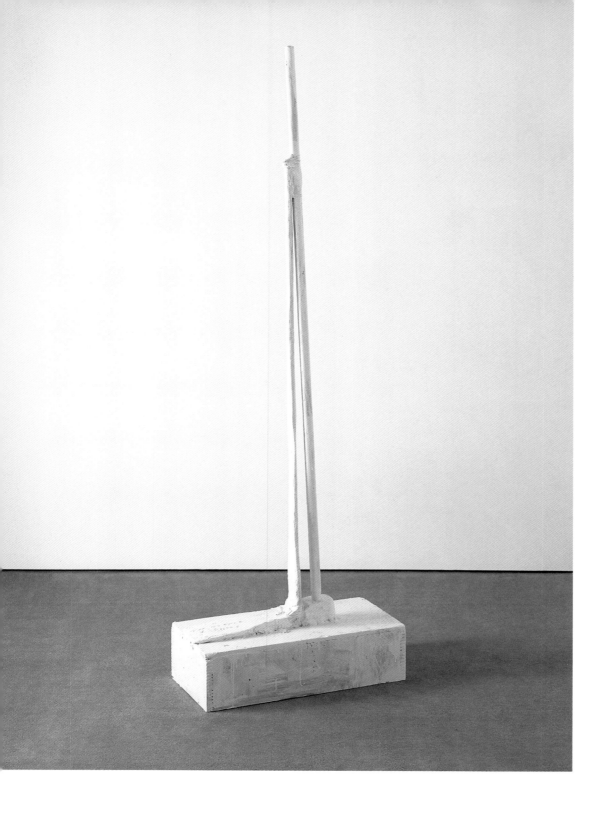

55 *(To F. P.) The Keeper of Sheep,*
Jupiter Island 1992

works, there are always those that revolve around similar themes and questions: motion and rest, space and time.

What can be behind such an arid object as Untitled (Bassano in Teverina 1980, cat. no. 19, p. 59)? A crude wooden box, almost a cube, three rough planks standing up with one perpendicular hurriedly nailed upright to the center of the back of the box and the other two slightly narrower pieces leaning against it from the front, held in position with clay, carelessly painted white on one side, with runs, droplets, bare patches, and bits stuck together and lumpily caked.

What is the allure of this thing that speaks the language of the building site? These rough-hewn materials are well-suited to demonstrate elemental forms of behavior such as lying, carrying, holding, leaning, and supporting—all within a given volume, defined here by the box-plinth. It is only on closer examination that the tall, slim composition reveals its anthropomorphic proportions. Seen from the side, there are visible echoes of the strictly regulated portrayal of the standing human figure in ancient Egyptian sculpture (fig. 18), reduced here to an abstract skeleton. Another sculpture, Untitled (Bassano in Teverina 1980, cat. no. 20, p. 59), evokes similar associations: again there is a pedestal, but now the axis and stasis of the human form are conveyed by means of finer, carefully finished materials.

Untitled (Rome 1983, cat. no. 32, p. 62) addresses the question of relative strengths, counter-weights and equilibrium using large forms, clear lines, and extremely precise, elegantly balanced proportions. Volume and surface, surface and line, stasis and dynamism, rest and motion are perfectly calibrated. These unextravagant materials fulfill completely their purpose and reflect Twombly's preference for economy and succinct, abstract formulations.

An early photograph by Plinio De Martiis shows Twombly in a sun-soaked rural setting, leaning against the trunk of a tall tree, looking into the distance out over the Lake of Bolsena, surrounded by a flock of sheep (p. 12). Clad in wool, he comes close here to his favorite identification figure—the shepherd. He was particularly drawn to the nomadic herdsmen who roamed the North African landscape with their animals, living in harmony with nature and its rhythms and seasons. He has compared their kind of freedom to that of the artist. But the shepherds of mythology and poetry were also his friends. In the figure of Hermes or Mercury, the ancients saw the shepherd as the human soul's guide and companion, a notion that can be viewed as anticipating the Christ figure of the Good Shepherd. Pan takes care of his flocks, as does Orpheus; in 1977 Twombly dedicated a large, three-part painting to Virgil's love-sick Thyrsis,[40] while *The Shepheardes Calender* (after a poem by Edmund Spenser), one of his most beautiful series on paper from 1977, describes a whole year, tracing the subtle color changes of one month to the next.[41]

Two of Twombly's three-dimensional works express this affinity he shared with the shepherd, a figure revered in many religions as a divine savior and so ascribed symbolic value in the great cultures, where it is depicted with a flock or a single

19 Cy Twombly, *Untitled*, 1972–73
Private collection, Rome

hunderts Fotografen und bildende Künstler, unter ihnen Marcel Duchamp, vor allem die Futuristen leidenschaftlich beschäftigte. Es ging um den Versuch, einen Bewegungsablauf durch Zerlegung in einzelne Phasen an einer Figur darzustellen. Twombly setzte sich in Bildern, vor allem in Werken auf Papier, Ende der sechziger und Anfang der siebziger Jahre mit den Lösungsversuchen der zitierten Vorgänger auseinander, indem er stilistische Kriterien ohne den gegenständlichen Bezug reflektierte. (Abb. 19) Was er mit verschobenen Rechtecken auf Papier demonstrierte, wird in einer Skulptur mit Hilfe von ausgedientem Hausrat vorgeführt. Auf einem verwitterten Tisch steht ein schmales Holzgestell, das den rechtwinkligen Rahmen abgibt für mehrere dünne, an einem Drehpunkt befestigte Latten. Mit Hilfe von Ringschrauben und einer Schnur blättern sie sich fächerförmig so auf, dass sie wie Radspeichen das Viertel eines Kreises beschreiben. Die Rahmenkonstruktion fixiert die erste Latte und hält die Schnur mit einem professionell geschlungenen Knoten in einer Öse, an der alles weitere hängt. Die Kordel führt so straff durch die Schraube in der Vorderkante der zweiten Latte, dass sie durch die Spannung im gewünschten Abstand verharrt. Bei der nächsten Latte sitzt die Schraube seitlich, eine doppelte Schlinge hält sie im Winkel von 50° fest; Latte vier, abgestürzt, hat ihre Schraube wie einen Bergsteiger am Seil hängen lassen und wird nur durch die Schnur leicht über der fünften gestützt, die kurz neben der sechsten aufliegt. Bei ihr endet wieder in einem kunstvoll geschwungenen Knoten die »Seilführung«.

Mehrfach kann man in Twomblys plastischem Werk natürlichen Fächerformen begegnen. Die Demonstration auf einem verwitterten Tisch, dargeboten wie in einer Versuchsanordnung, erinnert an die elementaren Gesetze, deren Analyse keines großen Aufwandes bedarf. Dazu gehört die Lauterkeit, mit der kein perfekter Ablauf konstruiert, sondern die Irregularität, die Katastrophe akzeptiert ist. Der Charme der alltäglichen Gegenstände vermittelt die Analogie zu Formen und Vorgängen in der Natur mit fast spielerischer Leichtigkeit.

Mehrere von Twomblys Skulpturen aus dem Jahr 1981 bilden den Anfang von Motivketten, die er später zu verschiedenen Zeiten und in unterschiedlicher Gestaltung weiterverfolgt. Mit *Aurora* (Rom 1981, Kat. 25, S. 73) beginnen die Schiffsdarstellungen, während mit *Anadyomene* (Rom 1981, Kat. 26, S. 82 und 83)

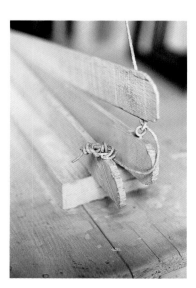

27 *Untitled*, Formia 1981

various media while exploring the work of Eadweard Muybridge, Marcel Duchamp, and Giacomo Balla.[42] This strange apparatus, with its fan-shovel of palm leaves typically waved to and fro, is reminiscent of the loosely swinging gesture with which the flock is guided and kept from dispersing: in short, it is reminiscent of gathering. At the same time, the palm leaves, as symbols of life, allude to what is being protected here, what is to be guided and saved. As the shepherd, whose instrument we see, toils hard and close to the earth, his staff is spattered with lumps of clay. Without the white, here synonymous with goodness—the shepherd's epithet—but also softening the roughness of the piece, the spiritual message would be harder to perceive. As it is, however, this object, supported by two struts on the dubious base of a scarcely confidence-inducing box, gleams brightly like the pure symbolic figure for whom it stands.

The sculpture *(To F. P.) The Keeper of Sheep* (Jupiter Island 1992, cat. no. 55, p. 68) is dedicated to the Portuguese poet Fernando Pessoa, who, under the pseudonym Alberto Caiero, published a book of forty-nine poems in 1911–12.[43] There is a similarity between this work and the sculpture of 1980 insofar as we again find a characteristic piece of equipment; this time we can recognize a hoe in the slender, upright figure on its base. Against a rounded rod with its own small square plinth leans the shorter tool. Its strong handle flattens out into a broad, horizontal blade, as though a wide foot were needed to steady both the handle and the rod. From the front, the viewer sees the figure tapering toward the top, and it is only from the side that its few constituent parts can be properly distinguished from one another. Looking down on it from the right, one can see an inscription on the blade of the hoe, as well as leaves wrapping themselves around the joint like young shoots. Throughout his life, Twombly frequently dedicated drawings and paintings to poets, painters, or philosophers, admiringly documenting what their works have meant to him and at the same time perpetuating their influence. The title *The Keeper of Sheep* reflects his sense of affinity with the figure of the shepherd who, in Pessoa's case, is not watching over sheep but over feelings. The taller rounded rod, a radical stylization of the human figure and since prehistoric times the simplest way of representing it, here portrays the upright posture of the lonely figure who can retain his overview and farsightedness only in this stance; leaning against him is his insignia, his support, and the tool of his trade. Thus a highly abstract composition acquires a concrete point of reference, which in turn opens up a wide horizon of meaning.

Among the sculptures of 1981, Untitled (Formia 1981, cat. no. 27, p. 71) occupies a special position. It addresses a theme that passionately engaged photographers and artists, including Duchamp, and especially the Futurists, in the early twentieth century. The challenge was to represent motion by showing one figure at different stages of a certain movement. In the late 1960s and early 1970s, Twombly produced paintings and above all works on paper in response to the attempted solutions of his forerunners; these works reflect their stylistic criteria while disregarding the original context (fig. 19). What he demonstrated on paper by means of displaced rectangles was then presented in three dimensions by means of old

Wellen gebeutelter Kahn, Spielball der Götter, leichte Beute für Piraten, Ziel kriegerischer Gegner oder Meeresungeheuer und einziger Boden unter den Füßen dessen, der »am Ionischen Meer« – das hier für die Meere der Welt steht – sein Schicksal vollendet, – wie immer er heißen mag, Odysseus, Aeneas – und endlich Land gewinnt.

Die vollkommene Schönheit und die Proportionen der Knidischen Aphrodite des Praxiteles, der die Göttin erstmals nackt zeigte, »überträgt Twombly symbolisch in geometrische Formen ... «.[53] In Zeichnungen und Bildern von 1966 und 1967 sind es Trapez und Rechteck. Sie machen durch die Inschrift »Cnidian« den Bezug deutlich; dabei ist das Motiv isoliert in den monochromen Bildgrund gesetzt. (Abb. 23) An die aquarische Herkunft der Göttin erinnert die landschaftliche Situation der Küste. In Werken von 1961 und 1962 hatte Twombly die Vorstellung von der aus dem Wasser aufsteigenden Venus mit der Diana von Ephesus verbunden. Über die blaue Horizontlinie des Meeres ergießen sich ans Land ihre schwellenden weiblichen Formen wie eine warme sonnige Woge. (Abb. 22)

In der Skulptur *Anadyomene* (Rom 1981, Kat. 26, S. 82 und 83), dreistufig aufgebaut, verschmelzen diese verschiedenen Komponenten. Twombly arbeitet hier nur mit geometrisch abstrakten Formen; wieder sind umgedrehte Kistchen, Bretter und Klötzchen zu einem architektonischen Aufbau getürmt. Ein alter Backtrog mit seinen ausgestellten Wänden wird umgestülpt zum breit hingelagerten Ponton, auf dem sich etwa halb so hoch die nächste Etage erhebt. Dass hier die beiden Deckel des Kistchens an Scharnieren offen nach außen stehen und über die Auflage hinausragen, schafft eine breite Querachse über dem Rechteck des Grundrisses. Auf der obersten Stufe präsentiert sich wie eine Altarfigur ein schräg nach hinten ansteigendes trapezförmiges Sperrholzbrettchen, oben durch zwei nach vorn gekrümmte Nägel an der senkrechten Stütze gehalten. Unterseitig ist es mit Kreide hellblau bemalt. In der Vorderansicht verläuft der hierarchische, auch in die Tiefe gestaffelte Aufbau von einem flacheren Trapez über eine zurückspringende Stufe zu einem steileren, schlankeren Trapez. In der Seitenansicht aber werden gegenständliche Assoziationen geweckt. Der einfachen Schiffsdarstellung von *Aurora* nicht unähnlich, erinnert sie an ein Boot, das mit Mast und Segel auf blauem Wasser dahintreibt; denn die überstehenden profilierten Kanten der Kistchendeckel rechts und links zeigen alte Spuren von hellem Lavendelblau an dem sonst gänzlich weißen Objekt. Durch die klare Komposition der Skulptur nimmt man den Wechsel von geometrischen Körpern und Flächen, die raffiniert ausgewogenen Relationen schnell wahr. Die blaue unterseitige Bemalung des Trapezes, die ein paar Spuren auf der Oberseite ankündigen, erschließt sich erst bei genauerer Betrachtung. Altar, Bühne, Tempelanlage – dieses Modell setzt die abstrakte Schönheit geometrischer Figuren, die Proportionen plastischer Formen in Bezug zu Venus, der mythischen Inkarnation von Liebe und Schönheit. Himmel und Meer, dem Twombly wunderbare Zeichnungsserien wie die *Gedichte an das Meer*[54] widmete, evoziert er mit lichtem Blau, in dem die beiden Elemente einander berühren.

household items. On a weathered table stands a narrow wooden structure, which serves as a right-angled frame for several thin laths fixed at a single point of rotation. With the help of ring screws and a cord, they fan out to describe a quarter circle, like the spokes of a wheel. The frame fixes the first lath and, with a very professional knot, fastens the cord to an eyelet from which everything else hangs. The cord passes so tautly through the screw at the top edge of the second strut it holds the strut firmly in the desired position. In the case of the next strut, the screw is on the side and a double knot holds it fast at an angle of 50°. Timber number four has dropped down leaving its screw behind it, like a mountaineer clinging to a rope; the cord only keeps it slightly away from the fifth, which is lying close to the sixth where another skillfully turned knot ends the "roping." There are a number of natural fan shapes in Twombly's sculptural works. The demonstration on the weathered table, presented like a scientific experiment, recalls those elementary laws amenable to reasonably straightforward analysis. This implies an honesty that does not set out to construct a perfect sequence of events, but accepts irregularities and catastrophes. The charm of these everyday items conveys their analogous relationship to forms and processes in nature with almost playful ease.

Several of Twombly's sculptures from 1981 lay the foundation for sequences of motifs that he would return to later at different times and in various forms. *Aurora* (Rome 1981, cat. no. 25, p. 73) is the start of his ship motifs, while *Anadyomene* (Rome 1981, cat. no. 26, pp. 82–83) is the first of the works echoing architectural forms.

Coastal regions and islands have always had a special appeal for Twombly, who did not grow up by the sea and made his first trip from New York to Naples by ship. Since antiquity, the sea and sailing—of central importance to the lands around the Mediterranean—have been an inexhaustible source of materials and ideas, pervading the region's myths, philosophy, and art.[44] Once again, Twombly's particular interest was directed toward modes of transport as embodying movement and energy, and inviting a whole spectrum of associations.

The plinth for *Aurora* is a long, smooth, simply constructed box of the kind used to protect pictures. Nailheads punctuate the edges, which also reveal the thickness of the wood. The original yellow shows faintly through the white paint. The base is capped by a matching top piece that makes it somewhat higher, thus changing its proportions and making it into a floor sculpture. Placed centrally on top of this is a model ship of the simplest kind. The elongated, squared-off hull with its broad bow suggests stability; a tall, thin mast rises up in the middle of the first deck, and exposed at the top is a nail. It holds the rigging, a slightly bent wire threaded through an eyelet and fixed to the forward deck—if the basic structure is to be read realistically.[45] The wire connects the nail—the highest point of this dignified vessel, its antenna, so to speak—and the "figurehead": over the bow, facing boldly upward, is a resplendent rose. The contrast between the soft blossom and the miniature proportions of this angular ship could not be greater.

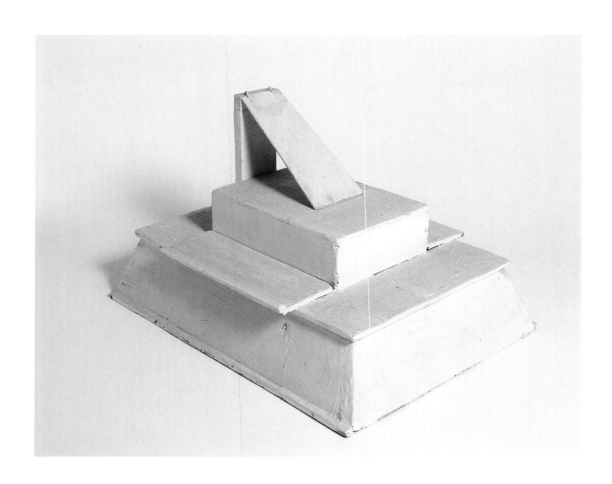

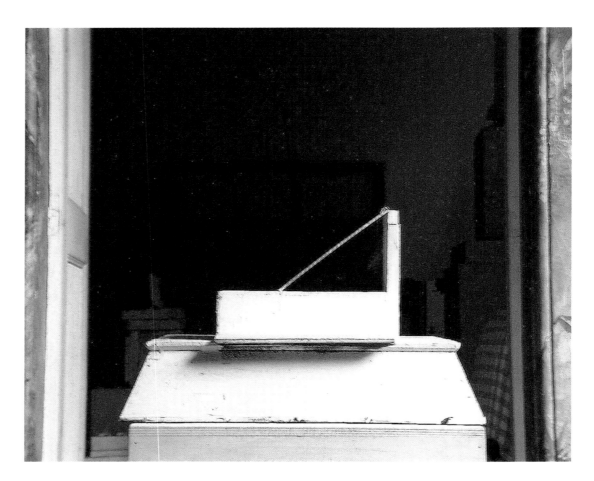

26 *Anadyomene*, Rome 1981

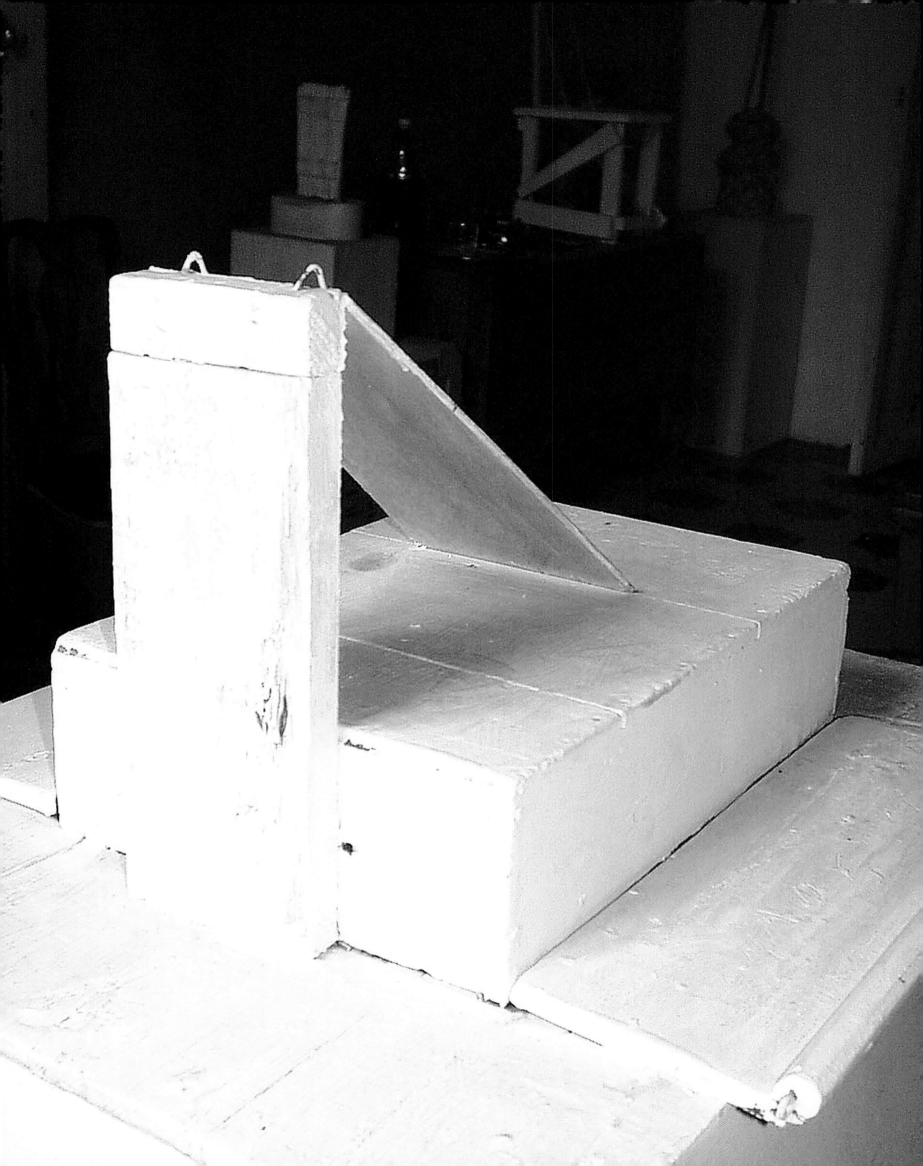

22 Cy Twombly, *The Birth of Venus*, 1963
Dia Center for the Arts, New York

Nochmals entstehen 1987 Arbeiten, in denen die Motive Trapez und Rechteck zentral behandelt werden. In *Ohne Titel* (Rom 1987, Kat. 45, S. 85) hängt, oben von einer Schnur im Lot gehalten, das vorn an die Plinthe gestützte Hochrechteck wie ein eleganter großer Schild.[55] Eine Analogie zu den Venus-Darstellungen ergibt sich nur aus der individuellen Symbolsprache des Künstlers, der in frühen Zeichnungen das Paar Venus und Mars thematisiert hatte. Zunächst befand sich rückseitig auf der Platte eine Inschrift. In roter Tinte war dort auf Papier zitiert die englische Übersetzung der Verse aus Rilkes frühem Gedicht *Fortschritt*: »In the pond broken off from the sky my feeling sinks as if standing on fishes.«[56] Twombly, der durchaus an seinen Skulpturen Veränderungen vornimmt, entfernte die Schrift im Juli 1999. Der wiederholt explizite Bezug zu Rilke ist hier also nicht länger gegeben; die Zeilen finden sich allerdings in Gemälden von 1985 und 1988 wieder.[57]

Neben Landschaft übt Architektur auf Twombly eine ganz besondere Faszination aus; seine Auseinandersetzungen mit dieser Disziplin reichen vom Studium bedeutender archäologischer Stätten, den Baudenkmälern versunkener Hochkulturen, über außereuropäische Bauformen bis zum Erwerb, der Restaurierung und dem Ausbau eigener Domizile und der Zusammenarbeit mit Renzo Piano und Paul Winkler an der Cy Twombly Gallery in Houston. In den achtziger Jahren absorbierte die Wiederherstellung einer Renaissancevilla in Bassano viel Zeit und gestalterische Energie; seit 1987 beschäftigte den Künstler der Ausbau seines Hauses und die Anlage seines Gartens in Gaeta, wo der Blick aus dem Atelier über die Bucht und auf das Tyrrhenische Meer hinausgeht. Aus jedem Detail der selbst gestalteten Umgebung spricht der untrügliche Sinn für Proportionen, Volumina, Licht. Hier führt Twombly den Gast auf den Hügel über der Stadt, zu der Rotunde, dem Grabmal des römischen Feldherrn Munatius Plancus.[58]

In Gaeta nahm Twombly ein literarisch angeregtes Thema wieder auf, das ihn 1980/81 schon beschäftigt hatte[59] und das er seither in Varianten formulierte. Ein solide verankerter, dynamisch gerade aufsteigender Rundstab bricht auf halber Höhe, knickt jäh nach vorn ab. In *Ohne Titel* (Gaeta 1984; Bronze, Rom 1987, Kat. 35, S. 89) wächst der Stab auf einer dünnen Platte, einem fahrbaren hölzernen Untersatz mit blockierten Rädern, aus einem steilen Hügel. Er fällt gewaltsam und in so spitzem Winkel, dass vor dem niedergesunkenen Ende noch Raum bleibt für den lose hingelegten Karton, der handschriftlich die Schlussverse aus Rilkes *Zehnter Duineser Elegie*[60] auf Englisch zitiert: »And we who have always / thought of happiness / climbing, would feel the emotion that almost / startles / when happiness / falls.« Der italienische Philosoph Giorgio Agamben erfasst subtil die Essenz dieses Werkes und seinen Bezug zu Rilkes Vorstellung von dem »fallenden Glück«, wenn er schreibt: »Es gibt im kreativen Schaffen eines jeden großen Künstlers, jedes Dichters, einen Augenblick, wo das Bild der Schönheit, dem er sich bis dahin geichsam mit steigender Bewegung anzunähern schien, nun plötzlich seine Richtung umkehrt und sich – wiederum in der Vertikalen gesehen – als ein Fallendes zeigt. Das ist die Bewegung, die Hölderlin in den Anmerkungen zu

23 Cy Twombly, *Cnidian Venus*, 1966
Dia Center for the Arts, New York

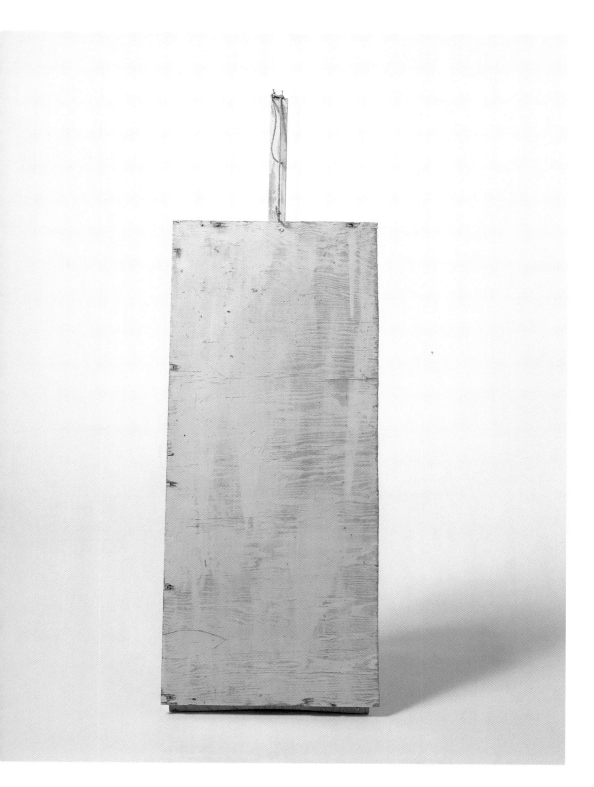

45 *Untitled*, Rome 1987

29 *Untitled*, Bassano in Teverina 1981
30 *Untitled*, Rome 1983

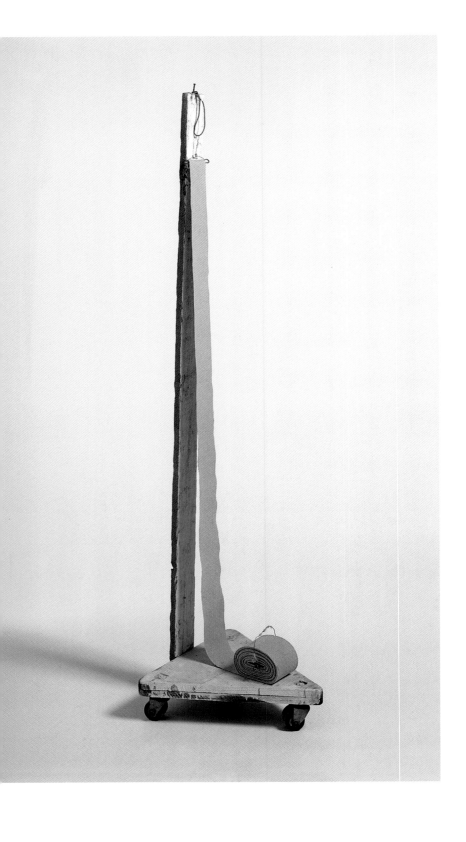

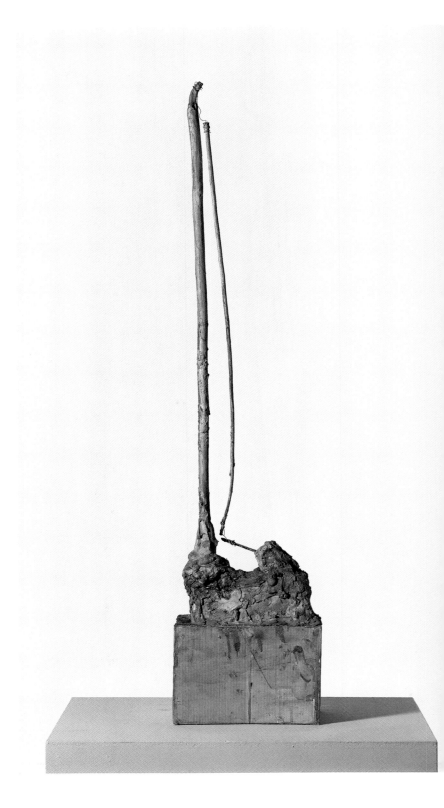

Everything is focused on its precious cargo; the entire energy of the object is concentrated there as if the rose were the reason for the voyage.

This is the first appearance in Twombly's sculptural work of the "queen of flowers," its form perfectly rendered in plastic.[46] The title *Aurora* is not, as one might imagine, an allusion to the Greek goddess of dawn, whose "rosy fingers" herald the approaching day. It refers to the battleship of the same name (fig. 20) which Leon Trotsky summoned from the naval port of Kronstadt to Petrograd as reinforcements. He instructed the captain not to carry out any orders from Kerensky and to take up a position on the Neva. When the city had largely been taken, with the exception of the Winter Palace where the government was still ensconced, Trotsky "suggested that the *Aurora* should fire a volley of blanks. It would be a pity to destroy the Palace for the sake of a few ministers. At nine o'clock the *Aurora* fired a volley of blanks."[47] The ministers offered no resistance; at ten past two in the morning they were arrested in the name of the Revolutionary Committee. Thus ended this "grotesque operation against a palace which was undefended and yet refused to fall,"[48] and thus the Russian Revolution began. It is not certain whether Twombly, who owns a reproduction of the battleship, made the sculpture with these historical events in mind or only gave it that name in retrospect.[49] But it is clear that he was playing with the discrepancy between the imposing quality of the angular vessel and the flower, whose symbolic value artists particularly appreciate. Incorporated into the white paintwork here, it blossoms like the sign of a gentle revolution—namely that of art—or like the smoke from guns that, for once, did not destroy.

Untitled (Rome 1984–85, cat. no. 36, p. 75) consists of a three-part plinth with the silhouette of a boat reduced to its most rudimentary features: a flat hull, an angled bow, and a stern. Made from an old board, the ship—supported on two four-sided blocks—is recognizable as such only from the work's main viewing side. From the narrow end, it is a purely abstract composition. The deeply ingrained signs of wear and tear covering the plinth and the boatlike crevices are painted over in white, but instead of lessening the imperfections, the white brings them to the fore, highlighting the damaged parts with runs of paint, irregular streaks, and traces of blue—the color of the sea. Despite its schematic character and possible associations with monuments or with ancient funerary decorations, alluding emblematically to the profession of the deceased, the interpretation of a work such as this must remain open.

Not so in the case of the sculpture *Winter's Passage: Luxor*, made in Porto Ercole in 1985 (cat. no. 37, p. 77). Twombly had originally intended his first trip to North Africa to end in Egypt, but his first opportunity to go there was not until 1962. In winter 1985 he returned for several weeks, staying mostly in Luxor. The title of the sculpture means more than the personal memory of a winter sojourn in a pleasantly warm climate—the kind wealthy Europeans have treated themselves to in the Winter Palace since the nineteenth century.[50]

Once again, the simplest of materials, scrap wood, is loosely layered. Four-sided

seiner Sophokles-Übersetzung ›Zäsur‹ oder ›arythmische Unterbrechung‹ nennt: Wenn das Wort, gleichsam mitten in seinem Schwung angehalten, einen Moment lang nicht das zeigt, was es sagt, sondern sich selbst. Wenn der Künstler auf dem Gipfel seiner Möglichkeiten nicht mehr schafft, sondern abschafft, ist dies der Punkt der unwiderruflichen Schöpfung – der unnennbare messianische Augenblick, wo die Kunst auf wundersame Weise stillsteht, beinahe bestürzt: in jedem Moment Fall und Auferstehung.«[61]

Für das fünfteilige Gemälde *Erforschen der Rose aus dem Gefühl der Verzweiflung*, das ein Jahr später in Bassano entsteht, spielt Twomblys Auseinandersetzung mit Rilke nochmals eine wesentliche Rolle.[62] Über jeder der großen Tafeln gibt ein kleines Holzpanel mit einem poetischen Zitat – Verse von Rilke, Leopardi und dem persischen Dichter Rumi – eine Art Motto bei. Die vierte und größte Tafel enthält den englischen Text von Rilkes selbst verfasster Grabschrift: »Rose, oh reiner Widerspruch, Lust, / Niemandes Schlaf zu sein unter soviel / Lidern«. Die Rose, altes abendländisches Symbol der Unio mystica, war für Rilke zeit seines Lebens »ein Grund des Entzückens und der grübelnden Andacht gewesen. Hier nun wird sie zum Gleichnis des ›reinen‹, das heißt versöhnten und als Weltgesetz in den eigenen Willen aufgenommenen Widerspruchs. Als ›Niemandes Schlaf unter so viel Lidern‹, als Fülle aus Nichts, wird sie zur symbolischen Blüte des Weltsinns. Gleichzeitig ist sie hier die Chiffre für das Sein und Wesen des toten Dichters.«[63]

In der Regel sind die Arbeitsphasen, in denen sich Twombly einem Medium widmet, getrennt. Die Skulptur *Ohne Titel* (Bassano in Teverina 1979, Kat. 38, S. 90 und 91), Teil des heute in der Cy Twombly Gallery ausgestellten Ensembles, steht dem Gemälde in mehrfacher Hinsicht nahe.[64] Seit 1959 hatte Twombly nie mehr so intensiv Buntfarbe, leuchtendes Rot, eingesetzt wie hier. Wenn Heiner Bastian zu den in Schlieren aus Rot, Rosa, Weiß und Grau verrinnenden Bildern schreibt: »In diesen fünf Tafeln ist das Auslöschen der Form, ihre verströmende Unhaltbarkeit in immer neuen, fließenden transparenten Lasuren der aktivste Teil«,[65] präsentiert sich die stumpfe weiße Erhebung auf dem niedrigen Museumssockel auf den ersten Blick eher ruhig. Die Ähnlichkeit zur Grabform stellen der rechteckige Grundriss, die Deckplatte und der auffallende Dekor am Kopfende her, ein erhöht dargebotenes lanzettförmiges Blatt, ein Lorbeer vielleicht. Tiefrot seine Innenseite, rot in dem weißen Anstrich Lachen, Pfützen, Gesudel wie Blut und helle Rinnsale auf dem rohen dunklen Holz der Rückseite. Was man als Spur im Weiß kaum registriert, verbindet sich plötzlich links mit Flecken, Gekritzel, von dem im rosa Geschmier nur das Wort »Rose« entzifferbar blieb. Vom Künstler selbst den Gemälden gegenübergestellt, teilt sich die Spannung zwischen Ruhe und leidenschaftlicher Vitalität, zwischen Abwesenheit und Gegenwart an diesem kleinen Objekt eindringlich mit. Dass Joachim Wolff den »Widerspruch« in Rilkes Grabschrift als »Inbegriff aller schmerzlichen menschlichen Diskrepanzen«[66] bezeichnet, bestätigt eine Zuordnung der Plastik zur Rilke-Thematik sowie zu seiner Werkgruppe der Epitaphien.

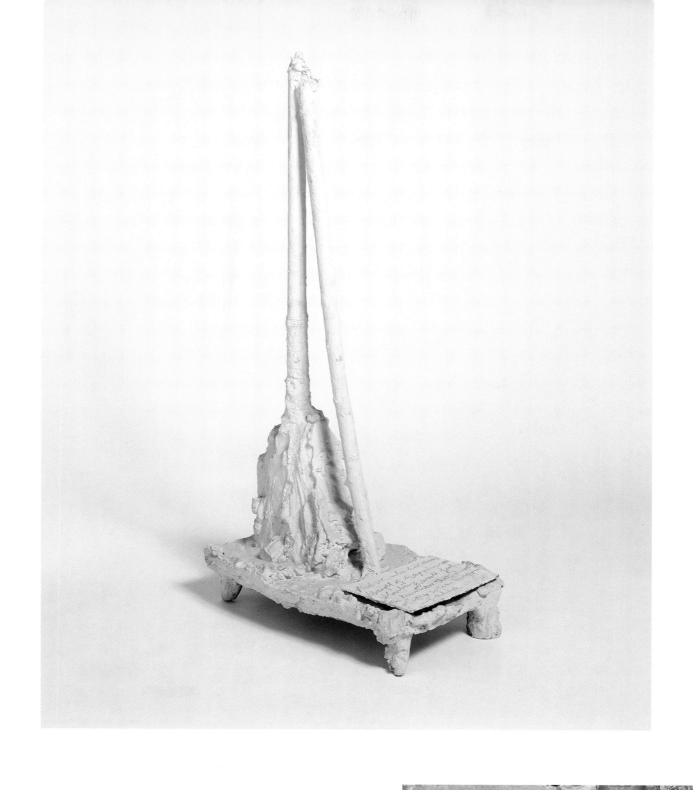

35 *Untitled*, Gaeta 1984
Bronze, Rome 1987

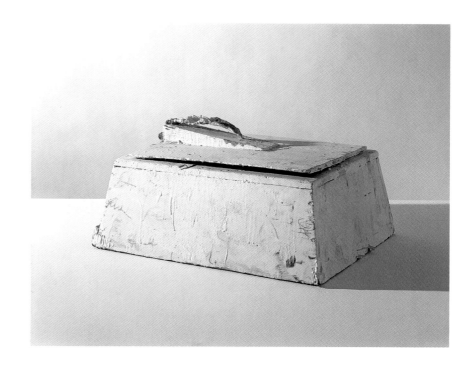

blocks support a rectangular board made of rough planks, lifting it off the museum pedestal and thereby dispelling any sense of heaviness or stasis from the central figure: a small bark on a flat surface open on all sides. Only slightly curved at bow and stern, the vessel resting on a board the same length as itself seems to be gliding along silently on its own shadow. The centrally placed cargo, a white block, seems to have no weight, a pale shrine that does not lower the level of the boat in the water. Everything is light, exact, and precise in the symmetrical construction of the work, with an emphasis on the horizontal interrupted only by the central mast, a roughly rounded piece of wood. Propped against the middle of the shrine in front, it rises up diagonally to the left, leaving no doubt as to the vessel's effective progress toward the right.

Many cultures compare human life to a voyage; the metaphors of the "river of life" and the "ship of life," with all their many variations, are also often linked to the notion that passage from this world into the next—the cycle of life, death and rebirth—involves crossing a river. In the case of the ancient Egyptians, the Nile was the main source of life. In their highly refined cult of the dead—developed over thousands of years to ensure immortality, above all for their Pharaohs—the river, which had its counterpart in the heavenly Nile, marked the boundary between East and West, Orient and Occident. Abydos, situated on the west bank, north of Thebes, was the town belonging to Osiris, ruler of the realm of the dead. It was here that the deceased were brought in their sarcophagi to be embalmed in readiness for the long process of cleansing. Christian Klemm has rightly interpreted the white cargo in Twombly's sculpture as a shrine on its journey from East to West, similar to those in countless images in Egyptian art, as well as to those placed in the small model ships that were used as burial offerings.[51] With the mention of winter in the title, redolent of the year in decline and the season

38 *Untitled,* Bassano in Teverina 1985

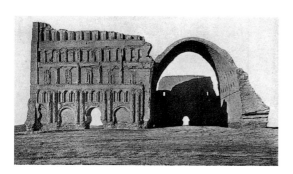

24 Halle des Chosrau I., Tâq-i Kisrâ, Irak,
6. Jh., Zustand nach 1818
Hall of Chosru I., Taq-i-Kisra, Iraq,
sixth century, state after 1818

In den achtziger und neunziger Jahren reflektiert und interpretiert Twombly mehrfach in der Plastik berühmte archaische Architekturformen: kultische Anlagen, monumentale Palast- und Sepulkralbauten wie Pyramiden oder das Grabmal des Kyros in Pasargadai.[67] Eine der wenigen betitelten Arbeiten heißt *Ktesiphon* (Gaeta 1987, Kat. 44, S. 93). Auf einem breiten, flachen Sockel – wieder eine leere Kiste mit starken Gebrauchsspuren – erhebt sich eine ungewöhnliche Bogenkonstruktion, die ihn gänzlich überspannt. Sie besteht aus drei in unterschiedlichem Abstand hintereinander montierten Reifen. Nur der mittlere, der breiteste, vierkantig zugeschnitten, beschreibt einen regelmäßigen Halbkreis. Der vordere, etwas niedriger, aber deutlich schmäler, hat den Scheitelpunkt leicht nach rechts verschoben, er steht nicht ganz gerade. Der hintere, von den dreien der höchste, von ähnlicher Form, knickt im oberen Segment zurück, sodass er nicht mehr frei stehen könnte. Halt wird in doppelter Weise geboten: Zwei schmiegsam dünne Brettchen verbinden den ersten und letzten Bogen auf ihrer Innenseite wie die Wangen eines Gewölbes. Zudem stabilisiert je ein Rundholz den ersten und mittleren sowie den mittleren und hinteren Reif im nach rechts verschobenen Scheitelbereich und bildet den Gewölbegrat ab. Eine verschmierte weiße Gipsschicht überzieht die seltsame Konstruktion bröckelig; sie ebnet die Risse und schafft zugleich in dem verwitterten Material durch den rauen Verputz oder den Auftrag weißer Farbe neue Unregelmäßigkeiten. Die Spannung der Komposition, ihre räumliche Energie, kommt aus den Gegensätzen: Dem rechteckigen Sockelblock steht die Rundform der Bogen gegenüber. Die beiden schmäleren, etwas hilflos-unregelmäßigen Reifen müssen sich mit dem mittleren messen, der die vollkommene, die ideale Form angibt. Verbunden und doch wieder nicht, geschlossen und doch offen, bleibt das Gebilde rätselhaft ohne den Titel. *Ktesiphon* ist der Name einer parthischen Gründung von 140 v.u.Z., südlich von Bagdad am Ufer des Tigris im heutigen Irak gelegen. Das machtpolitische Zentrum, Hauptstadt auch unter sassanidischer Herrschaft, wurde bis in die beginnende islamische Zeit sukzessive ausgebaut. Das bedeutendste, heute dort noch sichtbare Monument war Teil der Fassade und der Empfangshalle des späten Sassaniden-Palastes, bekannt als Tâq-i Kisrâ oder Halle des Chosrau I. (Abb. 24)[68] Obwohl nur ein kleiner Teil des Gebäudes überdauerte, ist eine Vorstellung seiner ursprünglichen Pracht von einigen frühen arabischen Geografen wie Ibn Khurdadhibih überliefert, der ihn als den schönsten je errichteten Palast bezeichnet.[69] Die vollständige Fassade war bis 1818 erhalten, als die rechte Hälfte während einer Überschwemmung einstürzte. Hauptcharakteristikum des Ziegelsteingebäudes war die 50 mal 25 Meter große Empfangshalle im Zentrum, die ein riesiges Gewölbe von 35 Meter Höhe deckte, das wie die meisten parthischen und sassanidischen nicht zentriert war; es ist das größte bekannte Beispiel dieses Typus.

Twombly bezieht sich auf die Ruine der einzigartigen Architektur, einen monumentalen Bogen, der die Zeiten überdauerte. Gegenstände, die ihm dienten, um die Ruinenteile darzustellen, ein Eselsjoch, dem Hals der Tiere angepasst, erinnern an Gewölbebezeichnungen, deren Schnitt die Rückenform von Lasttieren wiederholt. Beschreibt Twombly mit den beiden äußeren Bögen das Gewölbe

33 *Untitled*, Rome 1983. Bronze 50 *Untitled*, Gaeta 1990

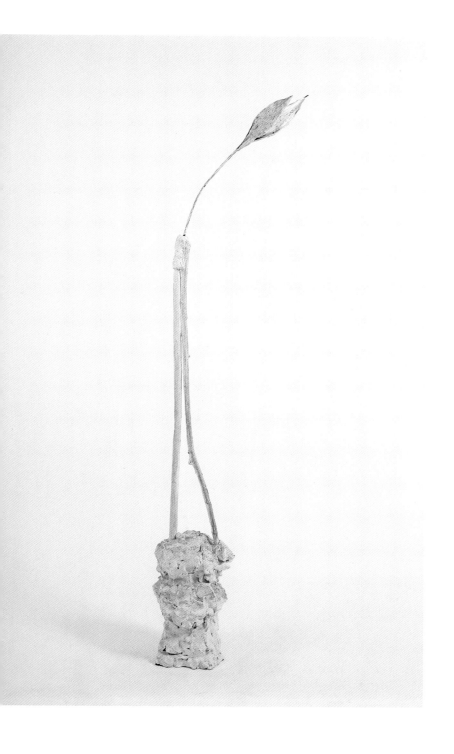

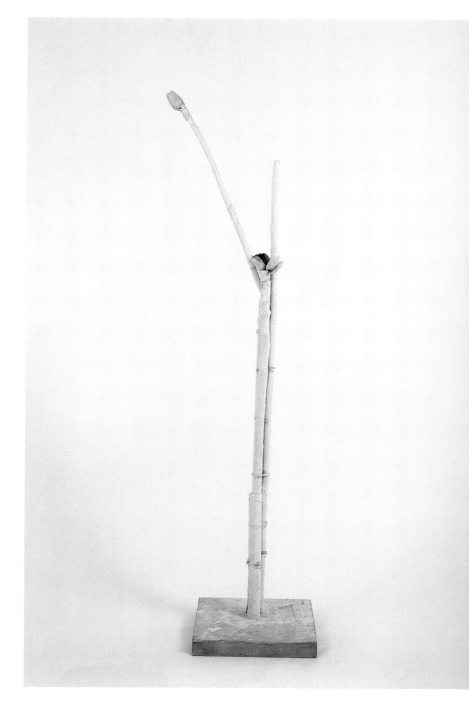

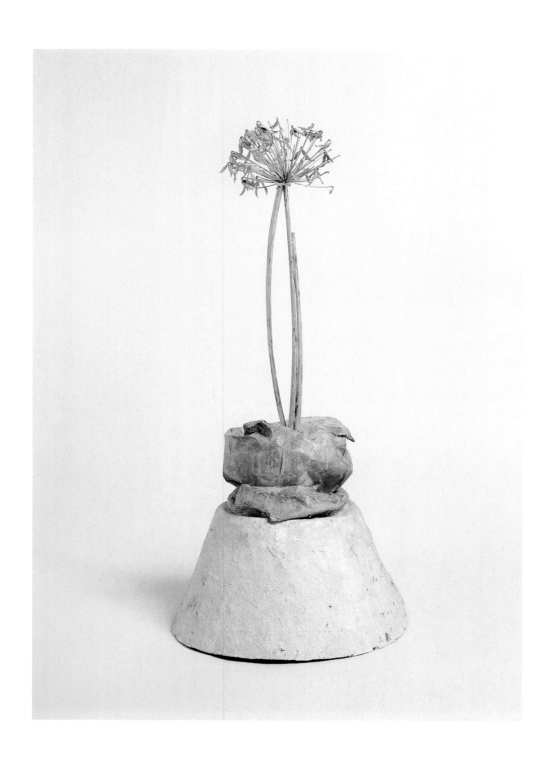

64 *Untitled*, Gaeta 1993

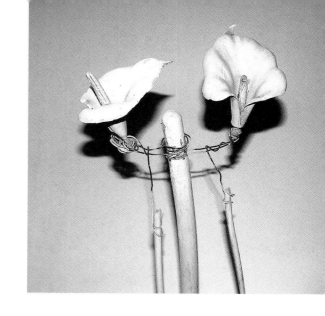

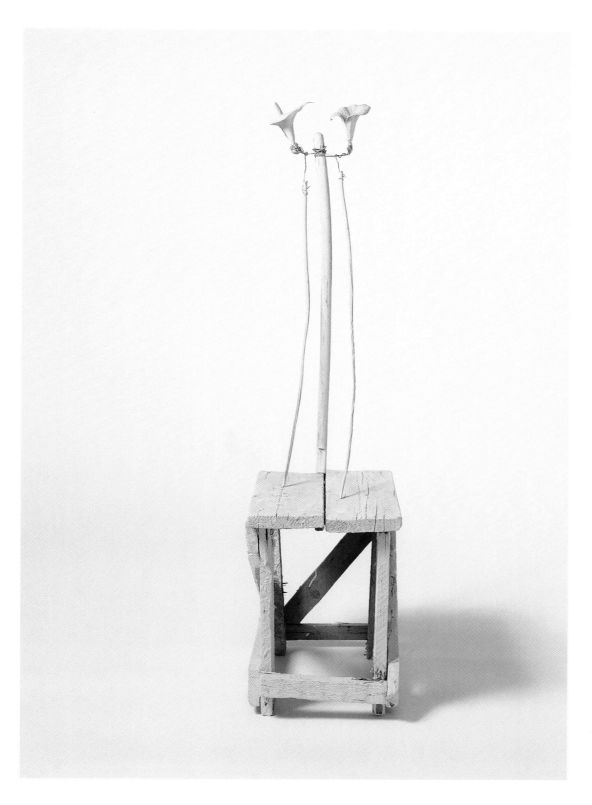

28 *Thicket*, Formia-Rome 1981

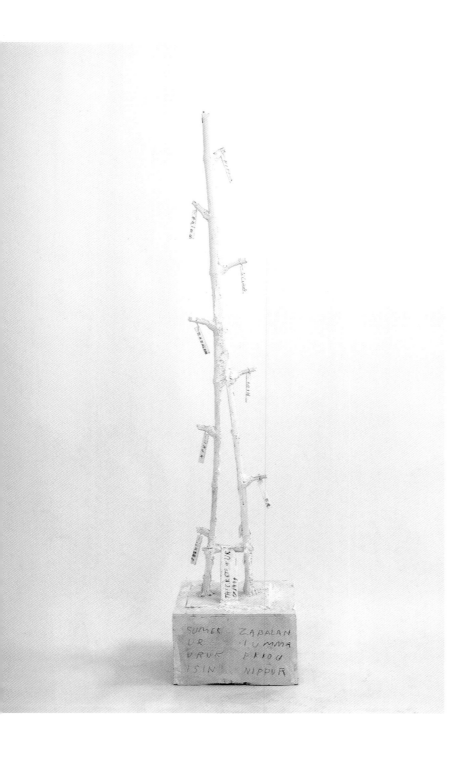

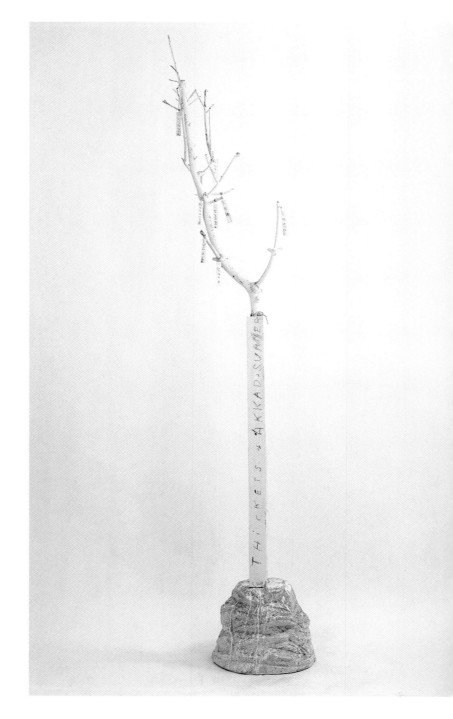

51 *Thicket (Thicket of Ur)*, Gaeta 1990
52 *Thicket (Thickets of Akkad · Sumer)*, Gaeta 1991

form—which does not develop three-dimensional depth, but is restricted to a front and back view—were emerging from undergrowth and rubbish. Yet the two views are different, distinguished by an external back staircase of the kind found on Mexican pyramids (fig. 25). Painted white with traces of pink, the figure—already dematerialized by virtue of its planar aspect—loses even more of its physical presence. It seems detached, distant, like a mirage on its high base, where a rather large inscription can barely be made out beneath the paint; in large, stretched-out cursive, the only word legible is "killing." This alarming trace, this subcutaneous signal, evokes memories of lost Central American cultures and their places of cult worship. Brutally, like the two nails in the top step, it rends the silence of pure contemplation, like a scream that will not die away.

Trees and flowers, mushrooms and leaves, all play a special part in Twombly's œuvre. Their presence is the immediate result of his intense observation of nature, and his joy in its colors and forms, in the way these forms grow, sprout, bud, blossom, and wither. Besides conveying their sheer sensuality—so very much alive in his paintings, collages, and drawings, his books and photographs—his work also tells of their origins, their history, their symbolic meaning in mythology, ritual, religion, and social convention, and their rich metaphorical presence in the literatures of the world. Thus, when not dealing in general terms with growth and proliferation, as in *Thicket* (Jupiter Island 1992, cat. no. 62, p. 101), Twombly uses a specific repertoire of palms, laurel, lotus flowers, roses, and tulips. In the history of painting, one finds well-documented cases of real desperation when the physical changes affecting organic subjects have outstripped the creative process. In Twombly's original sculptures, both flowers made from found objects or entirely by the artist's own hand, and (since 1981) true-to-life synthetic imitations are to be found. There are also paper flowers and even some real plants. While plants are the central theme in certain sculptures, in other cases they are simply details, and in still others they transcend the work of art: a mere mention in a title or inscription can summon up their presence. Untitled (Rome 1983, cat. no. 33, p. 97) is the first upright, slender sculpture of a single plant. The fragile original did not survive the casting of five bronze copies, only one of which is painted white. Two delicate stems rise up out of a high round plinth, originally made from three porous, knobbly balls of a sand-and-plaster mixture, one on top of the other: one stem is smooth and rounded like a broom handle, while the other is like an unskinned twig, slightly bent and rough. Emerging from the plinth, the coarser twig bends toward the straight stick on the opposite side until the two touch. A fine shoot sprouts from their united tip and—as though echoing its dual origin—opens out into two lanceolate leaves. Twombly returned to a related form of this theme in a sculpture made on Jupiter Island in 1992 (figs. 26, 27 and 40). Here, allusion to the familiar legend of the miracle of Joseph is clearer, since the leaves crown a crosier.[70] The earlier sculpture, however, has distinctly anthropomorphic traits: the double stems in the slender center section merge, with the fine stalk seemingly turned toward an

39 *Untitled,* Gaeta 1985

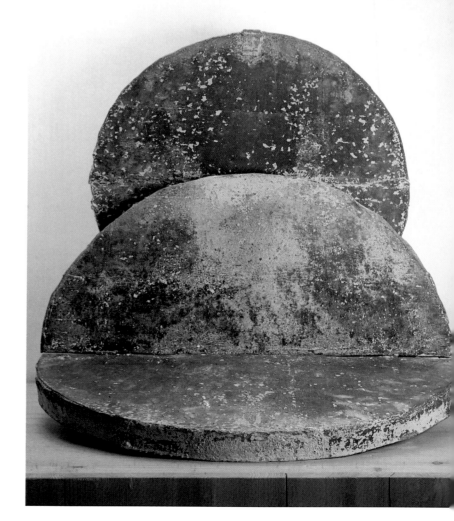

41 *Rotalla*, Gaeta 1986
42 *Rotalla*, Gaeta 1986
 Bronze, Pfäffikon 1990
 Edition 5/6

imaginary sun, and the space encircled by the leaves suggests an oval. But such parallels are always discreet in Twombly's sculptures: the human figure is depicted only in highly stylized form.

This aspect may again be present—albeit even more covertly—in Untitled (Gaeta 1990, cat. no. 50, p. 97), an equally tall, extremely slender floor sculpture. Out of the center of a flat, square base rise four round stems bound tightly together. Their different lengths create four steps. While two end bluntly, the other two blossom, one a little above the center and the second, a tulip shape, bending gently outward and far outreaching the others. The regularity of the intervals at which the stems are bound with fine wires is reminiscent of the knots in bamboo, an association completely at odds with the blossoms. In the East, the tulip joined the rose as a favorite of poets: "Tulips grow out of the grave of the lover, telling of the never dying flame of his love . . .—at the latest since Hafis they have also been associated with the martyrs, by which the martyrs of love are meant."[71] As a flower found in the steppes, the tulip also became a "symbol of the lonely lover ranging across the steppes."[72]

Twombly treated the rigid wooden stems as though their beautiful buds could miraculously blossom. In his books and photographs, he savored the passionate red of the tulip to the full.[73] Here the pervasive white translates it from the sensual into the realm of pure feeling. The clustered stems, which give the stability needed to support the tall figure and to elevate the blooms far above the ground—one somewhat constrained, the other radiantly free—underline the ideal aspect, which accounts for the formal reduction of mass and volume in favor of linearity and emphatic verticality (fig. 28).

The sculpture Untitled (Gaeta 1993, cat. no. 64, pp. 98 and 103) is yet another with a plant as its focal point. An upturned, round plasterer's tub, painted white, serves as a conical base; on it is an oiled paper bag, reinforced with plaster. With the bottom unfolded and the edge rolled up to form a rim, the whole becomes a crumpled, uneven base. Out of the center, on a tall, thin stem strengthened by little twigs, grows an agapanthus, unfolding its filaments in all directions. By using the African lily,[74] which flowers blue and white in Mediterranean gardens, Twombly drew again on an element from his immediate surroundings, which he then combined with leftovers from the renovations he had been doing on the house. This time he chose a real rather than an artificial flower; dried and thus preserved, the golden-beige plant with its tall stalk and elegant aspect conveys at one and the same time the beautiful illusion of an everlasting bloom and a sense of the infinite fragility, the infinite fleetingness, of all living things.

A smaller group of works with a certain affinity to this theme shows how Twombly may return to a motif after a prolonged interval. Thus, the Thicket sculptures all have different dates (1981, 1990, 1991, and 1992) and were made in different locations, but they still share the common allusion to ancient Eastern culture and the sensitive depiction of nature.

The inspiration for the first of these works was an extraordinary small Sumerian sculpture found in a royal tomb in Ur, today on view in the British Museum

31 Cy Twombly, *Rotalla*. Cat. 41, 42
Original und Bronzeguss, Kunstgießerei
Original and bronze cast at the foundry
Kunstgießerei Pfäffikon, Schweiz

41 *Rotalla*, Gaeta 1986

113

32 Joseph Beuys, *Capri-Batterie*, 1985

ganz aus der zähflüssigen Materialität des Gipsbreies entstandene Belag auf seiner Oberseite bildet den bewegten Horizont, aus dem das Rund aufsteigt, triefend von hellem Schlamm: ein Bild der Genesis oder der Moment des morgendlich auftauchenden Sonnenballs, der das Licht bringt und Leben ermöglicht. Die unterschiedliche Behandlung von Rekto und Verso hat, so betrachtet, darstellende Funktion: Das Abseitige erscheint rau, alt und dunkel. Im Bronzeguss *Ohne Titel* (Rom 1997, Kat. 40, S. 109), der die unterschiedlichen Materialien im Grau seiner Patina vereinheitlicht, reduziert sich dieser Kontrast. Das helle Licht ist mildem, dunklem Schimmer gewichen. Im Dämmer des Morgens oder Abends, im Zwielicht des Schöpfungsaktes führen Rechteck und Scheibe ihren Dialog von Ruhe und Bewegung, von Auf- und Untergehen.

Auch *Rotalla* (1986, Kat. 41, S. 112 und 113) entstand in Gaeta. Zwei kreisrunde Scheiben, ursprünglich ebenfalls Olivenfassdeckel, fügen sich zu einer rein frontal und symmetrisch organisierten Komposition. Die untere Hälfte der vorderen Scheibe liegt beinahe flach auf dem Galeriesockel; die obere, durch ein Scharnier mit der liegenden verbunden, lehnt schräg nach oben und wird von einer anderen Scheibe hinterfangen. (Abb. 31) So sieht man das erste und zweite Segment in perspektivischer Verkürzung und ahnt, hinter dem letzten verborgen, einen dritten, vollkommenen Kreis. Die Staffelung in Tiefe und Höhe wirkt hieratisch und doch durch die Kreisformen in sich bewegt. Auch hier ist neben der rein formalen Lesart eine landschaftliche möglich; so könnte man an einen Sonnenaufgang in drei Phasen denken; flach vorauseilendes Licht, die auftauchende und dann die den Horizont beherrschende Scheibe. Das Weiß dieser Plastik verleiht ihren Rundformen die Schönheit und Ausstrahlung, die das Gestirn in fast allen Religionen der Erde zum Gegenstand göttlicher Verehrung werden ließ. *Rotalla* – eine Wortschöpfung, die an das italienische »rotella«, das Rädchen, anklingt und die kreisende Bewegung meint – vereint die verschiedenen Bedeutungsebenen, vom realen Gegenstand, dem Rad, und der Sonnenscheibe mit ihrer komplexen Symbolik. Trotz der homogenen Oberfläche der Holzskulptur unterscheidet sich die Bronze (Gaeta 1990, Kat. 42, S. 112) auch hier wesentlich. Dazu genügt die dunkle bräunliche Patina, die näher bei den hölzernen Deckeln bleibt; der formale Aspekt dominiert stärker, eine metaphorische Deutung drängt sich weniger auf.

Wenn Cy Twombly von »rough sculpture« spricht, rechnet er zu den aus rohem Material gröber gestalteten Werken die ganz für die Aufsicht konzipierte Skulptur *Wenn die Zeit da ist, kommt der Wind und zerstört meine Zitronen* (Rom 1987, Kat. 43, S. 115). Der gesenkte Blick fällt auf die Oberseite einer flachen Bretterkiste, auf der das Endstück einer ungeschälten Holzbohle liegt. Wie die Kiste weiß gestrichen, rechts mit ihrer Kante bündig, links über sie hinausragend, eine große Zunge; sie trägt die kursive Grafit-Inschrift: »In time the wind will / come and destroy / my / Lemons«. Die einfache Aussage, der eine persönliche Erfahrung des Künstlers mit den meteorologischen Kaprizen im Golf von Gaeta zugrunde liegt, wird durch das überraschende Futurum hintersinnig. Der poetische Zeilenfall, der

between the coordinates of the seat and crossbar. That the flowers of the calla lily are reminiscent of the horns of the ram and that the extravagantly pointed tips recall its ears will occur only to those viewers aware of the original source of inspiration. In this *Thicket*, the two curved switches may readily be interpreted as long flower stalks bursting out of the rough undergrowth of the stool, grounding their fragile, light-seeking existence in robust, old material. These plants from northern and subpolar regions are found today in domestic gardens in Italy (fig. 30).[76] Their berries are poisonous; in some places they are reserved for funerary rites.[77] Perhaps their use here is a faint reference to the sepulchral origins of the Sumerian object, which owes its survival to its use as a burial offering.[78]

The two closely related *Thicket* sculptures made in Gaeta in 1990 and 1991 may be described as tree sculptures. They use sections of real plants, developing a new pictorial idea from their organic forms and symbolic meaning. *Thicket (Thicket of Ur)* (Gaeta 1990, cat. no. 51, p. 100) combines the notion of a tree with that of a ladder, albeit in its most primitive form. A raw bamboo cane, split along its lower section, its two "feet" held apart by a stick, has short branch stumps.[79] Wooden tags of an identical size, painted white on the front and with penciled inscriptions, dangle like leaves or botanical names on each of the eight buds, which become shorter and less functional the closer they are to the top. A photograph of the unfinished work shows that these tags were attached before the whole piece was painted a uniform white. Reading from the bottom up, they list "Sumer," the name for Mesopotamia and southern Babylon, and seven towns that were once important centers: Ur, Uruk, Isin, Zabalan, Iumma, Eridu, and Nippur. These are also written on the front of the base, a piece of wood, leaning against the stick that bears the inscription "Thicket of Ur." By reading the words, letter by letter, the viewer unconsciously becomes part of one of the greatest achievements of humankind, the invention of writing. Moving up and down the ladder to read the

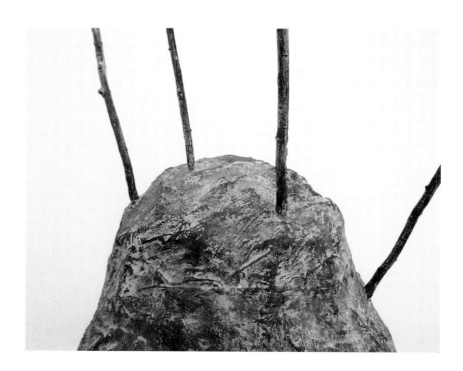

54 *Thermopylae*, Gaeta 1991
Bronze, Meudon 1992

Das alles überziehende Weiß nimmt der kompakten Hügelform ihre Massigkeit, betont den inneren Zusammenhang zwischen der Basis und ihren seltsamen Blüten. Steht entlang dem unteren Rand in Grafitbuchstaben weit gedehnt der Titel, so trägt die andere Seite, auch in Bleistift ausgeführt, als Inschrift die ersten Zeilen aus Konstantin Kavafis Gedicht von 1903: »HONOR TO THOSE WHO IN THE LIFE / THEY LEAD DEFINE AND GUARD / A THERMOPYLAE /...«[83] Durch dieses Zitat erfährt das historische Tugendbeispiel für Vaterlandstreue bis in den Tod, von dem Jacques-Louis David seine bekannte, melancholisch gebrochene Version schuf, eine moderne Generalisierung; Kavafis pessimistisch getönte Poesie lässt weder Zweifel am Erscheinen eines Ephialtes noch daran, »dass die Meder schließlich durchziehen werden«. Ein Denkmal also für eine ethische Haltung, die ihr Scheitern einbezieht.

Entspricht das Original der Verletzlichkeit dieser Sinnschicht, hebt im ein Jahr später entstandenen Bronzeguss (Meudon 1992, Kat. 54, S. 118 und 119) der Metallcharakter stärker den martialisch-brutalen Kern des kriegerischen Ereignisses hervor. Zwar fehlen die Verse von Kavafis, aber auch so wird das eindrückliche Monument in seiner Aktualität verständlich. Wer die Passagen bei Herodot nachliest, wird von den zerbrochenen Speeren an die seltsamen Stängel der Tulpen erinnert.

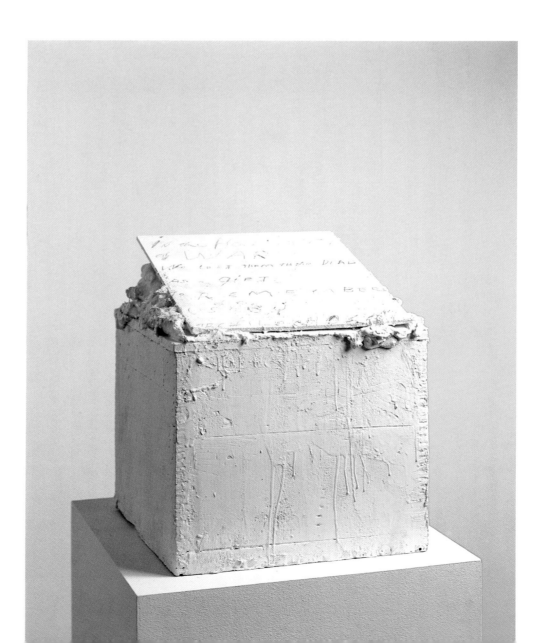

61 *Epitaph*, Jupiter Island 1992

names, the viewer reexperiences the fate of those lost cities, known only from their ruins, from small clay tablets, and from a small number of artistically designed objects.

A year later, in *Thicket (Thicket of Akkad·Sumer)* (Gaeta 1991, cat. no. 52, p. 100), Twombly varied this theme by hanging the same names—with the exception of Sumer, which he replaced with Tell Al Ubai—on wooden tags on a little tree with a firm foothold in a hummocky modeled base made of poured cement. Leaning up against the trunk of the tree is a narrow strip of wood with the inscription "Thicket of Akkad·Sumer." The bare, awkwardly twigged laurel tree—wondrously white—that Twombly has provided with artificial "leaves," embodies the natural cycle of growing and dying even as it incorporates the symbolism of the plant of Apollo. By decorating the ladder and the tree with inscriptions, Twombly combined text and image in a manner that became characteristic of his drawings and paintings. The labels fixed to the branches allude to the traditions of bucolic poetry and to early poetic brotherhoods, while at the same time they emanate the evocative power of the inscribed names—a stylistic device particularly used, in our day, by Anselm Kiefer. In these tenderly white trees, memory seems undramatic, its soft melancholia subduing the hopeful magic of all trees of life. Once again, Twombly has extracted his plants from the underwood of time.

Thicket (Jupiter Island 1992, cat. no. 62, p. 101) manifests a direct link between title and object. On the upper side of a wooden box, painted white and liberally smeared with plaster, a tangle of low, leafy shrubs grows under the glow of a wide-open, five-petaled flower. The inspiration again may be Sumerian, in this case a flower rosette, or it may be some kind of floral arrangement. The optimistic shrubbery, plant life in fertile silt, is a virtual parable of self-renewal, with the white paint creating the impression of miraculous radiance from within.

In 1985–86, in a group of works on a different theme, Twombly introduced circular forms, or segments of circles, using old lids from olive oil barrels as his raw material. This group includes Untitled (Gaeta 1985, cat. no. 39, pp. 108 and 110) and *Rotalla* (Gaeta 1986, cat. no. 41, pp. 112–13), both of which also exist as bronze casts (cat. no. 40, p. 109 and cat. no. 42, p. 112).

In the first of these, an almost semicircular section sits on a broad, shallow, roughly made box of heavily weathered wood. Thick white plaster covers the joint between the plinth and the equally wide half-disc, so that the rounded shape seems to be rising up out of an amorphous mass. But the disc is also covered in glutinously oozing plaster sludge, which descends in thick trails down the untreated back of the plinth. What from the front looks like an arc crowning a block and playing with the tension between circle and rectangle is also open to a different reading. The lumpy, viscous plaster covering the top side of the box forms a mobile horizon out of which the rounded form rises, dripping with pale silt: a picture of genesis or the moment at dawn when we first see the sun's orb, bringing light and giving life. From this perspective, there is meaning in

33 Etruskischer Bronzehelm, 500–480 v.u.Z.
Bronze Helmet, Etruscan, 500–480 B.C.
The British Museum, London

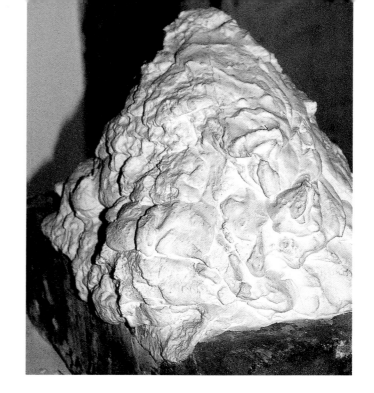

48 *Untitled*, Bassano in Teverina 1988

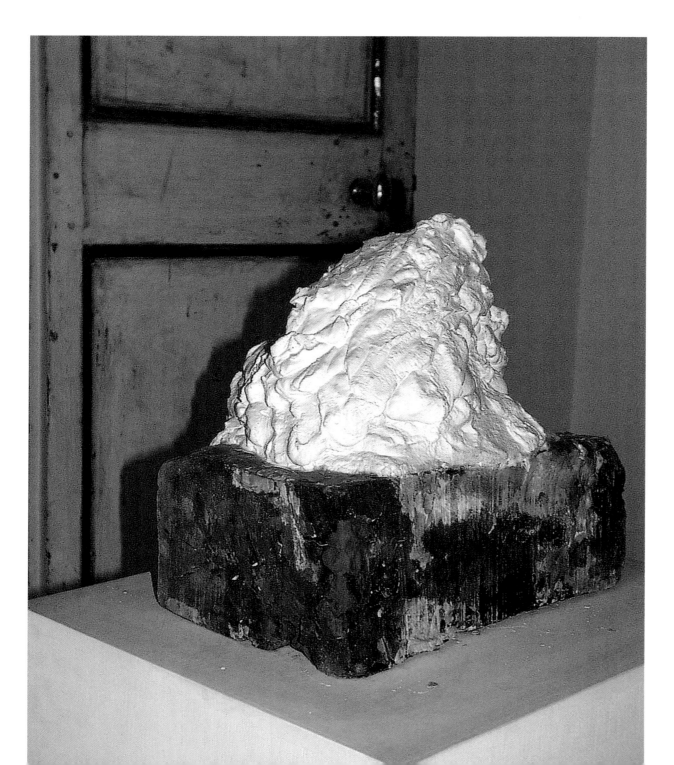

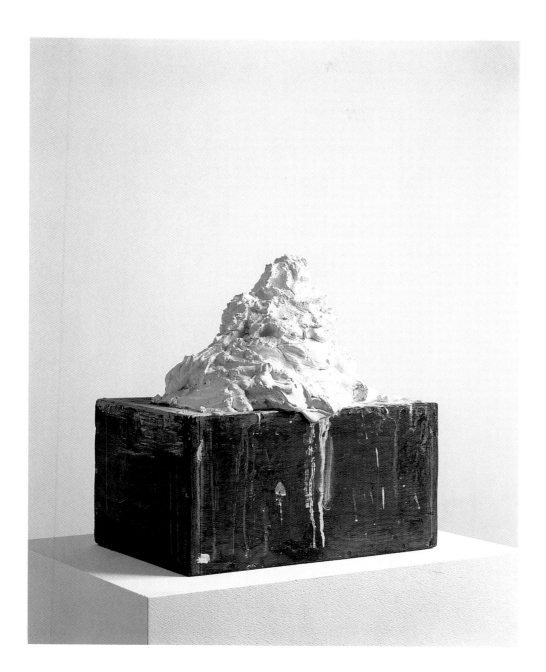

the different treatment of recto and verso: the back is raw, old, and dark. In the bronze cast, Untitled (Rome 1997, cat. no. 40, p. 109), which draws together what were originally different materials in the gray of its patina, this contrast is reduced. The bright light has given way to a milder, darker luster. In this dusk or dawn, the twilight of the act of creation, the rectangle and the disc are engaged in a dialogue on rest and motion, ascent and descent.

The sculpture *Rotalla* (1986, cat. no. 41, pp. 112–13) was also made in Gaeta. Two circular discs, again originally lids of olive oil barrels, are combined to make a purely frontal, symmetrically organized composition. The lower half of the front disc lies almost flat on the gallery pedestal; the upper half, connected by a hinge, leans back at an angle against another disc (fig. 31). Thus one sees the front two segments foreshortened and senses that there must be a third, complete circle

Epitaph (Jupiter Island 1992, Kat. 61, S. 120) heißt eine kleine, weiße Box, deren leichter Deckel von breiig überquellender Gipsmasse angehoben wird. Sie trägt die Inschrift: »in the Hospitality / of WAR / We left them their DEAD / As a GIFT / to REMEMBER / US BY / ARCHILOCHOS«. Der Künstler hatte die Zeilen aus einer Anthologie griechischer Lyrik[84] auf das Kästchen übertragen, das an die Zustellung letzter Habseligkeiten erinnert. Sie sprechen den bitter-scharfen Nachruf auf einen sinnlosen Tod.

Neben den unterschiedlichen Themen- und Motivgruppen enthält Twomblys skulpturales Œuvre Einzelstücke, allenfalls mit einer Variante, zu denen sich auch im Gesamtwerk keine oder kaum Verwandtschaften entdecken lassen.
In Bassano in Teverina 1988 und auf Jupiter Island 1992 entstanden zwei sehr ähnliche Plastiken. Die Sockel aus kurzen alten Vierkanthölzern, fleckig, rissig der eine, eingedunkelt der andere, sind sie schichtweise mit sämig weißem Gipsbrei beladen, bis er sich festigte zu kleinen, kegeligen Bergen mit der regelmäßig-unregelmäßigen Oberfläche der in zähem Fluss erstarrten Masse. Die Renaissance-Plastik kennt solche kleinen Berge aus der Werkstatt des Agostino Zoppo; sie führen ein nach den Schilderungen des Vergil und Ovid inszeniertes Panorama der heidnischen Unterwelt vor.[85] Twomblys erstes Exemplar *Ohne Titel* (Bassano in Teverina 1988, Kat. 48, S. 122) zeigt eine parallele blau-rote Kreidespur, eine diagonale Grenzlinie über die ganze Kuppe, Farben wie er sie in seinen Zeichnungen gerne den Göttern Venus und Apoll zuordnet. Ob darin allerdings eine geheime Anspielung auf einen heiligen Berg enthalten ist, bleibt offen, ebenso ob sich der Künstler an die in einer frühen Arbeit dargestellten Blue Ridge Mountains, jene uralten, buschig bewaldeten Bergrücken in seiner amerikanischen Heimat, erinnert,[86] und ob das auf Jupiter Island entstandene Exemplar *Ohne Titel* (Jupiter Island 1992, Kat. 56, S. 123) den mythischen Göttersitz ironisiert oder ob es einzig um das plastische Verhalten der zähen Materie geht, den Stoff, dem, wie seiner Basis Holz, bis heute elementare Bedeutung für die Herstellung von Skulptur zukommt.

Drei Einzelstücke mögen den Abschluss dieser Werkbetrachtung bilden, in der die wesentlichen stilistischen und thematischen Aspekte in Twomblys plastischem Werk angesprochen wurden. Während des produktiven Aufenthaltes auf Jupiter Island 1992 entstand auch die deckend weiß gefasste Plastik *Madame d'O.* (Kat. 63, S. 124, 126 und 127) Auf einem runden Sockel aus einem umgedrehten Blecheimer steckt in einem Kegel aus Gips zentral verankert ein gerader Rundstab, eingefasst von einer Manschette. Sperrig, mit einem Splint abgespreizt, mit Drähten vertäut, flankiert ihn ein splittriges, widerspenstiges Palmholz, das spitz und schräg über ihn hinausschießt. Ein großes »d'O« in blauer Farbe gibt auf dem Sockel fast in ganzer Höhe den Titel so prominent wie auf keiner anderen Plastik. Er teilt das ganze Vergnügen mit, das Twombly an diesem kürzesten aller Geschlechtsnamen fand, berühmt durch den Finanzminister von Henri III. und Henri IV.[87] Fehlen alle Hinweise auf Kleists *Marquise von O...*, so hat doch der

63 *Madame d'O*, Jupiter Island 1992

hidden in back. The layering in terms of depth and height appears hieratic and yet possesses an element of inner movement derived from the circular forms. Once again, apart from a purely formal interpretation, the work could be read as a landscape; one might, for instance, think of the three stages of a sunrise, the flat rays heralding the approaching sun, the sun itself emerging, and lastly the disc of the sun dominating the horizon. The white of the sculpture gives its rounded forms the beauty and radiance that have made this heavenly body the focus of divine worship in almost all parts of the world. *Rotalla*—a neologism with echoes of the Italian *rotella*, meaning little wheel and evoking the notion of circular motion—unites the various levels of the work, from real object, to wheel, to the disc of the sun with all its complex symbolism.

Despite the homogeneous surface of the wooden sculpture, the bronze cast (Gaeta 1990, cat. no. 42, p. 112) is significantly different. This could be due to the dark brownish patina alone, which seems closer to the original wooden lids; the formal aspect is more dominant, and there is less room for a metaphorical interpretation.

34 Bruce Nauman, *Model for Trench and Four Burried Passages*, 1977 Collection Jay Chiat, New York

When Twombly talks of "rough sculpture," along with the coarser works made from untreated materials, he also includes the sculpture *In Time the Wind Will Come and Destroy My Lemons* (Rome 1987, cat. no. 43, p. 115), which was conceived to be viewed only from above. As we look down on it, we see the top surface of a flat crate, on which lies the end section of a plank of wood that still has its bark. Painted white like the crate flush with it on the right and protruding beyond the lefthand edge like a giant tongue, it bears a handwritten legend in pencil: "In time the wind will / come and destroy / my / Lemons." This simple statement, the product of the artist's own experiences with the meteorological caprices of the Gulf of Gaeta, is given a deeper meaning by the surprising use of the future tense. The poetic line, which follows the curves of the plank and slides down on to the closed crate at the last word, mimics the movement of the wind: it passes over us as rough as the natural bark—and suddenly subsides. The double meaning of "In time the wind will come"—at the right time, punctually, or when the time is ripe—attributes certainty to the incalculable processes of nature, making it a metaphor of the transience of life. The lemon, synonymous with Mediterranean Italy, is longingly extolled in the poetry of northerners who regard the yellow fruit as an embodiment of the warming sun: Joseph Beuys memorably glorified it as a symbol of vitality in his *Capri-Batterie* (fig. 32).[80] Twombly's sculpture, however, prophesies the sad fate of the lemon: the wind will destroy it. The possessive pronoun "my" underlines the artist's identification with his subject. All these various elements come together as if in a poetic epitaph. The ancient symbols of wind and fruit envelop individual fate in the rhythms of nature, thereby gently taking the sting from the immutable.

Mortality and death have assumed increasing importance in Twombly's work since the late 1980s, with the artist frequently drawing on traditional forms of

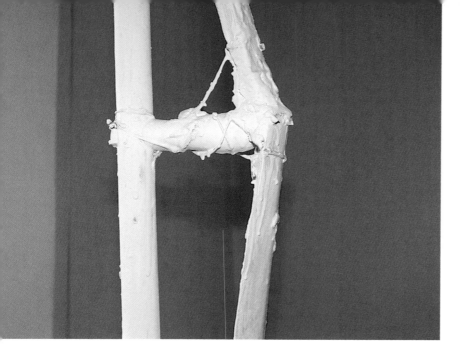

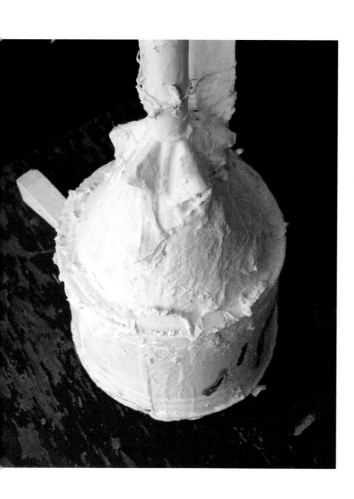

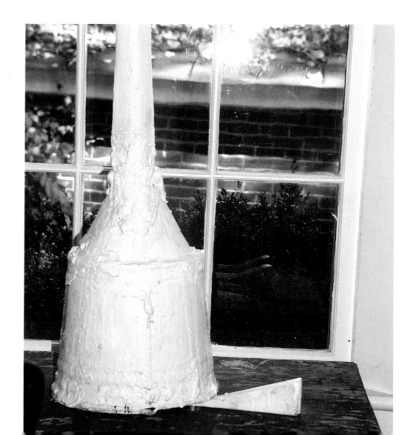

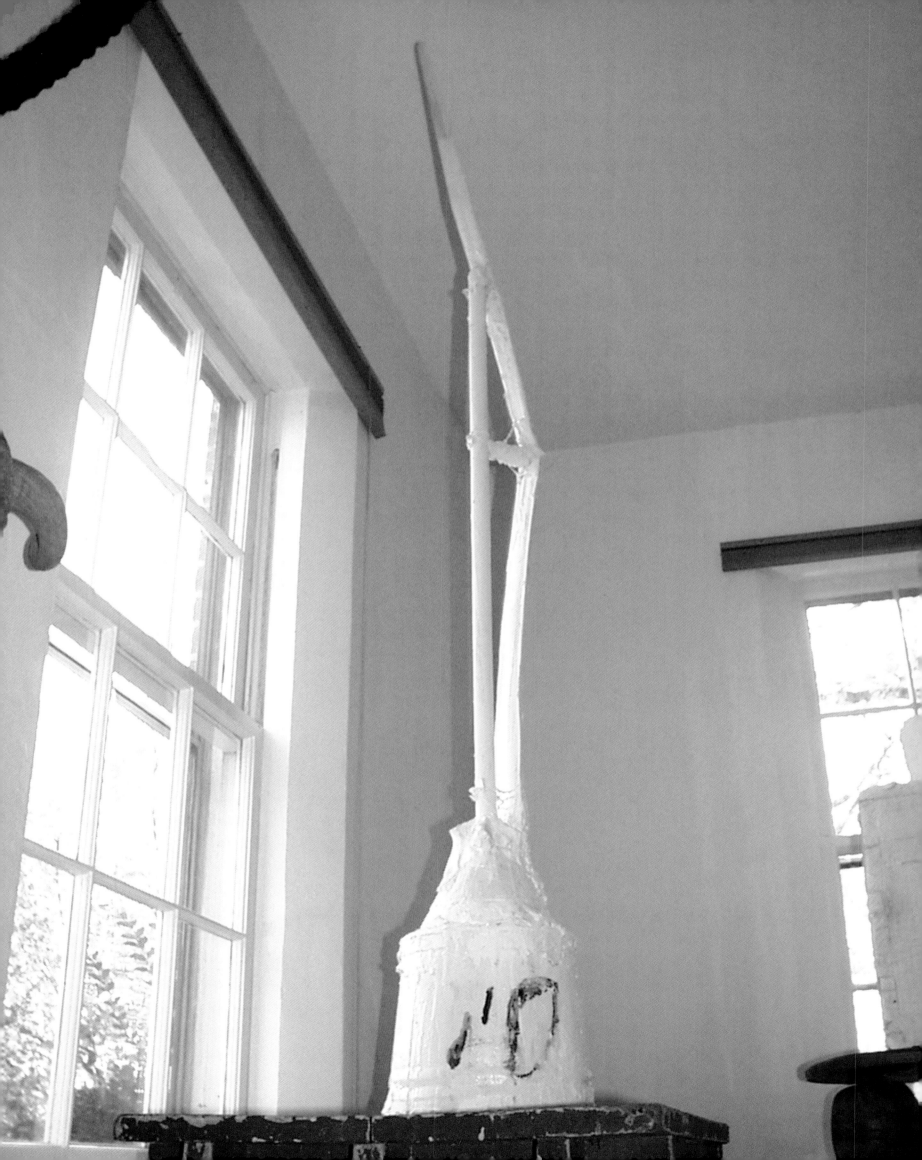

Gedanke, dass die »gebrechliche Einrichtung der Welt« im Spiel sein könne, angesichts dieses besonderen Gebildes nichts Abwegiges. Mit einem kleinen Keil hält Twombly die Skulptur im Lot, ein Mittel, das auch Bruce Nauman zum Bestandteil mancher Werke macht (Abb. 34), um zu justieren und zugleich die Instabilität zu unterstreichen. Die kleine einseitige Unterlage rückt gerade, lüpft dafür aber den runden Fuß der Plastik einen feinen Spalt vom Boden, ein Saum, der ein Geheimnis birgt. Wie eine flüchtige Spur, den Gegenstand verrätselnd, steht das mit dem Pinsel gemalte »d'O« in der Farbe dunkelblauen Wassers, mit dem es im Französischen homonym ist, auf dem weißen Grund. Hat es die Form der verwehten Lorbeerblätter Apolls, die Twombly über den freien Grund seiner Zeichnungen streut, malt er Orpheus' offenen »Mund der Natur«.[88] Jedenfalls vergibt der Maler ausnahmsweise hier das Blau, wie manchmal auch an Aphrodite Anadyomene, an das andere Geschlecht.

In *Chronik von Vulci* (Gaeta 1995, Kat. 65, S. 130) gleicht die Oberfläche eines niedrigen, längsrechteckigen Sockels einer Platzsituation. Auf ihr verteilen sich wie bei Giacomettis *Modell für einen Platz* von 1931–1932[89] (Abb. S. 164) vier ähnliche Elemente, gewonnen aus den kräftigen Stielen der Palmblätter, jedes leicht gekrümmt und nach oben verjüngt. Ihre geraden Schnittflächen, die das besondere Wachstum der Baumart erkennen lassen, haben die Form gleich-schenkliger Dreiecke. So zerlegt, wirken sie kaum wie Pflanzenteile, eher wie Knochen, was ihre Anordnung noch verstärkt: Drei Stücke liegen, eines steht, drei befinden sich auf der rechten Hälfte der Grundfläche, eines ist auf der linken isoliert, zwei sind dicht und parallel platziert, das vereinzelte rückt links an den Plattenrand. Erinnert die Komposition an Modelle eigenwilliger architektonischer Anlagen, weist der Titel *Chronik von Vulci* in eine spezielle Richtung.[90]
Das Leben des sehr religiösen etruskischen Volkes war durch die *Disciplina etrusca* geregelt. In drei Teile gegliedert, befasste sich der erste, die *Libri haruspici*, mit der Leberschau. Diese aus Mesopotamien stammende Wahrsagekunst, für die es im Alten Orient eine hoch entwickelte Technik gab und die man auch in Griechenland praktizierte, war in Etrurien das wesentliche Instrument, um den Willen der allmächtigen Götter zu erkunden. »Die Leber galt als Sitz des Lebens. Das Wirken einer bestimmten Gottheit machte sich bemerkbar durch die Ab-weichungen vom Normalzustand an der Oberfläche der Leber eines frisch ge-schlachteten Schafs und konnte vom Priester, dem ›haruspex‹, in seiner Botschaft gedeutet werden.«[91] Unter den überlieferten Lehrmodellen ist vor allem die 1877 gefundene *Bronzeleber von Piacenza* (Abb. 35) interessant, da diese Nachbildung des tierischen Organes die Einteilungen der Himmelsrichtungen mit den dort an-genommenen Göttersitzen aufweist. Neben den Leberhälften erkennt man die plastisch gewölbte Gallenblase, den dreieckig hochstehenden »Leberfinger«. Eine gewisse Ähnlichkeit von Twomblys deutlich größerer Skulptur mit solchen Modellen mag bestehen, aber nicht im Sinne einer naturgetreuen Nachbildung, vielmehr als eine Art Instrument zum geistigen Gebrauch, mit dem sich Verhält-nismäßigkeiten, Beziehungsgeflechte, Proportionen ablesen und Schlüsse ziehen

sepulchral art, such as gravestones, memorial plaques, and their inscriptions. After *In Time the Wind...* Twombly returned again explicitly to a similar theme. The most outstanding example is the sculpture made for Amelio-Brachot's Galerie Pièce-Unique. It is named *Thermopylae* (Gaeta 1991, cat. no. 53, p. 118) after the pass in Boeotia where, on August 17, 480 B.C., the Spartan King Leonidas and his men vainly tried to stop the invasion of the gigantic Persian army under Xerxes. As the result of an act of betrayal by Ephialtes, who showed the Medes the way round the otherwise unconquerable pass, all the Greeks perished. Herodotus describes the events in his *History*, mentioning the inscription of Simonides, which has become part of the German literary heritage in Friedrich Schiller's transla-tion: "Wanderer, kommst du nach Sparta, verkündige dorten, du habest / Uns hier liegen gesehn, wie das Gesetz es befahl [Traveller, if you should come to Sparta, then tell them there, that you did see us lying here, as the law would have it]."[81] Using woven willow covered with cloth, Twombly made a steep, rounded mound to evoke the place that is so very different today. Its slightly irregular surface calls to mind rocky mountain crags, although some might prefer to see it as an ancient battle helmet (fig. 33). Stiff and straight, four single tulips grow out of the top.[82] Firmly coiled wire attaches the artificial blooms to the tips of the leafless, knob-bly stems, as though on artificial limbs; they will not droop and their optimistic flowering will never end. As in an earlier sculpture (cat. no. 50, p. 97), Twombly has again chosen tulips. But in this work they symbolize martyrdom rather than perfect love. The presence of this flower, which originated in the Middle East, could also be a subtle allusion to the creative cross-fertilization that may result from even so traumatic an encounter between two cultures. The covering of white paint prevents the mound from appearing solid and emphasizes the connection between the base and its strange flowers. On one side is the title, in widely spaced pencil letters; on the other side, again in pencil, stand the first lines of a poem by Constantine Cavafy, written in 1903: "HONOR TO THOSE WHO IN THE LIFE / THEY LEAD DEFINE AND GUARD / A THERMOPYLAE..."[83] This quotation takes the historical sentiment of fighting to the death for one's country—well known through Jacques-Louis David's melancholic interpretation— and imbues it with a modern relevance: the pessimistic tone of Cavafy's poem leaves no doubt that an Ephialtes will appear or that "in the end the Medes will go through." *Thermopylae* is a monument to an ethical stance that accepts its own ineluctable failure.

While the original reflects the vulnerability of this level of meaning, the metal of the bronze cast produced a year later (Meudon 1992, cat. no. 54, pp. 118–19) un-derlines the brutal martial core of that moment of war. Although Cavafy's lines are missing, this impressive monument remains comprehensible in terms of its present-day significance. And if the viewer should read Herodotus' account of those events, no doubt the broken spears there will call to mind the curious stems of the tulips.

Epitaph (Jupiter Island 1992, cat. no. 61, p. 120) is the title of a small white box whose lid is slightly raised because of the mass of plaster oozing out of it. It bears

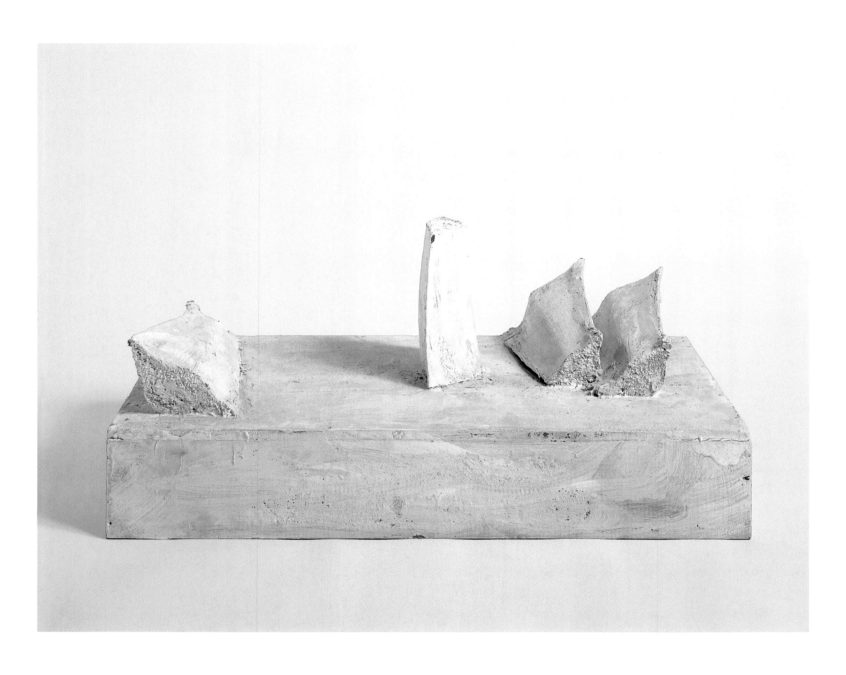

65 *Vulci Chronicle*, Gaeta 1995

an inscription taken from a Greek poem: "in the HOSPITALITY / of WAR / We LEFT THEM THEIR DEAD / As a giFT / TO REMEMBER / US BY / ARCHILOCHOS."[84] The box looks as though it could be used to contain a dead soldier's personal effects. The text resonates with the bitter recollection of a senseless death.

Besides the ensembles of works addressing different themes and motifs, Twombly's sculptural œuvre also contains individual works (occasionally also existing in a variant) that bear little or no identifiable relationship to the rest of his work.

In Bassano in Teverina in 1988 and on Jupiter Island in 1992, Twombly made two very similar sculptures. The plinths, made of short, square-sectioned blocks of wood—stained, one of them cracked and the other one grown dark—are heaped with layers of a grainy white plaster mass forming little conical mounds with the regular-irregular surface of a substance that has solidified in mid-flow. Small sculptural mounds of this kind are known to us from the Renaissance as products of the workshop of Agostino Zoppo; they depict a heathen underworld, according to the descriptions of Virgil and Ovid.[85] The first of these two sculptures by Twombly, Untitled (Bassano in Teverina 1988, cat. no. 48, p. 122), has a parallel blue-red chalk line running diagonally over the whole mass, colors that Twombly customarily attributes to Venus and Apollo in his drawings. The chalk line therefore could be a subtle allusion to a sacred mountain, but it could just as well recall the subject of an earlier work, the Blue Ridge Mountains, the ancient, heavily wooded mountain range in Twombly's American homeland.[86] In the same sense, the second of these two sculptures, Untitled (Jupiter Island 1992, cat. no. 56, p. 123), could be an ironical comment on the mythical seat of the gods, or it might simply be addressing the behavior of the viscous plaster, a substance that—like the wood of the substructure—retains elemental significance for sculpture to this day.

35 *Leber von Piacenza,* etruskisch, um 100 v.u. Z. *Bronze liver from Piacenza,* Etruscan, c. 100 B.C. Museo Civico, Piacenza

Three individual works bring to a close this discussion of the main stylistic and thematic elements in Twombly's sculptural work. During a productive stay on Jupiter Island in 1992, he made the solidly white sculpture *Madame d'O* (cat. no. 63, pp. 124, 126–27). On a round plinth made from an upturned bucket, a straight, rounded rod rises up out of the center of a plaster cone, enclosed by a collar. Flanking the rod is a splintered palm branch, angled outward and supported by a splint, cutting across the rod and extending well beyond it. A large "d'O" in blue paint on the plinth announces the title more prominently than on any other of Twombly's sculptures. It conveys the delight that Twombly takes in this shortest of family names, made famous by the finance minister to Henri III and Henri IV.[87] Although there are no references to Heinrich von Kleist's *Marquise von O…,* it may not be entirely unjustified, in view of the work itself, to imagine that the "fragile arrangement of the world" could be in play here. A small wedge keeps the sculpture upright, an aid that Bruce Nauman also employs in some of

36 Alberto Giacometti, *Paysage – tête couchée,* 1932 Musée national d'art moderne, Centre Georges Pompidou, Paris

lassen. Als Gegenstand bleibt sie rätselhaft. Auch der Vergleich mit besonderen astronomischen Geräten und architektonischen Anlagen (Abb. 37) bietet sich an, umso mehr, als Twomblys Titel *Vulci Chronicle* den Verweis auf das Zeitphänomen enthält, zu dem die Etrusker ganz eigene Vorstellungen entwickelt hatten: Dem Einzelnen – wie dem ganzen Volk – war nach ihrem Verständnis schicksalhaft eine unabänderliche Lebensdauer gewährt.

War von Twomblys Schiffsskulpturen bereits die Rede, verwendete er in den neunziger Jahren Ruderblätter, öfter auch ganze Riemen als konstitutive Elemente seiner Skulpturen, allerdings mehr aus formalen denn aus thematischen Gründen. Als knappe, schmalhohe Rundsockel dienen umgestülpte Blumentöpfe, dem Garten entnommene Dinge. *Ohne Titel* (Gaeta 1998, Kat. 66, S. 134 und 135) besteht aus zwei plastischen Teilen, einem auf der Blattkante stehenden, kurzen Ruder, an dem ein etwa gleich dicker Ast schwingt. Unten verbindet sie die Gipsmasse, etwas weiter oben halten Drahtumwicklungen die Stücke zusammen; eine weitere Verschnürung findet sich etwas über der Mitte, bevor der Ast vom kurzen Parallelverlauf wegschwingt und die beiden Komponenten sich zu einer Gabel spreizen. Es geht um das Spannungsverhältnis dieser beiden Elemente. Bei geringer formaler Anpassung laufen sie ein Stück weit parallel, um wieder krass auseinander zu gehen. Möchte man an die Konfrontation des geraden Ruders mit der Rundung des Bootskörpers denken, dreht sich Twomblys ungegenständliche Formulierung in erster Linie um ein wichtiges Motiv der Plastik: die Verbindung von gerader, statischer mit dynamisch gekrümmter Form, wie sie die christliche Kunst in Darstellungen des heiligen Sebastian kennt (Abb. 39), wenn sich sein Leib unter dem Martyrium am Baumstamm krümmt. Denken könnte man auch an eine Szene aus den Irrfahrten des Odysseus, wenn der Held sich an den Mast des Schiffes binden lässt, um dem Gesang der Sirenen zu widerstehen. (Abb. 38) Angewiesen ist die weiße Plastik mit ihren präzisen Proportionen, dem Spiel ihrer Übergänge von flachen zu vollplastischen Partien, ihrem Kontrast engster Verbindung und sperrigem Auseinanderstreben auf solche ikonografischen Zusammenhänge nicht.

Das Betrachten von Cy Twomblys Skulpturen vermittelte einen Eindruck von ihrer materiellen Beschaffenheit, von den in ihnen wirksamen Gestaltungsprinzipien, ihren Themen und Motiven und den allmählichen Veränderungen. Dennoch scheint sich dieser vielgestaltige Komplex, der seinen selbstverständlichen Raum im Gesamtwerk des Künstlers einnimmt, immer wieder dem sprachlichen Zugriff zu entziehen; er behält seine Offenheit.
Für ein Foto hatte Cy Twombly 1951 seine kleinen hellen Skulpturen mit der breitspurigen schwarzweißen Malerei konfrontiert und dabei Nähe und Unterschied seiner Arbeit in den beiden Gattungen verdeutlicht, denen er sich ungefähr gleichzeitig zuwandte. (Abb. 4) Von Anbeginn fand der Künstler in der Assemblage sein adäquates Prinzip für die dreidimensionale Gestaltung, die er, von wenigen Ausnahmen abgesehen, beibehielt; ebenso ausschließlich entschied er sich für

his works, both to straighten a piece and to underline its instability (fig. 34). The wedge puts the piece on an even keel, but only by lifting the round base of the sculpture slightly off the ground, revealing a seam that harbors a secret. Like a fleeting imprint of some kind, mystifying the object, the painted "d'O" against the white ground is the color of dark blue water, in keeping with its meaning when pronounced in French. To the extent that the inscription has the form of Apollo's windblown laurel leaves, which Twombly scatters across the empty spaces in his drawings, one might say he has painted Orpheus' open "mouth of nature."[88]

Be that as it may, the artist for once associates blue—sometimes also given to Aphrodite Anadyomene—with the other sex.

In the *Vulci Chronicle* (Gaeta 1995, cat. no. 65, p. 130), the upper surface of a low rectangular plinth resembles a city square. Like Giacometti's *Model for a Square* of 1931–32 (fig. 12, p. 164),[89] this piece has four similar elements, in this case made from sturdy palm-leaf stems, each one slightly curved and narrowing toward the top. The flat, cut surfaces, shaped like isosceles triangles, show the particular growth structure of this type of tree. Dissected in this way, they look less like parts of a plant than bones, an impression reinforced by their arrangement: three pieces are lying, one is standing; three are on the righthand side of the base while the fourth is on the left; and two are parallel and lie close to each other, while the single piece is pushed left toward the edge of the base. While the composition itself is reminiscent of idiosyncratic architectural designs, the title, *Vulci Chronicle*, points in a very specific direction.[90]

The Etruscans were a highly religious people and their lives were regulated by the *Disciplina etrusca*. The first of its three parts, the "Libri haruspici," concerned the interpretation of the liver. This Mesopotamian method of prophesying the future, highly developed among ancient Eastern peoples and also practiced in Greece, was the main instrument in Etruria for discovering the will of the all-powerful gods: "The liver was regarded as the seat of life. The acts of a particular god could be recognized in any deviations from the norm on the outer surface of the liver of a freshly slaughtered sheep, and could be interpreted by the priest, the 'haruspex.'"[91] Among the various teaching models that have survived, most of them made of clay, the bronze liver of Piacenza found in 1877 is particularly interesting (fig. 35): this copy of the animal organ also shows the different directions of the compass, along with the gods who were believed to dwell there. Apart from the liver halves, there is also a bulbous gall bladder,—the triangular, vertical "liver finger."

There may be a certain similarity between Twombly's distinctly larger sculptures and models of this kind, but not in the sense of a faithful depiction of the original; rather they serve as a kind of instrument for the intellect by means of which relationships, interconnections, and proportions may be read and conclusions drawn. As an object, it remains perplexing. Comparisons with special astronomical devices and architectonic structures (fig. 37) come to mind, all the more as Twombly's title, *Vulci Chronicle*, reflects the phenomenon of time, about which the Etruscans had developed very specific notions: in their view, individuals and the nation alike were allotted an unalterable life span by fate.

37 Monte Albán, México

66 *Untitled*, Gaeta 1998

38 *Odysseus und die Sirenen*, Mosaik,
Dougga, 2. Jahrhundert
Ulysses and the Sirens,
mosaic, Dougga, second century B.C.
Musée National du Bardo, Le Bardo

die Einzelskulptur. Atmen die ersten Figürchen in ihrer Kombinatorik den ironisch-poetischen Geist von Dada, ohne die zeitkritischen Anspielungen der Begründer, nach der ersten Europa- und Nordafrikareise werden die Formate wesentlich größer; selbst die wenigen kleinen Objekte wirken plötzlich monumental, spannungsgeladen und rätselhaft. Vom surrealistischen Interesse an den verborgenen Energien der Psyche stimuliert und von Beispielen primärer Formen angeregt, spiegeln sie das Interesse an magischen Zeichen und an fetischistischen Handlungen. Sie entrücken die absonderlichen Gebilde – auch sie überraschende Assemblagen – der intimen Handlichkeit und übersetzen sie ins Allgemeinere, Unpersönliche einer größeren Dimension. Einzelne Plastiken von 1954/55 enthalten Felder mit freier Zeichnung, die den Bildern dieser Zeit ähnlich sind. Als Vorformen weisen sie schon auf die späteren poetischen Inschriften. Twombly folgt nicht der Tendenz der fünfziger Jahre, Gegenstände in die Malerei zu integrieren und so aus der Fläche in den Raum vorzustoßen, sondern geht einen eigenen Weg, indem er Grafismen, Schrift und Text in die Malerei und Plastik einbezieht und sie so einer anderen Kunst, der Dichtung, öffnet.[92]

Als er 1976 nach einer Pause von siebzehn Jahren, in der er ein malerisches und zeichnerisches Œuvre von großer Intensität und Vielfalt entwickelt hatte, wieder dreidimensional arbeitete, bot die Kunstszene ein verändertes Bild. Längst war durch die Pop Art eine neue Beziehung zwischen Kunst und Alltagskultur hergestellt; während sich die Minimal Art elementaren geometrischen Formen zuwandte, revolutionierte Joseph Beuys mit dem erweiterten Kunstbegriff radikal die Vorstellung von Plastik. In Italien hatte die Arte Povera die »Banalität auf den Karren der Kunst steigen«[93] lassen und die Verwendung einfacher, durch ihr simples Dasein akzeptabler Materialien proklamiert. Twombly schloss sich weder Gruppen noch Bewegungen an. Wenn er »povere«, alltägliche Dinge verwendete, hatte dies ältere Wurzeln; er zelebriert ihre Ärmlichkeit gerade nicht, sondern lädt sie mit Bedeutung auf.

Twomblys Skulpturen sind seit 1948 weiß.[94] Dieses Weiß lässt sie leuchten, verleiht ihnen Schwerelosigkeit. »Oder ist es dies: Weiß ist ja gar keine Farbe, sondern ihr sichtbar gewordenes Fehlen und zugleich die Summe aller Farben?«[95] Weiß hat in Twomblys Skulptur viele Nuancen, von den verschiedenen Substanzen und der Art ihrer Verwendung erzeugt: Öl- und Wandfarbe, Cementito, Gips, Plastilin oder verschiedene Mischungen. Dieses Weiß, das in der Kunst nach 1945 für Neutralität, Anfang, Hoffnung, Licht, Spiritualität, für das Sublime stand, Twombly erprobte es in der Malerei im harten Kontrast zu Schwarz, bevor er ihm die offenen, diaphanen Bildgründe überließ für Ströme von Linien, Zeichen, Namen, und in der Umkehr über dunkle Flächen Gespinste aus weißer Kreide legte. In der Skulptur eint die lichte Bemalung die einzelnen Elemente zu homogener Gestalt und nimmt den einfachen Fügungen das Schlichte. Wo der informelle Auftrag, anscheinend nachlässig, die Oberfläche des Holzes nicht sättigt, sie nicht glatt, gleichmäßig deckt, geben Seiten und Rückseiten Indizien preis für die Geschichte der Fundstücke und den Akt ihrer neuen nobilitierenden Integration.

Twombly's ship sculptures have already been mentioned. In the 1990s, the artist used the blades of oars, or more frequently entire oars, as constitutive elements in his sculptures, albeit more for reasons of form than meaning. Upturned flower-pots from the garden serve as rudimentary, tall, narrow, rounded plinths. Untitled (Gaeta 1998, cat. no. 66, pp. 134–35) consists of two three-dimensional elements: a short oar standing upright on its blade and a curving branch of equal thickness. At the base, they are set into plaster, and wire holds the pieces together higher up; a little over halfway up, the two are tied together again before the branch breaks away from the short parallel section and the two components fork away from each other. The work is about the tension between these two elements. Formally dissimilar, they nevertheless run parallel for a time before abruptly parting company. Much as one might be tempted to think of the confrontation between a straight oar and the rounded hull of a boat, Twombly's nonrepresentational formulation hinges primarily on a preeminent motif in plastic art: the connection between straight, static forms and dynamic, curved forms, as exemplified in Christian art by representations of the Martyrdom of Saint Sebastian, when the tortured body curves against the trunk of the tree (fig. 39). One might also think of Ulysses bound to the mast in order not to succumb to the Sirens' song (fig. 38). And yet with its precise proportions, its interplay of transitions between flat and fully three-dimensional sections, and its contrast between intimate convergence and ungainly divergence, the sculpture does not depend on iconographic allusions of that kind.

39 Sodoma, *Hl. Sebastian*, um 1525/31
Sodoma, *S. Sebastian*, c. 1525/31
Palazzo Pitti, Galleria Palatina,
Firenze

Looking at Twombly's sculptures, one gains a sense of the material aspects, the shaping principles at work, their themes, motifs, and gradual transformations. Yet, at the same time, this multifaceted body of work, which is so essential a component of the artist's œuvre, defies language; it remains open-ended. For a photograph in 1951, Twombly juxtaposed his small, luminescent sculptures and his bold black-and-white paintings, highlighting the affinity and the disparity of his work in the two genres, which he had taken up at about the same time (fig. 4). From the outset, he found that assemblage suited his three-dimensional work, and he has, with few exceptions, pursued the principle ever since. He has also been consistent in his preference for one-off sculptures. While his first small figures breathe with the ironic-poetic spirit of Dada—without the contemporary, critical allusions of its founders—his formats become considerably larger after his first trips to Europe and North Africa. Even the few small objects suddenly seem monumental, highly charged, and enigmatic. Stimulated by the Surrealists' inter-est in the hidden energies of the psyche and inspired by examples of primary forms, his works reflect his interest in magic signs and fetishist ritual. They remove the curious forms—themselves arresting assemblages—from the intimacy of manual skill and imbue them with the more universal, impersonal essence of larger dimensions. Certain sculptures from 1954–55 contain areas of free draw-ing, similar to the pictures Twombly was making at the time. They are already prefigurations of the later poetic inscriptions. Twombly did not follow the 1950s

Die Umbildung der Objets trouvés wird wesentlich durch ihre Komposition erreicht. Viele dieser Skulpturen leben von der Zusammenstellung der Dinge in einer hierarchischen Ordnung von Sockel und Motiv. Der oft mehrstufige untere Teil grenzt aus und erhöht. Er erinnert nicht nur an den traditionellen Aufbau von Denkmälern, er bildet zugleich die Schichten, die Sedimente, die die Figur als das Letzte, Neueste mit ihrer Gegenwart krönt. Doch jede Sockelstufe entrückt das von ihr Getragene. Wie die Diskrepanz zwischen dem einfachen Gegenstand und seiner seltsam anmutenden Aufwertung durch die Präsentation, verdeutlicht auch dieser Wechsel in der Empfindung von Nähe und Ferne, dass es nicht um Abbildung geht, sondern um Zeichenhaftigkeit. Die auf das Elementare reduzierten gegenständlichen Formen, Motive aus der Natur, der Welt der Pflanzen, der technischen Erfindungen, der Architektur sind vielfach so aufgefasst, dass eine oder mehrere Ansichten ein ungegenständliches Gebilde zeigen, wenn nicht die Gesamtkomposition aus den geometrischen Grundformen Dreieck, Rechteck, Kreis besteht. Doppelte Lesarten bieten sich auch hier an: Der Stängel einer Pflanze zeichnet die reine Kurve, in der abgestützten hochschießenden Diagonalen glaubt man den mit ausholendem Schritt vorwärts Eilenden zu erkennen.

Wenn Bewegung als zentrales Thema dieser Skulpturen erscheint, ohne dass Twombly mit eigentlich beweglichen Elementen arbeitet,[96] gehört zu deren unterschiedlichen Darstellungsformen auch das Gegenteil, die Ruhe. Da sind alle die Gefährte zu Land und Wasser. Sie machen uns das Galoppieren, Rattern und Gleiten vor und verharren doch faszinierend auf ihren Sockeln. Die hierarchische Form der Monumente in vergänglichen Materialien imitierend, führen manche mit leiser Ironie das Drama von Ruhm und Dauer auf. Zeiger gehen »in kleinen Schritten neben unserm eigentlichen Tag«[97] und fallen plötzlich aus dem Takt; ein Stab bricht mitten entzwei. Die Bäume, die Pflanzen, die Blumen sind in Bewegung. Sie sprießen unerwartet, zeigen die Merkmale ihres Wachstums, recken sich hoch, lehnen an totes Holz und stehen doch unheimlich weiß, schön und still. Der Wechsel der Jahreszeiten mit winterlichem Innehalten, die Bewegung des Windes tönt in diesen Skulpturen an. »Weiße Ruinen bleiben immer neu ...«[98] – täuschen sie über den unaufhaltsamen, leise bröckelnden Verfall?

Und die Bewegung des Betrachters? Twombly arbeitet mit unterschiedlichen Kompositionstypen. Zum einen sind die Gegenstände wie bei der Altarform mit einer Hauptansicht frontal dargeboten, doch enthalten auch hier Seiten- und Rückansichten selbst in anscheinend vernachlässigter Ausarbeitung wesentliche Informationen zum Erleben des Werkes. Bei einer Reihe von Skulpturen, bei denen die Vorder- und Rückansicht gleich oder ähnlich sind, überrascht die Seitenansicht mit einem abweichenden Motiv. (Kat. 36, S. 75) Der Gegenstand ist in die Tiefe nicht vollplastisch entwickelt; in anderen Fällen glaubt man eine abstrakte Komposition vor sich zu haben. Der Betrachter, der etappenweise Positionswechsel vollzieht, sieht sich in harten Schnitten mit der Doppel- und Mehrgesichtigkeit der Dinge konfrontiert. In den letzten Jahren bevorzugte Twombly vollplastisch durchgearbeitete Gebilde, die der Blick sanft gleitend wahrnimmt. Räumlich verschränkte Stäbe, in sich gewundene Stängel auf runden

tendency to leave the flat surface and obtrude into space by integrating objects into paintings; instead he embarked on a different path, incorporating *graphismes*, writing, and text into painting and sculpture, thus opening them to another art, poetry.[92]

After a pause of seventeen years, during which he built up an œuvre of paintings and drawings of utmost intensity and diversity, Twombly started to work in three dimensions once again. The art scene was now a changed place. Pop Art had long since established a new relationship between art and everyday life; while the Minimalists were turning to elementary, geometric forms, Joseph Beuys had expanded the concept of art, radically revising the notion of sculpture. In Italy, *Arte Povera* had allowed "banality to climb onto the bandwagon of art" and proclaimed the use of uncomplicated materials acceptable by virtue of their very simplicity.[93] Twombly neither attached himself to groups nor followed movements. When he used *povere*, everyday items, he was returning to far older roots; he was not celebrating their poverty, but rather infusing them with new meaning.

Since 1948, Twombly's sculptures have been white.[94] This whiteness gives them an airy luminescence. "Or is it that as in essence whiteness is not so much a color as the visible absence of color, and at the same time the concrete of all colors?"[95] White has many nuances in Twombly's sculptures, depending on the substances used and how they are applied: oil paint and house paint, cementito, plaster, clay, and other mixtures. This white had been present in art since 1945, when it represented neutrality, new beginnings, hope, light, spirituality, and the sublime: Twombly first tested it in his paintings, as a stark contrast to black, before using it to create diaphanous picture grounds, covered with streams of lines, signs, and names, or reversing the process and weaving a tissue of white chalk across dark surfaces. In sculpture, the light paint draws together the individual elements into a homogeneous form and purges their simple configurations of all artlessness. Where the informal, seemingly casual application of the paint does not fully cover the surface of the wood, leaving it irregular and uneven, the sides and backs of the sculptures bear indications of the history of the found objects and of the act of their recent, ennobling integration into the work itself.

The transformation of the *objets trouvés* is largely achieved through composition. Many of the sculptures live by the combination of different elements in a hierarchical arrangement of plinth and motif. The often stepped substructures raise the work up and set it apart. Not only are they reminiscent of traditional designs for monuments and memorials; they also form the strata, the sedimentation, that the figure, as the latest and newest layer, crowns with its presence. Every tier removes that which it supports. Like the discrepancy between the simple object and the curious enhancement of its presentation, the alternating perception of proximity and distance makes it clear that these sculptural works are not representational but metaphorical. Figural objects reduced to their most elementary form, motifs from nature, the world of plants, technological inventions, architecture—all these are often treated in such a way that, from one or

Sockeln entsprechen diesem Wandel. In ruhigem Verharren an einem Standort blickt man indessen auf jene eher niedrigen Skulpturen (Kat. 2 und 65, S. 19 und 130), die das simultane Erfassen einer Art Platzanlage oder das Lesen einer Inschrift, eines Epitaphs erfordern; hier folgen die Augen den Zeilen. (Kat. 43, S. 115)

Alle diese Vorstellungen von Bewegung führen zu der Reflexion über die Kategorien von Zeit und Raum. Neben den linearen Verläufen mit Anfang und Ende werden andere Arten von Zeit spürbar. Mythische, historische und ästhetische Temporalstrukturen wirken zusammmen, gleitend verschiebt sich die Aufmerksamkeit. Gottfried Boehm stellte dar, dass zu den besonderen Leistungen dieses Künstlers die Erinnerungsarbeit gehört, mit der er Vergangenes der Gegenwart ins Gedächtnis holt und in die Zukunft weiterwirken lässt.[99] Dies gilt in ganz besonderer Weise für seine Skulpturen. In geschlossener Setzung verdichten sie die durch die Zeiten sich wandelnden Vorstellungen. Twomblys Erinnern greift weit aus, sucht nach Spuren, Scherben, Lettern, Chiffren. Könnte, was er in sein weißes Licht hebt, zunächst beliebig anmuten, die subjektive Auswahl dieser Affinitäten scheint von präziser Intuition geleitet, als folgten sie einer Systematik, die der Geschichte der Menschheit nachspürt. Formen und Titel erinnern an frühe Hochkulturen. Der Alte Orient wird gegenwärtig in seinen Städten, in den Erfindungen, die die Welt veränderten und aktuell blieben wie die Schrift und das Rad. Jene ursprüngliche Einfühlsamkeit in Fauna und Flora, die aus seinen Zeugnissen spricht, bezaubert. Aus der Erinnerung an das Alte Ägypten tauchen die Schiffe auf und die Auffassung der menschlichen Figur, die als kanonisches Schema in ein Regelwerk eingebunden ist. Wo immer Anthropomorphes anklingt, deuten Statik und Proportionen auf sie zurück. Monumentale Grabarchitekturen und Riten halten die Sehnsucht nach Unsterblichkeit wach. Mit der Welt der Griechen verbinden sich historische Ereignisse und ihre Überlieferung in Literatur und Geschichtsschreibung, Kriege und Schlachten, individuelles Ethos und heroischer Untergang, aber auch der Reichtum ihrer Mythen, die Größe ihrer Dichtung. Wenn Twombly die antiken Götter durch ihre Attribute darstellt, strahlen diese die vitale Kraft ihres mythischen Kerns aus, in dem sich einst eine bestimmte menschliche Erfahrung verdichtete. In seinen Skulpturen stehen sie vor allem für die Liebe, die Musik, die Poesie. Dem *Reich der Flora*, dem Twombly 1961 eines der schönsten Bilder widmete,[100] entnimmt er alte, im Mittelmeerraum verbreitete Kulturpflanzen, geprägt von der Geschichte ihrer Art und ihren schillernden symbolischen Bedeutungen. Ihr Wachsen, Blühen und Vergehen steht für das Zeitmaß des organischen Lebens. Der Hirte, »Hüter der Herden«, ur-alte Symbolgestalt, Randfigur der Gesellschaft, Wanderer unter dem Himmel, den Zeiten der Natur am nächsten, vertritt die Verbindung von Mensch und Tier, die Verantwortung gegenüber der Kreatur.

Wie die Zeiten, sind auch die Räume weit, die hier durchschritten werden. Sie sind auf der Landkarte verzeichnet, wir bereisen die Orte, die Monumente, die Ruinen; wir kennen die Geometrie, die sie vermessen kann. In kleinen Figuren feiert Twombly ihre Schönheit und damit die Fähigkeit des Menschen zur Aus-

more perspectives, they are perceived as nonrepresentational configurations, insofar as the overall composition does not consist of basic geometric forms such as the triangle, the rectangle, and the circle. The works invite dual readings: the stem of a plant describes a pure curve, and in the jutting diagonal, one seems to discern a figure striding out, hurrying forward.

If motion is a central theme of these sculptures without Twombly's actually employing moving parts,[96] motion's opposite, rest, belongs to their diverse modes of presentation as well. The vehicles are all on land and water. But as much as they may appear to gallop, rattle, or glide along, they remain intriguingly immobile on their plinths. Imitating the hierarchic form of monuments and using transient materials, some of them seem to be playing out the drama of fame and permanence with a hint of mild irony. Just as we live our lives, "with little steps our clocks keep pacing,"[97] and then suddenly lose a beat, a staff breaks in two. The trees, the plants, and the flowers are in motion. They blossom unexpectedly, bearing the signs of their growth, stretching upward, leaning against dead wood, and yet standing there uncannily white, beautiful, and still. The changing seasons, with their wintry calm, and the movements of the wind—all this resonates in these sculptures: white ruins are "forever new…"[98]—do they blind us to the irrevocable, crumbling decay?

And the movement of the viewer? Twombly works with different types of composition. On the one hand, there are the objects presented frontally, as though on an altar, although the side and back views—even in apparently careless constructions—contain information that is important to our experience of the work. In a number of sculptures where the front and back view are the same or similar, from the side it may display a surprisingly different motif (cat. no. 36, p. 75). But the object is not always fully three-dimensional from back to front. We often seem to be looking at an abstract composition. Moving step by step from one position to another, the viewer is abruptly confronted with different faces of the work. On the other hand, in recent years, Twombly has begun to favor fully three-dimensional works over which the viewer's gaze may gently wander. Intersecting staves of wood and coiled stems on round plinths mark this change. These relatively low sculptures (cat. nos. 2 and 65, pp. 19 and 130) require the viewer to stand still, look down on them, and take in what could be the layout of a city square, or to read an inscription or an epitaph; here, the viewer's eyes follow the lines of writing (cat. no. 43, p. 115).

All these notions of movement lead us to reflect on time and space. Besides linear progressions with a beginning and an end, other kinds of time are also evident. Mythological, historical, and aesthetic time structures comingle; one's attention shifts impercpetibly. Gottfried Boehm has demonstrated that one of Twombly's major achievements is his work with memory, bringing the past back to the present and finding a place for it in the future.[99] This is particularly true of his sculptures. As a self-contained group, they allow certain themes to become more concentrated as they change. Twombly's memory casts its nets wide, seeking traces, shards, letters, and ciphers. While it may seem at first that whimsy governs

bildung allgemeiner Vorstellungen. Die Horizonte dieses Künstlers umfassen einen geistigen Raum von ungeheurer Dimension.[101] Wie aus phylogenetischen und ontogenetischen Erfahrungen und mit dem unermüdlich aufmerksamen Erleben einer individuellen Existenz in allmählicher Fügung gebildet, verkörpern seine Skulpturen die Metamorphosen des Seienden.

40 Cy Twombly, *Untitled,*
 Jupiter Island 1992. Detail

the selection of motifs he raises up into his white light, his choice of affinities seems to be guided by precise intuition, as though following a universal methodology that traces the history of humankind.[100] Forms and titles recall advanced civilizations from the distant past. The East of antiquity is present with its cities and the inventions that changed the world and yet remain as relevant as ever, such as the wheel and writing. The primordial empathy for fauna and flora that imbues Twombly's work is spellbinding. Memories of ancient Egypt invoke seagoing vessels and the notion of the human figure, whose schematic canon is an integral part of a definitive set of rules and measures. Wherever there are indications of anthropomorphism, the rigidity and proportions of the figures point back to this set. Monumental tombs and ritual keep the longing for immortality alive. Connected with the world of the Greeks are events and accounts in literature and historical texts—wars and battles, individual ethos, and heroic decline—as well as their myths and the splendor of their poetry. When Twombly alludes to the gods through their attributes, they continue to emanate the vital power of their mythological core. In his sculptures, the gods stand above all for love, music, and poetry. From the *Kingdom of Flora*, to which Twombly dedicated one of his most beautiful pictures in 1961,[101] he draws old icons of the plants that grow around the Mediterranean, infused as they are with history and shimmering symbolic meaning. Their growth, blossoming, and decay reflect the cycles of organic life. The "Keeper of Sheep"—an ancient symbolic figure with a marginal place in society, wandering under the open skies, closest to the rhythms of nature—represents the link between humans and the animal world, our responsibility toward all creatures.

Like the time span represented, the spaces in these works, too, are vast. They are marked on the map; we travel to places, monuments, and ruins, and know the geometry by which they might be measured. In small figures, Twombly celebrated the beauty of that geometry, and hence the human capacity to construct general principles. The horizons of this artist embrace an immense intellectual and emotional expanse. As though formed from phylogenetic and ontogenetic experience—and from a tirelessly alert awareness of an individual existence— Twombly's sculptures embody the metamorphoses of Being.

Die abgekürzten Hinweise »Bastian«, »Del Roscio« und »Lambert« beziehen sich auf die Werkkataloge der Gemälde, der Skulpturen und der Zeichnungen Cy Twomblys: Siehe Bibliographie, Catalogues raisonnés.

1 Vergleiche die weiblichen Formen in Gemälden der frühen Zeit, z.B. Bastian I, 22 und 23.

2 Es handelt sich um ein kleines Blasrohr aus dem Chemieunterricht. (Gespräch mit dem Künstler, Lexington, Oktober 1999).

3 Alberto Giacometti, *Le Palais à quatre heures du matin*, 1932/33, Holz, Glas, Draht, Schnur, 63,5 x 71,8 x 40 cm, The Museum of Modern Art, New York.

4 Del Roscio 9.

5 Twombly machte gesprächsweise (Rom, Juli 1999) darauf aufmerksam, dass die »Afrikanischen Zeichnungen« nicht alle während der Reise entstanden sind. Fotos von Robert Rauschenberg (Abb. 7, 8) stellen nach heutiger Kenntnis die einzigen Dokumente dar. Hierzu: Kirk Varnedoe, *Cy Twombly. Eine Retrospektive*, Ausst.-Kat. Berlin, Neue Nationalgalerie, München etc. (Schirmer/Mosel) 1994 (im Folgenden Varnedoe), S. 15–19.

6 Hierzu: Gerlinde Haas, *Die Syrinx in der griechischen Kunst*, Wien etc. (Hermann Böhlau Nachf.) 1985.

7 »Mich ziehen die primitiven, die rituellen und als Fetisch dienenden Elemente an, die symmetrische plastische Ordnung (die insbesondere sowohl primitiven als auch klassischen Konzepten zugrunde liegt und so beide miteinander in Beziehung setzt).« Zitiert nach Varnedoe, S. 62, Anm. 48.

8 Siehe z.B. Walter Hopps, *Robert Rauschenberg. The Early 1950s*, Ausst.-Kat. Houston, The Menil Collection (Houston Fine Art Press) 1991, Nr. 103, *Untitled (Elemental Sculpture)*, Kistchen, Ösenschraube, Nägel, Schnur und hängender Stein, ca. 101,5 x 14 x 10,2 cm, verschollen oder zerstört.

9 Die Skulptur wurde noch von Del Roscio mit dem Titel *Funerary Box for a Lime Green Python* geführt. Twombly hat ihn nun aufgegeben, u.a. da er tatsächlich nicht an eine Python, sondern an die aufgerichtete Kobra mit gespreizter Haube gedacht habe, wie sie im alten Ägypten dargestellt wird als Uraeus, göttlich und königlich, voll Weisheit, Macht und Wissen.

10 Die Löffel und die runden Taschenspiegel kommen in anderen Plastiken vor (Kat. 4, S. 26 und 27). Die umwickelten Latten wurden zu einem anderen Werk verarbeitet (Kat. 8, S. 34); die Leinenkaschierung am Sockel erfolgte zu einem späteren Zeitpunkt.

11 *Panorama*, 1954 (?), Bastian I, 50 (hier noch 1955 datiert), Daros-Sammlung, Schweiz. Zur Datierung siehe Varnedoe, S. 66, Anm. 89. Achim Hochdörfer, *Cy Twombly. Das skulpturale Werk*, Magisterarbeit Wien 1998, Typoskript (im Folgenden Hochdörfer), S. 33 f., schließt daraus, dass die Veränderung der Skulptur 1954 erfolgte. Spätestens Weihnachten 1954 hatte Rauschenberg das Atelier in der Fulton Street aufgegeben.

12 Frank O'Hara, »Cy Twombly«, in: *Art News*, 53 (1954) 8 (Dezember), S. 46, zitiert nach

13 Varnedoe, S. 20 f. Bei der erhaltenen Skulptur handelt es sich um Del Roscio 7.

13 Varnedoe, S. 20.

14 Die Skulptur, die der Künstler im früheren Zustand in der William Street, wo er seit Herbst 1954 wohnte, fotografierte, wurde erst für die Ausstellung bei Lucio Amelio 1979 mit der Umwicklung und der heutigen Plinthe versehen (dankenswerter Hinweis von Nicola Del Roscio).

15 Nicola Del Roscio, der das Negativ fand, stellte es freundlicherweise zur Verfügung. Cy Twombly erklärte mir gegenüber (Herbst 1999), dass er die Aufnahme in der William Street, also nach August 1954, gemacht habe.

16 Charles Olson, »Cy Twombly«, in: *Ich jage zwischen Steinen. Briefe und Essays*, hrsg. von Rudolf Schmitz, Bern/Berlin (Gachnang & Springer) 1998, S. 122.

17 Hierzu Varnedoe, S. 25–32; siehe auch Anna Costantini, »Before the End of the Journey: Testimony across the Atlantic«, in: Germano Celant (Hrsg.), *The Italian Metamorphosis 1943–1968*, Ausst.-Kat. New York, The Solomon R. Guggenheim Museum 1994, S. 32–38.

18 Zur Ikonografie des Pan u.a. John Boardman, *The Great God Pan. Survival of an Image*, London (Thames and Hudson) 1997. Twombly widmete der Figur 1975 zwei große Collagen: *Pan*, Öl, Kreide auf verschiedenen Papieren, 148 x 100,2 cm, Privatsammlung, Rom; Abb. in: *Cy Twombly*, Ausst.-Kat. Baden-Baden, Kunsthalle Baden-Baden 1984, Abb. S. 110 und 112.

19 Pablo Picasso, *Le Verre d'absinthe*, 1914, Bronze und Absinthlöffel, insgesamt sechs Exemplare, unterschiedlich bemalt, eines mit Sand bedeckt, 21,5 x 16,5 x 8,5 cm (Spies 36). Gespräch mit dem Künstler (Gaeta, Juni 1999).

20 Es handelt sich um ein Blatt aus Kunststoff, außen weiß, innen rot deckend bemalt.

21 Im Rückblick beendet die für Gian Enzo Sperone gemachte Skulptur *Ohne Titel*, Rom 1959 (Del Roscio 22), bei der zwei Terracottascherben auf einen Pflasterstein gebunden sind, als deutlicher Schlusspunkt ein erstes bedeutsames Kapitel in Twomblys skulpturalem Schaffen.

22 Hierzu: Varnedoe, S. 49 f.; *Portrait of a House – As the Artist*, Fotos von Deborah Turbeville, Texte von Carter Ratcliff und Sandi Britton, in: *Vogue*, 172 (1982) 12 (Dezember), S. 226–271, 337.

23 Twombly stellte 1954 in der *3rd Annual Exhibition of Painting and Sculpture* neben Cornell in der Stable Gallery aus (27. Januar – 20. Februar).

24 Wie Anm. 8, Abb. S. 28, sowie Abb. S. 158 oben.

25 Ebenda, Abb. S. 103 und Abb. S. 175.

26 Hierzu: François Lissarrague, »Frauen, Kästchen, Gefässe: Einige Zeichen und Metaphern«, in: *Pandora. Frauen im klassischen Griechenland*, Ausst.-Kat. Basel, Antikenmuseum und Sammlung Ludwig 1996, S. 91–101.

27 Rainer Maria Rilke, *Die Sonette an Orpheus*, 1922, 1. Teil, 26. Sonett. Die letzte Strophe lautet: »O du verlorener Gott! Du unendliche Spur! / Nur weil dich reißend zuletzt die Feindschaft verteilte, / sind wir die Hörenden jetzt und ein Mund der Natur.«

28 Bastian IV, 78. Vergleiche auch das Gemälde *The Veil of Orpheus* von 1968 (Bastian III, 72), dessen aus der Horizontalen aufsteigende Lineamente formale Ähnlichkeit zeigen.

29 Hierzu: Hochdörfer, S. 73 ff.

30 Erster Teil, 19. Sonett.

31 Hochdörfer, wie Anm. 29. Vergleiche Peter Pfaff, »Der verwandelte Orpheus. Zur ›ästhetischen Metaphysik‹ Nietzsches und Rilkes«, in: Karl Heinz Bohrer (Hrsg.), *Mythos und Moderne. Begriff und Bild einer Rekonstruktion*, Frankfurt am Main (edition suhrkamp) 1983, S. 290 ff.

32 Sie fand 1979 auch Ausdruck in den großen Gemäldezyklen *Fifty Days at Iliam* (Bastian IV, 13), und *Goethe in Italy* (Bastian IV, 14).

33 Sesostris II. (1901–1882 v.u.Z.), Mittleres Reich, 12. Dynastie; die Quellen zu diesem Pharao sind spärlich.

34 Twombly besitzt das Foto eines jahrtausendealten Lotos, den man als Grabbeigabe gefunden hat.

35 Lambert VI, 94–103, publiziert vier Collagen und sechs Arbeiten in Öl auf Papier. Er vermerkt (S. 106), dass der Lotos (hier der blaue, *Nymphaea caerulea*) auf einer Collage expressis verbis genannt wird. – Die amnesierende Wirkung der Pflanze (Wurzeln und Früchte), bekannt aus der Odysseus-Episode bei den Lotophagen, führte auch zu einer Deutung, die den Konsum des Lotos mit dem Trank aus der Lethe und dem Eintritt ins Totenreich gleichsetzt.

36 Diese Technik praktizierten die Studenten der Art Students League am Strand von Staten Island. Fotos von Robert Rauschenberg (Archiv des Künstlers) zeigen so entstandene Plastiken von Susan Weil; 1992 gießt Twombly auf Jupiter Island am Strand den Sockel von *Ohne Titel* (Del Roscio 116). Er setzte einzelne Formen als Basis zusammen, goss aber den Stiel mit ein. (Abb. 26, 27 und 40)

37 Bastian IV, 13, besonders Teil VIII, *Ilians in Battle*, Abb. S. 80–81.

38 Der Phallus spielte im Kult als Symbol oder Attribut anthropomorpher Gottheiten eine Rolle. Als Faktor animalischer und vegetabilischer Fruchtbarkeit wurde er oft verselbständigt dargestellt und als Glücksbringer verehrt.

39 Titel antiker Feldzugsberichte; berühmt die *Anabasis* des Xenophon; sie beschreibt den Vormarsch und Rückzug der 10000 Griechen (402–400 v.u.Z.) im Dienst Kyros d. J. gegen seinen Bruder Artaxerxes II. sowie die *Anabasis* des Arrian, bedeutendste erhaltene Schilderung des Alexanderzuges. – Nicola Del Roscio verdanke ich die Information, dass Twombly gelegentlich kleine Skizzen für Plastiken macht, aber auch wie wichtig die Empfindung ist, die ein Gegenstand auslöst. Manche Skulpturen reifen in einem langwierigen Prozess zu ihrer endgültigen Gestalt. Während eines Spazierganges von Cy Twombly und Del Roscio 1965 durch die Bowery wurden beide auf eine Kiste aufmerksam, die zur Fracht von Tee gedient hatte. Diese Kiste, die noch nach ihrem früheren Inhalt duftete, erinnerte Twombly an eine ähnliche, die er in einer frühen, zerstörten Skulptur verwendet hatte. Wieder in Italien, begann Del Roscio

The abbreviated titles "Bastian," "Del Roscio," and "Lambert" refer to the individual catalogues raisonnés of Cy Twombly's paintings, sculptures and drawings. See bibliography, catalogues raisonnés.

1 Compare this to the female forms in the paintings of the early period, e.g., Bastian I, 22 and 23.

2 This is a small blowpipe like those used in chemistry lessons (conversation with the artist, Lexington, October 1999).

3 Alberto Giacometti, *Le Palais à quatre heures du matin*, 1932/33, wood, glass, wire, and string, 63.5 x 71.8 x 40 cm, The Museum of Modern Art, New York.

4 Untitled, Lexington, 1951 (Del Roscio 9).

5 Twombly mentioned that the "African drawings" were not all made on his trip to Africa (conversation with the artist, Rome, July 1999). Photos by Rauschenberg are the only known records of these (figs. 7, 8). Kirk Varnedoe, *Cy Twombly: A Retrospective*, exh. cat. (New York: The Museum of Modern Art [Harry N. Abrams], 1994), pp. 16–19.

6 Gerlinde Haas, *Die Syrinx in der griechischen Kunst* (Vienna: Böhlau, 1985).

7 "I am drawn to the primitive, the ritual and fetish elements, to the symmetrical plastic order (peculiarly basic to both primitive and classic concepts, so relating the two)." Twombly quoted in Varnedoe, p. 56, note 48.

8 See, for instance, Untitled *(Elemental Sculpture)*, 1953, box, ring-screw, nails, twine, and hanging stone, c. 101.5 x 14 x 10.2 cm, lost or destroyed. Walter Hopps, ed., *Robert Rauschenberg: The Early 1950s*, exh. cat. (Houston: The Menil Collection [Houston Fine Art Press], 1991), cat. no. 103.

9 This sculpture was listed by Del Roscio with the title *Funerary Box for a Lime Green Python*. Twombly has since abandoned this title, partly because he did not have a python in mind but an upright cobra, with its neck dilated like a hood, as in old Egyptian illustrations where it depicts Uraeus, divine and regal, wise, powerful, and learned.

10 Spoons and round hand mirrors are also found in other sculptures (cat. no. 4). The wound sticks removed here were used in another work (cat. no. 8); the cloth was bonded to the plinth at a later date. The changes were likely made to the sculpture in 1954. Rauschenberg had given up the Fulton Street studio by Christmas 1954 at the latest. Achim Hochdörfer, "Cy Twombly: Das skulpturale Werk," Master's thesis, Vienna, 1998, pp. 33f.

11 *Panorama*, 1954 (?), Bastian I, 50 (here still dated 1955), Daros Collection, Switzerland. On the dating of this work, see Varnedoe, p. 60, note 89.

12 Frank O'Hara, "Cy Twombly," *Art News*, 53 (8 Dec. 1954): 46. Quoted in Varnedoe, p. 20f. The surviving sculpture is Del Roscio 7.

13 Varnedoe, p. 20.

14 This sculpture, which the artist photographed in an early state at the William Street studio, where he had been living since autumn 1954, acquired its wrapping and present plinth for the exhibition at Lucio Amelio's in 1979 (information kindly provided by Del Roscio).

15 We are grateful to Del Roscio, who found this negative, for making it available. Twombly said that he had taken this picture in William Street, i.e., after August 1954 (conversation with the artist, autumn 1999).

16 Charles Olson, "Cy Twombly," *Olson: The Journal of the Charles Olson Archives*, 8 (Autumn 1977): 14.

17 See Varnedoe, pp. 25–30; see also Anna Costantini, "Before the End of the Journey: Testimony Across the Atlantic," in *The Italian Metamorphosis 1943–1968*, ed. Germano Celant, exh. cat. (New York: The Solomon R. Guggenheim Museum, 1994), pp. 32–38.

18 On the iconography of Pan, see John Boardman, *The Great God Pan: Survival of an Image* (London: Thames and Hudson, 1997). In 1975 Twombly made two large collages on the subject *Pan*, both oil and crayon on different papers, 148 x 100.2 cm, private collection, Rome. *Cy Twombly*, exh. cat. (Baden-Baden: Kunsthalle Baden-Baden, 1984), pp. 110 and 112 (figs.).

19 Pablo Picasso, *Le Verre d'absinthe*, 1914, bronze and absinthe spoon, in an edition of six, variously painted, one covered with sand, 21.5 x 16.5 x 8.5 cm (Spies 36). Conversation with the artist, Gaeta, June 1999.

20 This is an artificial leaf, painted solidly white on the outside and red on the inside.

21 In retrospect, it is clear that the sculpture Untitled, Rome 1959 (Del Roscio 22), made for Gian Enzo Sperone with two terra-cotta shards on a paving stone, closed the first major chapter in Twombly's sculptural output.

22 Varnedoe, pp. 49f.; see also "Portrait of a House—As the Artist," photographs by Deborah Turbeville, texts by Carter Ratcliff and Sandi Britton, *Vogue* 172 (12 Dec. 1982): 262–71, 337.

23 In 1954 Twombly, along with Cornell, participated in the "3rd Annual Exhibition of Painting and Sculpture" at the Stable Gallery (27 January–20 February).

24 See figures in Hopps, pp. 28 and 158 (top).

25 Ibid., pp. 103 and 175.

26 François Lissarrague, "Women, Boxes, Containers," in *Pandora: Women in Classical Greece*, exh. cat. (Baltimore: Walters Art Gallery, 1995), pp. 91–101.

27 Rainer Maria Rilke, "Sonnets to Orpheus," in *Rainer Maria Rilke: Prose and Poetry*, ed. Egon Schwarz, trans. J. B. Leishman (New York: Continuum, 1984). The last three lines of part 1, no. 26, read: "O you god that has vanished! You infinite track! / Only because dismembering hatred dispersed you / are we hearers today and a mouth which else Nature would lack."

28 Bastian IV, 78. See also the painting *The Veil of Orpheus*, 1968, Bastian III, 72, for the similarity in the lines rising up from the horizontal.

29 Hochdörfer, pp. 73ff.

30 Rilke, "Sonnets to Orpheus," part I, no. 19.

31 Peter Pfaff, quoted in Hochdörfer, pp. 73ff. See also Peter Pfaff, "Der verwandelte Orpheus. Zur 'ästhetischen Metaphysik' Nietzsches und Rilkes," in *Mythos und Moderne: Begriff und Bild einer Rekonstruktion,* ed. Karl Heinz Bohrer (Frankfurt am Main: edition suhrkamp, 1983), pp. 290ff.

32 This is also evident in the major cycle of paintings *Fifty Days at Iliam* (Bastian IV, 13) and in *Goethe in Italy* (Bastian IV, 14).

33 Sesostris II (1901–1882 B.C.) ruled during the Middle Kingdom, 12th Dynasty; little is known of this pharaoh.

34 Twombly owns a photograph of a thousand-year-old lotus that was found among burial offerings.

35 Lambert VI, 94–103 publishes four collages and six works in oil on paper. Lambert notes that the lotus (here the blue *Nymphaea caerulea*) is named *expressis verbis* on a collage (p. 106). The amnesiac properties of the plant (roots and fruit), known from Odysseus' experiences with the Lotophagi, also led to the lotus' being credited with the same effect as drinking from the river Lethe and entering the kingdom of the dead.

36 Twombly developed this technique on his own on the beach of Staten Island. At various times Rauschenberg and Susan Weil practiced the same technique, as photographs by Rauschenberg show (archive of the artist). In 1992 on the beach of Jupiter Island, Twombly poured the plinth of Untitled (Del Roscio 116), combining a number of parts while integrating the stem (figs. 26, 27 and 40).

37 Bastian IV, 13, particularly part VIII, *Ilians in Battle*, pp. 80–81 (figs.).

38 In certain cults the phallus was frequently taken as a symbol or attribute of anthropomorphic deities. As a factor in animal and vegetable fertility, it was often portrayed in its own right and larger than life, and revered as a guardian against evil and a bringer of good luck.

39 This was the name given to campaign reports in antiquity, notably Xenophon's *Anabasis*, which describes the advance and retreat of 10,000 Greek soldiers (402–400 B.C.) in the service of Cyrus the Younger against his brother Artaxerxes II. Also notable is Arrian's *Anabasis*, the most important extant account of the campaign of Alexander the Great. I am grateful to Del Roscio for passing on to me the information that Twombly occasionally makes small sketches for his sculptures, and how important is the emotion that an object can provoke; some sculptures mature into their final form only over a long period of time. In 1965, when Twombly and Del Roscio were walking through the Bowery one day, both of them noticed a crate that had been used for transporting tea. This crate, still scented with its erstwhile contents, reminded Twombly of a similar one he had used in an earlier, now destroyed sculpture. On his return to Italy, Del Roscio started to keep an eye out for crates of this kind and to collect materials that he felt might come in handy one day. When he did indeed find a similar crate in Italy, it duly became the plinth for the sculpture *Anabasis*. With characteristic empathy, after the walk through the Bowery, Del Roscio would always keep a lookout for suitable *objets trouvés*.

40 *Thyrsis* (Bastian III, 8). See also Katharina Schmidt, "The Way to Arcadia: Thoughts on Myth and Image in Cy Twombly's Painting," in: *Cy Twombly*, exh. cat. (Houston: The Menil Collection [Houston Fine Art Press], 1990), p. 26.

nach einer solchen Kiste Ausschau zu halten und Material zu sammeln, von dem er glaubte, dass es vielleicht einmal nützlich sein könne. Als er nach Jahren eine solche Teekiste in Italien fand, diente sie der Skulptur *Anabasis* als Sockelteil. In einfühlsamer Weise beteiligte sich Del Roscio seit dem Spaziergang durch die Bowery am Sammeln von Fundstücken.

40 *Thyrsis* (Bastian, III, 8). Hierzu auch: Katharina Schmidt, »The Way to Arcadia: Thoughts on Myth and Image in Cy Twombly's Painting«, in: *Cy Twombly*, Ausst.-Kat. Houston, The Menil Collection (Houston Fine Art Press) 1990, S. 26.

41 *The Shepheardes Calender*, Bassano in Teverina, Winter 1977, Zyklus von 12 Blättern und einem Titelblatt, je 58 x 43 cm, in unterschiedlichen Techniken und auf verschiedenen Papieren, Privatsammlung, Rom. Die Dichtung von Edmund Spenser (1552–1599), bestehend aus zwölf Eklogen, erschien erstmals 1579 in London. Hierzu: Katharina Schmidt, »Zur Ausstellung«, in: *Cy Twombly. Serien auf Papier*, Ausst.-Kat. Bonn, Städtisches Kunstmuseum 1987; erstmals vollständig abgebildet in: *The Shepheardes Calender by Edmund Spenser illustrated by Cy Twombly*, London (Anthony D'Offay) 1985.

42 Siehe auch unten, Kat. Nr. 27, S. 71.

43 Alberto Caeiro [d. i. Fernando Pessoa], *O Guardador de Rebanhos / Der Hüter der Herden* (1911–1912), in: Fernando Pessoa, *Alberto Caeiro. Dichtungen/Ricardo Reis. Oden*, Portugiesisch und Deutsch, dt. von Georg Rudolf Lind, Zürich (Ammann Verlag) 1986, S. 10–83.

44 Hierzu: Hochdörfer, S. 86 ff.

45 Der Nagel ließe sich auch als Anspielung auf die Antenne des mit Funk ausgestatteten historischen Schiffes verstehen, was für die Kommunikation mit Trotzki wichtig war. Eine andere Episode, die sich während der Februar-Revolution in Petrograd abspielte, ist in diesem Zusammenhang erwähnenswert: »Die berühmte Szene auf dem Nevskij-Prospekt war unmissverständlich: Als Kosaken und Demonstranten aufeinander zu marschierten und eine Teilnehmerin sich aus dem Zug löste, nahm der Kosakenoffizier den Strauss roter Rosen entgegen, den sie ihm überreichte.« Manfred Hildermeier, *Die Russische Revolution 1905–1921*, Frankfurt am Main (edition suhrkamp) 1989, S. 134.

46 Der Künstler bewahrt ein frühes, jedoch nicht für den Werkkatalog autorisiertes Objekt mit einer Rose, das die Inschrift trägt: *THAT WHICH I SHOULD / HAVE DONE I DID NOT.*

47 Robert Payne, *The Life and Death of Lenin*, 1964; dt. *Lenin. Sein Leben und sein Tod*, München (Rütten & Loening) 1965, S. 287.

48 Ebenda, S. 288.

49 Zu manchen Titeln trug Nicola Del Roscio bei.

50 Das berühmte Hotel Winter Palace im viktorianischen Stil existiert noch immer in Luxor.

51 Siehe unten, S. 168; hierzu auch: Stéphane Rossini und Ruth Schumann-Antelme, *Osiris. Rites de l'immortalité de l'Egypte pharaoique*, Lavaur (Trismegiste) 1995; Erik Hornung, *Tal der Könige. Die Ruhestätte der Pharaonen*, Zürich (Artemis) 1982, S. 150.

52 Bastian IV, 61, 62 und 65.

53 Heiner Bastian, *Cy Twombly. Zeichnungen 1953–1973*, Berlin (Propyläen) 1973, Kommentar zu Nr. 56. Vergleiche Bastian III, 7–10.

54 *Poems to the Sea,* Sperlonga, Juli 1959; 24 Zeichnungen, zwischen 34,6 und 32,1 x 31,1 cm, Anstrichfarbe, Wachskreide, Kreide, Bleistift auf Papier, Dia Center for the Arts, New York. Siehe Cy Twombly, *Poems to the Sea*, hrsg. von Heiner Bastian, München (Schirmer/Mosel) 1990.

55 Der Künstler selbst gebrauchte den Begriff im Gespräch (Rom, Sommer 1999).

56 »...und in den abgebrochenen Tag der Teiche / sinkt, wie auf Fischen stehend, mein Gefühl.«

57 Siehe Bastian IV, 28, S. 120 und 50, S. 148f.

58 Das Grabmal des L. Munatius Plancus (zwischen 90 und 85 v.u.Z. – nicht vor 15 u.Z.), ein monumentaler Rundbau, trägt über dem Eingang eine Inschrift, die seine wichtigsten Funktionen und Verdienste nennt: Zensor, zweimal zum Feldherrn ausgerufen, Mitglied des Siebenmännerkollegiums für Götterspeisung, triumphierte über die Räter, stellte aus der Kriegsbeute den Tempel des Saturn her, verteilte Land in Italien in Benevent und gründete in Gallien die Kolonien Lyon und Raurica.« – Planco gilt als der Begründer von Augst; seine Statue steht im Hof des Basler Rathauses. Ein bedeutendes schriftliches Zeugnis ist sein Briefwechsel mit dem Freund Cicero. Hierzu: Gerold Walser (Hrsg.), *Der Briefwechsel des L. Munatius Plancus mit Cicero*, Basel (Helbing & Lichtenhahn) 1957.

59 *Ohne Titel*, 1980/81 (Del Roscio 56).

60 1967 entstand bereits ein Gemälde mit dem Titel *Duino* (Bastian III, 29).

61 Giorgio Agamben, in: *Cy Twombly. 8 Sculptures.* Ausst.-Kat. Rom, American Academy 1998, S. 5 (Übers. Daniele Dell'Agli).

62 *Analysis of the Rose as Sentimental Despair;* Bastian IV, 27, sowie seine Einführung, ebenda, S. 18 f.

63 Hans Egon Holthusen, *Rilke in Selbstzeugnissen und Bilddokumenten*, Reinbek (Rowohlt) 1958, S. 163.

64 Hochdörfer, der die Thematik auch am Beispiel dieses Gemäldezyklus behandelt, bezieht diese Skulptur hier nicht ein.

65 Bastian IV, Einführung, S. 19.

66 Joachim Wolff, *Rilkes Grabschrift. Manuskript- und Druckgeschichte, Forschungsbericht, Analysen und Interpretation*, Heidelberg (Lothar Stiehm Verlag) 1983, S. 110; Hochdörfer, S. 78.

67 Siehe Del Roscio 134.

68 Chosrau I. Anushirwan (Großkönig 531–579 u.Z.).

69 Um 864 u.Z.; Spuren einer frühen Luftaufnahme lassen erkennen, dass der erhaltene Iwan und die Fassade das Endstück einer typischen sassanidischen Gartenarchitektur bildeten, möglicherweise mit einem Gegenstück auf der Rückseite. Der Palast wurde Tâq-i Kisrâ – »Bogen des Chosrau« – genannt.

70 Apokryphe Schriften berichten, dass Maria im Alter von 14 Jahren, nachdem sie zehn Tage im Tempel gelebt hatte, auf Veranlassung des Hohepriesters den Tempel verlassen musste, um sich zu verheiraten. Ein Engel hatte diesen angewiesen, sämtliche Witwer zu versammeln. Alle sollten ihren Stab mitbringen und über Nacht ein Zeichen des Himmels abwarten. Als der Zimmermann Joseph aus Nazareth, der sich selbst eigentlich für unwürdig hielt, zum Tempel geführt wurde, erschien eine Taube über seinem Haupt, und das Ende seines Stabes begann zu blühen.

71 Uto von Melzer und Vincenz Ritter von Rosenzweig, *Nie ist wer liebt allein. Studienbücher zur persischen Dichtung Nr. 1: Rumi*, hrsg. von Nosratollah Rastega, bearbeitet und mit einem Anhang versehen von Monika Hutterstrasser, Graz (Leykam) 1994, S. 148.

72 Ebenda, S. 149.

73 Vergleiche *Ohne Titel*, 1974, 100 x 70,2 cm, Collage (Lambert VI, 93), sowie »Tulips I, II, III« in: *Cy Twombly. Photographs*, Ausst.-Kat. New York, Matthew Marks Gallery 1993.

74 Agapanthus, Schmucklilie oder Liebesblume. Die Gattung stammt aus Südafrika. Die orientalische Schmucklilie (*Agapanthus orientalis*, früher *Agapanthus umbellatus* und *Agapanthus africanus* genannt) wird im Mittelmeerraum im Freien angebaut. Pflanze mit Rhizom, langen breiten Blättern, einem hohen Stängel und bis zu 100 himmelblauen Blüten. Wird seit einiger Zeit als Schnittblumenpflanze kultiviert. Die Blumen wachsen in Cy Twomblys Garten.

75 Hierzu: *Treasures from the Royal Tombs of Ur*, Ausst.-Kat. Philadelphia, University of Pennsylvania Museum 1998, Kat. 8 (*Ram Caught in a Thicket*), S. 61 f.

76 Kalla (Calla) Schlangenwurz, Drachenwurz, Schweinsohr; Gattung der Aronstabgewächse; mit der einzigen Art *C. palustris*; mit grünem, kriechendem Rhizom, rundlich herzförmigen spitzen Blättern und kolbenförmigem Blütenstand mit weißem Hochblatt; die roten Beeren sind giftig. Die Kalla wächst ursprünglich an Teichrändern und in Waldsümpfen Mittel- und Nordeuropas, Sibiriens und Nordamerikas.

77 Vergleiche Robert Mapplethorpe, *Dennis Speight with Thorus, Jack with Crown, Skull and Crossbones, Jill Chapman, Dennis Speight with Flowers*, Serie von fünf Schwarzweißfotografien, 1983. Die Aufnahmen entstanden um die zentrale Fotografie des Totenschädels, die Mapplethorpe in Neapel vor der Kirche Purgatorio ad Arco, Via dei Tribunali, gemacht hatte; sie nehmen Bezug auf Darstellungen von Christus und Magdalena in der traditionellen religiösen Malerei. Auf der rechten Tafel hält Dennis Speight fünf Kalla-Blüten. Die Serie wurde 1984 in Ercolano in der Ausstellung *Terrae motus* gezeigt. Abb. im gleichnamigen Ausst.-Kat. der Fondazione Amelio, Istituto per l'Arte Contemporanea, Neapel (Electa Napoli) 1984, S. 104–108.

78 Die mesopotamische Figur, ehemals Bestandteil eines größeren, vermutlich kultischen Gegenstandes, wurde ursprünglich in Verbindung gebracht mit Genesis 22,13, wo der Engel Abraham einen im Dickicht verfangenen Widder zeigt, den Abraham anstelle von Isaak

41 *The Shepheardes Calender*, Bassano in Teverina, Winter 1977, cycle of 12 sheets and a title sheet, using different techniques and a variety of papers, each 58 x 43 cm, private collection, Rome. This poem by Edmund Spenser (1552–1599), consisting of twelve eclogues, was first published in London in 1579. See Katharina Schmidt, "Zur Ausstellung," in *Cy Twombly: Serien auf Papier*, exh. cat. (Bonn: Städtisches Kunstmuseum, 1987); first illustrated in full in *The Shepheardes Calender by Edmund Spenser illustrated by Cy Twombly* (London: Anthony D'Offay, 1985).

42 See also cat. no. 27, p. 71.

43 Alberto Caeiro [Fernando Pessoa], "O Guardador de Rebanhos [The Keeper of Sheep]" in *Selected Poems of Fernando Pessoa*, ed. and trans. Edwin Honig and Susan M. Brown (San Francisco: City Lights Books, 1998).

44 Hochdörfer, pp. 86ff.

45 This could also be seen as an allusion to the antenna of the historic ship *Aurora*, which already had radio communications and thus could receive orders from Trotsky. Another episode that occurred during the February Revolution in Petrograd is also worth mentioning in this context: "There was no mistaking the famous incident on the Nevsky Prospect: as the Cossacks and the demonstrators marched towards each other, a woman advanced from out of the crowd and offered a bunch of red roses to a Cossack officer, which he accepted." Manfred Hildermeier, *Die Russische Revolution 1905–1921* (Frankfurt am Main: edition suhrkamp, 1989), p. 134.

46 The artist has kept an early work (not included in the *catalogue raisonné*) with a rose, inscribed as follows: "THAT WHICH I SHOULD / HAVE DONE I DID NOT."

47 Robert Payne, *The Life and Death of Lenin* (London: Grafton, 1964), pp. 391–92.

48 Ibid., p. 393.

49 Some of these titles may be suggested by Nicola Del Roscio.

50 The famous Winter Palace Hotel, with all its Victorian style, still exists in Luxor.

51 See below, p. 151; see also Stéphane Rossini and Ruth Schumann-Antelme, *Osiris: Rites de l'immortalité de l'Egypte pharaoïque* (Lavaur: Trismegiste, 1995); Erik Hornung, *Tal der Könige: Die Ruhestätte der Pharaonen* (Zurich: Artemis, 1982), p. 150.

52 Bastian IV, 61, 62, and 65.

53 Heiner Bastian, *Cy Twombly: Zeichnungen 1953–1973* (Berlin: Propyläen, 1973), commentary to cat. no. 56. See Bastian III, 7–10.

54 *Poems to the Sea*, Sperlonga, July 1959, 24 drawings between 34.6 and 32.1 x 31.1 cm, house paint, wax crayon, chalk, and pencil on paper, Dia Center for the Arts, New York. See *Cy Twombly: Poems to the Sea*, ed. Heiner Bastian (Munich: Schirmer/Mosel, 1990).

55 The artist himself used this term in conversation (Rome, summer 1999).

56 "...und in den abgebrochenen Tag der Teiche / sinkt, wie auf Fischen stehend, mein Gefühl." From *Das Buch der Bilder*, book I, part 2. English translation from *Selected Poems of Rainer Maria Rilke*, trans. Robert Bly (New York: Harper & Row, 1981).

57 See Bastian IV, 28 and 50.

58 The tomb of L. Munatius Plancus (between 90 and 85 B.C. – not before 15 A.D.), a monumental, circular structure, has an inscription above the entrance that names his most important functions and achievements: "Censor, twice appointed general, member of the seven-man collegium for the nourishment of the gods, triumphed over the Rhaeticians, directed the Temple to Saturn to be reconstructed from the spoils of war, divided the land in Italy in Benevent, and, in Gaul, founded the colonies of Lyon and Raurica." Planco is regarded as the founder of Augst; his statue stands in the courtyard of the town hall in Basel. An important written record is his correspondence with his friend Cicero. See Gerold Walser, ed., *Der Briefwechsel des L. Munatius Plancus mit Cicero* (Basel: Helbing & Lichtenhahn, 1957).

59 Untitled, 1980–81 (Del Roscio 56).

60 The German reads thus: "Und wir, die an *steigendes* Glück / denken, empfänden die Rührung, / die uns beinah bestürzt, / wenn ein Glückliches *fällt*." In 1967 Twombly did a painting with the title *Duino* (Bastian III, 29).

61 Giorgio Agamben, quoted in *Cy Twombly: 8 Sculptures*, exh. cat. (Rome: American Academy, 1998), p. 5.

62 Bastian IV, 27. See his introduction, pp. 31f.

63 Hans Egon Holthusen, *Rilke in Selbstzeugnissen und Bilddokumenten* (Reinbek: Rowohlt, 1958), p. 163.

64 Hochdörfer, who discusses this theme with reference to the cycle of paintings, does not include this sculpture in his argument.

65 Bastian IV, introduction, p. 31.

66 Joachim Wolff, *Rilkes Grabschrift: Manuskript- und Druckgeschichte, Forschungsbericht, Analysen und Interpretation* (Heidelberg: Lothar Stiehm, 1983), p. 110; Hochdörfer, p. 78.

67 See Del Roscio 134.

68 Chosru I. Anushirwan (Grand King 531–579 A.D.).

69 Around 864 A.D.; an early aerial photograph shows that the surviving iwan and the facade constitute the end section in typical Sassanian garden architecture, possibly even with a matching structure behind. The palace was called Taq-i-Kisra, the "Hall of Chosru."

70 In the Apocrypha, it is said that at the age of fourteen, after the Virgin Mary had lived in the temple for ten days, she was ordered by the High Priest of the temple to leave in order to get married. The tale goes that an angel had commanded the High Priest to call together all widowers, who were to bring a staff with them and to wait during the night for a sign from heaven. When the carpenter Joseph of Nazareth, who regarded himself as wholly unworthy, was led to the temple, a dove appeared above his head and the end of his staff began to blossom.

71 Uto von Melzer and Vincenz Ritter von Rosenzweig, *Nie ist wer liebt allein: Studienbücher zur persischen Dichtung Nr. 1: Rumi*, ed. Nosratollah Rastega, appendix Monika Hutterstrasser (Graz: Leykam, 1994), p. 148.

72 Ibid., p. 149.

73 See Untitled, 1974, 100 x 70.2 cm, collage (Lambert VI, 93), and "Tulips I, II, III" in *Cy Twombly: Photographs*, exh. cat. (New York: Matthew Marks Gallery, 1993).

74 Agapanthus, decorative lily or love flower, comes from South Africa. The oriental agapanthus (*Agapanthus orientalis*, formerly known as *Agapanthus umbellatus* and *Agapanthus africanus*) is planted out of doors in Mediterranean countries. This plant has a rhizome, long broad leaves, a long stem, and up to a hundred sky-blue flowers. For some time it has been cultivated for use as a cut flower. These flowers grow in Twombly's garden.

75 See *Treasures from the Royal Tombs of Ur*, exh. cat. (Philadelphia: University of Pennsylvania Museum, 1998), cat. no. 8 (*Ram Caught in a Thicket*), pp. 61f.

76 Calla (snakeweed, green dragon, and adderwort); of the arum family, exists only as *C. palustris*. It has a green, creeping rhizome, rounded heart-shaped pointed leaves, and a white spathe; its red berries are poisonous. The calla's natural habitat is around the edges of ponds and in the woodland marshes of Central and Northern Europe, Siberia, and North America.

77 See Robert Mapplethorpe, *Dennis Speight with Thorus, Jack with Crown, Skull and Crossbones, Jill Chapman, Dennis Speight with Flowers*, series of five black-and-white photographs, 1983. These photographs all revolve around the central shot of a skull that Mapplethorpe took in Naples in front of the Church Purgatorio ad Arco, Via dei Tribunali; they allude to traditional representations of Jesus Christ and Mary Magdalen. On the righthand panel, Dennis Speight holds five calla lilies. This series was shown in 1984 in Ercolano in the exhibition "Terrae motus" (illus. in exh. cat. of the same name [Naples: Fondazione Amelio, Istituto per l'Arte Contemporanea, (Electa Napoli), 1984], pp.104–8).

78 The Mesopotamian figure, once part of a large object presumably used for cult worship, was originally associated with Genesis 22:13, where the angel shows Abraham a ram caught in a thicket, which Abraham then sacrifices instead of Isaac. Arthur C. Danto (Del Roscio, introduction, p. 23) concludes that the ram is therefore a generally known emblem for a sacrificial victim. Inana, or Istar, was the most important goddess in Mesopotamia. A complex figure, she was seen, among other things, as the goddess of sexual love and was compared with Venus.

79 Twombly bought this African object in Paris.

80 Joseph Beuys, *Capri-Batterie*, 1985, light bulb with socket-holder in wooden box and lemon, 8 x 11 x 6 cm, edition of 200 and some artist's proofs, signed and numbered on the certificate (Schellmann 546). See Lucio Amelio, quoted in *Joseph Beuys: Die Multiples/Beuys Stiftung Ulbricht im Kunstmuseum Bonn*, ed. Katharina Schmidt (Bonn, 1992), p. 59: "In September 1985 Beuys visited Capri for the last time... He simply walked in the garden and marvelled at Nature as he had done all his life. One day I found him specially delighted, with a small object in his hand that he had made the day before. Beuys asked the young German photographer Jochen Schmidt to take a picture of the Capri-Batterie, for that was what he called it..."

opfert; sie erhielt dementsprechend den Titel *Widder, im Dickicht verfangen*. Arthur Danto (Del Roscio, Einführung, S. 23) schließt daraus, dass es sich um ein allgemein verbreitetes Emblem für ein Schlachtopfer handelte. – Inana oder Istar war die bedeutendste Göttin Mesopotamiens. Die komplexe Gestalt wurde u.a. auch als Göttin der sexuellen Liebe gesehen und mit Venus verglichen.

79 Twombly erwarb das afrikanische Objekt in Paris. (Gespräch mit dem Künstler, Gaeta, Juni 1999).

80 Joseph Beuys, *Capri-Batterie*, 1985, Glühlampe mit Steckerfassung in Holzkiste, Zitrone, 8 x 11 x 6 cm, Auflage 200 und einige a. p., signiert und nummeriert auf Zertifikat (Schellmann 546). Hierzu Lucio Amelio, in: Katharina Schmidt (Hrsg.), *Joseph Beuys. Die Multiples. Beuys Stiftung Ulbricht im Kunstmuseum Bonn*, Bonn 1992, S. 59: »Im September 1985 besuchte Beuys Capri zum letzten Mal ... Er beschränkte sich darauf, im Garten zu spazieren und die Natur zu bewundern, wie er es sein Leben lang getan hatte. Eines Tages fand ich ihn besonders entzückt mit einem kleinen Gegenstand in der Hand, den er am Tag zuvor geschaffen hatte. Beuys bat den jungen deutschen Fotografen Jochen Schmidt, eine Aufnahme der *Capri-Batterie* zu machen, denn so nannte er das Objekt ...«

81 Von Friedrich Schiller in seinem Gedicht *Der Spaziergang*, 1795, deutsch zitiert.

82 Im Februar 1990 entstehen auf den Seychellen (D'Arros) Gouachen mit dem Titel *Les Fleurs du Mal*, anschließend, im Frühling und Frühsommer, Darstellungen von Blumen mit dicken langen Stängeln, auf denen schmale Blüten sitzen. Siehe Thomas Ammann (Hrsg.), *Cy Twombly. Souvenirs of D'Arros and Gaeta*, Zürich (Thomas Ammann Fine Art) 1992; im Sommer 1990 folgen in Bassano und Gaeta einige großformatige Arbeiten auf Papier mit dem Titel *Summer Madness,* in denen Twombly das Motiv der radial aus einem dunklen Hügel sprießenden Blumen behandelt (Bastian IV, 57 und 58).

83 Konstantin Kavafis, *Thermopylai* (1903): »Ehre sei jenen, die in ihrem Leben / Thermopylai besetzten und bewachen. / Niemals sich fortbewegend aus der Bindung, / Gerecht und grad in allen ihren Taten, / Jedoch mit Trauer schon und Herzensmilde; / Grossmütig, wenn sie reich sind, aber sollten / Sie arm sein, doch im Kleinen auch grossmütig, / Auch Hilfe bringend nach Vermögens Stärke, / Allzeit der Wahrheit ihre Rede weihend, / Nur ohne Hass auf sie, die Lüge pflegen. // Und grössre Ehre noch gebühret ihnen, / Wenn sie voraussehn (und voraus sehn viele), Dass Ephialtes wird am Schluss erscheinen / Und dass die Meder schliesslich werden durchziehn.« Konstantin Kavafis, *Gedichte. Das gesammelte Werk*, dt. von Helmut von den Steinen, Amsterdam (Castrum Peregrini Presse) 1985, S. 37.

84 Twombly zitiert »Archilochos 184« nach: Guy Davenport (Hrsg. und Übers.), *Archilochos, Sappho, Alkman. Three Lyric Poets of the Late Greek Bronze Age*, Berkeley etc. (University of California Press) 1980, S. 58 (dankenswerter Hinweis von Paul Winkler).

85 Hierzu: *Natur und Antike in der Renaissance*, Ausst.-Kat. Frankfurt am Main, Liebieghaus 1985, S. 378 ff.

86 Vgl. Cy Twombly, *Blue Ridge Mountains Transfixed by a Roman Piazza*, 1962 (Bastian II, 90).

87 O, François, Marquis d', Seigneur de Fresnes, etc. (um 1535–1594); aus einer alten Familie in der Normandie, verheiratet mit der Tochter von Villiers, der ihn bei Henri III. einführte. Dieser ernannte ihn 1578 zum Finanzminister, was er auch unter Henri IV. bis zu seinem Tode blieb. Berühmt-berüchtigt wurde er für seine Verschwendungssucht und die Rücksichtslosigkeit, mit der er durch Steuern seinen lasterhaften Lebenswandel finanzierte. D'O ließ gerne bei der Unterschrift seines Namens, auf dessen Kürze er stolz war, noch das Adelsprädikat weg. Twombly amüsierte sich über diesen kurzen Namen. – 1954 veröffentlichte Pauline Réage (erst 1994 geklärtes Pseudonym für die Kritikerin Dominique Aury) in Paris den Roman *Histoire d'O*, der später verfilmt wurde. Das Buch erregte wegen seiner pikanten Darstellung in eleganter literarischer Form großes Aufsehen. Twombly scheint es nicht zu kennen.

88 Wie Anm. 27.

89 Carola Giedion-Welker, *Plastik des XX. Jahrhunderts. Volumen und Raumgestaltung*, Zürich (Girsberg) 1955, S. 90f., bildet die *Bronzeleber von Piacenza* zusammen mit Giacomettis *Projet pour une place,* 1931–1932 (siehe unten, S. 164 und Abb. S. 164) ab, allerdings ohne Angabe, ob Giacometti das etruskische Objekt kannte (dankenswerter Hinweis von Reinhold Hohl); zu denken ist auch an Giacomettis *Paysage – tête couchée (Chute d'un corps sur un graphique)*, 1932, Gips, 25,5 x 68 x 37,5 cm, Musée national d'art moderne, Centre Georges Pompidou, Paris.

90 Gespräche mit dem Künstler und Nicola Del Roscio (Rom, Juli 1999).

91 Judith Rickenbach, »Die Leber als Spiegel des Willens. Die Leberschau in Mesopotamien, im alten Griechenland und in Etrurien«, in: *Orakel. Der Blick in die Zukunft*, Ausst.-Kat. Zürich, Museum Rietberg 1999, S. 58 ff. Hierzu auch: L. B. van der Meer, *The Bronze Liver of Piacenza. Analysis of a Polytheistic Structure*, Amsterdam (J. C. Gieben) 1987.

92 Hierzu auch Octavio Paz mit John Harvey, »The Cy Twombly Gallery at The Menil Collection. A Conversation«, in: *Res. Anthropology and Aesthetics*, (1995) 28 (Herbst), S. 181ff.

93 Zitiert nach Bettina Ruhrberg, *Arte Povera. Geschichte, Theorie und Werke einer künstlerischen Bewegung in Italien*, Dissertation Bonn 1992, Typoskript, S. 74.

94 In dem Künstlergespräch »Cy Twombly: An artist's artist«, das Kirk Varnedoe am 4. Oktober 1994 im Museum of Modern Art in New York veranstaltete, antwortete Richard Serra auf die Frage: »... what do you think about Twombly's sculpture?« – »I like them because they are white ... think of how many people have made white sculpture ... I saw a retrospective of Twombly in Spain, in Madrid's Palacio de Velázquez ... which is covered with glass. The light streams in, and what I was really taken with was the fragility of the sculptures and the fact that they reflected the light that way, like old plaster castaways. And the drawing, the tenuousness of the drawing reminded me somewhat of Giacometti.« In: *Res*, wie Anm. 92, S. 176.

95 Herman Melville, *Moby Dick* (Kap. 42 »Die Weisse des Wals«), dt. von Thesi Mutzenbecher unter Mitwirkung von Ernst Schnabel, Hamburg (Rowohlt) 1958, S. 144.

96 Bewegliche Teile an manchen Skulpturen wie Kat. 45, S. 85, sind aufgestützt, bewegen sich nicht frei.

97 Rainer Maria Rilke, *Die Sonette an Orpheus*, 1922, 1. Teil, 12. Sonett.

98 Wie Anm. 95, S. 142.

99 Gottfried Boehm, »Erinnern, Vergessen. Cy Twomblys ›Arbeiten auf Papier‹«, in: Katharina Schmidt (Hrsg.), *Cy Twombly. Serien auf Papier 1957–1987*, Ausst.-Kat. Bonn, Städtisches Kunstmuseum 1987, S. 1–12.

100 Bastian II, 7. Twombly bezieht sich auf das Gemälde von Nicolas Poussin in Dresden.

101 Hierzu auch Octavio Paz, wie Anm. 92, S. 181f.

81 Cited in German by Friedrich Schiller in his poem "Der Spaziergang," 1795.

82 In February 1990, on the Seychelles (Daros), Twombly painted the gouaches with the title *Les Fleurs du Mal*; in spring and early summer 1990, he produced images of flowers with long, thick stems and small blooms. See Thomas Ammann, ed., *Cy Twombly: Souvenirs of D'Arros and Gaeta* (Zurich: Thomas Ammann Fine Art, 1992). These were followed in summer 1990 in Bassano and Gaeta by a number of large-format works on paper, entitled *Summer Madness*, in which Twombly addressed the motif of flowers growing radially out of a dark mound (Bastian IV, 57 and 58).

83 Constantine Cavafy, "Thermopylae" (1903), in the translation by Edmund Kelley and Philip Sherrard, the full text reads: "Honor to those who in the life they lead / define and guard a Thermopylae. / Never betraying what is right / consistent and just in all they do, / but showing pity also, and compassion; / generous when they are rich / and when they are poor, / still generous in small ways / still helping as much as they can; / always speaking the truth, / yet without hating those who lie. // And even more honor is due to them / when they foresee (as many do foresee) / that in the end Ephialtes will make his appearance, / that the Medes will break through after all." In C. P. Cavafy, *Collected Poems*, trans. Edmund Kelley and Philip Sherrard, ed. George Savidis (Princeton: Princeton University Press, 1975), p. 15.

84 Twombly cites "Archilochos 184" in *Archilochos, Sappho, Alkman: Three Lyric Poets of the Late Greek Bronze Age*, ed. and trans. Guy Davenport (Berkeley: University of California Press, 1980), p. 58.

85 See *Natur und Antike in der Renaissance*, exh. cat. (Frankfurt am Main: Liebieghaus, 1985), pp. 378ff.

86 Cy Twombly, *Blue Ridge Mountains Transfixed by a Roman Piazza*, 1962 (Bastian II, 90).

87 O, François, Marquis d', Seigneur de Fresnes, etc. (c.1535–94) was from an old Normandy family, married to the daughter of the finance minister, who introduced him to Henri III. Henri III appointed him as finance minister in 1578, a post that he also held under Henri IV until his death. He became notorious for his extravagance and the ruthlessness with which he collected taxes in order to finance his lascivious life style. When d'O signed his name— proud of its brevity—he would omit the mark of nobility. Twombly was amused by this succinct name. In 1954 in Paris, Pauline Réage (the nom de plume of the critic Dominique Aury, who was not uncovered until 1994) published her novel *Histoire d'O*, which was later filmed. The book caused a considerable stir for the way it portrayed delicate issues of sexuality in an elegant literary style. Twombly appears not to know the book.

88 See note 27.

89 Carola Giedion-Welcker, *Plastik des XX. Jahrhunderts. Volumen und Raumgestaltung* (Zurich: Girsberg, 1955), pp. 90–91. This text illustrates the bronze liver of Piacenza together with Giacometti's *Projet pour une place*, 1931–32 (fig. 12, p. 164), albeit without indicating whether Giacometti knew this Etruscan object (information kindly supplied by Reinhold Hohl). One is also reminded of Giacometti's *Paysage–tête couchée (Chute d'un corps sur un graphique)*, 1932, plaster, 25.5 x 68 x 37.5 cm, Musée national d'art moderne, Centre Georges Pompidou, Paris.

90 Conversations with the artist and Nicola Del Roscio, Rome, July 1999.

91 Judith Rickenbach, "Die Leber als Spiegel des Willens: Die Leberschau in Mesopotamien, im alten Griechenland und in Etrurien," in *Orakel: Der Blick in die Zukunft*, exh. cat. (Zurich: Museum Rietberg, 1999), pp. 58ff. See also L. B. van der Meer, *The Bronze Liver of Piacenza: Analysis of a Polytheistic Structure* (Amsterdam: J. C. Gieben, 1987).

92 See also Octavio Paz with John Harvey, "The Cy Twombly Gallery at The Menil Collection: A Conversation." *Res. Anthropology and Aesthetics* 28 (Autumn 1995): 181–83.

93 Quoted in Bettina Ruhrberg, "Arte Povera: Geschichte, Theorie und Werke einer künstlerischen Bewegung in Italien" (Ph. D. diss., Bonn, 1992), p. 74.

94 In the conversation "Cy Twombly: An artist's artist," which Kirk Varnedoe organized on October 4, 1994 in the Museum of Modern Art in New York, Richard Serra answered the question "… what do you think about Twombly's sculpture?" with "I like them because they are white… think of how many people have made white sculpture… I saw a retrospective of Twombly in Spain, in Madrid's Palacio de Velázquez… which is covered with glass. The light streams in, and what I was really taken with was the fragility of the sculptures and the fact that they reflected the light that way, like old plaster castaways. And the drawing, the tenuousness of the drawing reminded me somewhat of Giacometti." Quoted in *Res*, p. 176 (see note 92).

95 Herman Melville, *Moby Dick or The Whale* (Evanston/Chicago: Northwestern University Press and The Newberry Library, 1988), p. 195.

96 Mobile parts on certain sculptures as in cat. no. 45 are supported but do not move freely.

97 Rainer Maria Rilke, "Sonnets to Orpheus" (part I, no. 12), in *Rainer Maria Rilke. Selected Poems*, trans. Albert Ernest Flemming (New York/Toronto: Methuen, 1986), p. 154.

98 Melville, p. 193.

99 Gottfried Boehm, "Erinnern, Vergessen: Cy Twomblys 'Arbeiten auf Papier,'" in *Cy Twombly: Serien auf Papier 1957–1987*, ed. Katharina Schmidt, exh. cat. (Bonn: Städtisches Kunstmuseum, 1987), pp. 1–12.

100 Bastian II, 7. Twombly is alluding to the painting by Nicolas Poussin in Dresden.

101 See also Paz, pp. 181f.

Cy Twombly, Roma 1960

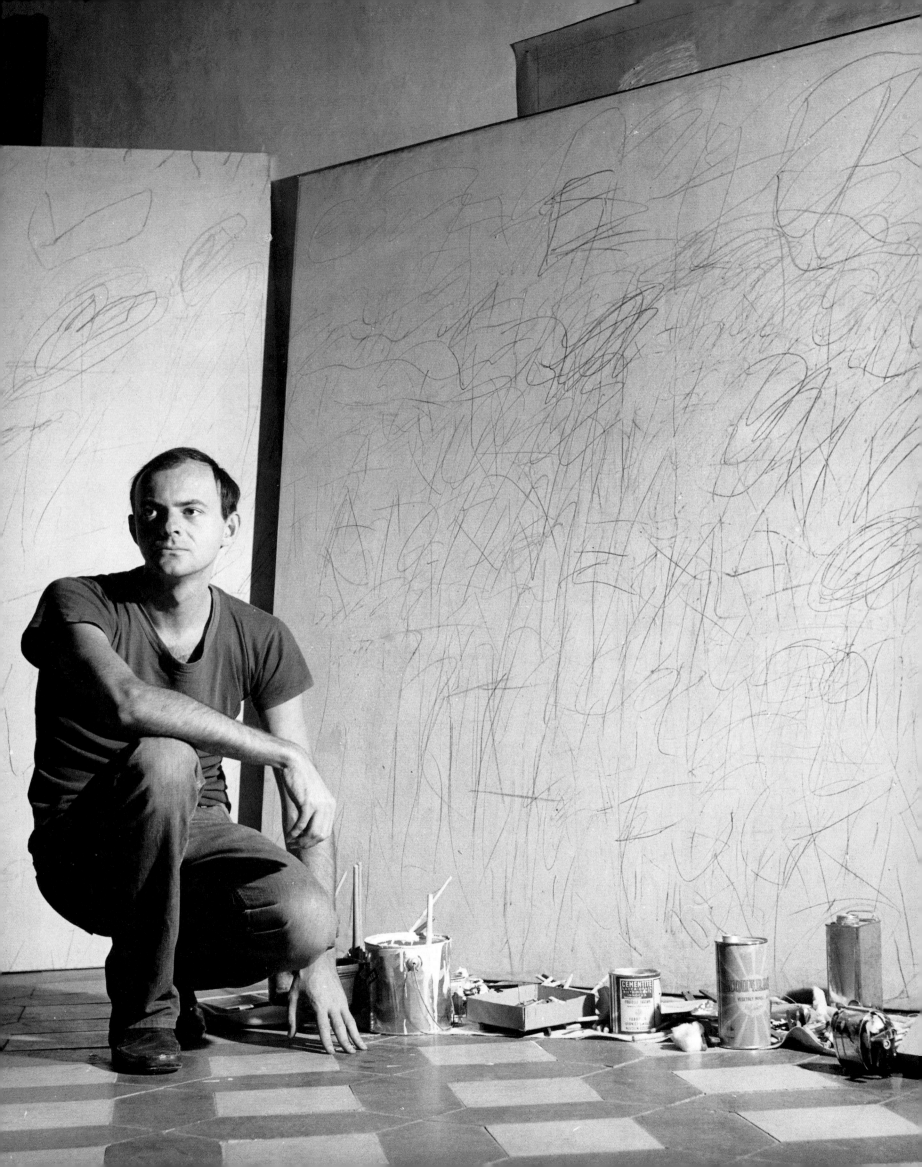

Material – Modell – Skulptur
Vom Aufheben der Dinge in die Vorstellung

Christian Klemm

In Cy Twomblys Kunst geht es um das Ineins von sinnlicher Dichte, von Körper-
und Hauterfahrung, von Gefühlen und Erinnerungen und zugleich deren Trans-
formierung und Metamorphose in Zeichen, Ideogramme, Farbmaterie, Licht-
räume, um das Festhalten vitaler Vibrationen und Erschütterungen, ohne dass
aus diesen Versteinerungen von Lebensspuren das Leben flieht. Eigentlich ist es
eine Art paralleles Unterfangen zu Alberto Giacomettis unmöglichem Projekt,
das unmittelbar Lebendige der menschlichen Begegnung in das Dauerhafte der
Skulpturen zu bannen. Diese ontologische Paradoxie, aller verewigenden Kunst
inhärent, wird im Spontanismus des existenzialistischen Informel besonders
virulent.

Cy Twombly gehört wie Robert Rauschenberg und Jasper Johns, mit denen er
sich früh befreundete, zu den Künstlern, die um 1950 bereits aufbauen konnten
auf der Errungenschaft der Gründergeneration der New York School: der existen-
ziellen, unmittelbaren, psychophysischen Konfrontation des Malers mit dem vir-
tuellen Bildraum der Leinwand. Gegenüber den heroischen Gesten der Abstrakten
Expressionisten Jackson Pollock und Franz Kline findet Twombly in seinen
Grafismen, in flüchtigen Zeichen am Rande des Lesbaren (Abb. 1), die Möglichkeit
der Spurensicherung seiner Emotionen. Was extrem subjektiv erscheint in seiner
spannungsvollen Sensibilität und Erfindungsfülle, nähert sich zugleich wieder
dem Ursprung des Zeichnens in kindlichen Versuchen und dem anonym Allge-
meinen von Graffiti. Diese Grenzzonen, jenseits des willensmäßig Forcierten,
verstandesmäßig Beherrschten, wurden von Roland Barthes weitläufig analysiert.[1]
Twombly notierte 1957 dazu: »Heute ist jede Linie die gegenwärtige Erfahrung
ihrer eigenen, ihr innewohnenden Geschichte. Sie erklärt nichts, sie ist das
Ereignis ihrer eigenen Verkörperung.«[2]

Und wie die Linie zu ihrer Autonomie findet und doch in ihrer Verkörperung
notwendig die Geschichte ihrer Entstehung vergegenwärtigt, entwickelt Twombly
auch für das andere elementare Kunstmittel, die Fläche, eine ähnlich kunstvolle
wie urtümlich kunstlose Weise. Sie ist als Bildfeld Deutungshorizont für alles auf
ihr Vorhandene, für die Emotionen virtuelle Räumlichkeit und zugleich objekt-
hafte Farbmaterie. Sie oszilliert zwischen Gestalt und Auflösung, erfährt eine
Behandlung, die in ihrer Vielschichtigkeit an alte, oft übertünchte und wieder
abbröckelnde, ausgebleichte Mauern erinnert. Auch hier setzt sich Twombly vom
Pathos der Gründergeneration ab: Nicht das wesenhaft Absolute der Farbflächen
Barnett Newmans oder Mark Rothkos sucht er, vielmehr das Haptisch-Erdver-
haftete, das in seinen Verläufen mehr der eigenen Materialität als der Willkür des
Malers zu gehorchen scheint und dadurch als etwas Naturwüchsiges erscheint.
Diese Bilder werden weder wie die Farbflächen Newmans als erhabenes Ereignis

1 Cy Twombly, *Free Wheeler*, 1955
Sammlung Marx, Berlin

Material – Model – Sculpture
Objects Transposed into Imagination

Christian Klemm

Cy Twombly's art aims to unite sensory intensity, somatic and epidermal experi-
ence, feelings, and memory, with the refashioning and metamorphosis of all
these things into signs, ideograms, paint, and light-filled spaces. It aims to arrest
and capture vital vibrations, stirrings, and upheavals in petrified traces of life
forms from which the life has not escaped. This undertaking provides a kind of
parallel to Alberto Giacometti's impossible project of injecting the living quality of
a human encounter into the durable presence of sculpture. Implicit in all art with
an aspiration to permanence, this same ontological paradox is endemic in the
cult of spontaneity that gave rise to Existentialist *Art informel*.
With Robert Rauschenberg and Jasper Johns, who became his friends early on,
Cy Twombly was one of those artists who in the early 1950s were able to build on
the achievement of the founding generation of the New York School: namely, the
painter's existential, direct, psycho-physical confrontation with the virtual space
of the canvas. However, Twombly eschewed the heroic gestures of the Abstract
Expressionists, Jackson Pollock and Franz Kline, in favor of *graphismes*, cursory
graphic signs at the outer limits of legibility (fig. 1), in which he found clues to
his own emotions. All that seems most subjective in his intense sensibility and
wealth of invention instantly refers back to the origins of drawing, both in the
work of children and in the anonymity of graffiti. These are the same borderline
areas, beyond the reach of willful compulsion and rational control, that Roland
Barthes analyzed at length.[1] As Twombly noted in 1957: "Each line now is the
actual experience with its own innate history. It does not illustrate—it is the
sensation of its own realization."[2]
The line finds its own way to autonomy and yet necessarily embodies the
history of its own genesis; for the other elementary component of art, the plane,
Twombly evolved a similarly artful and yet primordially artless mode of opera-
tion. As the pictorial field, the plane forms the interpretative horizon for every-
thing that exists on it; it is a virtual space for the emotions, and at the same time
it is paint substance, *matière*, with an objecthood of its own. Configured in a
many-layered way that recalls the repeatedly whitewashed, crumbling, faded sur-
face of old walls, it oscillates between gestalt and dissolution. Here, too, Twombly
distanced himself from the rhetoric of the founding generation. His goal was not
the absolute essence of Barnett Newman's or Mark Rothko's color fields but a
tactile, earthbound quality that seems to obey its own materiality rather than the
painter's will: in other words, a phenomenon of nature. We experience these
paintings neither as sublime events, like Newman's color fields, nor as a timeless
suspense, like the mood spaces of Rothko, but as matter saturated with time,
layered over strata of the past, and crumbling or shape-shifting its way into the

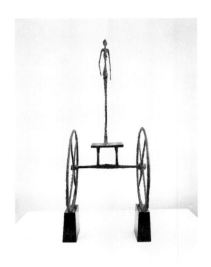

2 Alberto Giacometti, *Le Chariot*, 1950
Alberto Giacometti-Stiftung,
Kunsthaus Zürich

erlebt noch als zeitlos schwebend wie die Stimmungsräume Rothkos, sondern als in ihrer Materialität zeithaltig, über Vergangenheiten geschichtet und in die Zukunft zerfallend oder sich verwandelnd. Besonders die einander mehrfach überlagernden, gelöschten und wieder auftauchenden Schriftzüge machen diesen geschichtlichen und damit quasi erzählerischen Charakter deutlich: Der durch die hellen Farbschleier evozierte Raum öffnet sich in die Tiefe der Zeit. Eine Strukturanalogie zur Gegenwärtigkeit von Mythen drängt sich auf.

Die scheinbar simplen, sensibel verschmierten Oberflächen enthalten ungewöhnlich komplexe Anmutungsqualitäten, deren Widersprüchlichkeit nur in dem Vieldeutigen der Farbe Weiß aufgehoben werden kann.[3] Das bereits zitierte Statement von 1957, als Weiß von der New Yorker Szene bis Zero die Künstler faszinierte, beginnt: »Die Realität des Weiß könnte in der Dualität der Empfindung existieren (wie bei der Dialektik von Begehren und Furcht).«[4] Diese simultane Gegenbewegung von Anziehung und Distanzierung, die auch Giacometti in seinen Skulpturen, insbesondere im *Wagen*[5] (Abb. 2) gestaltete, zeichnet das Weiß als Nichts und Unendlichkeit, als Ort der Latenz vor dem Erscheinen und Entscheiden aus. Twombly vermag ihm durch materielle Verunreinigung die Körperlichkeit einer Haut zu geben und trotzdem das geistig Durchsichtige zu bewahren.

Die bald pastosen und wieder aufgekratzten, bald in Tropfen verfließenden Oberflächen verleihen deshalb auch den Gemälden etwas Haptisch-Gegenständliches und führen über das Objekthafte, das die Moderne allgemein vom Bild fordert, hinaus. In einigen um 1952 entstandenen Werken, die der Ausprägung des charakteristischen Stils unmittelbar vorangingen, reihte Twombly auf tief aufgewühltem, schmutzig weißlichem Grund dicht gedrängt fetischartige Zeichen, sodass das Gemälde die Dinglichkeit eines Lattenzauns oder einer Bretterwand evoziert. (Abb. 3) Und tatsächlich fügte er gleichzeitig eine Anzahl Stäbe von quadratischem Querschnitt zur flächig geschlossenen Skulptur zusammen. (Kat. 3, S. 21) Wenig später findet er das beschriebene Verhältnis von Grund und Zeichen; in parallel entstandenen Plastiken ragen Palmfächer oder andere zeichenhafte Elemente aus bemalten flachen Kisten, die als frontale Flächen in Erscheinung treten. (Kat. 5, S. 30)

Trägt bei den Gemälden das weiße Farbmaterial die Zeichen, ist es bei den Skulpturen genau umgekehrt: Hier werden Gegenstände zu Zeichen und durch den weißen Anstrich in den schwerelos lichten Raum poetischer Assoziationen überführt. Diese Metamorphose entrückt das Werk aus drei Ebenen gegenständlicher Realität: zunächst aus den Materialien selbst, aus denen der Künstler seine Plastiken zusammenwachsen ließ, sodann aus ihrem Modellcharakter als Musikinstrumente, Fahrzeuge oder dergleichen und schließlich aus ihrer Dinglichkeit als Skulptur. Vielleicht bieten diese drei Aspekte geeignete Kriterien, sich den in ihrer rätselhaften Selbstverständlichkeit ruhenden Gebilden zu nähern, wobei auch das Verhältnis zu den Gemälden punktuell mitbedacht werden soll.

future. This historical and thus quasi-narrative character is exemplified, above all, by the insertion of written characters, repeatedly superimposed, obliterated, and reemerging: light-filled veils of paint create a space that opens into depths of time. The obvious structural analogy in these works is with the eternal present of myth.

Deceptively simple, sensitively blurred, their surfaces enshrine uncommonly complex subliminal implications, and their contradictions can be resolved only through the multiple ambiguities of the color white.[3] Twombly's statement of 1957, already quoted in part, was made at a time when a wide range of artists, from the New York School to Zero, shared a fascination with white. The statement's first words are: "The reality of whiteness may exist in the duality of sensation (as the multiple anxiety of desire and fear)."[4] This idea of simultaneous attraction and repulsion—also expressed by Giacometti in such sculptures as *The Chariot* (fig. 2)—reveals white as both zero and infinity; white is the place of latency that precedes manifestation and decision. In his use of materials, Twombly adulterates his white in such a way as to endow it with the physicality of a skin while retaining a spiritual transparency.

The surfaces of the paintings, impasted and scratched away in some places, dispersing into drips and drops in others, create a palpable quality that goes somewhat beyond the modernist requirement that painting be an object. In a number of works made around 1952, immediately before Twombly established his own definitive style, he arranged tightly packed, fetishlike signs against a violently agitated, dirty, off-white ground, so that the painting evokes the objecthood of a picket fence or a matchboard wall (fig. 3). During the same period, he made a sculpture by assembling a number of square-section battens into a solid plane (cat. no. 3, p. 21). A little later, he discovered the sign/ground relationship described above and, in parallel with those works, produced sculptures in which palm-leaf fans or other signlike elements emerge from shallow painted boxes that are displayed frontally as vertical surfaces (cat. no. 5, p. 30).

In the paintings, white paint is the support for Twombly's signs; in the sculptures, the reverse is the case. Here, objects become signs, and white paint transports them into the gravity-free, light-filled space of poetic association. This metamorphosis detaches the work from three planes of objective reality: that of the actual materials used by the artist in making the sculptures; that of their character as models (of musical instruments, vehicles, or whatever); and that of their objecthood as sculpture. Perhaps these three aspects offer appropriate categories for approaching these enigmatically self-evident works.

I

The materials used by Twombly are primarily bits of wood, cardboard, and wire—the materials of *bricolage*, which Picasso first introduced into Western sculpture in his Cubist collages and constructions, and which have ever since remained the domain of the painter-sculptor. Unlike professional sculptors, many painter-sculptors do not start out with raw, amorphous material but use pre-worked

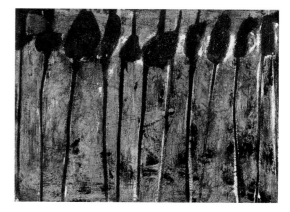

3 Cy Twombly, *Solon I*, 1952
Daros-Sammlung, Schweiz

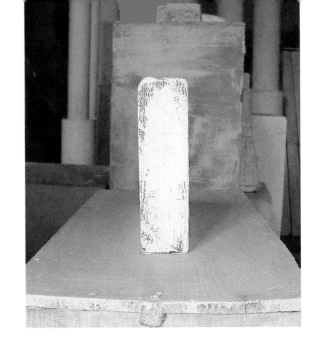

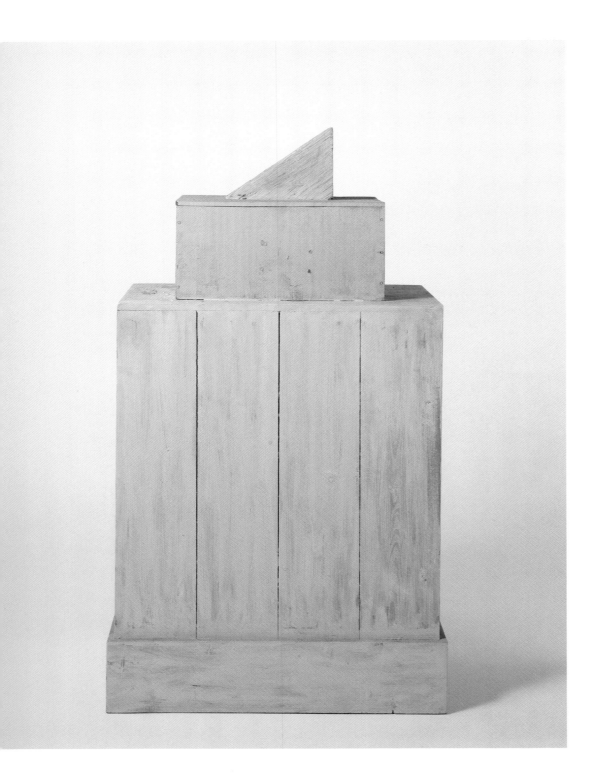

21 *Untitled*, Rome 1980

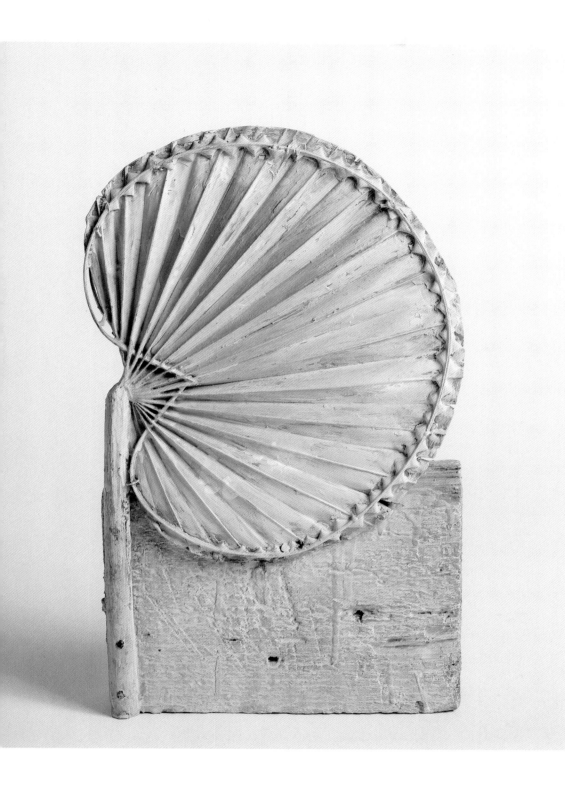

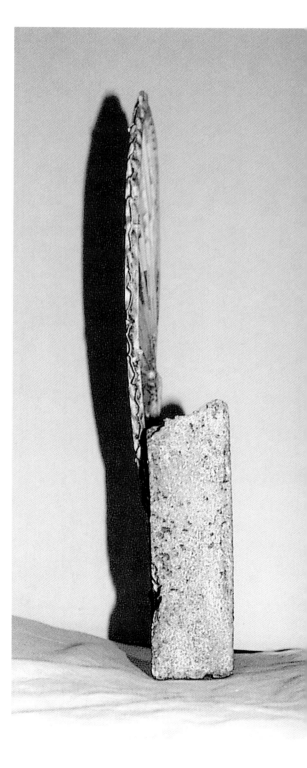

14 *Cycnus*, Rome 1978

Die Materialien, die Cy Twombly verwendet, sind zunächst Holzstückchen, Karton, Draht – Bricolage-Dinge, die Picasso mit seinen kubistischen Collagen und Konstruktionen in die abendländische Skulptur eingeführt hat und die seither die Domäne der Maler-Plastiker blieben. Im Gegensatz zu professionellen Bildhauern gehen viele von ihnen nicht von der rohen, amorphen Materie aus, sondern greifen sie in bereits bearbeiteten Stücken auf; mit dem Stoff ist so immer auch schon eine Form gegeben und gewählt. Zwar kennt man einige Arrangements des jungen Twombly aus spezielleren Objets trouvés, wie Türknäufen oder Stuhlbeinen, die von seiner frühen Begeisterung für Kurt Schwitters zeugen (Kat. 2, S. 19), doch im Folgenden zieht er schlichte, unspezifische Dinge vor – wichtig ist ihm nur, dass sie nicht neu sind, dass sie bereits eine Geschichte haben, eine anonyme, beiläufige, wie eben die Zeichen, die er auch in den Bildern verwendet.

Holz ist Twomblys bevorzugtes Material, in dem natürliches Wachstum durch die handwerkliche Verarbeitung kontinuierlich in menschliche Geschichte übergeht, voller mythischer Erinnerungen und doch von der gewöhnlichsten Alltäglichkeit; einer Alltäglichkeit, die, von der Allgegenwart des charakterlosen, beliebig und massenweise formbaren Kunststoffs verdrängt, heute wieder als etwas Kostbares, Authentisches erscheint. Dass in den sichtbaren Jahresringen die durchwachsene Zeit stets gegenwärtig bleibt, entspricht den Schichtungen der Bildgründe; die Lineamente der Fasern sind Spuren von Lebensvorgängen, vergleichbar Twomblys vital gespannten und emotional zitternden Strichen.

Meist nimmt Twombly das Holz in Form von Kistchen auf, die mit ihrem Inhalt ihren Herstellungszweck verloren haben; gerade dadurch sind sie leer wieder zu ihrem hölzernen, so oder so proportionierten »Kistchen-Dasein« zurückgekehrt, das nun neuen Assoziationen und Zusammenhängen offen steht. Das Dienende ist ihnen eigen, und so dienen sie oft als Sockel, gehen jedoch in dieser Funktion nicht auf; bleiben vielmehr eigenwertige, gleichberechtigte Elemente des Werkes. Am deutlichsten wird dies in Twomblys einfachsten Arbeiten, etwa in *Ohne Titel* von 1978 (Kat. 12, S. 47) mit dem einzelnen, leicht abgehobenen Brettchen, in dem nun zugleich das Liegende und Labile von gesägten Brettern im noch unspezifischen Rohzustand zur Geltung kommt. Latten haben in ihrer Gerichtetheit wieder einen anderen, dynamischeren Charakter, den Twombly in der aufschnellenden, zeichenhaft in den Raum ragenden Diagonale nützt. (Abb. 4; Kat. 32, S. 62) Selbst wenn man in diesen drei Verarbeitungsformen von Holz rein formal Körper, Fläche und Linie sehen wollte, spürte man sogleich, dass dies eine unzulässige Reduktion wäre, dass die sinnliche Substanz, Körperlichkeit, lebens- und geschichtenhaltige Rauheit wesentlich bleibt und das eigentliche Substrat bildet. Gelegentlich verwendete Cy Twombly, ohne dass man schon von Geräten sprechen mag, bereits weiter verarbeitete Holzstücke: einen Besenstiel, einen von Bauarbeitern roh gezimmerten Hocker (Abb. 5), mehrfach die runden Deckel von Olivenölfässern (Abb. 6; Kat. 39, S. 108 und 110; Kat. 41, S. 112 und 113) sowie Dinge, die im Garten oder beim Handwerk Gebrauch finden, etwa die dreieckigen

4 Cy Twombly, *Untitled*, 1983.
Cat. 32

In 1955, Twombly made a sculpture consisting of a bundle of wrapped elements (cat. no. 8, p. 34); the compulsive act of binding recalls ritual objects from primitive cultures. The fetish as the *nec plus ultra* of the "made" object, an object in which people seek to confine dangerous forces, is here invoked as one of the sources of art.

It was only at a relatively late stage that Twombly first employed amorphous materials, those to which the artist himself must give a form. Characteristically, however, the mixture that he used, a composition of sand and gypsum plaster, keeps its roughness and asserts its identity even after the formative process. His earliest recorded use of this material is in an object made up of two wheels and a triangle (cat. no. 16, p. 52), which recalls the signs used for war chariots in a slightly earlier series of paintings on the theme of the Trojan War (fig. 24).[9] It was made shortly after the *Goethe in Italy* paintings,[10] in which Twombly had come close to using paint in traditional ways (fig. 11). In the sculpture, as in those paintings, the nature of the material remains the primary means of expression; the stiff, porous, earthy mixture, with its capacity to disrupt geometric form, makes the piece look like a half-eroded archaeological object—a vestige of the defiant human will gradually succumbing to the formlessness of the earth. This chthonic chaos can also be fertile soil for the emergence of new life, as is shown by

11 Cy Twombly,
 Goethe in Italy.
 Scene I, 1978
 Kunsthaus Zürich

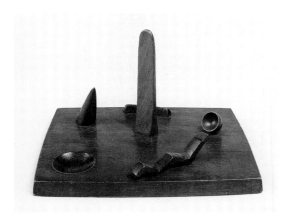

12 Alberto Giacometti,
Projet pour une place, 1931–1932
Peggy Guggenheim Collection, Venice

Spur menschlicher Willensaufbäumung, die sich im Gestaltlosen des Erdreiches verliert. Dass dieses chtonische Chaos aber zugleich den Nährboden neuen Lebens bildet, zeigt einerseits die Verwendung einer solchen oder ähnlichen Masse in Objekten mit pflanzlichen Elementen von 1983 (Kat. 30, S. 86) und 1992[11], andererseits die Skulptur *Ohne Titel* von 1985, in der eine Scheibe aus amorpher Aufschäumung auftaucht und so unmittelbar an die von Twombly auch in Bildern evozierte Schaumgeburt der Aphrodite erinnert. (Kat. 39, S. 108 und 110) Schließlich hat er selbst das Amorphe an sich oder besser das Formlose amorpher Substanz thematisiert: Auf einem Holzblock häuft sich Gipsgemenge – doch es zeigt sich, dass die Materie der Form, dem gestalthaften Sehen nicht entgeht. (Kat. 48, S. 122) Während die eine Seite mit ihren dunklen Verunreinigungen noch wie ein informelles Gemälde wahrgenommen wird, weckt die dynamische Schichtung der Massen auf der Gegenseite Erinnerungen an Tiergruppen; die Schmalseite aber nähert sich gar einer verwitterten Pyramide an, dieser kristallinen Urform von Bergen und Bauten.

II

Wenden wir uns nach dem materiellen Substrat von Cy Twomblys Skulpturen dem zweiten Aspekt zu, den wir »Modellcharakter« nannten. Die traditionelle akademische Unterscheidung von Materie, Form und Inhalt greift hier nicht mehr, denn wie in Ovids *Metamorphosen* durchdringen sich die Seinsbereiche in lebendigem Fluss. Mit der Materie ist oft die Form zugleich gegeben, der Inhalt wohnt beiden untrennbar inne. Das Werk hat nicht den Charakter eines Abbildes, sondern ist autonomes Ding, das als solches in der Ordnung der realen Dinge zur Kategorie Kunstwerk gehört, aber zugleich an andere Dinge oder Zusammenhänge erinnert. Reinhold Hohl hat für die surrealistischen Konstruktionen Giacomettis den Begriff »Schaumodell« eingeführt.[12] Er erscheint auch hier passend, weil ein solches die konzeptuelle Entleerung von »Inhalt« oder »Zeichen« vermeidet und zugleich Bezugsgröße und -art offen lässt. Giacomettis *Palast um vier Uhr früh*[13] (Abb. 23) regte Twombly zu seinen ersten eigenen Konstruktionen an, und noch in einer seiner jüngsten Arbeiten drängt sich der Vergleich mit dessen *Modell für einen Platz*[14] von 1931/32 auf. (Abb. 12)

Bereits eine der ersten Skulpturen mit Modellcharakter verweist auf ein Musikinstrument, die oft kunstvoll gearbeiteten Klangkörper, die schon auf antiken Friesen in Skulptur übersetzt wurden; sie faszinierten die Stilllebenmaler durch ihre abstrakt-harmonischen Formen, Picasso aber wegen ihren psychophysischen Assoziationen. Näher als dessen Gitarren-Konstruktionen ist Twomblys Plastik jedoch Jasper Johns' *Konstruktion mit Spielzeugklavier*.[15] Schon eine der frühesten Konstruktionen Twomblys von 1948[16] erinnert an eine Stimmgabel (Abb. 13); evident wird der Modellcharakter in der Skulptur *Ohne Titel* von 1959, die an eine Panflöte, eine Syrinx erinnert. (Kat. 9, S. 41) In diesem Falle ist der Bezug zum Mythos, wie ihn Ovid überliefert, manifest: Pan, Inbegriff des Trieb- und Naturhaften, entbrennt in Liebe zur Nymphe Syrinx; seiner Umarmung entzieht sie sich durch die Verwandlung in Schilfrohr, das unter den Händen und Lippen des

Twombly's use of a similar mixture both in works with plant elements made in 1983 (cat. no. 30, p. 86) and 1992,[11] and in the sculpture Untitled of 1985 (cat. no. 39, pp. 108 and 110), in which a disc emerges from a foaming amorphous mass in direct allusion to the theme (also present in Twombly's paintings) of the birth of Aphrodite. Finally, he made amorphous texture, or rather the shapeless-ness of amorphous material, into the subject of a work: a heap of plaster lies on a block of wood, yet the material cannot escape form or the viewer's gestalt-attuned eye (cat. no. 48, p. 122). While one side with its dark smudges is still perceived as an *informel* painting, the dynamic layering of masses on the other side suggests sculptural groups of animals. Seen endwise, the work recalls an eroded pyramid, the crystalline archetype of all mountains and buildings.

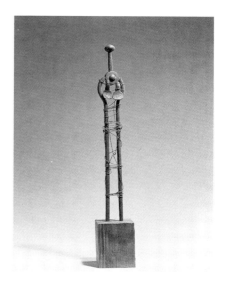

13 Cy Twombly, *Untitled*, 1948
Private collection

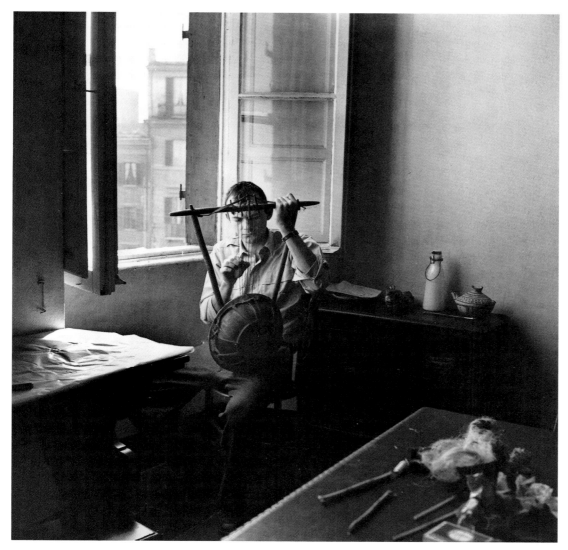

14 Robert Rauschenberg,
Cy Twombly mit einem Musikinstrument, Rom 1953
Cy Twombly with a musical instrument, Rome 1953

Hirtengottes aufklingt – Mythos vom Ursprung der Kunst in Sehnsucht und Entsagung, Sublimierung ins klingend Ungreifbare. Was früher figürlich ins Bild gesetzt wurde, schwingt hier nur noch ahnungsvoll mit; die Aussage des Mythos wird in der Struktur des Werkes selbst nachvollzogen. Die formale Idee geht auf die bereits erwähnte, sechs Jahre früher entstandene Skulptur *Ohne Titel* (Kat. 3, S. 21) zurück, eine Arbeit, die Robert Rauschenberg gehört, mit dem Twombly 1952/53 nach Europa und Nordafrika reiste. In Rom fotografierte ihn der Freund, wie er ein afrikanisches Musikinstrument studiert, dessen Form einer Lyra gleicht. (Abb. 14) Diese Skulptur mit ihren Umwicklungen, den Nägeln und Drähten erinnert eher an Fetische und nordafrikanische Zäune oder Lattenkonstruktionen, Motive, wie sie auch in Twomblys Bildern jener Jahre wirksam sind. Die Faszination durch das Obsessive und Repetitive des Rituals, das in ursprünglichen Kulturen die Psyche besetzt, dominiert hier, während es später von mythischen Allusionen oder freieren Gesten überlagert wird; die Entwicklung dieses Formgedankens von der früheren zur späteren Skulptur zeigt dies beispielhaft. Der Gedanke der Metamorphose, der Verwandlung, der allgegenwärtig das Werk Twomblys durchzieht, ist hier nicht auf die Veränderung der Gestalt, sondern auf die Verschiebung des religiösen Deutungshorizontes zu beziehen.

Mehrere Skulpturen Twomblys können als Modelle eines Fahrzeugs angesprochen werden, ein Motiv, das Giacometti mit dem *Chariot* in die neuere Kunst eingeführt

34 *Untitled*, Rome 1983
Bronze, Pfäffikon 1998
Rückseite · Back

II

From the material substrate of Twombly's sculptures, we turn to the second of their three aspects, which we called their "character as models." In Twombly's work, the traditional academic distinctions between material, form, and content no longer hold, since all levels of existence interpenetrate—as in Ovid's *Metamorphoses*—in a living flux. Form is often implicit in material, and content is inseparably wedded to both. The sculpture is not a representation but an autonomous object: within the class of real objects, it belongs to the category called works of art, but at the same time it carries reminders of other things and other contexts. Reinhold Hohl coined the term *visual model* to describe the Surrealist constructions of Giacometti.[12] It seems equally appropriate here, because a model avoids the conceptual vacuum of "content" or "sign" and leaves open the issue of the scale and type of reference. It was Giacometti's *Palace at 4 a.m.* (fig. 23)[13] that prompted Twombly's own first constructions, and one of his most recent works offers an analogy to Giacometti's *Model for a Public Square* of 1931/32 (fig. 12).[14]

Among Twombly's sculptures with a "character as models," one of the very earliest makes reference to a musical instrument, an often finely worked class of object that is featured in many of the sculptural friezes of classical antiquity. Musical instruments have fascinated many still-life painters by virtue of their abstract, harmonious forms; their psycho-physical associations fascinated Pablo Picasso in particular. However, Twombly's sculpture is closer to Johns's 1954 *Construction with Toy Piano*[15] than it is to Picasso's guitar constructions. One of Twombly's earliest sculptures, made in 1948,[16] is reminiscent of a tuning fork (fig. 13); the "model" character becomes even more evident in the sculpture Untitled of 1959, which suggests a set of panpipes (cat. no. 9, p. 41). In this case, the mythological reference, taken from Ovid, is clear: Pan, the god of instinct and of brute nature, burns with love for the nymph Syrinx, who evades his embraces by metamorphosing into a reed, which in turn becomes musical in the hands and at the lips of the god of shepherds. This is the myth of the origin of art as the sublimation of frustrated longing into melody and intangible form. What would once have been illustrated figuratively is present here only as a hint, an overtone; the meaning of the myth is recapitulated within the structure of the work. The formal idea goes back to a sculpture of six years earlier, already mentioned, Untitled (cat. no. 3, p. 21), which belongs to Rauschenberg with whom Twombly went on a trip to Europe and North Africa—in Rome, Rauschenberg photographed his friend looking at an African musical instrument shaped like a lyre (fig. 14). This 1953 sculpture, with its wrappings, nails, and wires, is reminiscent of fetishes or North African fences or lath constructions, all of which are motifs prominent in Twombly's paintings of the same period. It reveals his fascination with the obsessive and repetitive nature of ritual, with its hold on the psyche in primitive cultures. Later this becomes overlaid with mythical allusions or with freer gestures: a transition exemplified by the evolution of this particular formal idea within Twombly's sculpture. Here the idea of metamorphosis, omnipresent in

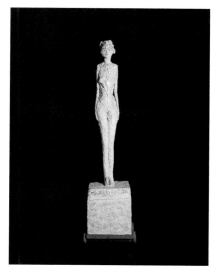

15　Alberto Giacometti,
Femme au chariot, 1943
Wilhelm Lehmbruck Museum Duisburg

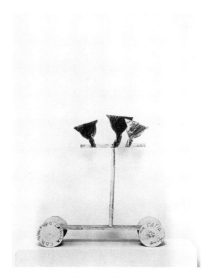

16 Cy Twombly, *Untitled*, Rome 1977
Collezione Tatiana Franchetti Twombly,
Roma

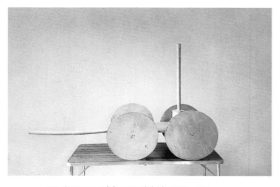

17 Cy Twombly, *Untitled*, 1991–92
Private collection

hat. Von einem altägyptischen Wagen angeregt, wird die zweirädrige Konstruktion zum Zeichen für das Erscheinen der Gottheit. In einem kleineren Werk bezieht sich Giacometti auf Nilbarken, wie sie im alten Ägypten als Grabbeigaben geläufig waren.[17] Dass Twombly auf die gleichen Inspirationsquellen zurückgreift, ist kaum erstaunlich, da dessen reifes Werk nur wenige Jahre vor seiner eigenen grundlegenden Stilbildung einsetzt. Beide sind von dem Klima existenzieller Gegenwärtigkeit und humanistischer Nostalgie geprägt, wie sie die Nachkriegszeit bestimmten, in der möglichst uralte, archaische Mythen wieder als Modelle ursprünglichen Menschseins erschienen. Seine erste wagenartige Skulptur schuf Twombly 1977, unmittelbar nachdem er mit den Röhrenplastiken zum dreidimensionalen Medium zurückgekehrt war. Der »Car Nymphaea Caerulea« (Abb. 16), seiner Frau Tatia gewidmet, gleicht mit seinem blauen Blütenbaum einem Prozessionswagen zum Fest der Nymphe. Das Gewächs steht als Gabe für die Göttin und zugleich für diese selbst. Es folgen einige abstraktere Konstruktionen mit nur einer Achse; ihre Form und die Möglichkeit ihrer Bewegung scheinen näher mit der latenten Dynamik der gleichzeitig in zahlreichen Varianten erprobten Diagonalgebilde verwandt. Der oben beschriebene Streitwagen aus amorphem Material führt diese Fügung aus Scheibe und Dreieck zu mythischen Vorstellungen zurück. (Kat. 16, S. 52) Die Ausdrucksqualitäten der beiden geometrischen Grundformen, Symbole für Beschleunigung und Angriff, scheinen durch ihre räumliche Verdreifachung in Anabasis (Abb. 18; Kat. 23, S. 56) zu ihrer definitiven Gestalt gesteigert; doch der denkmalgleichen Skulptur entspricht es, dass die Aggression ins Hieratische erhöht und stillgelegt wird. Die Rädchen der dreieckigen Basis weisen nicht in die Fahrtrichtung der mit Metallbändern beschlagenen Brustwehr, sondern stehen wie die Voluten eines Monumentes oder die Füße eines Blumentopfes radial nach außen. Diente dieses rollbare Brett einst für Zierbäume, so schließt es indirekt an das frühere Blütenbäumlein für Tatia an.

Twombly weilte 1962 und erneut 1985 in Ägypten.[18] Kurz nach dem letzten Aufenthalt begann er sich in Gaeta ein Haus auszubauen, von dem der Blick weit über das Tyrrhenische Meer schweift und so zu den in lichten Flächen schwebenden Barken auf den Gemälden der letzten Jahre anregte. Die Skulptur *Winterpassage: Luxor* von 1985 (Kat. 37, S. 77) bezieht sich wohl auf die Überquerung des Nils in der Hauptstadt des alten Ägyptens. Im »hunderttorigen Theben« führte sie von der Stadt der Lebenden auf dem Ostufer zur Stadt der Verstorbenen jenseits des Fruchtlandes am Rande der westlichen Wüste; unschwer erkennt man in der kostbaren Fracht des schlichten Kahns den Sarkophag. Der Austausch der Lebenden und Toten, die Rettung der lebendigen Gegenwart in die zukünftig weiterwirkende Vergangenheit gehört zu den zentralen Beweggründen der Formwerdung; sie gleicht der Entrückung der Opfer in Ovids Metamorphosen, in denen Sterbliche in Sterne, in Steine, in Bäume und Quellen, in jedes Jahr neu aufblühende Blumen verwandelt werden. Twomblys von Tulpen gekrönten Kubus beschrieb Franz Meyer als Modell eines Feldaltares, auf dem die Bauern der Gottheit des Ortes die Erstlinge ihrer Ernte darbieten.[19] (Kat. 34, S. 166) Ganz unmittelbar geht hier zur symbolischen Förderung der Fruchtbarkeit blühendes

Twombly's work, relates not to shape-shifting but to a shift of the horizon of religious interpretation.

A number of Twombly's sculptures may be read as model vehicles, a motif that Giacometti introduced into modern art in his 1950 *The Chariot*. Suggested by an ancient Egyptian chariot, this two-wheeled construction became a sign for the apparition of the divine. In a smaller work Giacometti refers to the Nile boats that were frequently included in ancient Egyptian grave goods.[17] It is no surprise to find Twombly sharing a source of inspiration with Giacometti, who reached artistic maturity only a few years before his own formative years began. The work of both artists bears the marks of a characteristic postwar blend of humanistic nostalgia and an existential concern with the here-and-now; it was a time when age-old myths, the more ancient the better, reemerged as models of archetypal humanity. Twombly made his first chariotlike sculpture in 1977, in the wake of the tube sculptures that had marked his return to working in three dimensions. Dedicated to his wife Tatia, "Car Nymphaea caerulea" (fig. 16), with its blue blossoming tree, is like a processional car for the festival of the nymph. The tree is an offering to the goddess and also stands for her. There followed a number of more abstract compositions with single axles; their form and their capacity for locomotion seem more closely related to the latent dynamic of Twombly's contemporaneous diagonal structures. The war chariot mentioned previously, made of amorphous material, takes this fitted combination of disc and triangle back to its mythical associations (cat. no. 16, p. 52). The expressive qualities of these two basic geometric forms, symbols of acceleration and attack, apparently find their definitive expression in the 1980 *Anabasis* (fig. 18; cat. no. 23, p. 56), but in this work, which looks like a monument, the aggression is sublimated and frozen into a heroic mode. The little wheels on the triangular base are not aligned to run in the direction indicated by the metal-banded breastwork but are arranged radially, like volutes on a monument or feet on a garden urn. The wheeled stand, once used to transport ornamental trees, has an indirect affinity with the earlier blossoming tree for Tatia.

In 1962 and again in 1985, Twombly spent some time in Egypt.[18] Shortly after his later visit, he began to remodel a house at Gaeta in Italy. Its extensive view over the Tyrrhenian Sea would inspire the images of boats, floating in expanses of light, in his paintings of recent years. The sculpture *Winter's Passage: Luxor* of 1985 (cat. no. 37, p. 77) presumably refers to the crossing of the Nile at the capital city of ancient Egypt: "hundred-gated Thebes." This was the journey from the city of the living, on the east bank of the Nile, to the city of the dead, beyond the fertile strip on the edge of the western desert. The frail craft bears a precious cargo that is unmistakably a sarcophagus. The interchange between the living and the dead, the transfer of the living present into the safekeeping of a past that endures into the future, is one of the central concerns of all formal creation. In Ovid's *Metamorphoses,* it is expressed in the miraculous rescues during which mortal victims are transformed into stars, trees, fountains, and annually returning flowers. It was Franz Meyer who described Twombly's cubic shape crowned with

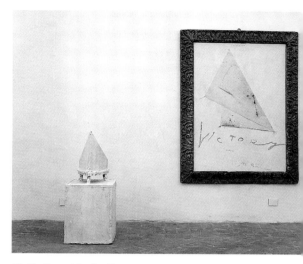

18 *Cy Twombly: Sculture*
Galleria Gian Enzo Sperone, Roma 1984
Anabasis, 1980. Cat. 23
Victory, 1984

19 Pasargadai, Grabmal Kyros' II,
achaimenidisch, nach 529 v.u.Z.
Pasargadai, Tomb of Cyrus II,
Achaemenid, after 529 B.C.

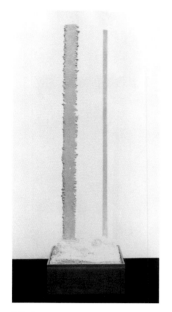

20 Barnett Newman,
Here I, 1950
The Menil Collection,
Houston

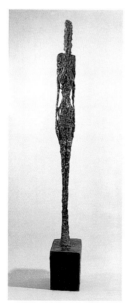

21 Alberto Giacometti,
Grande Figure, 1947
Kunstmuseum Basel,
Alberto Giacometti-
Stiftung

Leben in Verwesung über, berührt sich höchst ausdifferenzierte und strenge Gestalt mit Amorphem.

Die Modelle, die uns so umfassend über die materielle Kultur des alten Ägypten unterrichten, sind primär Grabbeigaben, Geräte zur Verwendung im Jenseits: Stets hält die verwittert zerbrechliche Materialität, die bleiche weißliche Schlemmung der Fügungen Twomblys diesen Bedeutungshorizont gegenwärtig. Modelle können aber auch Spielzeug sein, von der Schwere der materiellen Tatsachen befreite Dinge, die der ursprünglichen symbolischen Weltaneignung im kindlichen Spiel dienen. Die Imagination macht hier das Fehlen der lebenspraktischen Funktionen wett, denn im geistigen Gebrauch lassen sich die engen Schranken der Bedingtheiten überschreiten in Räume, die dem Erwachsenen durch das Gedränge der Alltäglichkeiten meist verstellt sind. So vermittelt in der Moderne der Modellcharakter oft wesentlich zwischen Kunst und Wirklichkeit. (Abb. 17) Er entspricht dem Konzeptuellen der neuen Weltbilder und tritt an die Stelle der Abbildfunktion der realistischen Tradition. Sicher beruht die Faszination, die die schlichten und zugleich vielfältige Gedanken und Gefühle weckenden Dinge ausstrahlen, nicht zuletzt darauf, dass Twombly diese elementare Dimension so rein zur Geltung bringt ohne in leere Schemata zu verfallen.

In gewisser Weise eignet den Werken auch als Skulpturen Modellcharakter: In ihren Proportionen, der relativen Größe und Hierarchisierung der übereinander geschichteten Teile entsprechen sie oft großen Denkmälern, von denen sie sich doch durch die Leichtigkeit ihrer Materialien, die Beiläufigkeit ihrer Herstellung unterscheiden. Schon früh zeigt sich diese Strukturanalogie, doch erst in den achtziger Jahren finden sich Skulpturen, in denen das zentral Erhöhte oder der Titel den modellhaften Bezug zu einem Monument explizit machen. Nach dem Ort, wo sich noch heute das Grabmal des Königs Kyros findet (Abb. 19), nannte Twombly eine Skulptur *Pasargade*;[20] *Thermopylae*, ein Grabhügel, aus dem Tulpen wachsen (Kat. 53, S. 118), *Epitaph* mit einer Inschrift des Dichters Archilochos (Kat. 61, S. 120) sind vergleichbare, bedeutungsvoll anders ausgebildete Werke. Die dichteste Gestaltung wird in einer relativ großen, hieratisch frontalen Skulptur erreicht, über deren hohen Sockel sich eine stumpfe, von einem Quader bekrönte Pyramide erhebt. (Kat. 47, S. 94) In ihrer geringen Tiefe und intensiven Bemalung gleicht sie den um 1955 geschaffenen Plastiken; doch ist auch die Rückseite bearbeitet und weist durch eine kleine Stütze in der Mitte das Trapez zugleich als Schrifttafel aus, ein Motiv, das Twombly wegen seiner Stellung zwischen Skulptur und Gemälde öfter reizte.

III

Nach dem Material und dem Modellcharakter sei der dritte Aspekt der Dinglichkeit dieser Objekte behandelt: ihre Zugehörigkeit zur Gattung Skulptur. Auch hier steht Twombly in weitläufigen Traditionen, Beziehungen, Anspielungen. Einige kunsthistorische Verbindungen wurden bereits gestreift: die Bedeutung des Modellbegriffs für die moderne Kunst, Picasso und Schwitters als Vorläufer für den Charakter der Konstruktionen als Bricolagen. Die Beziehungen zu seinen

tulips as a model of a "field altar," on which peasants sacrificed their first fruits to the local deity (cat. no. 34, p. 166).[19] Here, blooming life makes a direct transition into decay as a symbolic means of promoting fertility. Here, too, distinct and rigorous form comes into contact with the amorphous.

The models that most comprehensively reflect for us the material culture of ancient Egypt are primarily grave goods: utensils for use in the hereafter. Twombly's assemblages, with their frail, weathered material substance and their pale, off-white, washed-out finish, keep this dimension of meaning constantly before us. However, models can also be toys—objects liberated from the weight of material fact and used as aids in the archetypal childhood process of coming to terms with the world through play. Imagination compensates for the absence of practical, real-life function; when an object is used in mental play, it becomes possible to cross over from the narrow confines of reality into spaces from which the adult is mostly barred by the pressures of everyday life. In modernism, the principle of the artwork as model often mediates between art and reality (fig. 17). It reflects the conceptual nature of the new world-image and takes over from the representational function of realist tradition. Simple as Twombly's objects are, they provoke a multitude of ideas and feelings. Not the least of their fascination lies in the purity with which they express this elementary dimension without ever lapsing into empty schemata.

As sculptures, too, the works have the character of models. In their proportions, and in the relative sizes and hierarchical arrangements of their superimposed components, they often suggest large monuments from which they nevertheless distinguish themselves through their lightweight materials and casual fabrication. This structural analogy was already evident in Twombly's early work; however, not until the 1980s do we find sculptures in which a dominant feature or a title makes the reference to a monument explicit. Twombly named one sculpture after the place where the tomb of King Cyrus (fig. 19) is still to be seen, *Pasargade*.[20] Other analogous works, though significantly different in appearance, are *Thermopylae*, 1991, a grave mound from which tulips grow (cat. no. 53, p. 118), and *Epitaph*, 1992, with an inscription taken from the poet Archilochus (cat. no. 61, p. 120). The greatest degree of formal concentration is found in a relatively large, hieratically frontal sculpture of 1981 that consists of a tall base bearing a truncated pyramid crowned with a rectangular block (cat. no. 47, p. 94). With its lack of depth and its rich paint finish, this resembles the sculptures of the mid fifties, except that here the back of the work is elaborated, with a small prop in the center to show that this trapezium is intended as a free-standing inscription plaque—a motif that has often attracted Twombly because it holds an intermediate position between sculpture and painting.

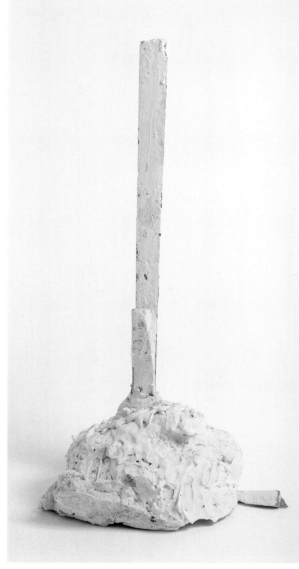

49 *Untitled*, Bassano in Teverina 1989

171

Kollegen Robert Rauschenberg und Jasper Johns, die Konsumgüter ihren Werken einverleibten, wären zu untersuchen.[21] Zwar greift auch Twombly Strandgut auf. Es ist aber von so primärer Art, dass er schon deshalb der Ironisierung oder Idealisierung von Zivilisationsmüll und Marketing durch diese der Pop Art näher stehenden Künstler entgeht. Andererseits unterscheiden sich seine schlichten Fundstücke durch ihre organische Substanz, ihre Lebenshaltigkeit von den aseptischen Objekten der Minimal Art, auch wenn sie sich wie diese oft geometrisch reinen Formen nähern. Eher wäre an eine Verwandtschaft mit Barnett Newman zu denken, an dessen drei Stelen *Here I, II, III* (Abb. 20),[22] diesen emphatisch modernen und amerikanischen Antworten auf Giacomettis *Große Figur* (Abb. 21).[23] Gerade in der Bindung ans Existenzielle und an eine ins Abstrakte gewendete anthropomorphe Anmutung stehen Newmans schwere Stahlobjekte Twombly näher, auch wenn er deren geschichtslos entrückten Heroismus nicht teilt. 1989 ließ er eine senkrechte Latte aus einem amorphen Sockelgebilde aufragen: Hier scheint er mit einem Augenzwinkern die beiden Haltungen versöhnt zu haben. (Kat. 49, S. 171)

Eine andere Entwicklungslinie der modernen Skulptur sollte noch stärker bedacht werden; sie führt von Paul Gauguin zu Giacometti und sucht wieder an das Kultbildhafte und Magische archaischer Figuren und Idole anzuknüpfen. Bei den zahlreichen mythologischen Bezügen, die in Twomblys Bildwelt wirksam sind, liegt diese Tradition nahe. Hier zeigen sich formale Verwandtschaften, die über Äußerlichkeiten hinausgehen: das Festhalten an Einheit und Präsenz des Werkes, eine hierarchische Stufung der Teile, Frontalität, Verwesentlichung der Elemente, auratische Ausstrahlung. So erweist sich der angeführte Vergleich mit dem »Feldaltar« als besonders fruchtbar: Das Kultische und Numinose wird ins anonym Niederschichtige und naturwüchsig Alltägliche gerückt, die erhabene Form ins Spontane und unemphatisch Selbstverständliche, in dem die individuelle Regung nicht in der Prätention der subjektiven Geste verharrt. Hier findet auch das Nicht-Anthropomorphe der von der menschlichen Figur dominierten Gattung Skulptur seine alten Wurzeln: in Kultsteinen und Altären, in Menhiren, Obelisken und Omphaloi, in Grabmälern und klassizistischen Gartenmonumenten – Konkretisationen kultischer Handlungen oder zwischen Mikro- und Makrokosmos vermittelnder religiöser Vorstellungen. *Rotalla* (Kat. 41–42, S. 112 und 113) steht diesen am nächsten: Zwei Scheiben steigen übereinander auf, die vordere halb in die Ebene gebrochen wie der Reflex des aus dem Meer aufsteigenden Gestirns, das sich so in seinem Erscheinen dem Betrachter öffnet. Körperlos und streng frontal auf die eine axiale Ansicht beschränkt, bleibt die Skulptur dem Betrachter ähnlich unfassbar und entrückt wie eine romanische Madonna mit thronendem Christuskind.

Eine solche Beschreibung führt vom Aufzeigen kunsthistorischer Zusammenhänge zu formalen oder phänomenologischen Bestimmungen dieser Dinge als Skulpturen – ihren spezifischen syntaktischen, plastischen, räumlichen Qualitäten. Der Modellcharakter der vorherrschend weißen Gebilde erweist sich auch darin, dass Twombly mit fast spielerischer Leichtigkeit die verschiedenen

III

The third aspect of the objecthood of these pieces, after their material and their "character as models," is their identity as sculpture. Here, again, Twombly operates within an extensive network of tradition, reference, and allusion. Some art-historical connections—the concept of the model in modernism, and Picasso and Schwitters as precursors for the *bricolage* element—have already been touched on. The links with Twombly's colleagues Rauschenberg and Johns, both of whom incorporate consumer goods within their works, would make an interesting study.[21] Like them, Twombly is a collector of flotsam and jetsam. But what he collects is too basic and simple to be used—as artists who stand closer to Pop Art use their material—either to debunk or to idealize the detritus of civilization and the marketing process. At the same time, Twombly's elementary found objects set themselves apart from the aseptic objects of Minimal Art by virtue of their organic substance, their life content, even though they show frequent affinities to Minimalism's pure geometric forms. A more plausible connection here would be with Newman, notably with his three stelae, *Here I, II, III* (fig. 20),[22] which are emphatically modern American ripostes to Giacometti's *Large Figure* (fig. 21).[23] In their existential implications, and in the anthropomorphic allusions that lurk within their abstraction, these heavy steel objects come close to those of Twombly, though his do not share Newman's rarefied, ahistorical cult of heroism. In 1989, Twombly planted a vertical lath in an amorphous base object, seeming to hint at a reconciliation of the two approaches (cat. no. 49, p. 171).

Even more germane to Twombly's work is another strain within the evolution of modern sculpture, one that leads from Paul Gauguin to Giacometti. This is the attempt to recapture the numinous and magical quality of archaic figures and idols. It is implicit in the many mythological allusions that are operative in Twombly's imagery. There are formal kinships here that go beyond the merely superficial: an insistence on unity and presence, the hierarchical arrangement of parts, frontality, an essentialization of elements, and the presence of an aura. The "field altar" analogy is an especially fruitful one: numinosity and worship are shifted into an anonymous, low-status, primitive, everyday context; the sublime form becomes spontaneous, understated, taken for granted. The individual impulse is not caught up in the pretensions of the subjective gesture. Here, again, sculpture—an art form dominated by the human figure—finds its way back to its archaic, non-anthropomorphic roots. Ritual stones and altars; menhirs, obelisks, and omphaloi; tombs and Neoclassical garden monuments; all are concrete expressions of cult actions or religious ideas that connect the microcosm and the macrocosm. *Rotalla,* 1986 and 1990 (cat. nos. 41–42, pp. 112 and 113) is the work that comes closest to these archaic roots. It consists of two discs, one positioned behind the other; the one in front is bent in half with the lower half lying flat, like the reflection of a half-risen sun or moon on the surface of the sea. Disembodied and strictly frontal, confined to a single axial viewpoint, the sculpture is as elusive and remote as a Romanesque Madonna with the Christ Child enthroned in her arms.

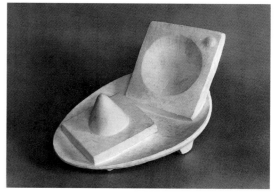

22 Alberto Giacometti, *Vide-poche*, 1932
Geschenk von Bruno und Odette Giacometti
an die Alberto Giacometti-Stiftung,
Kunsthaus Zürich

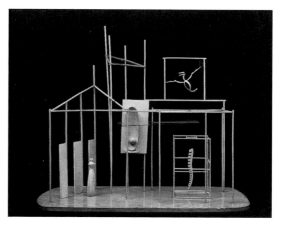

23 Alberto Giacometti,
Le Palais à quatre heures du matin, 1932/33
The Museum of Modern Art, New York

173

Probleme berührt und vielfältige Möglichkeiten erprobt, ohne sich festzulegen oder bestimmte Lösungen zu einem »Stil« zu vertiefen. Was über die Einansichtigkeit von *Rotalla* bemerkt wurde, gilt durchaus nicht immer; ebenso wenig lässt sich der Bezug zum Raum verallgemeinern. Freilich verfolgt der Künstler öfters die gleiche Idee in verschiedenen Ausformungen, wobei er vom Prüfen der Proportionen und ihres präzisen Ausdruckgehalts zum andersartigen Konstruieren der Form weiterschreitet. Auch die Plastizität prägt sich unterschiedlich aus, doch ergeben sich Gemeinsamkeiten aus den brüchigen Materialien und der Art, wie sie durch die weiße Tünche neutralisiert und zugleich fühlbar gemacht werden: Weder das muskulös Gespannte oder organisch Schwellende noch das lastend Massige oder ein formdefinierendes Leeres charakterisieren diese Skulpturen; vielmehr haben sie etwas Fragiles, Zeichenhaftes, dumpfer Stofflichkeit Enthobenes. Im Grenzfall nähern sie sich Spuren geistiger Energie, wie mit Rainer Maria Rilkes *Sonetten an Orpheus* explizit ausgesprochen wird: »Du unendliche Spur«. (Kat. 15, S. 48)

Als weitere allgemeine Bestimmung gilt es, die prinzipielle Einheit und Geschlossenheit dieser Werke gerade wegen des stets fühlbaren Gewordenseins und ihrer von Vergänglichkeit bedrohten Brüchigkeit zu betonen. Jedes einzelne ist ein Monument, nicht nach seiner Größe oder unverrückbaren Schwere, aber nach seiner Zeichenhaftigkeit und geistigen Energie. Viele dieser Gebilde gestalten primäre Vorstellungen: die als halber Kreis aus einem Quader aufsteigende Scheibe (Kat. 39, S. 108 und 110) erscheint als eine so elementare Fügung, dass man ihren Ursprung in unvordenklicher Zeit sucht und nicht als etwas Neues denken mag. Aus dieser Ganzheitlichkeit folgt das durchgehende Definiertsein der einzelnen Teile im Hinblick auf das Ganze: Nur auf ihren Verhältnissen untereinander und ins Gesamt beruhen ihre Bedeutsamkeiten. Dass alle Elemente notwendig dazu gehörig sind und mitbedacht werden müssen, zeigt sich besonders deutlich an den untersten, als Sockel wirkenden Partien.

Die Problematisierung des Sockels gehört zu den wichtigen Fragen der modernen Skulptur; wiederum Giacometti hat hier folgenreiche Lösungen entwickelt. Der Vergleich von *Vide-Poche* (Abb. 22)[24] – einem so genannten »objet sans base« – mit *Rotalla* zeigt die Integration des Sockels in die Skulptur und zugleich, dass Twombly an der fiktiven Objekthaftigkeit des Surrealismus nicht mehr interessiert ist. Wichtiger scheinen für ihn die zwar kleinen, aber im Verhältnis zu den winzigen Figürchen übermächtigen, häufig abgetreppten Quader, durch die Giacometti in den Skulpturen der Zeit um 1940 bis 1945 den Eindruck einer großen Ferne der erscheinenden Person vermitteln wollte. Eine ähnliche Umkehr in der Gewichtung von Sockel und Gesockeltem zeigt unter anderem Twomblys Skulptur *Ohne Titel* von 1978. (Kat. 12, S. 47) Sie demonstriert die völlige Integration des Sockels als gleichwertigen Teil ins Werkganze. Spätere Arbeiten Giacomettis entfalten die räumliche Funktion der Standplatte als Ort der aufragenden oder schreitenden Figuren; Twombly verfährt bei seinen »Schiff«-Plastiken (Kat. 37 und 46, S. 75 und 94) ähnlich. Wie schon bei Giacomettis *Palast um vier Uhr früh* von 1932/33 (Abb. 23) wird die tragende Ebene durch

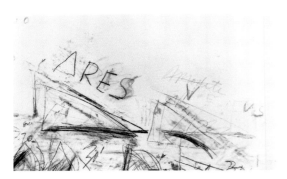

24 Cy Twombly, *Fifty Days at Iliam (A Painting in Ten Parts). Ilians in Battle*, 1978. Detail Philadelphia Museum of Art

Description of this kind leads on from art-historical cross-references to formal or phenomenological definitions of the objects as sculpture—their specific syntactical, plastic, and spatial qualities. The "character as models" of these mainly white forms appears in the almost playful lightness with which Twombly touched on all these different issues and explored their many possibilities without ever committing himself or deepening any particular solution into a "style." Not all are reduced to a single, built-in viewpoint, as *Rotalla* is, nor is it possible to generalize about their relationship to ambient space. The artist often pursued a single idea through a variety of forms, progressing from experiments with proportions and their precise expressive content to completely different ways of constructing the work. The objects also differ in plastic terms, though shared features include the fragile, friable nature of the materials, and the way in which white paint neutralizes them and at the same time makes them palpable. In these sculptures, there is no muscular tension, organic growth, massive weight, or a form-defining void; instead, they are frail and signlike, sublimated beyond the dullness of mere matter. In some borderline cases, they are like traces, tracks of spiritual energy, as evoked in one title that is a direct quotation from the *Sonette an Orpheus* of Rainer Maria Rilke: *Du unendliche Spur* [Thou unending trace] (cat. no. 15, p. 48).

Another defining quality shared by these works is the fact that, because they display palpable signs of their making and of the imminent threat of dissolution, it becomes all the more necessary to emphasize their unity and self-containment. Each individual work is a monument by virtue not of its size or its immovable bulk, but of its force as a sign and its mental energy. Many of these sculptural forms express archetypal notions: the disc emerging as a semicircle from a rectilinear block (cat. no. 39, pp. 108 and 110) is so elemental that one tends to see it as immemorially ancient rather than as new. Throughout, in keeping with this holistic quality, the individual parts define themselves in relation to the whole. Their meanings rest solely on their relationships with each other and with this totality. All parts are necessary, and all must be thought of together—as is particularly evident in the lowest, plinthlike portions of the works.

The role of the base is a central issue in modernist sculpture. Here, again, Giacometti made some important advances. A comparison between his *Vide-poche* (fig. 22), a so-called *objet sans base*, and Twombly's *Rotalla* shows, first, that Twombly integrated the base into the sculpture and, second, that he no longer cared about the fictive objecthood of Surrealist sculpture. What interested him more was the array of small (though, in relation to their figures, huge) blocks, many of them stepped, that Giacometti used in many of his sculptures of 1940–45 to convey the impression that the person in the work is seen from a great distance. A similar reversal in the relative weighting of the base and the object on the base is seen in Twombly's sculpture Untitled, of 1978 (cat. no. 12, p. 47). This demonstrates the integration of the base as an equal part of the work as a whole. Later works by Giacometti develop the spatial function of a flat base as the location of his erect or striding figures; Twombly does something similar

eine Schattenzone vom Museumssockel abgehoben; in sie taucht das Ruder von *Am Ionischen Meer.* (Kat. 46, S. 78) Die Aufwertung der sockelartigen Elemente und ihre völlige Integration wirken in ihrer Gegenläufigkeit zur Moderne fast wie ein ironischer Kommentar zu der oft angestrengt »demokratisch« beflissenen Abschaffung des Sockels.

IV

Betrachten wir abschließend kurz die Skulpturen Twomblys im Werkganzen. Denn sie bleiben die Arbeiten eines Maler-Plastikers, wie sie in der Kunst des 20. Jahrhunderts so wichtig wurden. Typisch für sie ist, dass Aussagen über die primären skulpturalen Eigenschaften wie Raumbezug, Plastizität, Ansichtigkeit kaum generalisierbar sind. Nicht Spezialisten dieser Gattung im traditionellen Sinn, legen sie geringeren Wert auf die vollständige Durchdringung ihrer spezifischen Probleme oder auf ihre implizierten handwerklichen Fähigkeiten; vielmehr experimentieren sie in einem verwandten Feld mit Fragestellungen, die aus ihrem eigentlichen, der Malerei, kommen, um dieses besser zu verstehen. Die unterschiedlichen Bedingungen führen zu interessanten Verschiebungen im Verhältnis der gleichen Kunstmittel; so konnten wir die Inversion in den Funktionen der Zeichen und Farben bei den beiden Gattungen bemerken. Ähnliches gilt für die Zeitstruktur: Während die Gemälde in ihrer weiten, flächigen Ausdehnung ganz von Abläufen bestimmt sind – sich selbst erzählende Linien, Spuren von sich entwickelnden Emotionen, sich rituell wiederholende skripturale Gesten – und folgerichtig in zeitlich zu lesende Serien auseinander treten, bleibt die Skulptur in den »ewigen Augenblick« gebannt, die Metamorphose vollzogen, die Verfolgungsjagd von Pan und Syrinx in der Flöte vollendet. Das Dingliche der Plastik gestattet kaum eine Wiedergabe des Bewusstseinsstroms, doch kondensiert sich in ihr das Ereignis zu unausweichlicher, zeichenhafter Dichte. Der Bewegungsimpuls, die Spannung der Geste verharren in ihr unaufgelöst. Dass sich so zwischen Malerei und Plastik ein vielfach anregendes Wechselspiel ergibt, erkannte bereits Matisse; der alte Paragone, der vor allem in der Renaissance ausgekostete Wettstreit der beiden Gattungen, mutiert zu einem neuen und fruchtbaren Prinzip. Es ist kein Zufall, dass nach Plastiken wie dem »Panflöten-Monument« (Kat. 9, S. 41) auch die Gemälde um 1960 einen anderen Charakter annehmen; in zentrierten Figurationen gestalten sie mythische Ereignisse – die größte Dichte wird bei einer der Plastik entsprechenden, zeichenhaften Konzentration in *Rache des Achill* erreicht. (Abb. 25)[25] Hier scheint die Malerei zugleich die Wünschbarkeit der skulpturalen Ausdrucksweise absorbiert zu haben; jedenfalls tritt ihre Produktion ganz zurück. Ihr Neueinsatz in den späteren siebziger Jahren kündigt sich nun umgekehrt in den nach 1970 stets wichtiger werdenden Collagen an, die nicht nur an sich plastischen Charakter annehmen, sondern öfter auch Reproduktionen stark plastisch wirkender Objekte ins Bild bringen.[26] (Abb. 26) Die früher gelegentlich von der Unterkante hineinragenden, als Umrisse gezeichneten Rechtecke nähern sich nun als aufgesetzte Papiere auch materiell den Sockelelementen der Skulpturen. Diese Ableitung bestätigt deren bereits

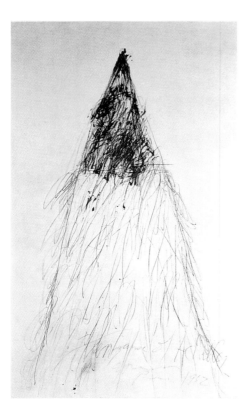

25 Cy Twombly,
Vengeance of Achilles, 1962
Kunsthaus Zürich

in his "ship" sculptures (cat. nos. 36 and 47, pp. 75 and 94). As in Giacometti's *Palace at 4 a.m.* of 1932/33 (fig. 23), the bearing surface in *By the Ionian Sea*, 1987 (cat. no. 46, p. 78) is set off from the museum base by a shadow zone into which the oar dips. The value attached by Twombly to his baselike elements and their complete integration into the sculpture go so much against the modernist grain that they can read almost like a gentle mockery of the painstakingly "democratic" modernist campaign to abolish the base.

IV

In conclusion, Twombly's sculptures are and remain the works of a painter-sculptor, a supremely important category of twentieth-century artists. It is charac-teristic of works by such artists that they offer no scope for generalizations about the primary qualities of sculpture, such as spatial reference, plasticity, and pre-ferred viewpoint. As non-specialists standing outside the tradition of the art form, such artists tend to be comparatively unconcerned with finding a comprehensive solution to sculpture's specific problems or indeed with the nature of the craft skills implicit in it; they are interested in experimenting in a related field on issues that arise from their own art, that of painting, in the hope of understanding it better. These differences mean that, even where the materials and techniques are the same, the relationships between them undergo some striking shifts, as in the reversal, already mentioned, of the functions of signs and colors between the two art forms. The same applies to the structuring of time. Paintings exist in extension and are therefore defined by processes that represent lapses of time: lines that tell their own stories, trails of evolving emotions, ritually repetitive calligraphic gestures. These elements can thus be distinguished from each other as components of a chronological series. Sculpture, on the other hand, resides as if by enchantment in an eternal present: the metamorphosis is done, and Pan's pursuit of Syrinx has attained its final resolution in the form of the panpipes. The objecthood of sculpture makes it virtually impossible for it to reproduce the stream of consciousness. In it, the event coalesces into the ineluctable density of a sign. The motor impulse, the tension of the gesture, remain within it, un-resolved.

As Henri Matisse discovered, this sets up a stimulating interaction between paint-ing and sculpture; the old *paragone*—the rivalry between the two arts that the Renaissance enjoyed so much—has mutated into a new and fruitful principle. It is no coincidence that in the early 1960s, after such sculptures as the "panpipes monument" (cat. no. 9, p. 41), Twombly's paintings took on a different character. They are centered figurations of mythical events; the densest of them, with a con-centration comparable to that of the earlier sculpture, is *Vengeance of Achilles* of 1962 (fig. 25).[25] Here, painting seems to have subsumed within itself the desired sculptural expression, enough so that sculpture disappeared from Twombly's work for a time. It was to return in the late 1970s, its appearance being heralded, from 1970 onwards, by the increasing prominence of collages in Twombly's work, which not only took on an inherently sculptural quality but often included

bemerkte, alle Teile integrierende Einheit und erhellt zugleich einen gemeinsamen Ursprung von Malerei und Plastik im Verfahren der Collage, des Zusammenfügens von Vorgefundenem, Älterem, Anonymem und Ursprünglichem. Das früheste uns von einer Abbildung bekannte Werk Twomblys ist nicht von ungefähr eine Assemblage, mit der sich der junge Mann auf einer Porträtfotografie von 1946 als Künstler ausweist. (Abb. S. 14 und 15)

Dass um 1978 die Produktion von Skulpturen rasch zunimmt und ein ganz neues Gewicht erhält, geht parallel mit der Neuorientierung von Twomblys Malerei seit *Goethe in Italien*.[27] Die einleitend beschriebene Differenzierung von weißer Farbfläche und skripturalen Lineamenten fließt zu einer neuen Einheit zusammen; von Farbe gesättigte Malmaterie überflutet plötzlich die Leinwand und nimmt in ihrer Peinture die Energien der impulsiven Graffiti auf. Damit verschwinden aus den Bildern, die sich ozeanischen Landschaften in der Art von Monets *Seerosen* nähern, die Zeichen: Diese finden nun in den Skulpturen ihre Gestaltung. Im Folgenden entwickelt sich ein steter Dialog zwischen den beiden Medien. Zunächst verfolgen beide die Ausformung dynamischer Verläufe, später treten mit den Blüten und Schiffen mehr motivische Gemeinsamkeiten in den Vordergrund.

Seit dieser Zeit schuf Cy Twombly Jahr für Jahr einige wenige Skulpturen. Dies falle ihm leichter, bemerkt er, als das Malen von Bildern. Muss er deren Körper immer von Grund auf neu auf der Leinwand erzeugen, fällt ihm bei den Plastiken das dingliche Dasein schon mit den Fundstücken zu. Teils begegnen sie ihm selbst, teils werden sie ihm zugetragen. Eine letzte Möglichkeit, scheint es, in der profanen Zeit von Marketing und Cyberspace die alten Mythen, die alten Würdeformen nochmals zu evozieren, gegenständlich gewordene Erinnerungen. Das direkt, in naivem Ernst und ungebrochener Selbstverständlichkeit, nicht mehr Mögliche, aber immer noch Bedeutungsvolle, Gewünschte, nostalgisch Erhoffte, fügt Twombly – nicht mehr aus Erz gegossen oder Marmor geschlagen – mit der durchsichtig leisen Ironie dessen, der das Erhabene aus dem Schlichtesten schöpft. So vergewissert er sich des Wesentlichen im menschlichen Leben und entrückt durch das weiße Schlemmen die Dinge aus ihrer Schwere in den lichten Raum der Vorstellungen.

reproductions of markedly three-dimensional objects (fig. 26).[26] The rectangles that had sometimes appeared, drawn as outlines and jutting into the picture from the lower edge, now appeared as added pieces of paper, thus with an inbuilt affinity to the material used in the base elements of Twombly's sculptures. This derivation confirms the previously discussed integrating effect of the bases, and also the shared origins of Twombly's painting and sculpture in the collage process: the act of assembling preexistent, old, anonymous, archetypal contents. It is no coincidence that the earliest work by Twombly that is known to us in reproduction, and also the work in which the youthful artist established his artistic credentials, is an assemblage shown in a portrait photograph of 1946 (illustrated on pp. 14 and 15).

In about 1978, Twombly's output of sculpture increased sharply and took on an entirely new emphasis, which went hand in hand with the reorientation of his painting after *Goethe in Italy*.[27] The distinction, described earlier, between white paint surface and calligraphic line was replaced by a new unity in the paintings of this time. Suddenly, the canvas was deluged with paint saturated with pigment and handled with all the impulsive energy of Twombly's earlier graffiti. At the same time, signs that were disappearing from the paintings—which began to turn into oceanic landscapes, like Claude Monet's *Waterlilies*—began to appear in the sculptures. There evolved a constant dialogue between the two media. Initially, both pursued the formulation of dynamic sequences; later, the shared elements were more on the level of motifs, such as flowers and ships.

Since then, Twombly has made a few sculptures every year. He remarks that it comes more easily to him than painting pictures. With a painting, he has to create the body of the work from scratch, every time, on the canvas; in sculpture, the inclusion of found objects means that the thing starts off with an existence, an objecthood, of its own. Sometimes such objects offer themselves to him; sometimes they are brought to him by others. In a secular age of marketing and cyberspace, these objects represent one last, surviving opportunity to evoke the old myths and the old dignities—memories transformed into objects. What he does cannot now be done straightforwardly and naively, with all its old serious-ness intact, and yet it is still significant; it is still wanted and nostalgically hoped for. Twombly does it not by casting in bronze or carving in marble, but with the transparent, understated irony of one who garners sublimity from the simplest things. And so he secures the essential in human life and, with a veil of white-wash, exempts things from gravity and transports them into the light-filled space of imagination.

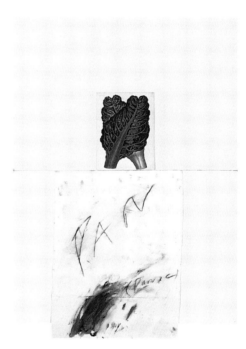

26 Cy Twombly, *Pan,* 1975
Private collection, Rome

Harald Szeemann zeigte 1986 in der Ausstellung *Spuren, Skulpturen und Monumente ihrer präzisen Reise* fünf Skulpturen von Cy Twombly. 1987 nahm er in seine Retrospektive des Künstlers 20 Skulpturen auf, nach der Ausstellung 1981 in Krefeld die bis dahin umfangreichste und vielbeachtete Darstellung dieses Werkkomplexes. Cy Twombly entschloss sich im Anschluss daran neun Originalskulpturen als Dauerleihgabe im Kunsthaus Zürich zu belassen. 1994 wandelte er dieses Depositum in eine Schenkung um. Christian Klemm, als Konservator immer wieder in persönlichem Kontakt mit dem Künstler, veröffentlichte aus diesem Anlass im Jahresbericht des Kunsthauses Zürich ein Essay zu Cy Twomblys Skulpturen. Er folgte dem Wunsch des Künstlers, seinen Text in überarbeiteter Form für diese Publikation zur Verfügung zu stellen.

1 Roland Barthes, »Non multa sed multum«, in: Yvon Lambert, *Catalogue raisonné des œuvres sur papier de Cy Twombly*, Bd. 6, Mailand (Multhipla Edizioni) 1979, S. 7–13; ders., »Sagesse de l'art«, in: *Cy Twombly. Paintings and Drawings 1954–1977*, Ausst.-Kat. New York, Whitney Museum of American Art 1979, S. 9–22. Beide Texte Deutsch in: Roland Barthes, *Cy Twombly*, Berlin (Merve Verlag) 1983.

2 Cy Twombly, »Malerei bestimmt das Gebilde«, in: *blätter und bilder. Eine Zeitschrift für Dichtung, Musik und Malerei*, (1961) 12 (Januar/Februar), S. 62 f. Zuerst Englisch unter dem Titel »Signs«, in: *L'Esperienza Moderna*, (1957) 2 (August/September), S. 62. Deutsch neu übersetzt in: Kirk Varnedoe, *Cy Twombly. Eine Retrospektive*, Ausst.-Kat. Berlin, Neue Nationalgalerie, München etc. (Schirmer/Mosel) 1994 (im Folgenden Varnedoe), S. 28 f.

3 Harald Szeemann in: *Cy Twombly. Bilder, Arbeiten auf Papier, Skulpturen*, Ausst.-Kat. Zürich, Kunsthaus Zürich 1987, S. 8 f.

4 Wie Anm. 2.

5 Alberto Giacometti, *Le Chariot*, 1950, Bronze, 167 x 69 x 69 cm, Alberto Giacometti-Stiftung, Kunsthaus Zürich.

6 Alberto Giacometti, *Femme au chariot*, 1943, Gips, Bleistift und Holzwagen, Höhe 164 cm, aus Mitteln der Peter Klöckner-Stiftung erworben 1986, Wilhelm Lehmbruck Museum Duisburg.

7 Twombly zitiert die englische Übersetzung der letzten Verse aus der zehnten *Duineser Elegie* (1922) von Rainer Maria Rilke: »Und wir, die an *steigendes* Glück / denken, empfänden die Rührung, / die uns beinah bestürzt, / wenn ein Glückliches *fällt*.«

8 In der Ausstellung als Bronze. Die Version in Karton, Gips und Ton im Kunsthaus Zürich kann wegen ihrer Zerbrechlichkeit nicht bewegt werden.

9 Cy Twombly, *Fifty Days at Iliam (A Painting in Ten Parts)*, 1978, 10 Teile, verschiedene Techniken auf Leinwand, unterschiedliche Maße, Philadelphia Museum of Art (Bastian IV 13); ähnlich auch in Zeichnungen, zum Beispiel dem Blatt der Graphischen Sammlung des Kunsthauses Zürich, *Twombly* (Kat. Zürich 1987), wie Anm. 3, Nr. 106.

10 Cy Twombly, *Goethe in Italy (Scene I* und *Scene II)*, 1978, je 2 Teile, verschiedene Techniken auf Leinwand oder Papier, unterschiedliche Maße, Kunsthaus Zürich (Bastian IV 14/15).

11 Del Roscio 116.

12 Reinhold Hohl, *Alberto Giacometti*, Stuttgart (Verlag Gerd Hatje) 1971, S. 78.

13 Alberto Giacometti, *Le Palais à quatre heures du matin*, 1932/33, Holz, Glas, Draht, Schnur, 63,5 x 71,8 x 40 cm, The Museum of Modern Art, New York.

14 Alberto Giacometti, *Projet pour une place*, 1931–1932, Holz, 31,4 x 22,5 x 19,4 cm, Peggy Guggenheim Collection, Venedig, The Solomon R. Guggenheim Foundation.

15 Jasper Johns, *Construction with Toy Piano*, 1954, Graphit und Collage auf Leinwand, auf hölzernem Spielzeugklavier, 29,3 x 23,2 x 5,6 cm, Öffentliche Kunstsammlung Basel, Kunstmuseum.

16 Cy Twombly, *Untitled*, Lexington 1948, Eisen, Draht, Holz, 57 x 9,5 x 9,5 cm, Privatsammlung (Del Roscio 7).

17 Wie Anm. 12, S. 295, Abb. 60; ebenda Abb. 56 der ägyptische Streitwagen, der als Vorbild diente.

18 Zu Twomblys ägyptischen Eindrücken siehe Varnedoe, S. 48 f.

19 Franz Meyer, »Die Spuren subjektiver Existenz. Ausstellung Cy Twombly im Kunsthaus Zürich«, in: *Neue Zürcher Zeitung*, 7. März 1987, S. 65.

20 Cy Twombly, *Pasargade*, 1994, Holz, Stein, weiße Farbe, 32 x 80 x 31,5 cm, Privatsammlung Rom (Del Roscio 134). Auf der Rückseite Zeilen aus der englischen Übersetzung eines Gedichtes von Giorgos Seferis: »Memory of Pasargade / to separate the light from the silence / and light from the calm«.

21 Sie waren dazu von Robert Motherwell angeregt, der 1951 eine Dada-Anthologie publizierte (*The Dada Painters and Poets. An Anthology*, New York 1951).

22 Barnett Newman, *Here I (to Marcia)*, 1950, Gips, 244 x 68 x 69 cm, The Menil Collection, Houston, Geschenk von Annalee Newman (Bronzeguss, 2 Exemplare, 1962); *Here II*, 1965/66 (2 nicht identische Exemplare), Cortenstahl, 284,5 x 200,7 x 129,5 cm, Privatsammlung Schweiz; *Here III*, 1965/66 (3 Exemplare), Stele: rostfreier Stahl, 302 x 20,5 x 7,5 cm, Sockel: Cortenstahl, 33 x 60 x 47 cm, Öffentliche Kunstsammlung Basel, Kunstmuseum.

23 Alberto Giacometti, *Grande figure*, 1947, Bronze, 198,5 x 23 x 41,5 cm, Öffentliche Kunstsammlung Basel, Kunstmuseum, Depositum der Alberto Giacometti-Stiftung.

24 Alberto Giacometti, *Vide-poche*, 1932, Gips, 17,5 x 21 x 30 cm, Geschenk von Bruno und Odette Giacometti an die Alberto Giacometti-Stiftung, Kunsthaus Zürich.

25 Cy Twombly, *Vengeance of Achilles*, 1962, Öl, farbige Kreide, Bleistift auf Leinwand, 300 x 175 cm, Kunsthaus Zürich (Bastian II 134).

26 Siehe Lambert VI, 68–90, und die beiden Collagen *Pan* von 1975 (VI, 166–167).

27 In den Panneaux mit den großen, blumenartigen »Schatten« der Gemäldefolge *Fifty Days at Iliam* (wie Anm. 9) nähert sich Twombly schon stark der neuen, in *Goethe in Italy* zum Durchbruch kommenden Auffassung. Auf der zweiten und dritten Umschlagseite von *Cy Twombly, Fifty Days at Iliam. A Painting in Ten Parts*, hrsg. von Heiner Bastian, Berlin (Propyläen Verlag) 1979, sind übrigens die üppig tief grün bewachsenen Abhänge um Twomblys Atelier in Bassano in Teverina zu sehen, die wohl zu den Inspirationsquellen von *Goethe in Italy* zählen.

In 1986, Harald Szeemann featured five sculptures by Cy Twombly in the exhibition *Spuren, Skulpturen und Monumente ihrer präzisen Reise*. A year later, he included 20 sculptures in his retrospective of Cy Twombly—after the 1981 exhibition in Krefeld the largest presentation to date of Twombly's sculptures and the object of a great deal of attention. Immediately afterwards, Cy Twombly decided to give the Kunsthaus Zürich nine original sculptures on permanent loan. In 1994, he converted this loan into a gift. On this occasion, Christian Klemm, who as curator had been in regular contact with the artist, published an essay on Cy Twombly's sculptures in the annual report of the Kunsthaus Zürich. Complying with the artist's wish, he has revised his text for inclusion in the present publication.

1 Roland Barthes, "Non multa sed multum," (with translation into English and Italian), in: *Catalogue raisonné des œuvres sur papier de Cy Twombly*, vol 6: 1973–1976, ed. Yvon Lambert (Milan: Multhipla Edizioni, 1979), pp. 7–13; Roland Barthes, "The Wisdom of Art", in *Cy Twombly: Paintings and Drawings 1954–1977*, exh. cat. (New York: Whitney Museum of American Art, 1979), pp. 9–22; both essays in: Roland Barthes, *The Responsibility of Forms* (New York: Hill and Wang, 1985), pp. 157–76 and 177–94.

2 *Cy Twombly: A Retrospective*, ed. Kirk Varnedoe, exh. cat. (New York: The Museum of Modern Art and Harry N. Abrams, 1994), p. 27.

3 On this, see Harald Szeemann in *Cy Twombly: Painting, Works on Paper, Sculpture,* exh. cat. (London: Whitechapel Art Gallery, 1987), p. 9f.

4 See note 2.

5 Alberto Giacometti, *Le Chariot*, 1950, bronze, patinated in a gold tone, on black-painted wooden base, 167 x 69 x 69 cm, Alberto Giacometti-Stiftung, Kunsthaus Zürich.

6 Alberto Giacometti, *Femme au chariot,* 1943, plaster, pencil, and wooden truck, height 164 cm, acquired with funds from Peter Klöckner-Stiftung 1986, Wilhelm Lehmbruck Museum Duisburg.

7 Twombly quotes the English translation of the last lines of the tenth *Duino Elegy* (1922) by Rainer Maria Rilke. The original German reads: "Und wir, die an *steigendes* Glück / denken, empfänden die Rührung, / die uns beinah bestürzt, / wenn ein Glückliches *fällt*."

8 This appears in the exhibition in a bronze version. The version in cardboard, plaster, and clay in the Kunsthaus Zürich is too fragile to travel.

9 Cy Twombly, *Fifty Days at Iliam (A Painting in Ten Parts)*, 1978, 10 parts, various media on canvas, various dimensions, Philadelphia Museum of Art (Bastian IV 13). Similar signs appear in drawings, such as the one in the Graphische Sammlung Kunsthaus Zürich; see *Cy Twombly: Bilder, Arbeiten auf Papier, Skulpturen*, exh. cat. (Zurich: Kunsthaus Zürich 1987), no. 106.

10 Cy Twombly, *Goethe in Italy (Scene I, Scene II)*, 1978, each 2 parts, various media on canvas or paper, various dimensions, Kunsthaus Zürich (Bastian IV 14/15).

11 Del Roscio 116.

12 Reinhold Hohl, *Alberto Giacometti: Sculpture, Painting, Drawing* (London: Thames and Hudson, 1972), p. 78.

13 Alberto Giacometti, *Le Palais à quatre heures du matin*, 1932/33, wood, glass, wire, and twine, 63.5 x 71.8 x 40 cm, The Museum of Modern Art, New York.

14 Alberto Giacometti, *Projet pour une place*, 1931/32, wood, 31.4 x 22.5 x 19.4 cm, Peggy Guggenheim Collection, Venice, The Solomon R. Guggenheim Foundation.

15 Jasper Johns, *Construction with Toy Piano*, 1954, graphite and collage on canvas, on wooden toy piano, 29.3 x 23.2 x 5.6 cm, Öffentliche Kunstsammlung Basel.

16 Cy Twombly, Untitled, Lexington 1948, iron, wire, and wood, 57 x 9.5 x 9.5 cm, private collection (Del Roscio 7).

17 See note 12, p. 295, fig. 60; ibid., fig. 56 in the same publication shows the Egyptian war chariot that was the source.

18 On the artist's impressions of Egypt, see *Cy Twombly: A Retrospective* (note 2), p. 48f.

19 Franz Meyer, "Die Spuren subjektiver Existenz. Ausstellung Cy Twombly im Kunsthaus Zürich," *Neue Zürcher Zeitung* (March 7, 1987), p. 65.

20 Cy Twombly, *Pasargade*, 1994, wood, stone, and white paint, 32 x 80 x 31.5 cm, private collection, Rome (Del Roscio 134). On the reverse, appear lines from the English translation of a poem by George Seferis: "Memory of Pasargade / to separate the light from the silence / and light from the calm."

21 The stimulus for this came from Robert Motherwell, who published a Dada anthology, *The Dada Painters and Poets: An Anthology* (New York: George Wittenborn, 1951).

22 Barnett Newman, *Here I* (to Marcia), 1950 (bronze casting, edition of 2, 1962), plaster, 244 x 68 x 69 cm, The Menil Collection, Houston, Gift of Annalee Newman; *Here II*, 1965/66 (edition of 2 non-identical examples), corten steel, 284.5 x 200.7 x 129.5 cm, private collection, Switzerland; *Here III*, 1965/66 (3 examples), stela, stainless steel, 302 x 20.5 x 7.5 cm, base, corten steel, 33 x 60 x 47 cm, Öffentliche Kunstsammlung Basel.

23 Alberto Giacometti, *Grande figure*, 1947, bronze, 198.5 x 23 x 41.5 cm, Öffentliche Kunstsammlung Basel, Kunstmuseum, Depositum der Alberto Giacometti-Stiftung.

24 Alberto Giacometti, *Vide-poche*, 1932, plaster, 17.5 x 21 x 30 cm, Gift of Bruno and Odette Giacometti to Alberto Giacometti-Stiftung, Kunsthaus Zürich.

25 Cy Twombly, *Vengeance of Achilles*, 1962, oil, colored chalk, and pencil on canvas, 300 x 175 cm, Kunsthaus Zürich (Bastian II 134).

26 Cf. Lambert VI, 68–90 and 166–67 (*Pan*, 1975).

27 The large, flower-like "shadows" on the panels of the series *Fifty Days at Iliam* (see note 9) show Twombly already inclining toward the new approach that officially dates from *Goethe in Italy*. The inside front and back covers of *Cy Twombly: Paintings and Drawings 1954–1977* (see note 1) show the dense greenery of the slopes around Twombly's studio at Bassano in Teverina, which were probably contributory sources of inspiration for *Goethe in Italy*.

Biographie

1928
Cy Twombly wird am 25. April in Lexington, Virginia (USA), geboren.

1942–1946
Twombly erhält Kunstunterricht durch den spanischen Maler Pere (Pierre) Daura, der der Pariser Kunstszene angehört hatte, bevor er nach Rockbridge Baths, nahe Lexington, übersiedelte. Seine Vorlesungen konzentrieren sich auf Stilgeschichte und die europäische Malerei im 20. Jahrhundert. Er porträtiert den jungen Cy Twombly, für den er zur prägenden Figur wird. Erste Skulpturen und Assemblagen entstehen.

1947
Verbringt den Sommer in Ogunquit, einer Künstlerkolonie in Maine, und in Groveland, Massachusetts. Im Herbst immatrikuliert er sich an der Boston Museum School, deren Lehrer vom deutschen Expressionismus beeinflusst sind. Twombly interessiert sich vor allem für Dada, Kurt Schwitters, Chaim Soutine; er lernt durch Abbildungen Arbeiten von Alberto Giacometti und Jean Dubuffet kennen, die ihn nachhaltig beeindrucken.

1948
Studiert an der Boston Museum School.

1949
Wechselt an das neu gegründete Department of Art der Washington and Lee University in Lexington.

1950
Studium an der Art Students League in New York bei Will Barnet, Morris Kantor und Vaclav Vytlacil. Freundschaft mit seinem Studienkollegen Robert Rauschenberg; sieht in New York Ausstellungen von Jackson Pollock, Mark Rothko, Barnett Newman, Clyfford Still, Robert Motherwell, Willem de Kooning und Franz Kline in den Galerien von Betty Parsons, Samuel Kootz und Charles Egan.

1951
Verbringt das Sommer- und Wintersemester am Black Mountain College, North Carolina, wo im Sommer Ben Shahn und Robert Motherwell als Artists-in-Residence lehren. Im November erste Einzelausstellung mit Gemälden in der Seven Stairs Gallery in Chicago; im Dezember erste Ausstellung in New York in der Kootz Gallery, zusammen mit Gandy Brodie.

1952
Reisen mit Rauschenberg nach Florida und Kuba. Im Sommer am Black Mountain College, wo Franz Kline, Jack Tworkov und John Cage unterrichten. Reisestipendium des Richmond Museum of Fine Arts, das Twombly und Rauschenberg im Spät-

sommer nach Italien, Nordafrika und Spanien führt; längere Aufenthalte in Rom und Marokko.

1953
Im Februar erste Ausstellung in Italien in der Galleria Via della Croce 71 in Rom. Im März zeigt er in der Galleria d'arte contemporanea in Florenz in einer gemeinsamen Ausstellung mit Robert Rauschenberg in Tétuan hergestellte Wandbehänge (nicht erhalten). Rückkehr nach New York, Arbeit an Gemälden, Skulpturen und Monotypien in Rauschenbergs Atelier in der Fulton Street. Ausstellung parallel zu Rauschenberg in Eleanor Wards Stable Gallery in New York, einem mit Hilfe der beiden Künstler renovierten ehemaligen Pferdestall. Ausstellung in der Little Gallery in Princeton. Militärdienst und Fortsetzung der künstlerischen Arbeit.

1954
Im August Entlassung aus der Armee; noch bis Jahresende Arbeit in Rauschenbergs Atelier in der Fulton Street; dort macht er großformatige Gemälde wie *Panorama* und Skulpturen; hat ab Herbst ein Domizil in der William Street, wo Gemälde wie *The Geeks, Free Wheeler, Academy* sowie Skulpturen entstehen; auf Staten Island Arbeit an Gipsskulpturen im Sand (nicht erhalten).

1955
Im Januar erste Einzelausstellung in der Stable Gallery mit Gemälden, Zeichnungen und Skulpturen. Im Februar erhält Twombly einen einjährigen Lehrauftrag am Art Department des Southern Seminary in Buena Vista, Virginia.

1956
Im Januar zweite Einzelausstellung in der Stable Gallery, wieder mit Skulptur.

1957
Im Januar dritte und letzte Einzelausstellung in der Stable Gallery mit *Panorama* sowie Skulpturen. Übersiedlung nach Italien; im Sommer auf der Insel Procida im Kreis italienischer Künstler und Kunstfreunde. Im Spätherbst entstehen in Rom die Gemälde *Olympia, Arcadia, Blue Room* und *Sunset*; Serie der Grottaferrata-Zeichnungen.

1958
Twombly arbeitet in Rom; Einzelausstellung in Plinio De Martiis' Galerie La Tartaruga.

1959
Im Frühling Rückkehr in die USA; in New York Heirat mit Luisa Tatiana Franchetti. In Lexington arbeitet er an großformatigen, fast monochrom weißen Gemälden. Zweite Reise nach Kuba, Aufenthalte in Yucatán, Mexiko. Rückkehr nach Italien; Sommeraufenthalt in Sperlonga an der tyrrhenischen Küste, wo bedeutende Zeichnungen entstehen. Im Dezember Geburt des Sohnes Cyrus Alessandro; malt *The Age of Alexander*. Nach Vollendung von zwei weiteren Skulpturen ruht die plastische Arbeit bis 1976.

1960
Twombly zieht in Rom in die Via Monserrato. Im April zweite Einzelausstellung in der Galerie La Tartaruga; zeichnet im Juli auf Ischia; im August Reise nach Griechenland, verbringt den Herbst

auf dem Familiensitz Castel Gardena in den italienischen Dolomiten, wo er sich immer wieder aufhalten wird. Im Oktober erste Ausstellung in der Leo Castelli Gallery, New York.

1961
In Rom Atelier an der Piazza del Biscione, wo Twombly während der kommenden fünf Jahre arbeitet. Hier entstehen u. a. die Gemälde *Triumph of Galatea, Ferragosto I–V, Empire of Flora, Bay of Naples* und *School of Athens*. Juni/Juli auf den Kykladen; im August auf Mykonos: Zeichnungsserie der *Delian Odes* (teilweise zerstört).

1962
Im Januar/Februar Ägyptenreise auf dem Nil bis in den Sudan; Sommer in Griechenland und an der türkischen Mittelmeerküste; in Rom entstehen *Birth of Venus, Hero and Leander, Leda and the Swan*.

1963
Im Januar/Februar Reise nach Menfi und Selinunte auf Sizilien; Sommeraufenthalt in Sperlonga. Ausstellungen in Rom, Köln, Turin und Genf. Im Dezember malt Twombly in Rom das neunteilige Werk *Discourse on Commodus*.

1964
Im März in New York Ausstellung von *Discourse on Commodus* bei Leo Castelli. Frühling in Griechenland; im Juli/August in den Dolomiten; malt im Herbst in München die Bilder, die dort anschließend in der Galerie Friedrich + Dahlem zusammen mit den Zeichnungen *Notes from a Tower* ausgestellt werden.

1965
Im Frühjahr Reise nach Paris, London, Brüssel und Amsterdam; Sommer auf Mykonos, Patmos, Samos und an der türkischen Mittelmeerküste. Im Oktober zeigen die Krefelder Museen im Haus Lange Twomblys erste große Museumsausstellung (anschließend in Brüssel und Amsterdam). Arbeitet im Herbst in New York in der 52. Straße; Ende des Jahres in Lexington.

1966
Im Februar Ausstellung bei Leo Castelli. Im Frühling in Rom erste »Graue Gemälde«, die sich in den folgenden Jahren zu einer bedeutenden Werkgruppe entwickeln. Sommer im Castel Gardena und in Sant' Angelo auf Ischia; Herbst in New York.

1967
Im Januar entsteht in der Canal Street eine zweite Serie von »Grauen Gemälden«; im Februar zeigt die Galleria Notizia in Turin die »Grauen Gemälde« aus dem Vorjahr. Rückkehr nach Italien; im Oktober Ausstellung der neuen »Grauen Gemälde« bei Leo Castelli; Oktober/November Arbeit in New York und Lexington und in der Werkstatt von Tatyana Grossman in West Islip bei New York. Ende November Rückkehr nach Italien per Schiff.

1968
Im Januar im Milwaukee Art Center erste Retrospektive Cy Twomblys in den USA (Gemälde und Zeichnungen seit 1956). Atelier in New York, Bowery Street 356, das er für längere Zeit behält.

Biography

1928
Cy Twombly born on April 25 in Lexington, Virginia.

1942–1946
Studies art with the Spanish painter Pere (Pierre) Daura, who belonged to the Paris art scene prior to settling in Rockbridge Baths (near Lexington). His lectures focus on stylistic history and twentieth-century European art. Daura does a portrait of the young Cy Twombly, on whom he becomes a major influence. Earliest sculptures and assemblages.

1947
Spends the summer in Ogunquit, an artists' colony in Maine, and in Groveland, Massachusetts. In the autumn, enrolls at the Boston Museum School, whose teachers are influenced by German Expressionism. Twombly's main interests are Dada, Kurt Schwitters, and Chaim Soutine. Becomes acquainted with copies of works by Alberto Giacometti and Jean Dubuffet, who make a lasting impression on him.

1948
Studies at the Boston Museum School.

1949
Studies at the newly founded Department of Art at Washington and Lee University (Lexington).

1950
Studies at the Art Students League in New York with Will Barnet, Morris Kantor, and Vaclav Vytlacil. Forms a friendship with fellow student Robert Rauschenberg. Sees exhibitions by Jackson Pollock, Mark Rothko, Barnett Newman, Clyfford Still, Robert Motherwell, Willem de Kooning, and Franz Kline in the galleries of Betty Parsons, Samuel Kootz, and Charles Egan.

1951
Spends the summer and winter semesters at Black Mountain College, North Carolina, where Ben Shahn and Robert Motherwell teach in the summer as artists-in-residence. In November, first solo exhibition of paintings at the Seven Stairs Gallery in Chicago; in December, first New York exhibition at the Kootz Gallery, together with Gandy Brodie.

1952
Journeys with Rauschenberg to Florida and Cuba. Spends the summer at Black Mountain College, where Franz Kline, Jack Tworkov, and John Cage teach. Receives a travel stipend from the Virginia Museum of Fine Arts, Richmond, which takes him and Rauschenberg to Italy, North Africa, and Spain in late summer; sojourns in Rome and Morocco.

1953
In February, first exhibition in Italy at the Galleria Via della Croce 71 in Rome; exhibition of wall hangings made in Tétuan, now lost, at the Galleria d'arte contemporanea in Florence. Returns to New York, and works on paintings, sculptures, and monotypes in Rauschenberg's studio on Fulton Street. Exhibition parallel to Rauschenberg's at Eleanor Ward's Stable Gallery in New York, a former stable renovated with the two artists' help. Exhibition at the Little Gallery in Princeton. Military service and continuation of artistic activities.

1954
In August, discharge from the army. Works in Rauschenberg's studio on Fulton Street until the year's end on large-scale paintings, such as *Panorama*, and sculptures. From autumn, lives on William Street, where he paints *The Geeks*, *Free Wheeler*, and *Academy*; works on sculptures. On Staten Island, works on plaster sculptures in sand (lost).

1955
In January, first solo exhibition at the Stable Gallery (paintings, drawings, and sculptures). In February, takes a one-year contract in the Art Department of the Southern Seminary in Buena Vista, Virginia.

1956
In January, second solo exhibition at the Stable Gallery.

1957
In January, third and last solo exhibition at the Stable Gallery, which includes *Panorama*. Moves definitely to Italy; spends the summer in a circle of Italian artists and art lovers on the island of Procida. In the late autumn, in Rome, completes the paintings *Olympia*, *Arcadia*, *Blue Room*, and *Sunset*, and the series of Grottaferrata drawings.

1958
Works in Rome. Solo exhibition in Plinio De Martiis' Galleria La Tartaruga.

1959
In the spring, returns to the United States; marries Luisa Tatiana Franchetti in New York. In Lexington, works on large-scale, nearly monochromic white paintings. Makes a second journey to Cuba; sojourns in Yucatán, Mexico. Returns to Rome; spends the summer in Sperlonga, where he does an important series of drawings. In December, son Cyrus Alessandro is born; Twombly paints *The Age of Alexander*. After completion of two sculptures, discontinues work in that medium until 1976.

1960
Resides in Rome on the Via Monserrato. In April, second solo exhibition in the Galeria La Tartaruga. In July, on Ischia, works on drawings. In August, journeys to Greece. Spends the autumn in the Castel Gardena in the Italian Dolomites, a family seat to which he will return again and again. In October, first solo exhibition in the Leo Castelli Gallery, New York.

1961
In Rome, moves into an atelier on the Piazza del Biscione, where he will work for the next five years. Paints *Triumph of Galatea*, *Ferragosto I–V*, *Empire of Flora*, *Bay of Naples*, *School of Athens*, and other works. Spends June/July on the Cyclades, and August on Myconos, working on the drawing series *Delian Odes* (partially lost).

1962
In January/February, travels to Egypt, journeying up the Nile into Sudan. Spends the summer in Greece and on the Mediterranean coast of Turkey. In Rome, paints *Birth of Venus*, *Hero and Leander*, and *Leda and the Swan*.

1963
In January/February, makes a journey to Menfi and Selinunte on Sicily. Undertakes a summer sojourn at Sperlonga, where important drawings result. Exhibitions in Rome, Cologne, Turin, and Geneva. In December, completes the nine-part painting *Discourse on Commodus*.

1964
In March, exhibition of *Discourse on Commodus* in Leo Castelli's gallery in New York. Spends the spring in Greece and July/August in the Dolomites. In the autumn, in Munich, paints the pictures subsequently shown in the Galerie Friedrich and Dahlem, along with the drawings *Notes from a Tower*.

1965
In the spring, makes a journey to Paris, London, Brussels, and Amsterdam; spends the summer on Myconos, Patmos, Samos, and on the Mediterranean coast of Turkey. In August, first large-scale museum exhibition at the Krefeld Museum, in the Haus Lange (subsequently in Brussels and Amsterdam). In the autumn, works in New York on 52nd Street; is working at year's end in Lexington.

1966
In February, exhibition at the Leo Castelli Gallery. In the spring, in Rome, works on the "Grey Paintings," which will develop in the following years into an important group of works. Spends the summer in Castel Gardena and in Sant'Angelo on Ischia; in the autumn, returns to New York.

1967
In January, on Canal Street, works on a second series of "Grey Paintings." In February, the Galleria Notizia in Turin shows the "Grey Paintings" of the previous year. Returns to Italy. In October, exhibition of the new "Grey Paintings" at Leo Castelli's Gallery. In October/November, works in New York and Lexington, and in the workshop of Tatyana Grossman in West Islip lithographs (near New York). In late November, returns to Italy.

1968
In January, first retrospective in the United States, at the Milwaukee Art Center (paintings and drawings since 1956). Opens a studio in New York at 356 Bowery Street, which he will keep for a number of years. Paints the three *Orion* paintings, *Synopsis of a Battle*, and *Veil of Orpheus*, as well as the first version of *Treatise on the Veil*. Spends August in Castel Gardena and the autumn in the

Hier entstehen die drei *Orion*-Gemälde, *Synopsis of a Battle, Veil of Orpheus* sowie die erste Fassung von *Treatise on the Veil*. August im Castel Gardena; Herbst im Bowery-Atelier in New York. Im Dezember für einige Zeit Rauschenbergs Gast auf Captiva Island in Florida; durch Leonardo da Vincis Déluge-Zeichnungen, Anatomie-, Wetter- und Draperiestudien Anregung zu einer Serie von Collagen. Im Dezember in der Nicholas Wilder Gallery in Los Angeles Ausstellung der in New York entstandenen »Grauen Gemälde«. Von Los Angeles Reise nach Mexiko, Besuch archäologischer Stätten.

1969
Im Januar Rückreise nach New York über die Karibik-Insel St. Martin. Die hier entstandenen Zeichnungen werden in den 14 großformatigen Gemälden weiterentwickelt, die Twombly von Mai bis Oktober im Palazzo del Drago am Lago di Bolsena malt: Bolsena-Bilder.

1970
Arbeit im Bowery-Atelier in New York, Besuche in Lexington; März auf Captiva Island. Im Sommer Reise nach Irland, Rückkehr nach Rom, wo er die zweite Fassung von *Treatise on the Veil* malt.

1971
Im Februar Ausstellungen bei Gian Enzo Sperone in Turin und Yvon Lambert in Paris. Auf Capri entstehen Zeichnungen und Collagen. Nach dem tragischen Tod von Nini Pirandello, der Frau seines römischen Galeristen Plinio De Martiis, malt er fünf Bilder: *Nini's Paintings.* Im November Rückkehr nach New York und Aufenthalt auf Captiva Island.

1972
Im Januar Ausstellung bei Leo Castelli; im Frühling wieder in Rom. Twombly beginnt die Arbeit an dem monumentalen Gemälde *Anatomy of Melancholy,* in Anlehnung an das gleichnamige Buch von Robert Burton von 1621; als Twombly es 22 Jahre später in Lexington vollendet, ist es grundlegend verändert und trägt den Untertitel *Say Goodbye, Catullus, to the Shores of Asia Minor.* Im Sommer auf Capri, im Winter auf Captiva Island: Zeichnungen.

1973
Im April Retrospektive in der Kunsthalle Bern (Gemälde und Zeichnungen; anschließend in München); Überblicksausstellung der Zeichnungen im Kunstmuseum Basel. Heiner Bastian publiziert eine erste Monografie der Zeichnungen. Im August wieder im Castel Gardena: *24 Short Pieces*; im November mit Freunden Reise nach Indien.

1974
Februar auf Captiva Island; beendet in Rom *Natural History Part I – Mushrooms,* ein Portfolio mit 12 Drucken. Galerieausstellungen in München, Turin, Paris und Neapel.

1975
Winter auf Captiva Island; Erwerb einer Renaissance-Villa in Bassano in Teverina, nördlich von Rom, die er in den nächsten drei Jahren renoviert; Anbau eines Ateliers, wo er in den kommenden Jahren jeweils im Sommer arbeitet.

Im März Ausstellung im Institute of Contemporary Art, Philadelphia (Gemälde, Zeichnungen, einige frühe Skulpturen); anschließend in San Francisco. Im Frühsommer wieder in Rom, Beginn der Arbeit an den großformatigen Collagen wie *Mars and the Artist* und *Apollo and the Artist.*

1976
Bereitet im Winter in Neapel eine Ausstellung in der Galleria Lucio Amelio vor; Ende Februar Reise nach Captiva Island; im Mai in New York eine größere Serie von Zeichnungen, die Leo Castelli im September präsentiert. Ausstellungen im Musée d'Art Moderne de la Ville de Paris (Zeichnungen 1954–1976), bei Leo Castelli (Aquarelle), bei Gian Enzo Sperone in Rom (großformatige Papierarbeiten, darunter *Leda and the Swan, Idilli* und *Narcissus*); Abschluss eines zweiten Portfolios mit Drucken: *Natural History Part II – Some Trees of Italy.*
Nach einer Unterbrechung von 17 Jahren macht Twombly erneut Skulpturen. Die plastische Arbeit gewinnt in den folgenden Jahren zunehmend an Bedeutung; der Korpus wächst bis 1997 auf 148 Werke an.

1977
Sommer in Bassano: Vollendung des dreiteiligen Gemäldes *Thyrsis.* Beginn des zehnteiligen, monumentalen Zyklus *Fifty Days at Iliam,* inspiriert durch Homers *Ilias* (benutzt die Übersetzung von Alexander Pope). Von antiken Streitwagen abgeleitete Motive erscheinen jetzt auch in der Skulptur.

1978
Im Sommer vollendet Twombly *Fifty Days at Iliam* in Bassano. Das Werk wird im November von der Lone Star Foundation bei Heiner Friedrich in New York gezeigt. Beginn der beiden mehrteiligen Gemälde *Goethe in Italy.* Im Herbst publiziert Heiner Bastian die erste Monografie über Twomblys Gemälde.

1979
Im Frühjahr zeigt die Galleria Lucio Amelio in Neapel elf Skulpturen und macht erstmals wieder auf Twomblys plastisches Werk aufmerksam. Retrospektive im Whitney Museum of American Art mit Werken von 1954–1977. Yvon Lambert publiziert den Catalogue raisonné der Werke auf Papier, Band 6 (1973–1976). Juni/Juli in Rom und Bassano in Teverina: mehrere Skulpturen. Im Herbst Reise nach Russland und Afghanistan; Dezember/Januar auf den Îles des Saintes in der Karibik: Serie von Aquarellen.

1980
Twombly zeigt auf der Biennale von Venedig den Zeichnungszyklus *Five Days Wait at Jiayuguan.* Juli/August in Bassano Arbeit an mehreren Skulpturen; im September Griechenlandreise.

1981
Erstmals im Juli/August in Formia in der Bucht von Gaeta: Zeichnungen und Skulpturen; später in Bassano. Im September wird im Museum Haus Lange in Krefeld die erste Museumsausstellung von Twomblys Skulpturen gezeigt, organisiert von Marianne Stockebrand (23 Plastiken von 1955 bis 1981). Im November entstehen in Rom die groß-

formatigen *Bacchus*-Collagen; Wanderausstellung von Werken auf Papier (1954–1976) in den USA und Kanada.

1982
Anfang des Jahres in New York, arbeitet nach seiner Rückkehr nach Italien in Gaeta. Sommer in Bassano: *Naxos-, Suma-* und *Lycian-*Zeichnungen. Von Juni bis September zeigt die documenta 7 in Kassel Gemälde und vier neuere Skulpturen.

1983
Anfang Februar Reise nach Key West in Florida: Zeichnungen; Ende März über New York Rückkehr nach Rom. Im Juni mit dem Sohn Alessandro Reise in den Jemen. Im August in Bassano *Anabasis-*Zeichnungen.

1984
Beendet im Winter in Key West die *Proteus-* Zeichnungen. Im Mai Ausstellung im Musée d'art contemporain in Bordeaux (Werke auf Papier); im Sommer in Bassano Arbeit an dem Triptychon *Hero and Leandro.* Twombly erhält im September den Internationalen Preis für bildende Kunst des Landes Baden-Württemberg. Aus diesem Anlass Ausstellung in der Kunsthalle Baden-Baden, organisiert von Katharina Schmidt (die mythologischen Themen in seinem Werk; Gemälde und Zeichnungen). Im Oktober Ausstellung von fünf Skulpturen in der Galleria Gian Enzo Sperone in Rom. Im Herbst publiziert Heiner Bastian den Catalogue raisonné des druckgrafischen Werkes seit 1953.

1985
Verbringt den Winter in Ägypten, vorwiegend in Luxor; arbeitet später in Gaeta an Skulpturen.

1986
Frühling in Gaeta, Sommer in Bassano; vollendet dort *Hero and Leandro* und den Gemälde-Zyklus *Analysis of the Rose as Sentimental Despair.* Twombly gestaltet einen Bühnenvorhang für die Opéra Bastille in Paris; Herbst und Winter in Gaeta, wo er ein Haus kauft. In den folgenden Jahren beaufsichtigt er dessen Renovierung und die Anlage eines Gartens mit einem Zitronenhain.

1987
Im Februar im Kunsthaus Zürich umfassende Retrospektive, organisiert von Harald Szeemann (Gemälde, Zeichnungen und 20 Skulpturen; anschließend in Madrid, London, Düsseldorf und Paris). Juli/August in Bassano. Retrospektive von Twomblys Serien auf Papier, organisiert von Katharina Schmidt im Kunstmuseum Bonn (anschließend in Barcelona). Twombly wird zum Mitglied der American Academy and Institute of Arts and Letters in New York ernannt. Er erhält den Rubens-Preis der Stadt Siegen. Herbst und Winter in Gaeta.

1988
Im Frühjahr Arbeit in Gaeta an großformatiger Malerei auf Papier: zwei Versionen von *Venere sopra Gaeta*; Skulpturen. In Rom entsteht der Zyklus der neun »Grünen Gemälde«, Twomblys Biennale-Beitrag, den vier Skulpturen ergänzen. Ernennung zum Chevalier dans l'Ordre des Arts et des Lettres. Herbst in den USA, Winter in Gaeta.

Bowery studio in New York. In December, visits at Rauschenberg's home on Captiva Island in Florida; Leonardo da Vinci's deluge drawings and anatomical, weather, and drapery studies stimulate a series of collages. In December, in the Nicholas Wilder Gallery in Los Angeles, exhibition of the "Grey Paintings" painted in New York. From Los Angeles, journeys to Mexico, making visits to archaeological sites.

1969
In January, returns to New York via the Caribbean island of St. Martin. Drawings made there are developed further in the fourteen large-scale pictures painted between May and October in the Palazzo del Drago on the Lago di Bolsena (Bolsena-Paintings).

1970
Works in the Bowery studio in New York, making visits to Lexington; spends March on Captiva Island. In the summer, journeys to Ireland. Returns to Rome, where he paints the second version of *Treatise on the Veil*.

1971
In February, exhibition in the galleries of Gian Enzo Sperone in Turin and Yvon Lambert in Paris. On Capri, works on drawings and collages. After the tragic death of Nini Pirandello, wife of Plinio De Martiis, the gallery owner who showed Twombly's works in Rome, paints five pictures: *Nini's Paintings*. In November, returns to New York with a sojourn on Captiva Island.

1972
In January, exhibition at Leo Castelli's Gallery. In the spring, back in Rome. Begins work on the monumental painting *Anatomy of Melancholy*, in reference to the eponymous book by Robert Burton (1621); when finished twenty-two years later in Lexington, it will have been fundamentally changed and bear the title *Say Goodbye, Catullus, to the Shores of Asia Minor*. Spends the summer on Capri and the winter on Captiva Island, working on drawings.

1973
In April, retrospective exhibition in the Kunsthalle Bern (paintings and drawings; subsequently in Munich), and a synoptical exhibition of the drawings in the Kunstmuseum Basel. Heiner Bastian publishes a monograph on the drawings. In August, back in Castel Gardena, completes *24 Short Pieces*. In November, journeys with friends to India.

1974
Spends February on Captiva Island. In Rome, completes *Natural History Part I–Mushrooms*, a portfolio with twelve prints. Gallery exhibitions in Munich, Turin, Paris, and Naples.

1975
Spends the winter on Captiva Island. Acquires a renaissance *palazzo* in Bassano in Teverina, north of Rome, which he will renovate in the course of the next three years; begins construction of an attached atelier where he will work during the following summers. In March, exhibition at the Institute of Contemporary Art, Philadelphia

(paintings, drawings, and several early sculptures; subsequently in San Francisco). In the early summer, returns to Rome and starts various large-scale collages such as *Mars and the Artist* and *Apollo and the Artist*.

1976
During the winter, in Naples, prepares an exhibition for the Galleria Lucio Amelio. In late February, travels to Captiva Island. In May, in New York, completes a major series of drawings, which Leo Castelli presents in September. Exhibitions in the Musée d'Art Moderne de la Ville de Paris (drawings 1956-1976), at Leo Castelli (watercolors), and at Gian Enzo Sperone in Rome (large-scale works on paper, including *Leda and the Swan*, *Idilli*, and *Narcissus*). Completes a second portfolio of prints: *Natural History Part II–Some Trees of Italy*. After some seventeen years, returns to sculpture, which becomes increasingly important to him: his œuvre grows to 148 pieces by 1997.

1977
Spends the summer in Bassano; completes the three-part painting *Thyrsis*. Begins work on the monumental, ten-part cycle *Fifty Days at Iliam*, inspired by Homer's *Iliad* (Alexander Pope translation). Motifs derived from ancient chariots begin to appear in his sculpture.

1978
Completes *Fifty Days at Iliam* at Bassano. The opus is shown by the Lone Star Foundation in New York at the Heiner Friedrich Gallery. Begins the two multi-part paintings *Gœthe in Italy*. In the autumn, Heiner Bastian publishes a monograph on Twombly's paintings.

1979
In the spring, the Galleria Lucio Amelio in Naples shows eleven sculptures, thus drawing attention for the first time to this part of Twombly's œuvre. Retrospective at the Whitney Museum of American Art (works from 1954–1977). Yvon Lambert publishes the *catalogue raisonné* of works on paper, volume 6 (1973–1976). In June/July, in Rome and at Bassano in Teverina, works on several sculptures. In the autumn, journeys to Russia and Afghanistan. Spends December/January on the Îles des Saintes in the Caribbean, working on a series of watercolors.

1980
Shows the drawing cycle *Five Days Wait at Jiayuguan* at the Biennale of Venice. Spends July/August in Bassano, working on several sculptures; in September, journeys to Greece.

1981
In July/August, takes first sojourn in Formia in the Bay of Gaeta, concentrating on drawings and sculptures. Later in Bassano. In September, the first museum exhibition of his sculptures in the Museum Haus Lange in Krefeld, organized by Marianne Stockebrand (twenty-three sculptures from 1955–1981). In November, in Rome, produces the large-scale *Bacchus* collages. Traveling exhibition of works on paper (1954–1976) in the United States and Canada.

1982
Spends the beginning of the year in New York. Upon returning to Italy, works in Gaeta. Spends the summer in Bassano, working on the *Naxos*, *Suma*, and *Lycian* drawings. From June until September, shows paintings and four new sculptures in the *documenta 7* in Kassel.

1983
In early February, travels to Key West, Florida (drawings). In late March, returns via New York to Rome. In June, journeys with son Alessandro to Yemen. In August, in Bassano, works on the *Anabasis* drawings.

1984
In the winter, completes the *Proteus* drawings in Key West. In May, exhibition in the Musée d'art contemporain in Bordeaux (works on paper). In the summer, in Bassano, works on the tryptich *Hero and Leandro*. In September, receives the Internationaler Preis für bildende Kunst des Landes Baden-Württemberg; in connection therewith, an exhibition at the Kunsthalle Baden-Baden is organized by Katharina Schmidt (mythological themes in his œuvre; paintings and drawings). In October, exhibition of five sculptures in the Galleria Gian Enzo Sperone in Rome. In the autumn, Heiner Bastian publishes the *catalogue raisonné* of prints since 1953.

1985
Spends the summer in Egypt, mostly in Luxor; later, works in Gaeta on sculptures.

1986
Spends the spring in Gaeta and the summer in Bassano; completes *Hero and Leandro* and the painting cycle *Analysis of the Rose as Sentimental Despair*. Designs a stage curtain for the Opéra Bastille in Paris. Spends the fall and winter in Gaeta, where he buys a house. In the following years, he will supervise its renovation and the planting of a garden with a lemon grove.

1987
In February, a comprehensive retrospective at the Kunsthaus Zürich, organized by Harald Szeemann (paintings, drawings and twenty sculptures; subsequently in Madrid, London, Dusseldorf, and Paris). In July/August, works in Bassano. A retrospective of his series on paper is organized by Katharina Schmidt at the Kunstmuseum Bonn (subsequently in Barcelona). Is named member of the American Academy and Institute of Arts and Letters in New York. Receives the Rubens-Preis of the City of Siegen. Spends the autumn and winter in Gaeta.

1988
In the spring, works in Gaeta on large-scale paintings on paper, including two versions of *Venere sopra Gaeta*, and sculptures. In Rome, paints the cycle of nine "Green Paintings," his Biennale contribution, supplemented by four sculptures. Is named Chevalier dans l'Ordre des Arts et des Lettres. Spends the autumn in the United States and the winter in Gaeta.

1989

Im Februar in der Galerie Sperone Westwater in New York frühe Gemälde sowie Skulpturen der Jahre 1951–1953; im September große Einzelausstellung in der Menil Collection in Houston (Gemälde, Zeichnungen und Skulpturen; anschließend in Des Moines). Das Philadelphia Museum of Art erwirbt *Fifty Days at Iliam*. Oktober auf den Seychellen, im Dezember Reise nach Istanbul.

1990

Im Januar/Februar Arbeit auf den Seychellen-Inseln La Digue und Darros an einer Serie von Zeichnungen. Im Frühling in Gaeta eine weitere Serie von Zeichnungen, die die Thomas Ammann Fine Art, Zürich, im Sommer zusammen mit Skulpturen präsentiert. Im März reist Twombly nach Zürich, Paris und Madrid, im April wird ihm die Skowhegan Medal for Painting verliehen. Sommer in Bassano, verbringt den Winter in Sorrent.

1991

Fertigstellung der Skulptur *Thermopylae* für eine Herbstausstellung in der Galerie Pièce-Unique in Paris. Folgt im Sommer der Reiseroute des Dichters Byron in Griechenland bis Epirus und fährt anschließend auf die Insel Syros. Im Juli in Bassano mit den beiden Versionen der *Quattro Stagioni*, im Herbst in Gaeta mit Skulptur beschäftigt. Das Kunsthaus Zürich richtet einen Raum mit neun Plastiken ein, die 1994 als Schenkung in die Sammlung gelangen. Band 7 des Catalogue raisonné der Zeichnungen (1977–1982) erscheint.

1992

Winter auf Jupiter Island in Florida, wo eine bedeutende Gruppe von Skulpturen entsteht; bezieht im Frühjahr ein Haus in seiner Heimatstadt Lexington; dort verbringt er von nun an mehrere Monate des Jahres. Stellt in Gaeta ein Triptychon mit Schiffsmotiven fertig. Im Herbst publiziert Heiner Bastian den ersten Band des Catalogue raisonné der Gemälde.

1993

Winter auf Jupiter Island; im Sommer in Gaeta, wo Twombly die Gemälde *Autunno* und *Inverno* aus dem ersten Zyklus der *Quattro Stagioni* vollendet. Erste Ausstellung von Fotografien in der Matthew Marks Gallery in New York. Die Washington and Lee University in Lexington verleiht Twombly die Ehrendoktorwürde.

1994

Mietet in Lexington ein leeres Lagerhaus, um an dem Gemälde *Say Goodbye, Catullus, to the Shores of Asia Minor* zu arbeiten. Verbringt die Monate Juni/Juli wieder in Gaeta, stellt dort *Primavera* und *Estate* der ersten Version von *Quattro Stagioni* fertig. Ende September im Museum of Modern Art in New York umfangreiche Retrospektive, organisiert von Kirk Varnedoe (Gemälde, Arbeiten auf Papier, Skulpturen; anschließend in Houston, Los Angeles und Berlin). Parallel dazu zeigt die Gagosian Gallery in New York erstmals das vollendete Gemälde *Say Goodbye, Catullus, to the Shores of Asia Minor*. Reist Anfang November nach Italien; besucht München, Berlin, Prag und

Paris; arbeitet in Gaeta an der zweiten Version der *Quattro Stagioni*.

1995

Im Februar Eröffnung der zweiten Station seiner Retrospektive und der Cy Twombly Gallery der Menil Collection in Houston. Sie zeigt permanent Gemälde, Skulpturen und Arbeiten auf Papier seit 1954. Frühling in Lexington, Sommer in Gaeta; malt dort an der der zweiten Version der *Quattro Stagioni* weiter. Die Stadt Goslar verleiht ihm den Kaiserring; im August über Berlin Reise nach St. Petersburg.

1996

Sommer in Gaeta, Arbeit an Skulpturen und drei Gruppen von Monotypien, die das Whitney Museum of American Art im Herbst zeigt. Im Oktober nimmt er in Japan den Premium Imperiale entgegen; verbringt den Winter in Lexington und auf St. Barthélemy in der Karibik.

1997

Erste Einzelausstellung von Twomblys Skulptur in den USA in der Gagosian Gallery in New York mit zehn Bronzen. Nicola Del Roscio publiziert den Catalogue raisonné der Skulpturen.

1998

Im Winter in Lexington: Arbeit an Skulpturen.

1999

Ausstellung von acht Skulpturen in der American Academy, Rom. Im Mai Reise in den Iran, Besuch von Isphahan. Anschließend in Gaeta Arbeit an drei Gemälden *Study on Turner* für ein Projekt in der National Gallery, London; im August Arbeit an Skulptur in Bassano. Herbst und Winter in Lexington.

2000

Rückreise nach Rom im März über Basel. Im April im Kunstmuseum Basel umfassende Retrospektive der Skulptur, organisiert von Katharina Schmidt in Zusammenarbeit mit Paul Winkler (66 Skulpturen von 1948–1998; anschließend The Menil Collection, Houston).

1989
In February, exhibition in the Sperone Westwater Gallery in New York (early paintings as well as sculptures from 1951–1953); in September, in The Menil Collection in Houston, major solo exhibition (paintings, drawings, and sculptures; subsequently in Des Moines). The Philadelphia Museum of Art acquires *Fifty Days at Iliam*. Spends October on the Seychelles; in December, journeys to Istanbul.

1990
In January/February, on the Seychelles islands La Digue and Daros, works on a series of drawings. In the spring, in Gaeta, completes a further series of drawings, presented together with sculptures in the summer by Thomas Ammann Fine Art, Zurich. In March, travels to Zurich, Paris, and Madrid; in April, receives the Skowhegan Medal for Painting. Spends the summer in Bassano and the winter in Sorrent.

1991
Completes the sculpture *Thermopylae* for an autumn exhibition in the Galerie Pièce-Unique in Paris. In the summer, retraces Lord Byron's journey through Greece until Epirus; afterward travels to the island of Syros. Is occupied in July in Bassano with the two versions of the *Quattro Stagioni*, and in the autumn in Gaeta with sculpture. The Kunsthaus Zürich inaugurates a room with nine sculptures donated to the collection in 1994. Volume seven of the *catalogue raisonné* of drawings (1977–1982) appears.

1992
Spends the winter on Jupiter Island, Florida, where an important group of sculptures results. In the spring, takes up residence in a house in his hometown of Lexington, where he will spend thenceforth several months a year. In Gaeta, completes a triptych of nautical motifs. In the autumn, Heiner Bastian publishes volume one of the *catalogue raisonné* of paintings.

1993
Spends the winter on Jupiter Island. In the summer, in Gaeta, finishes the paintings *Autunno* and *Inverno* from the first cycle of the *Quattro Stagioni*. First exhibition of photographs at the Matthew Marks Gallery in New York. Washington and Lee University awards Twombly an honorary doctorate.

1994
Rents an empty warehouse in Lexington in order to work on the painting *Say Goodbye, Catullus, to the Shores of Asia Minor*. Spends June/July back in Gaeta; completes there *Primavera* and *Estate* of the first version of the *Quattro Stagioni*. In late September, an extensive retrospective at The Museum of Modern Art in New York is organized by Kirk Varnedoe (paintings, works on paper and sculptures; subsequently in Houston, Los Angeles, and Berlin). Simultaneously, the Gagosian Gallery in New York shows for the first time the completed *Say Goodbye, Catullus, to the Shores of Asia Minor*. In early November, travels to Italy; visits Munich, Berlin, Prague, and Paris. Works in Gaeta on the second version of the *Quattro Stagioni*.

1995
In February, opening of the second stage of his retrospective and of the Cy Twombly Gallery at The Menil Collection in Houston, a permanent display of paintings, sculpture, and works on paper since 1954. Spends the spring in Lexington and the summer in Gaeta, where he continues work on the second version of the *Quattro Stagioni*. The City of Goslar awards him the Kaiserring. In August, journeys to St. Petersburg via Berlin.

1996
Spends the summer in Gaeta, working on sculptures and three groups of monotypes shown in autumn by the Whitney Museum of American Art. In October, in Japan, receives the Premium Imperiale. Spends the winter in Lexington and on St. Barthélemy in the Caribbean.

1997
First solo exhibition of his sculpture in the United States, at the Gagosian Gallery in New York (ten bronzes). Nicola Del Roscio publishes the *catalogue raisonné* of sculptures.

1998
Spends the winter in Lexington, working on sculptures.

1999
Exhibition of eight sculptures in the American Academy, Rome. In May, journeys to Iran and visits Isphahan. In Gaeta, works on the three paintings of *Study on Turner* for a project at the National Gallery, London. In August, works on sculptures in Bassano. Spends the autumn and winter in Lexington.

2000
In March, returns to Rome via Basel. In April, at the Kunstmuseum Basel, a comprehensive retrospective of sculptures is organized by Katharina Schmidt in collaboration with Paul Winkler (sixty-six sculptures from 1948–1998; subsequently The Menil Collection, Houston).

Ausstellungen
mit Skulptur in Auswahl

Einzelausstellungen

1953
Princeton, The Little Gallery, *Cy Twombly. Drawings, Paintings, Sculpture*, 25. Oktober–7. November 1953.

1955
New York, The Stable Gallery, *Cy Twombly*, 10.–29. Januar 1955.

1956
New York, The Stable Gallery, *Cy Twombly*, 2.–19. Januar 1956.

1957
New York, The Stable Gallery, *Cy Twombly*, 2.–19. Januar 1957.

1975
Philadelphia, Institute of Contemporary Art, University of Pennsylvania, *Cy Twombly. Paintings, Drawings, Constructions 1951-1974*, 15. März–27. April 1975. San Francisco, San Francisco Museum of Art, 9. Mai–22. Juni 1975.

1979
Neapel, Galleria Lucio Amelio, *Cy Twombly. 11 sculture*, Vernissage 25. Mai 1979.

1981
Krefeld, Museum Haus Lange, *Cy Twombly. Skulpturen. 23 Arbeiten aus den Jahren 1955 bis 1981*, 27. September–15. November 1981.

1984
Rom, Galleria Gian Enzo Sperone, *Cy Twombly. Sculture*, Vernissage 25. Oktober 1984.

1985
Köln, Galerie Karsten Greve, *Cy Twombly*, 16. November 1985–8. Januar 1986.

1986
New York, Hirschl & Adler Modern, *Cy Twombly*, 12. April–7. Mai 1986.

1987
Zürich, Kunsthaus Zürich, *Cy Twombly. Bilder, Arbeiten auf Papier, Skulpturen*, 18. Februar–29. März 1987. Madrid, Palacio de Vélazquez/Palacio de Cristal, 22. April–30. Juli 1987. London, Whitechapel Art Gallery, 25. September–15. November 1987. Düsseldorf, Städtische Kunsthalle, 11. Dezember 1987–31. Januar 1988. Paris, Musée national d'art moderne, Galeries contemporaines, Centre Georges Pompidou, 16. Februar–17. April 1988. Bonn, Städtisches Kunstmuseum Bonn, *Cy Twombly. Serien auf Papier 1957-1987*, 2. Juni–9. August 1987.

1989
New York, Sperone Westwater, *Cy Twombly. Paintings and Sculptures 1951 and 1953*, 1.–28. Februar 1989.
Houston, The Menil Collection, *Cy Twombly*, 8. September 1989–4. März 1990. Des Moines, Des Moines Art Center, 28. April–17. Juni 1990.

1990
Zürich, Thomas Ammann Fine Art, *Cy Twombly. Drawings and 8 Sculptures*, 11. Juni–1. September 1990.

1991
Paris, Galerie Amelio-Brachot/Pièce-Unique, *Cy Twombly. Thermopylae*, 2. Oktober–20. Dezember 1991.

1992
Paris, Galerie Pièce-Unique, *Cy Twombly*, 2. Oktober–30. November 1992.

1993
Paris, Galerie Karsten Greve, *Cy Twombly. Peintures, œuvres sur papier et sculptures*, 29. Mai–20. Oktober 1993.

1994
Zürich, Thomas Ammann Fine Art, *Cy Twombly*, 15. Juni–15. September 1994.
New York, The Museum of Modern Art, *Cy Twombly. A Retrospective*, 21. September 1994–10. Januar 1995. Houston, The Menil Collection, 12. Februar–19. März 1995. Los Angeles, The Museum of Contemporary Art, 9. April–11. Juni 1995. Berlin, Neue Nationalgalerie, 31. August–19. November 1995.
New York, C & M Arts (in Zusammenarbeit mit der Galerie Karsten Greve), *Cy Twombly*, 27. September–12. November 1994.

1995
Berlin, Galerie Max Hetzler, *Cy Twombly. Skulptur*, 3. Juni–22. Juli 1995.

1996
São Paulo, *23 Bienal Internacional São Paulo, Sals epeciais*, 5. Oktober–8. Dezember 1996.

1997
Köln, Galerie Karsten Greve, *Cy Twombly*, 25. Juni–30. September 1997.
New York, Gagosian Gallery, *Cy Twombly. Ten Sculptures*, 5. November–20. Dezember 1997.

1998
Rom, American Academy, *Cy Twombly. 8 Sculptures*, 29. September–15. November 1998.

2000
Basel, Öffentliche Kunstsammlung / Kunstmuseum Basel, *Cy Twombly. Die Skulptur / The Sculpture*, 15. April–30. Juli 2000; Houston, The Menil Collection, 20. September–7. Januar 2001.

Gruppenausstellungen

1982
Kassel, *documenta 7*, 19. Juni–28. September 1982.

1984
Basel, Merian-Park, *Skulptur im 20. Jahrhundert*, 3. Juni–30. September 1984.

1985
Zürich, Kunsthaus Zürich, *Spuren, Skulpturen und Monumente ihrer präzisen Reise*, 29. November 1985–23. Februar 1986.

1986
London, Whitechapel Art Gallery, *In Tandem. The Painter-Sculptor in the Twentieth Century*, 27. März–25. Mai 1986.
Wien, Messepalast, *De Sculptura*, 16. Mai–20. Juli 1986.
Madrid, Fundación Caixa de Pensiones, *Italia aperta. Nicola De Maria, Sol Lewitt, Hidetoshi Nagasawa, Giulio Paolini, Cy Twombly, Emilio Vedova*, 29. Mai–31. Juni 1986.
Düsseldorf, Städtische Kunsthalle Düsseldorf, *SkulpturSein*, 13. Dezember 1986–1. Februar 1987.

1987
London, Anthony d'Offay Gallery, *About Sculpture*, 28. Januar–14. Juni 1987.

1988
Neapel, Galleria Lucio Amelio, *Oggetto. Beuys, Broodthaers, Duchamp, Johns, Manzoni, Man Ray, Rauschenberg, Schwitters, Twombly, Warhol*, Vernissage 25. März 1988.
Berlin, Hamburger Bahnhof, *Zeitlos. Kunst von heute im Hamburger Bahnhof, Berlin*, 22. Juni–25. September 1988.
Venedig, Giardini di Castello, *La Biennale di Venezia. XLIII Esposizione Internazionale d'Arte – Il luogo degli artisti*, 26. Juni–25. September 1988.

1990
Tokyo, The Watari Museum of Contemporary Art, *LightSeed. Wolfgang Laib, Cy Twombly, Michel Verjux*, 1. Dezember 1990–24. Februar 1991.

1991
New York, Whitney Museum of American Art, *1991 Biennial Exhibition*, 2. April–16. Juni 1991.
Genf, Galerie Bonnier, *Une touche suisse*, 27. April–1. Juni 1991.

1994
Rom, American Academy, *L'arte americana nelle collezioni private italiane*, 27. Mai–30. Juni 1994.
Basel, Museum für Gegenwartskunst, *Zimmer in denen die Zeit nicht zählt. Die Sammlung Udo und Anette Brandhorst*, 5. Juni–25. September 1994.
Wien, Museum moderner Kunst Stiftung Ludwig, *Malfiguren. Clemente, Immendorff, Kirkeby, Morley, Nitsch, Twombly*, 7. Juli–18. September 1994.

1995
London, Anthony d'Offay Gallery, *Sculpture*, Frühling 1995.
Houston, The Menil Collection, *Defining Space*, 24. Mai–24. September 1995.

Selected Exhibitions

One-Person Exhibitions with Sculpture

1953
Princeton, New Jersey, The Little Gallery,
"Cy Twombly: Drawings, Paintings, Sculpture,"
October 25–November 7.

1955
New York, The Stable Gallery, "Cy Twombly,"
January 10–29.

1956
New York, The Stable Gallery, "Cy Twombly,"
January 2–19.

1957
New York, The Stable Gallery, "Cy Twombly,"
January 2–19.

1975
Philadelphia, Institute of Contemporary Art,
University of Pennsylvania, "Cy Twombly:
Paintings, Drawings, Constructions 1951–1974,"
March 15–April 27. Travelled to San Francisco,
San Francisco Museum of Art, May 9–June 22.

1979
Naples, Galleria Lucio Amelio, "Cy Twombly:
11 sculture," opening May 25.

1981
Krefeld, Germany, Museum Haus Lange, "Cy
Twombly: Skulpturen. 23 Arbeiten aus den Jahren
1955 bis 1981," September 27–November 15.

1984
Rome, Galleria Gian Enzo Sperone, "Cy Twombly:
Sculture," opening October 25.

1985
Cologne, Galerie Karsten Greve, "Cy Twombly,"
November 16–January 8, 1986.

1986
New York, Hirschl & Adler Modern, "Cy Twombly,"
April 12–May 7.

1987
Zurich, Kunsthaus Zürich, "Cy Twombly: Bilder,
Arbeiten auf Papier, Skulpturen," February
18–March 29. Travelled to Madrid, Palacio de
Vélazquez/Palacio de Cristal, April 22–July 30;
London, Whitechapel Art Gallery, September
25–November 15; Dusseldorf, Städtische
Kunsthalle Düsseldorf, December 11–January 31,
1988; Paris, Musée national d'art moderne,
Galeries contemporaines, Centre Georges
Pompidou, February 16–April 17, 1988.
Bonn, Städtisches Kunstmuseum, "Cy Twombly:
Serien auf Papier 1957–1987," June 2–August 9.

1989
New York, Sperone Westwater, "Cy Twombly:
Paintings and Sculptures 1951 and 1953,"
February 1–28.
Houston, The Menil Collection, "Cy Twombly,"
September 8–March 4, 1990. Travelled to
Des Moines, Iowa, Des Moines Art Center,
April 28–June 17.

1990
Zurich, Thomas Ammann Fine Art, "Cy Twombly:
Drawings and 8 Sculptures," June 11–September 1.

1991
Paris, Galerie Amelio-Brachot/Pièce-Unique, "Cy
Twombly: Thermopylae," October 2–December 20.

1992
Paris, Galerie Pièce-Unique, "Cy Twombly,"
October 2–November 30.

1993
Paris, Galerie Karsten Greve, "Cy Twombly:
Peintures, œuvres sur papier et sculptures,"
May 29–October 20.

1994
Zurich, Thomas Ammann Fine Art, "Cy Twombly,"
June 15–September 15.
New York, The Museum of Modern Art,
"Cy Twombly: A Retrospective," September
21–January 10, 1995. Travelled to Houston, The
Menil Collection, February 12–March 19, 1995;
Los Angeles, The Museum of Contemporary Art,
April 9–June 11, 1995; Berlin, Neue National-
galerie, August 31–November 19, 1995.
New York, C & M Arts (in collaboration with the
Karsten Greve Gallery), "Cy Twombly," September
27–November 12.

1995
Berlin, Galerie Max Hetzler, "Cy Twombly:
Skulptur," June 3– July 22.

1996
São Paulo, "23 Bienal Internacional São Paulo,
Sals epeciais," October 5– December 8.

1997
Cologne, Galerie Karsten Greve, "Cy Twombly,"
June 2–September 30.
Rome: American Academy, "Cy Twombly:
8 Sculptures," September 29–November 15.
New York, Gagosian Gallery, "Cy Twombly:
Ten Sculptures," November 5–December 20.

2000
Basel, Switzerland, Öffentliche Kunstsammlung
Basel/Kunstmuseum, "Cy Twombly: Die Skulp-
tur/The Sculpture," April 15–July 30. Travelled to
Houston, The Menil Collection, September 20–
January 7, 2001.

Group-Exhibitions with Sculpture

1982
Kassel, Germany, "documenta 7,"
June 19–September 28.

1984
Basel, Merian-Park, "Skulptur im 20. Jahr-
hundert," June 3–September 30.

1985
Zurich, Kunsthaus Zürich, "Spuren, Skulpturen
und Monumente ihrer präzisen Reise,"
November 29–February 23, 1986.

1986
London, Whitechapel Art Gallery, "In Tandem:
The Painter-Sculptor in the Twentieth Century,"
March 27–May 25.
Vienna, Messepalast, "De Sculptura,"
May 16–July 20.
Madrid, Fundación Caixa de Pensiones, "Italia
aperta: Nicola De Maria, Sol Lewitt, Hidetoshi
Nagasawa, Giulio Paolini, Cy Twombly, Emilio
Vedova," May 29–June 31.
Dusseldorf, Städtische Kunsthalle Düsseldorf,
"SkulpturSein," December 13–February 1, 1987.

1987
London, Anthony d'Offay Gallery,
"About Sculpture," January 28–June 14.

1988
Naples, Galleria Lucio Amelio, "Oggetto: Beuys,
Broodthaers, Duchamp, Johns, Manzoni, Man Ray,
Rauschenberg, Schwitters, Twombly, Warhol,"
opening March 25.
Berlin, Hamburger Bahnhof, "Zeitlos: Kunst von
heute im Hamburger Bahnhof," June 22–
September 25.
Venice, "La Biennale di Venezia: XLIII Esposizione
Internazionale d'Arte: il luogo degli artisti," June
26–September 25.

1990
Tokyo, The Watari Museum of Contemporary Art,
"LightSeed: Wolfgang Laib, Cy Twombly, Michel
Verjux," December 1–February 24, 1991.

1991
New York, Whitney Museum of American Art,
"1991 Biennial Exhibition," April 2–June 6, 1991.

1994
Rome, American Academy, "L'arte americana nelle
collezioni private italiane," May 27–June 30.
Basel, Switzerland, Museum für Gegenwartskunst,
"Zimmer in denen die Zeit nicht zählt: Die
Sammlung Udo und Anette Brandhorst,"
June 5–September 25.
Vienna, Museum moderner Kunst Stiftung
Ludwig, "Malfiguren: Clemente, Immendorff,
Kirkeby, Morley, Nitsch, Twombly," July 7–
September 18.

1995
London, Anthony d'Offay Gallery, "Sculpture,"
spring 1995.
Houston, The Menil Collection, "Defining Space,"
May 24–September 24.

Ausgewählte Bibliografie

Werkkataloge

Bastian, Heiner, Hrsg., *Cy Twombly. Das Graphische Werk 1953–1984. A Catalogue Raisonné of the Printed Graphic Work*, München/New York 1984. Text von Heiner Bastian.

Bastian, Heiner, Hrsg., *Cy Twombly. Catalogue Raisonné of the Paintings*, Bd. 1: *1948–1960*, München 1992; Bd. 2: *1961–1965*, München 1993; Bd. 3: *1966–1971*, München 1994; Bd. 4: *1972–1995*, München 1995. Text von Heiner Bastian.

Lambert, Yvon, Hrsg., *Cy Twombly. Catalogue raisonné des œuvres sur papier de Cy Twombly*, Bd. 6; *1973–1976*, Mailand 1979, Text von Roland Barthes; Bd. 7: *1977–1982*, Mailand 1991, Text von Philippe Sollers.

Roscio, Nicola Del, *Cy Twombly. Catalogue Raisonné of Sculpture*, Bd. 1: *1946–1997*, München 1997. Text von Arthur C. Danto.

Text von Cy Twombly

»Signs«, in: *L'Esperienza Moderna*, (1957) 2 (August/September), S. 62. Wiederabgedruckt in: Kirk Varnedoe, *Cy Twombly. A Retrospective*, Ausst.-Kat. New York, The Museum of Modern Art 1994, S. 27. Deutsch als: »Malerei bestimmt das Gebilde«, in: *blätter und bilder. Eine Zeitschrift für Dichtung, Musik und Malerei*, (1961) 12 (Januar/Februar), S. 62–63. Neu übersetzt in: Kirk Varnedoe, *Cy Twombly. Eine Retrospektive*, Ausst.-Kat. Berlin, Neue Nationalgalerie, München etc. 1995, S. 28–29.

Monografien, Werkpublikationen, Aufsätze

Ammann, Thomas, Hrsg., *Cy Twombly. Souvenirs of D'Arros and Gaeta*, Zürich 1992.

Barthes, Roland, »Non multa sed multum«, (mit englischer und italienischer Übersetzung), in: Yvon Lambert, Hrsg., *Catalogue raisonné des oeuvres sur papier de Cy Twombly*, Bd. 6: *1973–1976*, Mailand 1979, S. 7–13. Deutsch in: Roland Barthes, *Cy Twombly*, Berlin 1983, S. 7–35; neu übersetzt in: ders., *Der entgegenkommende und der stumpfe Sinn. Kritische Essays III*, Frankfurt am Main 1990, S. 165–183.

Barthes, Roland, »Sagesse de l'art / The Wisdom of Art«, in: *Cy Twombly. Paintings and Drawings 1954–1977*, Ausst.-Kat. New York, Whitney Museum of American Art 1979, S. 9–22. Deutsch in: ders., *Cy Twombly*, Berlin 1983, S. 65–94; neu übersetzt in: ders., *Der entgegenkommende und der stumpfe Sinn. Kritische Essays III*, Frankfurt am Main 1990, S. 187–203.

Bastian, Heiner, Hrsg., *Cy Twombly. Zeichnungen 1953–1973*, Frankfurt am Main etc. 1973.

Bastian, Heiner, Hrsg., *Cy Twombly. Bilder, Paintings 1952–1976*, Frankfurt am Main etc. 1978.

Bastian, Heiner, Hrsg., *Cy Twombly. Fifty Days at Iliam. A Painting in Ten Parts*, Frankfurt am Main etc. 1979.

Bastian, Heiner, Hrsg., *Cy Twombly. 24 Short Pieces*, München 1989.

Bastian, Heiner, Hrsg., *Cy Twombly. Poems to the Sea*, München 1990.

Bastian, Heiner, Hrsg., *Cy Twombly. Letter of Resignation*, München 1991.

Boehm, Gottfried, »Mnemosyne. Zur Kategorie des erinnernden Sehens«, in: ders., Karlheinz Stierle, Gundolf Winter, Hrsg., *Modernität und Tradition. Festschrift für Max Imdahl zum 60. Geburtstag*, München 1985, S. 37–57.

Bois, Yve-Alain, »Der liebe Gott steckt im Detail. Reading Twombly«, in: *Abstraction, Gesture, Ecriture. Paintings from the Daros Collection*, hrsg. von Stephan Schmidheiny (Alesco AG), Zürich etc. 1999, S. 61–84.

Brandhorst, Udo und Anette, Hrsg., *Octavio Paz, Eight Poems. Cy Twombly, Ten Drawings*, Köln 1993.

Busse, Klaus-Peter, *Cy Twombly. Hero and Leander*, Witten/Köln 1994.

Busse, Klaus-Peter, *Erzählung, Landschaft und Text im Werk von Cy Twombly*, Dortmund 1998.

Engelbert, Arthur, *Die Linie in der Zeichnung. Klee – Pollock – Twombly*, Essen 1985, S. 106–200.

Franzke, Andreas, *Skulpturen und Objekte von Malern des 20. Jahrhunderts*, Köln 1982, S. 193–194.

Göricke, Jutta, *Cy Twombly. Spurensuche*, Dissertation Philosophisch-Technische Hochschule Aachen 1994, München 1995.

Harris, Mary Emma, *The Arts at Black Mountain College*, Cambridge, Mass. 1987.

Heyden, Thomas, *Zu Sehen und zu Lesen. Anmerkungen zum Verständnis des Geschriebenen bei Cy Twombly*, Magisterarbeit Universität Bonn 1986, Nürnberg 1986.

Hoppe-Sailer, Richard, »Aphrodite Anadyomene. Zur Konstitution von Mythos bei Cy Twombly«, in: Gottfried Boehm, Karlheinz Stierle, Gundolf Winter, Hrsg., *Modernität und Tradition. Festschrift für Max Imdahl zum 60. Geburtstag*, München 1985, S. 125–142.

Hoppe-Sailer, Richard, »Bilderfahrung und Naturvorstellung bei Cy Twombly«, in: Max Imdahl, Hrsg., *Wie eindeutig ist ein Kunstwerk?*, Köln 1986, S. 103–129.

Hoppe-Sailer, Richard, »Cy Twombly. Ohne Titel, 1959/63«, in: Norbert Kunisch, Hrsg., *Erläuterungen zur Modernen Kunst. 60 Texte von Max Imdahl, seinen Freunden und Schülern*, Kunstsammlungen der Ruhr-Universität Bochum 1990, S. 267–272.

Huber, Hans-Dieter, *System und Wirkung. Rauschenberg – Twombly – Baruchello. Fragen der Interpretation und Bedeutung zeitgenössischer Kunst. Ein systemanalytischer Ansatz*, München 1989, S. 127–154.

Imhof, Dora, *Cy Twombly und die Mythologie der Antike. Eine Synthese von Lebensnähe und Traditionsbezug*, Lizentiatsarbeit Universität Basel, Typoskript, 1995.

Jäger, Joachim, »Cy Twombly«, in: Gerhard Finck, Hrsg., *Die Maler und ihre Skulpturen. Von Edgar Degas bis Gerhard Richter*, Essen/Köln 1997, S. 248.

Langenberg, Ruth, *Cy Twombly. Eine Chronologie gestalteter Zeit*, Hildesheim etc. 1998.

Meier, Britta, *Paraphrasen von Körper und Raum als semiotische Praxis bei Cy Twombly*, Bochum 1996.

Restany, Pierre, *Lyrisme et Abstraction*, Mailand 1960, S. 94.

Salzburger Landessammlungen Rupertinum, Hrsg., *Cy Twombly* (Publikation anlässlich der Verleihung des Herbert-Boeckl-Preises an Cy Twombly), Salzburg 1996.

Selz, Peter, »Amerikaner im Ausland«, in: *Amerikanische Kunst im 20. Jahrhundert, Malerei und Plastik 1913–1993*, Ausst.-Kat. Berlin, Martin-Gropius-Bau 1993, S. 201–210.

Shapiro, David, »What ist the Poetic Object«, in: *The Menil Collection. A Selection from the Paleolithic to the Modern Era*, New York 1987, S. 274–278.

Stocchi, Emilia, *Les sculptures de Cy Twombly*, Mémoire de Maitrise, La Sorbonne Paris 1996.

Kataloge: Einzelausstellungen

Cy Twombly, Ausst.-Kat. New York, The Stable Gallery, 1956.

Cy Twombly. Zeichnungen 1953–1973, Ausst.-Kat. Basel, Kunstmuseum Basel 1973. Texte von Franz Meyer und Heiner Bastian.

Cy Twombly. Paintings, Drawings, Constructions 1951–1974, Ausst.-Kat. Philadelphia, Institute of Contemporary Art, University of Pennsylvania und San Francisco Museum of Art 1975. Texte von Suzanne Delehanty und Heiner Bastian.

Selected Bibliography

Catalogues Raisonnés

Bastian, Heiner. *Cy Twombly: Das Graphische Werk 1953–1984 / A Catalogue Raisonné of the Printed Graphic Work*. Munich: Schellmann; New York: New York University Press, 1984.

———. *Cy Twombly: Catalogue Raisonné of the Paintings*. Vol. 1, *1948–1960*. Munich: Schirmer/Mosel, 1992.

———. *Cy Twombly: Catalogue Raisonné of the Paintings*. Vol. 2, *1961–1965*. Munich: Schirmer/Mosel, 1993.

———. *Cy Twombly: Catalogue Raisonné of the Paintings*. Vol. 3, *1966–1971*. Munich: Schirmer/Mosel, 1994.

———. *Cy Twombly: Catalogue Raisonné of the Paintings*. Vol. 4, *1972–1995*. Munich: Schirmer/Mosel, 1995.

Lambert, Yvon. *Cy Twombly: Catalogue raisonné des œuvres sur papier de Cy Twombly*. Vol. 6, *1973–1976*. Milan: Multipla Edizioni, 1979. Text by Roland Barthes.

———. *Cy Twombly: Catalogue raisonné des œuvres sur papier de Cy Twombly*. Vol. 7, *1977–1982*. Milan: Multipla Edizioni, 1991. Text by Philippe Sollers.

Roscio, Nicola Del. *Cy Twombly: Catalogue Raisonné of Sculpture*. Vol. 1, *1946–1997*. Munich: Schirmer/Mosel, 1997. Text by Arthur C. Danto.

Text by Cy Twombly

"Signs." *L'Esperienza Moderna*, no. 2 (August–September 1957): 62. Reprinted in *Cy Twombly: A Retrospective*, exh. cat., p. 27. New York: The Museum of Modern Art, 1994.

Selected Literature on Cy Twombly

Ammann, Thomas, ed. *Cy Twombly: Souvenirs of D'Arros and Gaeta*. Zurich: Thommas Ammann Fine Art, 1992.

Barthes, Roland. "Non multa sed multum." In *Cy Twombly: Catalogue raisonné des œuvres sur papier de Cy Twombly*, by Yvon Lambert, vol. 6, pp. 7–13. Milan: Multipla Edizioni, 1979. Newly translated as "Cy Twombly: Works on Paper." In *The Responsibility of Forms: Critical Essays on Music, Art, and Representation*, by Roland Barthes, pp. 166–76. New York: Hill and Wang, 1985.

———. "Sagesse de l'art [The Wisdom of Art]." In *Cy Twombly: Paintings and Drawings 1954–1977*, exh. cat., pp. 9–22. New York: Whitney Museum of American Art, 1979. Newly translated in *The Responsibility of Forms: Critical Essays on Music, Art, and Representation*, by Roland Barthes, pp. 177–94. New York: Hill and Wang, 1985.

Bastian, Heiner. *Cy Twombly: Zeichnungen 1953–1973*. Frankfurt/Main, Berlin, and Vienna: Verlag Ullstein, Propyläen Verlag, 1973.

———. *Cy Twombly: Bilder/Paintings 1952–1976*. Frankfurt/Main, Berlin, and Vienna: Propyläen Verlag, 1978.

———. *Cy Twombly: Fifty Days at Iliam—A Painting in Ten Parts*. Frankfurt/Main, Berlin, and Vienna: Propyläen Verlag, 1979.

———. *Cy Twombly: 24 Short Pieces*. Munich: Schirmer/Mosel, 1989.

———. *Cy Twombly: Poems to the Sea*. Munich: Schirmer/Mosel, 1990.

———. *Cy Twombly: Letter of Resignation*. Munich: Schirmer/Mosel, 1991.

Boehm, Gottfried. "Mnemosyne. Zur Kategorie des erinnernden Sehens." In *Modernität und Tradition: Festschrift für Max Imdahl zum 60. Geburtstag*, edited by Gottfried Boehm, Karlheinz Stierle, and Gundolf Winter, pp. 37–57. Munich: W. Fink, 1985.

Bois, Yve-Alain. "Der liebe Gott steckt im Detail. Reading Twombly." In *Abstraction, Gesture, Ecriture: Paintings from the Daros Collection*, edited by Stephan Schmidheiny and Alesco AG, pp. 61–84. Zurich: Scalo, 1999.

Brandhorst, Udo and Anette, eds. *Octavio Paz: Eight Poems—Cy Twombly: Ten Drawings*. Cologne: Udo and Anette Brandhorst 1993.

Busse, Klaus-Peter. *Cy Twombly: Hero and Leander*. Witten and Cologne, 1994.

———. *Erzählung, Landschaft und Text im Werk von Cy Twombly*. Dortmund: Universität Dortmund / Institut für Kunst, 1998.

Cy Twombly, (published on the occasion of the Herbert-Boeckl-Preis award to Cy Twombly) edited by Salzburger Landessammlungen Rupertinum, Salzburg, 1996.

Engelbert, Arthur. *Die Linie in der Zeichnung: Klee—Pollock—Twombly*, pp. 106–200. Essen: Die Blaue Eule, 1985.

Franzke, Andreas. *Skulpturen und Objekte von Malern des 20. Jahrhunderts*, pp. 193–94. Cologne: Dumont, 1982.

Göricke, Jutta. *Cy Twombly: Spurensuche*. (Ph. D. diss., Aachen, 1994.) Munich: S. Schreiber, 1995.

Harris, Mary Emma. *The Arts at Black Mountain College*. Cambridge, Mass.: MIT Press, 1987.

Heyden, Thomas. *Zu Sehen und zu Lesen: Anmerkungen zum Verständnis des Geschriebenen bei Cy Twombly*. (Master's thesis, Bonn, 1986.) Nuremberg, 1986.

Hoppe-Sailer, Richard. "Aphrodite Anadyomene: Zur Konstitution von Mythos bei Cy Twombly." In *Modernität und Tradition: Festschrift für Max Imdahl zum 60. Geburtstag*, edited by Gottfried Boehm, Karlheinz Stierle, and Gundolf Winter, pp. 125–42. Munich: W. Fink, 1985.

———. "Bilderfahrung und Naturvorstellung bei Cy Twombly." In *Wie eindeutig ist ein Kunstwerk?*, edited by Max Imdahl, pp. 103–29. Cologne: Dumont, 1986.

———. "Cy Twombly: Ohne Titel, 1959/63." In *Erläuterungen zur Modernen Kunst: 60 Texte von Max Imdahl, seinen Freunden und Schülern*, edited by Norbert Kunisch, pp. 267–72. Bochum: Kunstsammlungen der Ruhr-Universität Bochum, 1990.

Huber, Hans-Dieter. *System und Wirkung: Rauschenberg—Twombly—Baruchello / Fragen der Interpretation und Bedeutung zeitgenössischer Kunst / Ein systemanalytischer Ansatz*, pp. 127–154. Munich: W. Fink, 1989.

Imhof, Dora. "Cy Twombly und die Mythologie der Antike: Eine Synthese von Lebensnähe und Traditionsbezug." Master's thesis, Basel, 1995.

Jäger, Joachim. "Cy Twombly." In *Die Maler und ihre Skulpturen: Von Edgar Degas bis Gerhard Richter*, edited by Gerhard Finck, p. 248. Essen and Cologne: Dumont, 1997.

Langenberg, Ruth, *Cy Twombly: Eine Chronologie gestalteter Zeit*. Hildesheim, Zurich, and New York: Olms, 1998.

Meier, Britta. *Paraphrasen von Körper und Raum als semiotische Praxis bei Cy Twombly*. Bochum, 1996.

Restany, Pierre. *Lyrisme et Abstraction*, p. 94. Milan: Apollinaire, 1960.

Selz, Peter. "Americans Abroad." In *American Art in the 20th Century: Painting and Sculpture 1913–1993*, exh. cat., pp. 177–185. London: Royal Academy of Art and Saatchi Gallery. Munich: Prestel; London: Royal Academy of Art, Berlin: ZEITGEIST Gesellschaft, 1993.

Shapiro, David. "What is the Poetic Object." In *The Menil Collection: A Selection from the Paleolithic to the Modern Era*, pp. 274–8. New York: Harry N. Abrams, 1987.

Stocchi, Emilia. "Les sculptures de Cy Twombly." Master's thesis, Paris, 1996.

Exhibition Catalogues on the Artist

1956
New York: The Stable Gallery. *Cy Twombly*.

Cy Twombly, Ausst.-Kat. Hannover, Kestner-Gesellschaft 1976. Text von Heiner Bastian.

Cy Twombly. 11 sculture, Ausst.-Kat. Neapel, Galleria Lucio Amelio 1979.

Cy Twombly. Skulpturen. 23 Arbeiten aus den Jahren 1955 bis 1981, Ausst.-Kat. Krefeld, Museum Haus Lange 1981. Text von Marianne Stockebrand.

Cy Twombly, Ausst.-Kat. Baden-Baden, Staatliche Kunsthalle Baden-Baden 1984. Text von Katharina Schmidt.

Cy Twombly. Sculture, Rom, Galleria Gian Enzo Sperone 1984.

Cy Twombly, Köln, Galerie Karsten Greve 1984.

Cy Twombly, New York, Hirschl & Adler Modern 1986. Text von Roberta Smith.

Cy Twombly. Bilder, Arbeiten auf Papier, Skulpturen, Ausst.-Kat. Zürich, Kunsthaus Zürich 1987. Texte von Cy Twombly, Harald Szeemann, Frank O'Hara, Pierre Restany, Roland Barthes, Roberta Smith, Demosthenes Davvetas.

Cy Twombly. Cuadros, trabajos sobre papel, esculturas, Ausst.-Kat. Madrid, Palacio de Vélazquez/Palacio de Cristal 1987 (Texte wie Katalog Zürich 1987).

Cy Twombly. Paintings, Works on Paper, Sculpture, Ausst.-Kat. London, Whitechapel Art Gallery 1987 (Texte wie Katalog Zürich 1987).

Cy Twombly. Peintures, œuvres sur papier, sculptures, Ausst.-Kat. Paris, Musée national d'art moderne, Galeries contemporaines, Centre Georges Pompidou 1988. (Texte wie Katalog Zürich 1987; anstatt Frank O'Hara, Text von Bernard Blistène).

Cy Twombly. Bilder, Arbeiten auf Papier, Skulpturen, Ausst.-Kat. Düsseldorf, Städtische Kunsthalle Düsseldorf 1988. (Texte wie Katalog Zürich 1987).

Cy Twombly. Serien auf Papier 1957–1987, Ausst.-Kat. Bonn, Städtisches Kunstmuseum Bonn 1987. Text von Gottfried Boehm.

Cy Twombly. Poems to the Sea (1959), Ausst.-Kat. Bridgehampton/New York, Dia Art Foundation 1988. Text von Charles Olson.

Cy Twombly. Paintings and Sculptures 1951 and 1953, Ausst.-Kat. New York, Sperone Westwater Gallery 1989. Texte von Charles Olson und Robert Motherwell.

Cy Twombly, Ausst.-Kat. Houston, The Menil Collection und Des Moines, Des Moines Art Center 1990. Text von Katharina Schmidt (überarbeitete englische Fassung des Textes aus Ausst.-Kat. Baden-Baden 1984).

Cy Twombly. Drawings and 8 Sculptures, Ausst.-Kat. Zürich, Thomas Ammann Fine Art 1990.

Cy Twombly. Thermopylae, Ausst.-Kat. Paris, Galerie Amelio-Brachot/Pièce-Unique 1991.

Cy Twombly, Ausst.-Kat. Paris, Galerie Pièce-Unique 1993.

Cy Twombly. Peintures, œuvres sur papier et sculptures, Ausst.-Kat. Paris, Galerie Karsten Greve 1992.

Cy Twombly. Photographs, Ausst.-Kat. New York, Matthew Marks Gallery 1993. Text von William Katz.

Cy Twombly, Ausst.-Kat. Zürich, Thomas Ammann Fine Art 1994.

Cy Twombly, Ausst.-Kat. New York, C & M Arts (in Zusammenarbeit mit der Galerie Karsten Greve) 1994. Text von Sally Yard.

Cy Twombly. A Retrospective, Ausst.-Kat. New York, The Museum of Modern Art 1994; Houston, The Menil Collection 1995; Los Angeles, The Museum of Contemporary Art 1995. Text von Kirk Varnedoe.

Cy Twombly. Eine Retrospektive, Ausst.-Kat. Berlin, Neue Nationalgalerie 1995. Text von Kirk Varnedoe (deutsche Übersetzung von Ausst.-Kat. New York 1994).

23 Bienal Internacional São Paulo, Ausst.-Kat. São Paulo, Pavillon Cirillo Matarazzo 1996.

Cy Twombly. Ten Sculptures, Ausst.-Kat. New York, Gagosian Gallery 1997. Text von David Sylvester.

Cy Twombly, Ausst.-Kat. Köln, Galerie Karsten Greve 1997. Texte von Oswald Schwemmer und Hubert Damisch.

Cy Twombly. 8 Sculptures, Ausst.-Kat. Rom, American Academy 1998. Text von Giorgio Agamben.

Cy Twombly. Die Skulptur / The Sculpture, Ausst.-Kat. Basel, Öffentliche Kunstsammlung Basel / Kunstmuseum 2000; Houston, The Menil Collection 2000; Texte von Katharina Schmidt und Christian Klemm.

Kataloge: Gruppenausstellungen mit Skulptur

documenta 7, Kassel, Museum Fridericianum, Orangerie, Neue Galerie Auepark 1982.

Skulptur im 20. Jahrhundert, Basel, Merian-Park 1984.

Spuren, Skulpturen und Monumente ihrer präzisen Reise, Ausst.-Kat. Zürich, Kunsthaus Zürich 1985. Texte von Harald Szeemann, Laszlo Glozer, Roland Barthes.

Italia aperta. Nicola De Maria, Sol Lewitt, Hidetoshi Nagasawa, Giulio Paolini, Cy Twombly, Emilio Vedova, Ausst.-Kat. Madrid, Fundación Caixa de Pensiones 1986. Texte zu Cy Twombly von Gillo Dorfles, Roland Barthes, Heiner Bastian.

In Tandem. The Painter-Sculptor in the Twentieth Century, Ausst.-Kat. London, Whitechapel Art Gallery 1986. Text von Lynne Cooke.

De Sculpture, Ausst.-Kat. Wien, Messepalast 1986 (basiert auf Ausst.-Kat. Kunsthaus Zürich 1985).

SkulpturSein, Ausst.-Kat. Düsseldorf, Städtische Kunsthalle Düsseldorf 1986. Texte von Jürgen Harten und Johann Gottfried Herder (basiert auf Ausst.-Kat. Kunsthaus Zürich 1985).

About Sculpture, Ausst.-Kat. London, Anthony d'Offay Gallery 1987 (basiert auf Ausst.-Kat. Kunsthaus Zürich 1985).

Oggetto. Beuys, Broodthaers, Duchamp, Johns, Manzoni, Man Ray, Rauschenberg, Schwitters, Twombly, Warhol, Ausst.-Kat. Neapel, Galleria Lucio Amelio 1988.

La Biennale di Venezia. XLIII Esposizione Internazionale d'Arte – Il luogo degli artisti, Ausst.-Kat. Venedig, Biennale 1988. Text zu Cy Twombly von Roland Barthes.

Zeitlos. Kunst von heute im Hamburger Bahnhof, Ausst.-Kat. Berlin, Hamburger Bahnhof 1988. Text zu Cy Twombly von Harald Szeemann.

LightSeed. Wolfgang Laib, Cy Twombly, Michel Verjux, Ausst.-Kat. Tokyo, Watari-um, The Watari Museum of Contemporary Art 1990. Text zu Cy Twombly von Harald Szeemann.

1991 Biennial Exhibition, Ausst.-Kat. New York, Whitney Museum of American Art 1991.

Une Touche Suisse, Ausst.-Kat. Genf, Galerie Bonnier 1991. Text von Jan Runnqvist.

L'arte americana nelle collezioni private italiane / American Art in Italian Collections, Ausst.-Kat. Rom, American Academy 1994. Texte von Martha Boyden, Maurizio Calvesi, Giovanni Carandente, Gabriella Drudi.

Zimmer in denen die Zeit nicht zählt. Die Sammlung Udo und Anette Brandhorst, Ausst.-Kat. Basel, Museum für Gegenwartskunst 1994. Text zu Cy Twombly von Katharina Schmidt.

Malfiguren. Clemente, Immendorff, Kirkeby, Morley, Nitsch, Twombly, Ausst.-Kat. Wien, Museum moderner Kunst Stiftung Ludwig 1994. Text zu Cy Twombly von Achille Bonito Oliva.

Sculpture, Ausst.-Kat. London, Anthony d'Offay Gallery 1995.

Zeitschriftenaufsätze zu Twomblys Skulptur, chronologisch

Crehan, Hubert, »Cy Twombly at Stable Gallery«, in: *Art Digest,* (Januar 1955).

O'Hara, Frank, »Cy Twombly at Stable Gallery«, in: *Art News,* 53 (1955) 9 (Januar), S. 46.

1973
Basel, Switzerland: Öffentliche Kunstsammlung Basel / Kunstmuseum. *Cy Twombly: Zeichnungen 1953–1973*. Texts by Franz Meyer and Heiner Bastian.

1975
Philadelphia: Institute of Contemporary Art, University of Pennsylvania. *Cy Twombly: Paintings, Drawings, Constructions 1951–1974*. Catalogue produced for travel to San Francisco: San Francisco Museum of Art, 1975. Texts by Suzanne Delehanty and Heiner Bastian.

1976
Hannover, Germany: Kestner-Gesellschaft. *Cy Twombly*. Text by Heiner Bastian.

1979
Naples: Galleria Lucio Amelio. *Cy Twombly: 11 sculture*.

1981
Krefeld, Germany: Museum Haus Lange. *Cy Twombly: Skulpturen. 23 Arbeiten aus den Jahren 1955 bis 1981*. Text by Marianne Stockebrand.

1984
Baden-Baden, Germany: Staatliche Kunsthalle. *Cy Twombly*. Text by Katharina Schmidt.

Rome: Galleria Gian Enzo Sperone. *Cy Twombly: Sculture*.

Cologne: Galerie Karsten Greve. *Cy Twombly*.

1986
New York: Hirschl & Adler Modern. *Cy Twombly*. Text by Roberta Smith.

1987
Zurich: Kunsthaus Zürich. *Cy Twombly: Bilder, Arbeiten auf Papier, Skulpturen*. Texts by Cy Twombly, Harald Szeemann, Frank O'Hara, Pierre Restany, Roland Barthes, Roberta Smith, and Demosthenes Davvetas. Catalogue produced for travel to Madrid: Palacio de Vélazquez/Palacio de Cristal, 1987, *Cy Twombly: Cuadros, trabajos sobre papel, esculturas*; London: Whitechapel Art Gallery, 1987, *Cy Twombly: Paintings, Works on Paper, Sculpture*; Dusseldorf: Städtische Kunsthalle Düsseldorf, 1987–88, *Cy Twombly: Bilder, Arbeiten auf Papier, Skulpturen*; Paris: Musée national d'art moderne, Galeries contemporaines, Centre Georges Pompidou, 1988, *Cy Twombly: Peintures, œuvres sur papier, sculptures*.

Bonn: Städtisches Kunstmuseum Bonn. *Cy Twombly: Serien auf Papier 1957–1987*. Text by Gottfried Boehm.

1988
Bridgehampton, New York: Dia Art Foundation. *Cy Twombly: Poems to the Sea (1959)*. Text by Charles Olson.

1989
New York: Sperone Westwater Gallery. *Cy Twombly: Paintings and Sculptures 1951 and 1953*. Texts by Charles Olson and Robert Motherwell.

Houston: The Menil Collection. *Cy Twombly*. Text by Katharina Schmidt. Catalogue produced for travel to Des Moines, Iowa: Des Moines Art Center, 1990.

1990
Zurich: Thomas Ammann Fine Art. *Cy Twombly: Drawings and 8 Sculptures*.

1991
Paris: Galerie Amelio-Brachot / Pièce-Unique. *Cy Twombly: Thermopylae*.

1992
Paris: Galerie Pièce-Unique. *Cy Twombly*.

Paris: Galerie Karsten Greve. *Cy Twombly: Peintures, œuvres sur papier et sculptures*.

1993
New York: Matthew Marks Gallery. *Cy Twombly: Photographs*. Text by William Katz.

1994
Zurich: Thomas Ammann Fine Art. *Cy Twombly*.

New York: The Museum of Modern Art. *Cy Twombly: A Retrospective*. Text by Kirk Varnedoe. Catalogue produced for travel to Houston: The Menil Collection, 1995; Los Angeles: The Museum of Contemporary Art, 1995.

New York: C & M Arts, in collaboration with the Karsten Greve Gallery. *Cy Twombly*. Text by Sally Yard.

1996
São Paulo: Pavillon Cirillo Matarazzo. *23 Bienal Internacional São Paulo*.

1997
New York: Gagosian Gallery. *Cy Twombly: Ten Sculptures*. Text by David Sylvester.

Cologne: Galerie Karsten Greve. *Cy Twombly*. Texts by Oswald Schwemmer and Hubert Damisch.

1998
Rome: American Academy. *Cy Twombly: Eight Sculptures*. Text by Giorgio Agamben.

2000
Basel, Switzerland: Öffentliche Kunstsammlung Basel / Kunstmuseum. *Cy Twombly: Die Skulptur/The Sculpture*. Texts by Katharina Schmidt and Christian Klemm. Catalogue produced for travel to Houston: The Menil Collection, 2000.

Selected Group Exhibition Catalogues Including Sculpture

1982
Kassel, Germany: Museum Fridericianum, Orangerie, Neue Galerie Auepark. *documenta 7*.

1984
Basel, Switzerland: Merian-Park, *Skulpturen im 20. Jahrhundert*.

1985
Zurich: Kunsthaus Zürich. *Spuren, Skulpturen und Monumente ihrer präzisen Reise*. Texts by Harald Szeemann, Laszlo Glozer, and Roland Barthes.

1986
Madrid: Fundación Caixa de Pensiones. *Italia aperta: Nicola De Maria, Sol Lewitt, Hidetoshi Nagasawa, Giulio Paolini, Cy Twombly, Emilio Vedova*. Texts by Gillo Dorfles, Roland Barthes, and Heiner Bastian.

London: Whitechapel Art Gallery. *In Tandem: The Painter-Sculptor in the Twentieth Century*. Text by Lynne Cooke.

Vienna: Messepalast. *De Sculptura*.

Dusseldorf: Städtische Kunsthalle Düsseldorf. *SkulpturSein*. Text by Jürgen Harten.

1987
London: Anthony d'Offay Gallery. *About Sculpture*.

1988
Naples: Galleria Lucio Amelio. *Oggetto: Beuys, Broodthaers, Duchamp, Johns, Manzoni, Man Ray, Rauschenberg, Schwitters, Twombly, Warhol*.

Venice: Biennale. *La Biennale di Venezia: XLIII Esposizione Internazionale d'arte: il luogo degli artisti*. Text on Cy Twombly by Roland Barthes.

Berlin: Hamburger Bahnhof. *Zeitlos: Kunst von heute im Hamburger Bahnhof*. Text on Cy Twombly by Harald Szeemann.

1990
Tokyo: WATARI-UM, The Watari Museum of Contemporary Art. *LightSeed: Wolfgang Laib, Cy Twombly, Michel Verjux*. Text on Cy Twombly by Harald Szeemann.

1991
New York: Whitney Museum of American Art. *1991 Biennial Exhibition*.

Geneva: Galerie Bonnier. *Une Touche Suisse*. Text by Jan Runnqvist.

1994
Rome: American Academy. *L'arte americana nelle collezioni private italiane [American Art in Italian Collections]*. Texts by Martha Boyden, Maurizio Calvesi, Giovanni Carandente, and Gabriella Drudi.

Basel, Switzerland: Öffentliche Kunstsammlung Basel / Museum für Gegenwartskunst. *Zimmer in denen die Zeit nicht zählt: Die Sammlung Udo und Anette Brandhorst*. Text on Cy Twombly by Katharina Schmidt.

Vienna: Museum moderner Kunst Stiftung Ludwig. *Malfiguren: Clemente, Immendorff, Kirkeby, Morley, Nitsch, Twombly*. Text on Cy Twombly by Achille Bonito Oliva.

1995
London: Anthony d'Offay Gallery. *Sculpture*.

Sawin, Martica, »Cy Twombly at Stable Gallery«, in: *Arts Magazine*, (Februar 1957), S. 57.

Pincus-Witten, Robert, »Cy Twombly at the Institute of Contemporary Art, Philadelphia«, in: *Artforum*, 13 (1975) 10 (Juni/August), S. 63.

Olson, Charles, »Cy Twombly« [1952], in: ders., *Ich jage zwischen Steinen. Briefe und Essays*, hrsg. von Rudolf Schmitz, Bern / Berlin (Gachnang & Springer) 1998, S. 122.

Pohlen, Annelie, »Cy Twombly. Museum Haus Lange / Krefeld«, in: *Flash Art*, 105 (1981), S. 59.

Catoir, Barbara, »Skulpturen von Cy Twombly. Plastische Beschwörungen der Antike«, in: *Frankfurter Allgemeine Zeitung*, (1981) 240 (16. Oktober), S. 27.

Renate, Puvogel, »Cy Twombly – Skulpturen«, in: *Das Kunstwerk*, 35 (1982) 1 (Januar), S. 59–60.

Pohlen, Annelie, »Cy Twombly in Haus Lange«, in: *Artforum*, 20 (1982) 8 (April), S. 87–88.

Johnen, Jörg, »Cy Twombly. Skulpturen im Museum Haus Lange«, in: *Kunstforum*, 49 (1982) April/Mai, S. 203.

Kuspit, Donald, »Cy Twombly at Hirschl & Adler Modern«, in: *Artforum*, 25 (1986) Oktober, S. 129.

Szeemann, Harald, »Cy Twombly. Bilder – Skulpturen – Zeichnungen«, in: *Mitteilungsblatt der Zürcher Kunstgesellschaft*, Zürich (1987) 1, S. 6–13.

Meyer, Franz, »Die Spuren subjektiver Existenz. Ausstellung Cy Twombly im Kunsthaus Zürich«, in: *Neue Zürcher Zeitung*, (7. März 1987), S. 65.

Caley, Shaun, »Venice Biennial. A Report on the Major Pavilions from Venice. The Italian Pavilion«, in: *Flash Art*, (1988) 142 (Oktober), S. 105–106.

Dagen, Philippe, »Cy Twombly au Centre Pompidou. Le plaisir du rien«, in: *Le Monde*, (20. Februar 1988), S. 12.

Davvetas, Demosthenes, »The Erography of Cy Twombly«, in: *Artforum,* 27 (1989) April, S. 130–132.

Norden, Linda, »Cy Twombly at Sperone West-water«, in: *Art in America*, (1989) 10 (Oktober), S. 208–209.

Carrier, David, »Why We Love What We See«, in: *Art International*, (1990) 11 (Sommer), S. 66–69.

Klemm, Christian, »Zehn Skulpturen von Cy Twombly«, in: *Kunsthaus Zürich. Mitteilungsblatt der Zürcher Kunstgesellschaft*, (Januar 1991), S. 10.

Codrington, Andrea, »Hamburger Bahnhof: no art-world whistle stop«, in: *Journal of Art*, 4 (1991) Dezember, S. 23.

Händler, Ruth, »Lust auf Farbe, Lust auf Form«, in: *Art*, (1992) 9 (September), S. 24–43.

Klemm, Christian, »Cy Twombly im Kunsthaus Zürich«, in: *Kunsthaus Zürich. Zürcher Kunstgesellschaft. Jahresbericht 1994*, S. 97–106.

Boehm, Gottfried, »Cy Twombly. Erinnern, Vergessen«, in: *Kunstforum International*, (1994) 127 (Juli/September), S. 250–251.

Krauss, Rosalind und Peter Schjeldahl, »Cy Was Here«, in: *Artforum*, (September 1994), S. 70–74.

Danto, Arthur C., »Cy Twombly's Art. The Stammering Beauty of ›Demotic‹ Drawing at MoMA«, in: *The Nation*, (Oktober 1994), S. 31.

Szeemann, Harald, »Cy Twombly. Die ganze Kraft steckt in der Linie«, in: *Art*, (1995) 9 (September), S. 38–49.

Krauss, Rosalind, »Le Cours de Latin«, in: *Les Cahiers du Musée National d'Art Moderne*, (1995) 53 (Herbst), S. 5–23.

Varnedoe, Kirk mit Francesco Clemente, Brice Marden und Richard Serra, »Cy Twombly. An artist's artist«, in: *Res. Anthropology and Aesthetics*, (1995) 28 (Herbst), S. 163–179.

Literatur zu den Ateliers von Twombly und der Cy Twombly Gallery in Houston, in Auswahl

Lawford, Valentine, »Roman Classic Surprise«, in: *Vogue*, 148 (1966) 9 (November), S. 182–187, 193–196.

Turbeville, Deborah, »Portrait of a House – As the Artist«, Photoessay; Texte: Carter Ratcliff »The Artist: His Work« und Sandi Britton »The Artist: His House« in: *Vogue*, New York 12 (Dezember 1982), S. 262–271, 337.

D'Huart, Annabelle, »Ateliers d'Artistes, 1978«, in: *Cahiers de L' Energumène*, 1984 (Mai/August), S. 117–122.

Davvetas, Demosthenes, »Cy Twombly sur l'Olympe...«, in: *Décoration Internationale*, (1988) 103 (März), S. 96–98.

Tardiff, Richard J. und Lothar Schirmer, Hrsg., *Horst. Photographien aus sechs Jahrzehnten*, München etc. 1991, Abb. 131–133.

Igliori, Paola, Hrsg., *Entrails, Heads & Tails*, New York 1992, o. S.

Herrera, Hayden, »Cy Twombly: A Homecoming«, in: *Harper's Bazaar*, (1994) 3393 (August), S. 142–147.

Kazanjian, Dodie, »The Painted Word«, in: *Vogue*, New York, (1994) 9 (September), S. 546–557, 617.

Casadio, Mariuccia, »Twombly«, in: *L' Uomo Vogue*, (1995) 258 (Februar), S. 250–259.

Stein, Karen D., »Art House«, in: *Architectural Record*, 183 (1995) 5 (Mai), S. 78–83.

Paz, Octavio mit Harvey, John »The Cy Twombly Gallery at The Menil Collection«, in: *Res. Anthropology and Aesthetics*, (1995) 28 (Herbst), S. 180–183.

Herbstreuth, Peter, »Die Cy Twombly Galerie der Menil-Stiftung in Houston«, in: *Kunstforum* 133 (1996), S. 471–473.

Stern, William F., »The Twombly Gallery and the Making of Place«, in: *Cite. The Architectural Design Review of Houston*, (Frühjahr 1996), S. 16–19.

Weber, Bruce, *A House Is Not a Home*. Boston 1996.

Seidner, David, *Artist's Studios*, Paris 1999, S. 136–145.

Selected Essays, Articles, and Reviews, Chronological

Crehan, Hubert. "Cy Twombly at Stable Gallery." *Art Digest* (January 1955).

O'Hara, Frank. "Cy Twombly at Stable Gallery." *Art News*, 53, no. 9 (January 1955): 46.

Sawin, Martica. "Cy Twombly at Stable Gallery." *Arts Magazine* (February 1957): 57.

Pincus-Witten, Robert. "Cy Twombly at the Institute of Contemporary Art, Philadelphia." *Artforum* 13, no. 10 (June–August 1975): 63.

Olson, Charles. "Cy Twombly (1952)." *Olson: The Journal of the Charles Olson Archives*, no. 8 (Autumn 1977): 13–15.

Pohlen, Annelie. "Cy Twombly: Museum Haus Lange/Krefeld." *Flash Art*, no. 105 (1981): 59.

Catoir, Barbara. "Skulpturen von Cy Twombly: Plastische Beschwörungen der Antike." *Frankfurter Allgemeine Zeitung*, no. 240 (October 1981): 16, 27.

Renate, Puvogel. "Cy Twombly—Skulpturen." *Das Kunstwerk*, 35, no. 1 (January 1982): 59–60.

Pohlen, Annelie. "Cy Twombly im Museum Haus Lange." *Artforum*, 20, no. 8 (April 1982): 87–88.

Johnen, Jörg. "Cy Twombly: Skulpturen im Museum Haus Lange." *Kunstforum*, 49 (April/May 1982): 203.

Kuspit, Donald. "Cy Twombly at Hirschl & Adler Modern." *Artforum*, 25 (October 1986): 129.

Szeemann, Harald. "Cy Twombly: Bilder—Skulpturen—Zeichnungen." *Mitteilungsblatt der Zürcher Kunstgesellschaft*, no. 1 (1987): 6–13.

Meyer, Franz. "Die Spuren subjektiver Existenz: Ausstellung Cy Twombly im Kunsthaus Zürich." *Neue Zürcher Zeitung* (7 March 1987): 65.

Dagen, Philippe. "Cy Twombly au Centre Pompidou: Le plaisir du rien." *Le Monde* (20 February 1988): 12.

Caley, Shaun. "Venice Biennial: A Report on the Major Pavilions from Venice / The Italian Pavilion." *Flash Art*, no. 142 (October 1988): 105—6.

Davvetas, Demosthenes. "The Erography of Cy Twombly." *Artforum*, 27 (April 1989): 130–32.

Norden, Linda. "Cy Twombly at Sperone Westwater." *Art in America*, no. 10 (October 1989): 208–9.

Carrier, David. "Why We Love What We See." *Art International*, no. 11 (summer 1990): 66–69.

Klemm, Christian. "Zehn Skulpturen von Cy Twombly." *Kunsthaus Zürich. Mitteilungsblatt der Zürcher Kunstgesellschaft*, (January 1991): 10.

Codrington, Andrea. "Hamburger Bahnhof: no art-world whistle stop." *Journal of Art*, no. 4 (December 1991): 23.

Händler, Ruth. "Lust auf Farbe, Lust auf Form." *Art*, no. 9 (September 1992): 24–43.

Klemm, Christian. "Cy Twombly im Kunsthaus Zürich." *Kunsthaus Zürich. Zürcher Kunstgesellschaft. Jahresbericht 1994*: 97–106.

Boehm, Gottfried. "Cy Twombly: Erinnern, Vergessen." *Kunstforum International*, no. 127 (July–September 1994): 250–51.

Krauss, Rosalind and Peter Schjeldahl. "Cy Was Here." *Artforum* (September 1994): 70–74.

Danto, Arthur C. "Cy Twombly's Art: The stammering beauty of 'demotic' drawing at MoMA." *The Nation* (October 1994): 31.

Szeemann, Harald. "Cy Twombly: Die ganze Kraft steckt in der Linie." *Art*, no. 9 (September 1995): 38–49.

Krauss, Rosalind. "Le Cours de Latin." *Les Cahiers du Musée National d'Art Moderne*, no. 53 (Autumn 1995): 5–23.

Varnedoe, Kirk, with Francesco Clemente, Brice Marden, and Richard Serra. "Cy Twombly: An Artist's Artist." *Res. Anthropology and aesthetics*, no. 28 (Autumn 1995): 163–79.

Selected Literature on Twombly's Studios and the Cy Twombly Gallery, Houston, Chronological

Lawford, Valentine. "Roman Classic Surprise." *Vogue*, 148, no. 9 (November 1966): 182–87, 193–96.

Turbeville, Deborah. "Portrait of a House—As the Artist." Texts by Carter Ratcliff, "The Artist: His Work," and Sandi Britton, "The Artist: His House." *Vogue*, no. 12 (December 1982): 262–71, 337.

D'Huart, Annabelle. "Ateliers d'Artistes, 1978." *Cahiers de L'Energumène*, (May–August 1984): 117–22.

Davvetas, Demosthenes. "Cy Twombly sur l'Olympe. . ." *Décoration Internationale*, no. 103 (March 1988): 96–98.

Tardiff, Richard J., and Lothar Schirmer, eds. *Horst. Photographien aus sechs Jahrzehnten*, n.p., figs. 131–33. Munich: Schirmer/Mosel, 1991.

Igliori, Paola, ed. *Entrails, Heads & Tails*, n.p. New York: Rizzoli International, 1992.

Herrera, Hayden. "Cy Twombly: A Homecoming." *Harper's Bazaar*, no. 3393 (August 1994): 142–47.

Kazanjian, Dodie. "The Painted Word." *Vogue*, no. 9 (September 1994): 546–57, 617.

Casadio, Mariuccia. "Twombly." *L'Uomo Vogue*, no. 258 (February 1995): 250–59.

Stein, Karen D. "Art House." *Architectural Record*, 183, no. 5 (May 1995): 78–83.

Paz, Octavio, with John Harvey. "The Cy Twombly Gallery at The Menil Collection." *Res. Anthropology and aesthetics*, no. 28 (Autumn 1995): 180–83.

Herbstreuth, Peter. "Die Cy Twombly Galerie der Menil-Stiftung in Houston." *Kunstforum*, 133 (1996): 471–73.

Stern, William F. "The Twombly Gallery and the Making of Place." *Cite: The Architectural Design Review of Houston* (Spring 1996): 16–19.

Weber, Bruce. *A House is not a Home*. Boston: Bulfinch Press, 1996.

Seidner, David. *Artists' Studios*, pp. 136–45. Paris: Assouline, 1999.

1000 N10

screws
screws

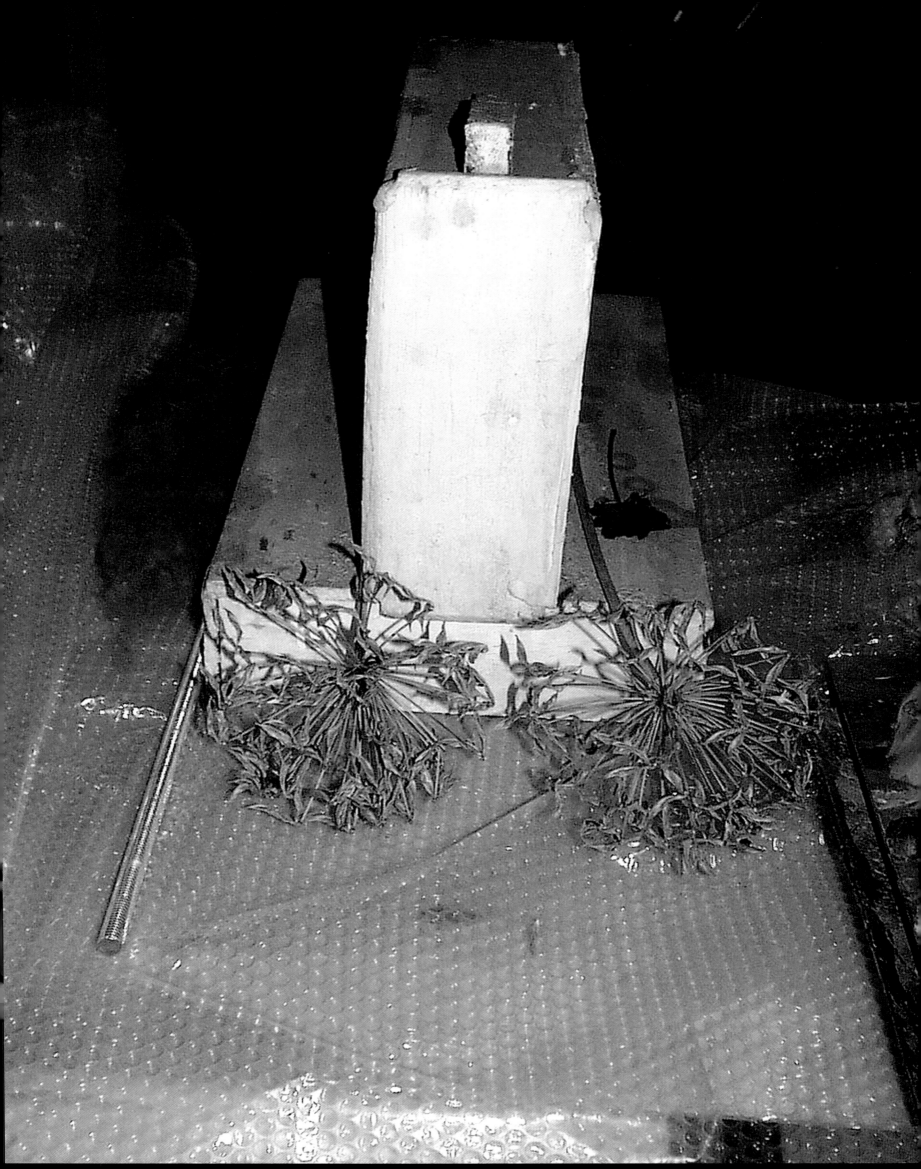

Ausgestellte Werke

1
Ohne Titel, Lexington 1946
Holz, Metall
36,8 x 8,9 x 9,2 cm
Daros-Sammlung, Schweiz
Del Roscio 4
Abb. S. 17

2
Ohne Titel, Lexington 1948
Holz, Porzellanknauf, metallener Raffhalter,
Stoff, Wandfarbe
35,8 x 26,7 x 30,5 cm
Sammlung des Künstlers, Rom
Del Roscio 8
Abb. S. 19

3
Ohne Titel, New York 1953
Holz, Draht, Schnur, Nägel, Wandfarbe,
Wachs, Stoff
38,1 x 25 x 10,1 cm
Sammlung Robert Rauschenberg
Del Roscio 10
Abb. S. 21

4
Ohne Titel, New York 1954
Holz, Glas, Spiegel, Stoff, Schnur, Draht,
Holzlöffel, Ölkreide, Wandfarbe, Wachs
203,2 x 35 x 28 cm
Cy Twombly Gallery, The Menil Collection,
Houston
Del Roscio 14
Abb. S. 26, 27

5
Ohne Titel, New York 1954
Holz, Palmblätter, Schnur, Wandfarbe, Stoff,
Nägel, Draht
139 x 60 x 12,4 cm
Sammlung des Künstlers, Rom
Del Roscio 15
Abb. S. 30

6
Ohne Titel, New York 1955
Holz, Holzlöffel, Wandfarbe, Leinen, Leim, Nägel
105 x 15,5 x 15,5 cm (89,5 x 8,2 x 8,2 cm
ohne Sockel)
Sammlung des Künstlers, Rom
Del Roscio 16
Abb. S. 32, 33

7
Ohne Titel, New York 1955
Holz, Holzlöffel, Stoff, Nägel, Wandfarbe, Seil
29,8 x 30,5 x 18,4 cm
Sammlung des Künstlers, Rom
Del Roscio 17
Abb. S. 33

8
Ohne Titel, New York 1955
Holz, Stoff, Schnur, Wandfarbe
56,5 x 14,3 x 13 cm
Sammlung des Künstlers, Rom
Del Roscio 18
Abb. S. 34

9
Ohne Titel, Rom 1959
Holz, Stoff, Pappkarton, Wandfarbe, Nagel
67 x 33,8 x 26,2 cm
Kunsthaus Zürich
Del Roscio 19
Abb. S. 41

10
Ohne Titel, New York 1959
Holz, Plastikblatt, Gips, rotes Pigment,
Wandfarbe, gelbe und blaue Farbe
70,4 x 34,6 x 39,4 cm
Sammlung des Künstlers, Rom
Del Roscio 21
Abb. S. 42, 43

11
Ohne Titel, Rom 1976
Papprohren, Stoff, Wandfarbe, Papierklebeband
193,6 x 16,8 x 16,8 cm
Sammlung des Künstlers, Rom
Del Roscio 27
Abb. S. 44

12
Ohne Titel, Rom 1978
Holz, weiße Farbe, Leim
23,4 x 51,4 x 32,4 cm
Kunsthaus Zürich
Del Roscio 31
Abb. S. 47

13
Ohne Titel, Rom 1978
Holz, Stoff, Draht, Nägel, weiße Farbe
43,8 x 222,2 x 17,8 cm
Cy Twombly Gallery, The Menil Collection,
Houston
Del Roscio 33
Abb. S. 51

14
Cycnus, Rom 1978
Holz, Palmblatt, weiße und rosa Farbe, Nägel
40,6 x 24,7 x 5,7 cm
Sammlung des Künstlers, Rom
Del Roscio 35
Abb. S. 157

15
Orpheus (Du unendliche Spur), Rom 1979
Holz, Nägel, weiße Farbe, Bleistift
266 x 244,5 x 22,2 cm
Sammlung des Künstlers, Rom
Del Roscio 39
Abb. S. 48

16
Ohne Titel, Bassano in Teverina 1979
Gips, Sand
50,1 x 45 x 22,8 cm
Kunsthaus Zürich
Del Roscio 41
Abb. S. 52

17
Ohne Titel, Bassano in Teverina 1979
(Guss Rom 1979)
Bronze (Edition 4/6)
47,6 x 45,7 x 22,8 cm
Sammlung des Künstlers, Rom
Del Roscio 42
Abb. S. 53

18
Ohne Titel, Bassano in Teverina 1979
Holz, Gips, Sand, Nägel, weiße und blaue Farbe
177,1 x 60 x 63,5 cm
Sammlung des Künstlers, Rom
Del Roscio 43
Abb. S. 53, 55

19
Ohne Titel, Bassano in Teverina 1980
Holz, Nägel, Ton, Metall, weiße Farbe
202,7 x 59 x 39,7 cm
Privatsammlung, Rom
Del Roscio 46
Abb. S. 58, 59

20
Ohne Titel, Bassano in Teverina 1980
Holz, Nägel, weiße Farbe, Draht, Metallband
273 x 41,4 x 64,8 cm
Sammlung des Künstlers, Rom
Del Roscio 47
Abb. S. 59

21
Ohne Titel, Rom 1980
Holz, weiße Farbe, Nägel
130,3 x 73 x 41,4 cm
Sammlung des Künstlers, Rom
Del Roscio 50
Abb. S. 156

22
Ohne Titel, Bassano in Teverina 1980
Gips, Sand
36 x 36,5 x 27 cm
Sammlung des Künstlers, Rom
Del Roscio 52
Abb. S. 117

23
Anabasis, Bassano in Teverina 1980
Holz, Ton, Sperrholz, Metallstreifen, Nägel,
weiße Farbe, Stoff, Laufrollen, Papier,
Heftklammern
116,8 x 48,9 x 49,5 cm
Sammlung des Künstlers, Rom
Del Roscio 53
Abb. S. 56

24
Der Hüter der Herden, Bassano in Teverina 1980
Holz, Palmblätter, Gips, Draht, Nägel, Ton,
Metallstreifen, Leim, weiße Farbe
192,6 x 91,2 x 94 cm
Privatsammlung, Rom
Del Roscio 55
Abb. S. 64

Works in the Exhibition

1
Untitled, Lexington 1946
Wood, metal
14^1/$_2$ x 3^1/$_2$ x 3^5/$_8$ inches
36.8 x 8.9 x 9.2 cm
Daros Collection, Switzerland
Del Roscio 4
Ill. p. 17

2
Untitled, Lexington 1948
Wood, porcelain knobs, metal curtain tie-back,
cloth, house paint
14^1/$_8$ x 10^1/$_2$ x 12 inches
35.8 x 26.7 x 30.5 cm
Collection the artist, Rome
Del Roscio 8
Ill. p. 19

3
Untitled, New York 1953
Wood, wire, twine, nails, house paint,
wax on cloth
15 x 9^7/$_8$ x 4 inches
38.1 x 25 x 10.1 cm
Collection Robert Rauschenberg
Del Roscio 10
Ill. p. 21

4
Untitled, New York 1954
Wood, glass, mirrors, cloth, twine, wire,
wooden spoons, oil crayon, house paint, wax
80 x 13^7/$_8$ x 11 inches
203.2 x 35 x 28 cm
Cy Twombly Gallery, The Menil Collection,
Houston
Del Roscio 14
Ill. p. 26, 27

5
Untitled, New York 1954
Wood, palm leaves, twine, house paint,
cloth, nails, wire
54^3/$_4$ x 23^7/$_8$ x 4^7/$_8$ inches
139 x 60 x 12.4 cm
Collection the artist, Rome
Del Roscio 15
Ill. p. 30

6
Untitled, New York 1955
Wood, wooden spoons, house paint, cloth,
glue, nails
41^1/$_4$ x 6^1/$_8$ x 6^1/$_8$ inches
(35^1/$_4$ x 3^1/$_4$ x 3^1/$_4$ inches without base)
105 x 15.5 x 15.5 cm
(89.5 x 8.2 x 8.2 cm without base)
Collection the artist, Rome
Del Roscio 16
Ill. p. 32, 33

7
Untitled, New York 1955
Wood, wooden spoons, cloth, nails,
house paint, rope
11^3/$_4$ x 12 x 7^1/$_4$ inches
29.8 x 30.5 x 18.4 cm
Collection the artist, Rome
Del Roscio 17
Ill. p. 33

8
Untitled, New York 1955
Wood, cloth, twine, house paint
22^1/$_4$ x 5^5/$_8$ x 5^1/$_8$ inches
56.5 x 14.3 x 13 cm
Collection the artist, Rome
Del Roscio 18
Ill. p. 34

9
Untitled, Rome 1959
Wood, cloth, cardboard, house paint, nail
26^3/$_8$ x 13^3/$_8$ x 10^3/$_8$ inches
67 x 33.8 x 26.2 cm
Kunsthaus Zurich
Del Roscio 19
Ill. p. 41

10
Untitled, New York 1959
Wood, plastic leaf, plaster, pigment, house paint
27^3/$_4$ x 13^5/$_8$ x 15^5/$_8$ inches
70.4 x 34.6 x 39.4 cm
Collection the artist, Rome
Del Roscio 21
Ill. p. 42, 43

11
Untitled, Rome 1976
Cardboard tubes, cloth, house paint, paper tape
76^1/$_4$ x 6^5/$_8$ x 6^5/$_8$ inches
193.6 x 16.8 x 16.8 cm
Collection the artist, Rome
Del Roscio 27
Ill. p. 44

12
Untitled, Rome 1978
Wood, paint, glue
9^1/$_8$ x 20^1/$_4$ x 12^3/$_4$ inches
23.4 x 51.4 x 32.4 cm
Kunsthaus Zurich
Del Roscio 31
Ill. p. 47

13
Untitled, Rome 1978
Wood, cloth, wire, nails, paint
17^1/$_4$ x 87^1/$_2$ x 7 inches
43.8 x 222.2 x 17.8 cm
Cy Twombly Gallery, The Menil Collection,
Houston
Del Roscio 33
Ill. p. 51

14
Cycnus, Rome 1978
Wood, palm leaf, paint, nails
16 x 9^3/$_4$ x 2^1/$_4$ inches
40.6 x 24.7 x 5.7 cm
Collection the artist, Rome
Del Roscio 35
Ill. p. 157

15
Orpheus (Du unendliche Spur), Rome 1979
Orpheus (Thou unending trace)
Wood, nails, paint, graphite
104^3/$_4$ x 96^1/$_4$ x 8^3/$_4$ inches
266 x 244.5 x 22.2 cm
Collection the artist, Rome
Del Roscio 39
Ill. p. 48

16
Untitled, Bassano in Teverina 1979
Plaster, sand
19^1/$_4$ x 17^3/$_4$ x 9 inches
50.1 x 45 x 22.8 cm
Kunsthaus Zurich
Del Roscio 41
Ill. p. 52

17
Untitled, Bassano in Teverina 1979
(cast Rome 1979)
Bronze, Edition 4/6
18^3/$_4$ x 18 x 9 inches
47.6 x 45.7 x 22.8 cm
Collection the artist, Rome
Del Roscio 42
Ill. p. 53

18
Untitled, Bassano in Teverina 1979
Wood, plaster, sand, nails, paint
69^3/$_4$ x 23^5/$_8$ x 25 inches
177.1 x 60 x 63.5 cm
Collection the artist, Rome
Del Roscio 43
Ill. p. 53, 55

19
Untitled, Bassano in Teverina 1980
Wood, nails, clay, metal, paint
79^7/$_8$ x 23^1/$_4$ x 15^5/$_8$ inches
202.7 x 59 x 39.7 cm
Private collection, Rome
Del Roscio 46
Ill. p. 58, 59

20
Untitled, Bassano in Teverina 1980
Wood, nails, paint, wire, metal strapping
107^1/$_2$ x 16^3/$_8$ x 25^1/$_2$ inches
273 x 41.4 x 64.8 cm
Collection the artist, Rome
Del Roscio 47
Ill. p. 59

21
Untitled, Rome 1980
Wood, paint, nails
51^3/$_8$ x 28^3/$_4$ x 16^3/$_8$ inches
130.3 x 73 x 41.4 cm
Collection the artist, Rome
Del Roscio 50
Ill. p. 156

22
Untitled, Bassano in Teverina 1980
Plaster, sand
14^1/$_8$ x 14 x 10^5/$_8$ inches
36 x 36.5 x 27 cm
Collection the artist, Rome
Del Roscio 52
Ill. p. 117

25
Aurora, Rom 1981
Holz, Plastikrose, Draht, Schnur, Gips, Nägel,
weiße Farbe
134,6 x 109,5 x 21,1 cm
Privatsammlung, Rom
Del Roscio 58
Abb. S. 73

26
Anadyomene, Rom 1981
Holz, Nägel, blaue Wachskreide,
weiße Farbe, Stoff, Ösenschraube
47 x 57,1 x 73,6 cm
Privatsammlung, Rom
Del Roscio 59
Abb. S. 82, 83

27
Ohne Titel, Formia 1981
Holz, Nägel, Schnur, weiße Farbe,
Ringschrauben
152 x 88,4 x 33,6 cm
Privatsammlung, Rom
Del Roscio 60
Abb. S. 70, 71

28
Dickicht, Formia-Rom 1981
Holz, Weidenäste, Plastikblumen, Nägel,
Draht, weiße, rosa und rote Farbe
123,8 x 29,8 x 54,6 cm
Sammlung des Künstlers, Rom
Del Roscio 61
Abb. S. 99

29
Ohne Titel, Bassano in Teverina 1981
Holz, naturfarbenes Gurtband, Faden,
Plastik-Metall-Rollen, Draht, Nägel,
weiße Farbe
154,3 x 39,4 x 38,4 cm
Sammlung des Künstlers, Rom
Del Roscio 62
Abb. S. 86

30*
Ohne Titel, Rom 1983
Holz, Gips, Pappkarton, Draht, Plastiktulpe,
weiße Farbe
141,6 x 24,1 x 32,4 cm
Kunsthaus Zürich
Del Roscio 63
Abb. S. 86

31**
Ohne Titel, Rom 1983 (Guss Rom 1983)
Bronze (Edition 5/6)
141,6 x 24,1 x 32,4 cm
Cy Twombly Gallery, The Menil Collection,
Houston
Del Roscio 64
ohne Abbildung

32
Ohne Titel, Rom 1983
Holz, Nägel, Gips, Ton, Leim, weiße Farbe
185,7 x 160 x 35 cm
Kunsthaus Zürich
Del Roscio 66
Abb. S. 62

33
Ohne Titel, Rom 1983 (Guss Rom 1983)
Bronze, weiße Farbe (Edition 2/5)
176 x 22,8 x 41 cm
Privatsammlung Rom
Del Roscio 67
Abb. S. 97

34
Ohne Titel, Rom 1983 (Guss Pfäffikon 1998)
Bronze (Edition 2/4)
82 x 55,8 x 52 cm
Sammlung des Künstlers, Rom
Del Roscio 70
Abb. S. 166

35
Ohne Titel, Gaeta 1984 (Guss Rom 1987)
Bronze, bemalt mit weißer Farbe,
Bleistift (Edition 2/4)
120,6 x 36,2 x 57,1 cm
Privatsammlung
Del Roscio 72
Abb. S. 89

36
Ohne Titel, Rom 1984/85
Holz, Gips, Nägel, weiße und blaue Farbe,
Metallhalter
51,3 x 52,7 x 23,7 cm
Sammlung des Künstlers, Rom
Del Roscio 74
Abb. S. 75

37
Winterpassage: Luxor, Porto Ercole 1985
Holz, Nägel, weiße Farbe, Papier,
Leim, Spuren von Kupfersulphat
54 x 105,7 x 51,4 cm
Kunsthaus Zürich
Del Roscio 75
Abb. S. 77

38
Ohne Titel, Bassano in Teverina 1985
Holz, Gips, Plastikblatt, Nägel, rotes Pigment,
weiße Farbe
33 x 46 x 60,3 cm
Cy Twombly Gallery, The Menil Collection,
Houston
Del Roscio 82
Abb. S. 90, 91

39
Ohne Titel, Gaeta 1985
Holz, Gips, Nägel, weiße und graue Farbe,
Eisenring, Metallhalter
82,1 x 74 x 34,2 cm
Sammlung des Künstlers, Rom
Del Roscio 84
Abb. S. 108, 110

40
Ohne Titel, Gaeta 1985 (Guss Rom 1997)
Bronze (Edition 2/3)
82,5 x 73,6 x 33,8 cm
Privatsammlung
Del Roscio 85
Abb. S. 109

41
Rotalla, Gaeta 1986
Holz, Metall, Stoff, Nägel, weiße Farbe
71,1 x 68 x 50,1 cm
Kunsthaus Zürich
Del Roscio 87
Abb. S. 112, 113

42*
Rotalla, Gaeta 1986 (Guss Pfäffikon 1990)
Bronze (Edition 5/6)
71,1 x 68 x 50,1 cm
Privatsammlung
Del Roscio 88
Abb. S. 112

43
*Wenn die Zeit da ist, kommt der Wind und
zerstört meine Zitronen*, Rom 1987
Holz, Gips, Nägel, weiße Farbe
26,2 x 97,8 x 50,1 cm
Sammlung des Künstlers, Rom
Del Roscio 90
Abb. S. 115

44
Ktesiphon, Gaeta 1987
Holz, Gips, Metallstreifen, Nägel,
weiße Farbe, Draht
65,4 x 90,8 x 52,7 cm
Sammlung des Künstlers, Rom
Del Roscio 91
Abb. S. 93

45
Ohne Titel, Rom 1987
Holz, Nägel, Schnur, Papier, weiße Farbe,
Gips, Sperrholz
123,2 x 41,3 x 41,3 cm
Sammlung des Künstlers, Rom
Del Roscio 93
Abb. S. 85

46
Am Ionischen Meer, Gaeta 1987
Holz, Nägel, Gips, Ton, Leim, blauer Farbstift,
Spuren blauer Farbe, weiße Farbe
30,8 x 58 x 49,8 cm
Kunsthaus Zürich
Del Roscio 95
Abb. S. 78

47
Ohne Titel, Bassano in Teverina 1987
Holz, Gips, Nägel, Ton, weiße Farbe,
Spuren roter Farbe, rote und blaue Wachskreide
128,9 x 152 x 29,8 cm
Sammlung des Künstlers, Rom
Del Roscio 100
Abb. S. 94

48
Ohne Titel, Bassano in Teverina 1988
Holz, Gips, Ton, Spuren brauner,
blauer und roter Farbe
32,4 x 35,5 x 21 cm
Sammlung des Künstlers, Rom
Del Roscio 102
Abb. S. 122

23
Anabasis, Bassano in Teverina 1980
Wood, clay, plywood, metal strips, nails,
paint, cloth, casters, paper, staples
46 x 19¼ x 19½ inches
116.8 x 48.9 x 49.5 cm
Collection the artist, Rome
Del Roscio 53
Ill. p. 56

24
The Keeper of Sheep, Bassano in Teverina 1980
Wood, palm leaves, plaster, wire, nails, clay,
metal strips, glue, paint
75⁷⁄₈ x 36 x 37 inches
192.6 x 91.2 x 94 cm
Private collection, Rome
Del Roscio 55
Ill. p. 64

25
Aurora, Rome 1981
Wood, plastic flower, wire, twine, plaster, nails, paint
53 x 43¹⁄₈ x 8³⁄₈ inches
134.6 x 109.5 x 21.1 cm
Private collection, Rome
Del Roscio 58
Ill. p. 73

26
Anadyomene, Rome 1981
Wood, nails, crayon, paint, cloth, screw eye
18½ x 22½ x 29 inches
47 x 57.1 x 73.6 cm
Private collection, Rome
Del Roscio 59
Ill. p. 82, 83

27
Untitled, Formia 1981
Wood, nails, cord, paint, screw eyes
59⁷⁄₈ x 34⁷⁄₈ x 13¼ inches
152 x 88.4 x 33.6 cm
Private collection, Rome
Del Roscio 60
Ill. p. 70, 71

28
Thicket, Formia-Rome 1981
Wood, wicker, plastic flowers, nails, wire, paint
48³⁄₄ x 11³⁄₄ x 21½ inches
123.8 x 29.8 x 54.6 cm
Collection the artist, Rome
Del Roscio 61
Ill. p. 99

29
Untitled, Bassano in Teverina 1981
Wood, webbing, thread, plastic and metal casters,
wire, nails, paint
60³⁄₄ x 15½ x 16 inches
154.3 x 39.4 x 38.4 cm
Collection the artist, Rome
Del Roscio 62
Ill. p. 86

30*
Untitled, Rome 1983
Wood, plaster, cardboard, wire,
plastic flower, paint
55⁷⁄₈ x 9½ x 12³⁄₄ inches
141.6 x 24.1 x 32.4 cm
Kunsthaus Zurich
Del Roscio 63
Ill. p. 86

31**
Untitled, Rome 1983 (cast Rome 1983)
Bronze, Edition 5/6
55⁷⁄₈ x 9½ x 12³⁄₄ inches
141.6 x 24.1 x 32.4 cm
Cy Twombly Gallery, The Menil Collection,
Houston
Del Roscio 64
not ill.

32
Untitled, Rome 1983
Wood, nails, plaster, clay, glue, paint
73¹⁄₈ x 63 x 13³⁄₄ inches
185.7 x 160 x 35 cm
Kunsthaus Zurich
Del Roscio 66
Ill. p. 62

33
Untitled, Rome 1983 (cast Rome 1983)
Painted bronze, Edition 2/5
69³⁄₈ x 9 x 16 inches
176 x 22.8 x 41 cm
Private collection, Rome
Del Roscio 67
Ill. p. 97

34
Untitled, Rome 1983 (cast Pfäffikon 1998)
Bronze, Edition 2/4
32¼ x 22 x 20½ inches
82 x 55.8 x 52 cm
Collection the artist, Rome
Del Roscio 70
Ill. p. 166

35
Untitled, Gaeta 1984 (cast Rome 1987)
Painted bronze, graphite, Edition 2/4
47½ x 14¼ x 22½ inches
120.6 x 36.2 x 57.1 cm
Private collection
Del Roscio 72
Ill. p. 89

36
Untitled, Rome 1984/85
Wood, plaster, nails, paint, metal fastener
20³⁄₁₆ x 19¹⁄₈ x 10⁷⁄₈ inches
51.3 x 52.7 x 23.7 cm
Collection the artist, Rome
Del Roscio 74
Ill. p. 75

37
Winter's Passage: Luxor, Porto Ercole 1985
Wood, nails, paint, paper, glue,
traces of copper sulphate
21¼ x 41⁵⁄₈ x 20¼ inches
54 x 105.7 x 51.4 cm
Kunsthaus Zurich
Del Roscio 75
Ill. p. 77

38
Untitled, Bassano in Teverina 1985
Wood, plaster, plastic leaf, nails, pigment, paint
13 x 18¹⁄₈ x 23³⁄₄ inches
33 x 46 x 60.3 cm
Cy Twombly Gallery, The Menil Collection,
Houston
Del Roscio 82
Ill. p. 90, 91

39
Untitled, Gaeta 1985
Wood, plaster, nails, paint, iron ring,
metal fastener
32³⁄₈ x 29³⁄₄ x 13½ inches
82.1 x 74 x 34.2 cm
Collection the artist, Rome
Del Roscio 84
Ill. p. 108, 110

40
Untitled, Gaeta 1985 (cast Rome 1997)
Bronze, Edition 2/3
32½ x 29 x 13³⁄₄ inches
82.5 x 73.6 x 33.8 cm
Private collection
Del Roscio 85
Ill. p. 109

41
Rotalla, Gaeta 1986
Wood, metal, cloth, nails, paint
28 x 26³⁄₄ x 19³⁄₄ inches
71.1 x 68 x 50.1 cm
Kunsthaus Zurich
Del Roscio 87
Ill. p. 112, 113

42**
Rotalla, Gaeta 1986 (cast Pfäffikon 1990)
Bronze, Edition 2/6
28 x 26³⁄₄ x 19³⁄₄ inches
71.1 x 68 x 50.1 cm
Cy Twombly Gallery, The Menil Collection,
Houston
Del Roscio 88
Ill. p. 112

43
*In Time the Wind Will Come and Destroy
My Lemons*, Rome 1987
Wood, plaster, nails, paint
11¹⁄₈ x 38½ x 19³⁄₄ inches
26.2 x 97.8 x 50.1 cm
Collection the artist, Rome
Del Roscio 90
Ill. p. 115

44
Ctesiphon, Gaeta 1987
Wood, plaster, metal strips, nails, paint, wire
25³⁄₄ x 35³⁄₄ x 20⁷⁄₈ inches
65.4 x 90.8 x 52.7 cm
Collection the artist, Rome
Del Roscio 91
Ill. p. 93

45
Untitled, Rome 1987
Wood, nails, twine, paper, paint, plaster, plywood
48½ x 16¼ x 16¼ inches
123.2 x 41.3 x 41.3 cm
Collection the artist, Rome
Del Roscio 93
Ill. p. 85

46
By the Ionian Sea, Gaeta 1987
Wood, nails, plaster, clay, glue, pencil, paint
12¹⁄₈ x 22⁷⁄₈ x 19⁵⁄₈ inches
30.8 x 58 x 49.8 cm
Kunsthaus Zurich
Del Roscio 95
Ill. p. 78

49
Ohne Titel, Bassano in Teverina 1989
Holz, Gips, Nägel, Spuren roter, grüner und
blauer Farbe, weiße Farbe
75,6 x 31,1 x 32,7 cm
Sammlung des Künstlers, Rom
Del Roscio 104
Abb. S. 171

50
Ohne Titel, Gaeta 1990
Holz, Stoff- und Plastiktulpenblüten, Draht,
Ton, weiße Farbe, Metall, Wachs, Faden
167,6 x 35 x 34,3 cm
Sammlung des Künstlers, Rom
Del Roscio 107
Abb. S. 97

51
Dickicht (Dickicht von Ur), Gaeta 1990
Bambus, Metall, Holz, Draht, Holzschildchen,
weiße Farbe, Bleistift, Gips
188,3 x 38,1 x 36,2 cm
Sammlung des Künstlers
Del Roscio 109
Abb. S. 100

52
Dickicht (Dickichte von Akkad · Sumer), Gaeta 1991
Holz (Stamm eines Bäumchens), weißer Zement,
Draht, Schnur, Papier, Holzschildchen, weiße
Farbe, Nägel, schwarze Tinte
260,3 x 58,4 x 57,1 cm
Sammlung des Künstlers, Rom
Del Roscio 110
Abb. S. 100

53
Thermopylae, Gaeta 1991
Gips auf Weidengeflecht, grobgewebter Stoff,
Graphit, Holzstöcke, gipsüberzogenenes Tuch
mit Blumen auf Plastikstielen
137 x 89 x 66 cm
Cy Twombly Gallery, The Menil Collection,
Houston
Del Roscio 111
Abb. S. 118

54
Thermopylae, Gaeta 1991 (Guss Meudon 1992)
Bronze (Edition 3/3)
137 x 89 x 66 cm
Cy Twombly Gallery, The Menil Collection,
Houston
Del Roscio 112
Abb. S. 118, 119

55
(Für F. P.) Der Hüter der Herden,
Jupiter Island 1992
Holz, Stoff, Gips, Nägel, weiße Farbe
194,6 x 29,2 x 63,5 cm
Sammlung des Künstlers, Lexington
Del Roscio 115
Abb. S. 68

56
Ohne Titel, Jupiter Island 1992
Holz, Gips
48,2 x 33,6 x 44,4 cm
Cy Twombly Gallery, The Menil Collection,
Houston
Del Roscio 117
Abb. S. 123

57
Ohne Titel, Jupiter Island 1992
Gebrannter Synthetikton
4,1 x 27,3 x 13,7 cm
Sammlung des Künstlers, Leihgabe an die
Cy Twombly Gallery, The Menil Collection,
Houston
Del Roscio 118
Abb. S. 76

58
Ohne Titel, Jupiter Island 1992
Gebrannter Synthetikton
4,4 x 25,7 x 14 cm
Sammlung des Künstlers, Leihgabe an die
Cy Twombly Gallery, The Menil Collection,
Houston
Del Roscio 119
Abb. S. 76

59
Ohne Titel, Jupiter Island 1992
Gebrannter Synthetikton
4,6 x 28,6 x 11,4 cm
Sammlung des Künstlers, Leihgabe an die
Cy Twombly Gallery, The Menil Collection,
Houston
Del Roscio 120
Abb. S. 76

60
Ohne Titel, Jupiter Island 1992
Gebrannter Synthetikton
7,9 x 22,8 x 10,5 cm
Sammlung des Künstlers, Leihgabe an die
Cy Twombly Gallery, The Menil Collection,
Houston
Del Roscio 121
Abb. S. 76

61
Epitaph, Jupiter Island 1992
Holz, Gips, Sperrholz, weiße Farbe
40,7 x 38,7 x 38,1 cm
Cy Twombly Gallery, The Menil Collection,
Houston
Del Roscio 125
Abb. S. 120

62
Dickicht, Jupiter Island 1992
Holz, Plastikblätter, Gips, weiße Farbe
47,8 x 33,8 x 23,5 cm
Cy Twombly Gallery, The Menil Collection,
Houston
Del Roscio 126
Abb. S. 101

63
Madame d'O, Jupiter Island 1992
Holz, Metall, Draht, Gips, blaue und weiße Farbe
177,8 x 40,6 x 27 cm
Sammlung des Künstlers, Lexington
Del Roscio 130
Abb. S. 124, 126, 127

64
Ohne Titel, Gaeta 1993
Weißbemalter Eisentopf, Papiertüte,
getrocknete Blume
78,1 x 36,2 x 37,1 cm
Sammlung des Künstlers, Rom
Del Roscio 131
Abb. S. 98, 103

65
Chronik von Vulci, Gaeta 1995
Holz, weiße Farbe, Palmwedel, Gips
27,9 x 61,3 x 33 cm
Sammlung des Künstlers, Rom
Del Roscio 140
Abb. S. 130

66
Ohne Titel, Gaeta 1998
Holz, Gips, Draht, Blumentopf aus Plastik,
weiße Farbe
128,6 x 24,1 x 19,9 cm
Sammlung des Künstlers, Rom
Abb. S. 134, 135

* nur in Basel
** nur in Houston

47
Untitled, Bassano in Teverina 1987
Wood, plaster, nails, clay, paint, crayon
50³/₄ x 59⁷/₈ x 11³/₄ inches
128.9 x 152 x 29.8 cm
Collection the artist, Rome
Del Roscio 100
Ill. p. 94

48
Untitled, Bassano in Teverina 1988
Wood, plaster, clay, traces of paint
12³/₄ x 14 x 8⁷/₈ inches
32.4 x 35.5 x 21 cm
Collection the artist, Rome
Del Roscio 102
Ill. p. 122

49
Untitled, Bassano in Teverina 1989
Wood, plaster, nails, paint
29³/₄ x 12¹/₄ x 12⁷/₈ inches
75.6 x 31.1 x 32.7 cm
Collection the artist, Rome
Del Roscio 104
Ill. p. 171

50
Untitled, Gaeta 1990
Wood, cloth, plastic flowers, wire, clay, paint,
metal, wax, thread
66 x 13¹/₃ 13¹/₂ inches
167.6 x 35 x 34.3 cm
Collection the artist, Rome
Del Roscio 107
Ill. p. 97

51
Thicket (Thicket of Ur), Gaeta 1990
Bamboo, metal, wood, wire, wooden tags,
paint, graphite, plaster
74¹/₈ x 15 x 14¹/₄ inches
188.3 x 38.1 x 36.2 cm
Collection the artist
Del Roscio 109
Ill. p. 100

52
Thicket (Thickets of Akkad · Sumer), Gaeta 1991
Wood (tree trunk), cement, wire, twine, paper,
wooden tags, paint, nails, ink
102¹/₂ x 23 x 22¹/₂ inches
260.3 x 58.4 x 57.1 cm
Collection the artist, Rome
Del Roscio 110
Ill. p. 100

53
Thermopylae, Gaeta 1991
Plaster on wicker, coarsely woven cloth, graphite,
wooden sticks, plaster-coated cloth with flowers
on plastic stems
54 x 35 x 26 inches
137 x 89 x 66 cm
Cy Twombly Gallery, The Menil Collection,
Houston
Del Roscio 111
Ill. p. 118

54
Thermopylae, Gaeta 1991 (cast Meudon 1992)
Bronze, Edition 3/3
54 x 35 x 26 inches
137 x 89 x 66 cm
Cy Twombly Gallery, The Menil Collection,
Houston
Del Roscio 112
Ill. p. 118, 119

55
(To F. P.) The Keeper of Sheep,
Jupiter Island 1992
Wood, cloth, plaster, nails, paint
76⁵/₈ x 11¹/₂ x 25 inches
194.6 x 29.2 x 63.5 cm
Collection the artist, Lexington
Del Roscio 115
Ill. p. 68

56
Untitled, Jupiter Island 1992
Wood, plaster
19 x 13¹/₄ x 17¹/₂ inches
48.2 x 33.6 x 44.4 cm
Cy Twombly Gallery, The Menil Collection,
Houston
Del Roscio 117
Ill. p. 123

57
Untitled, Jupiter Island 1992
Baked synthetic clay
1⁵/₈ x 10³/₄ x 5³/₈ inches
4.1 x 27.3 x 13.7 cm
Collection of the artist on loan to Cy Twombly
Gallery, The Menil Collection, Houston
Del Roscio 118
Ill. p. 76

58
Untitled, Jupiter Island 1992
Baked synthetic clay
1³/₄ x 10¹/₈ x 5¹/₂ inches
4.4 x 25.7 x 14 cm
Collection of the artist on loan to Cy Twombly
Gallery, The Menil Collection, Houston
Del Roscio 119
Ill. p. 76

59
Untitled, Jupiter Island 1992
Baked synthetic clay
1⁷/₈ x 11¹/₄ x 4¹/₂ inches
4.6 x 28.6 x 11.4 cm
Collection of the artist on loan to Cy Twombly
Gallery, The Menil Collection, Houston
Del Roscio 120
Ill. p. 76

60
Untitled, Jupiter Island 1992
Baked synthetic clay
3¹/₈ x 9 x 4¹/₈ inches
7.9 x 22.8 x 10.5 cm
Collection of the artist on loan to Cy Twombly
Gallery, The Menil Collection, Houston
Del Roscio 121
Ill. p. 76

61
Epitaph, Jupiter Island 1992
Wood, plaster, plywood, paint
16 x 15¹/₄ x 15 inches
40.7 x 38.7 x 38.1 cm
Cy Twombly Gallery, The Menil Collection,
Houston
Del Roscio 125
Ill. p. 120

62
Thicket, Jupiter Island 1992
Wood, plastic leaves, plaster, paint
18⁷/₈ x 13³/₈ x 9¹/₄ inches
47.8 x 33.8 x 23.5 cm
Cy Twombly Gallery, The Menil Collection,
Houston
Del Roscio 126
Ill. p. 101

63
Madame d'O, Jupiter Island 1992
Wood, palm frond, metal, wire, plaster, paint
70 x 16 x 10⁵/₈ inches
177.8 x 40.6 x 27 cm
Collection the artist, Lexington
Del Roscio 130
Ill. p. 124, 126, 127

64
Untitled, Gaeta 1993
Painted iron pot, paper bag, dried flower
30³/₄ x 14¹/₄ x 14⁵/₈ inches
78.1 x 36.2 x 37.1 cm
Collection the artist, Rome
Del Roscio 131
Ill. p. 98, 103

65
Vulci Chronicle, Gaeta 1995
Wood, paint, palm fronds, plaster
11 x 24¹/₈ x 13 inches
27.9 x 61.3 x 33 cm
Collection the artist, Rome
Del Roscio 140
Ill. p. 130

66
Untitled, Gaeta 1998
Wood, plaster, wire, plastic flower pot, paint
50⁵/₈ x 9¹/₂ x 7⁷/₈ inches
128.6 x 24.1 x 19.9 cm
Collection the artist, Rome
Not in Del Roscio
Ill. p. 134, 135

* Basel only
** Houston only

Quellen

Courtesy Alesco AG, Zürich S. 17.
British Museum, London S. 54, 104.
Tres Camenzind, Zürich S. 34 u., 112 r., 166.
Mimmo Capone, Rom S. 19 o., 30, 33 o., 33 u.,
42 u., 44, 48 o., 52 o., 56 l., 56 r., 59 l., 59 r., 62 o.,
64, 71 u., 73, 75 o., 82 o., 85 u., 86 l., 89 o., 93 o.,
94, 97 u.l., 97 u.r., 98 o., 99 u., 100 l., 100 r., 108,
109, 117, 130 o., 156 u., 157 l., 169 o., 171.
Nicola Del Roscio S. 13 o.l., 13 M.r., 13 u., 74,
96 o., 96 u., 102, 105, 113 o., 158, 168 u.
Plinio De Martiis S. 12 u.
Hartwig Fischer S. 70 u., 103.
The Solomon R. Guggenheim Museum, New York,
Foto David Heald S. 164.
Hickey-Robertson, Houston S. 21, 26 o., 51 o.,
68 o., 76 (alle 4), 91, 101 o., 118 o., 120, 123.
Kunsthaus Zürich (Reto Klink) S. 41, 47 u., 77 o.,
78 o., 86 r., 112 l.
Kunsthaus Zürich S. 154, 163, 173 o., 176.
The Menil Collection, Foto Paul Hester S. 170 o.
Ugo Mulas Estate S. 12 r.
The Museum of Modern Art, New York S. 173 u.
Douglas M. Parker, Los Angeles S. 20, 49, 84 o., 84 u.
Museo Civico, Piacenza S. 131 o.
Robert Rauschenberg S. 12 o., 22, 23, 28, 37, 165 u.
Friedrich Rosenstiel, Köln S. 70 o.
Werner Schloske S. 151.
Jochen Schmidt S. 114.
Katharina Schmidt, Basel: S. 2, 13 o. r., 26 u., 27,
32 o., 32 u., 34 o., 42 o., 43, 47 o., 48 u., 51 u., 52
u., 53 l., 53 r., 55, 58 o., 58 u., 62 u., 68 u., 71 o.l.,
71 o.r., 75 u., 77 u., 78 u., 82 u., 83, 85 o., 89 u., 90
l., 90 r., 93 u., 97 o., 98 u., 99 o., 101 u., 110, 113 u.,
115, 118 u., 119, 122 o., 122 u., 124, 126 (alle 3),
127, 130 u., 134 o., 134 u., 135, 142, 156 o., 157
r., 159 o., 159 u., 160 o., 160 u., 161, 162, 196,
197, 207.
Sotheby's International, New York S. 165 o.
Cy Twombly, S. 19 u., 36, 39.
Dorothy Twombly S. 15.
Wilhelm Lehmbruck Museum Duisburg S. 167.

Andere Bildquellen

SCHMIDT S. 14: *Cy Twombly. A Retrospective,*
Ausst.-Kat. New York, The Museum of Modern Art
1994, S. 11; S. 18: *Hans Arp,* Ausst.-Kat. Kunsthalle
Nürnberg 1994, S. 119; S. 29: Heiner Bastian, *Cy
Twombly. Bilder Paintings 1952–1976, Volume 1,*
Berlin 1978, Nr. 6; S. 40: Gerlinde Haas, *Die Syrinx
in der griechischen Bildkunst,* Wien etc. 1985,
S. 160; S. 45: *Museen der Welt. Der Louvre. Ägypten,
Vorderer Orient, Klassische Antike,* mit Texten
von Chr. Ziegler u. a., München 1993, S. 255; S. 50:
G.-K. Loukomski, *Art étrusque. Etude illustrée sur
la peinture murale de Corneto-Tarquinia,* Paris 1930,
Taf. 73; S. 60: *Egyptian Art in the Age of the
Pyramids,* Ausst.-Kat. New York, The Metropolitan
Museum of Art 1999, S. 207; S. 72: Harry Wilde,
Trotzki, Reinbek 1995, S. 118; S. 92: Ernst Diez,
Die Kunst der islamischen Völker (Handbuch für
Kunstwissenschaft), Berlin 1915, S. XIII; S. 95:
Distribuidora Turística Peninsular Fitzmacolor,
Mérida, 1981; S. 121: Ellen MacNamara, *The
Etruscans,* London 1993, S. 41; S. 125: Galerie
Hauser & Wirth, Zürich; S. 131: *Giacometti. La
collection du Centre Georges Pompidou, Musée
national d'art moderne,* hrsg. von Agnès de la
Beaumelle, Paris 1999, S. 85; S. 133 Postkarte,
anonym, 1981; S. 136: *Mosaiques romaines de
Tunisie,* Tunis o.J., S. 164; S. 137: Mina Gregori,
*Uffizien und Palazzo Pitti. Die Gemäldesammlungen
von Florenz,* München 1994, S. 291.
KLEMM S. 152: *Cy Twombly, A Retrospective,*
Ausst.-Kat. New York, The Museum of Modern Art
1994, S. 97; S. 155: ebenda, S. 77; S. 168 o.: *Cy
Twombly. Skulpturen,* Ausst.-Kat. Krefeld, Museum
Haus Lange 1981, S. 8; S. 169 u.: Karl Schefold,
Die Griechen und ihre Nachbarn (Propyläen Kunst-
geschichte Bd. 1), Berlin 1984, Abb. 348a; S. 170
u.: *Die Sammlung der Alberto Giacometti-Stiftung,*
bearbeitet von Christian Klemm, Zürich 1990, S.
93; S. 174: Heiner Bastian, *Cy Twombly. Catalogue
Raisonné of the Paintings,* Bd. 4, *1972–1995,*
München 1995, S. 81; S. 179: *Cy Twombly,* Ausst.-
Kat. Baden-Baden, Staatliche Kunsthalle 1984,
S. 110.

Zitate

S. 38: Charles Olson »Cy Twombly«, in: Charles
Olson, *Ich jage zwischen Steinen. Briefe und Essays,*
hrsg. von Rudolf Schmitz, Bern/Berlin (Gachnang &
Springer) 1998, S. 122; S. 88: Giorgio Agamben, in:
Cy Twombly. 8 Sculptures. Ausst.-Kat. Rom, Ameri-
can Academy 1998, S. 5 (Übers. Daniele Dell'Agli).

Photograph Credits

Courtesy Alesco AG, Zurich: p. 17
British Museum, London: p. 54, 104.
Tres Camenzind, Zurich: p. 34 bottom, 112 right,
166.
Mimmo Capone, Rome: p. 19 top, 30, 33 top, 33
bottom, 42 bottom, 44, 48 top, 52 top, 56 left,
56 right, 59 left, 59 right, 62 top, 64, 71 bottom,
73, 75 top, 82 top, 85 bottom, 86 left, 89 top,
93 top, 94, 97 bottom left, 97 bottom right, 98
top, 99 bottom, 100 left, 100 right, 108, 109, 117,
130 top, 156 bottom, 157 left, 169 top, 171.
Nicola Del Roscio: p. 13 top left, 13 center right,
13 bottom, 74, 96 top, 96 bottom, 102, 105,
113 top, 158, 168 bottom.
Plinio De Martiis: p. 12 bottom.
Hartwig Fischer: p. 70 bottom, 103.
The Solomon R. Guggenheim Museum, New York,
Photo David Heald: p. 164.
Kunsthaus Zurich (Reto Klink): p. 41, 47 bottom,
77 top, 78 top, 86 right, 112 left.
Kunsthaus Zurich: p. 154, 163, 173 top, 176.
The Menil Collection, Houston. Paul Hester:
p. 170 top. Hickey-Robertson, Houston: p. 21,
26 top, 51 top, 68 top, 76 (all 4), 91, 101 top,
118 top, 120, 123
Ugo Mulas Estate: p. 12 right.
The Museum of Modern Art, New York:
p. 173 bottom.
Douglas M. Parker, Los Angeles: p. 20, 49, 84 top,
84 bottom.
Museo Civico, Piacenza: p. 131 top.
Robert Rauschenberg: p. 12 top, 22, 23, 28, 37,
165 bottom.
Friedrich Rosenstiel, Cologne: p. 70 top.
Werner Schloske: p. 151.
Jochen Schmidt: p. 114.
Katharina Schmidt, Basel: p. 2, 13 top right, 26
bottom, 27, 32 top, 32 bottom, 34 top, 42 top, 43,
47 top, 48 bottom, 51 bottom, 52 bottom, 53 left,
53 right, 55, 58 top, 58 bottom, 62 bottom, 68
bottom, 71 top left, 71 top right, 75 bottom, 77
bottom, 78 bottom, 82 bottom, 83, 85 top, 89
bottom, 90 left, 90 right, 93 bottom, 97 top, 98
bottom, 99 top, 101 bottom, 110, 113 bottom, 115,
118 bottom, 119, 122 top, 122 bottom, 124, 126
(all 3), 127, 130 bottom, 134 top, 134 bottom,
135, 142, 156 top, 157 right, 159 top, 159 bottom,
160 top, 160 bottom, 161, 162, 196, 197, 207.
Sotheby's International, New York: p. 165 top.
Cy Twombly: p. 19 bottom, 36, 39.
Dorothy Twombly: p. 15.
Wilhelm Lehmbruck Museum Duisburg: p. 167.

Additional sources

ESSAY SCHMIDT p. 14: *Cy Twombly: A Retrospec-
tive,* exh. cat. (New York: The Museum of Modern
Art, 1994), p. 11; p. 18: *Hans Arp,* exh. cat. (Nurem-
berg: Kunsthalle Nürnberg, 1994), p. 119; p. 29:
Heiner Bastian. *Cy Twombly: Bilder Paintings
1952–1976 / Volume 1.* Berlin: Propyläen Verlag,
1978. no. 6; p. 40: Gerlinde Haas. *Die Syrinx in der
griechischen Bildkunst.* Vienna Cologne Graz:
Böhlau, 1985. p. 160; p. 45: *Museen der Welt: Der
Louvre / Ägypten, Vorderer Orient, Klassische
Antike,* texts by Christa Ziegler et al. Munich and
London: C. H. Beck and Scala Books, 1993. p. 255;
p. 50: G.-K. Loukomski. *Art étrusque: Etude illus-
trée sur la peinture murale de Corneto-Tarquinia.*
Paris: Editions Duchartre, 1930. plate 73; p. 60:
Egyptian Art in the Age of the Pyramids, exh. cat.
(New York: The Metropolitan Museum of Art,
1999), p. 207; p. 72: Harry Wilde. *Trotzki.* Reinbek:
Rowohlt, 1995. p. 118; p. 92: Ernst Diez. *Die Kunst
der islamischen Völker* (Handbuch der Kunstwissen-
schaft). Berlin: Akademische Verlagsgesellschaft
Athenaion, 1915. p. XIII; p. 95: Distribuidora Turís-
tica Peninsular Fitzmacolor, Mérida, 1981; p. 121:
Ellen MacNamara. *The Etruscans.* London: British
Museum Publications, 1993. p. 41; p. 125: Galerie
Hauser & Wirth, Zurich; p. 131: *Giacometti: La
collection du Centre Georges Pompidou, Musée
national d'art moderne.* Ed. Agnès de la Beaumelle.
Paris: Centre Georges Pompidou and Réunion des
Musées Nationaux, 1999. p. 85; p. 133 anonymous
post-card, 1981; p. 136: *Mosaiques romaines de
Tunisie.* Tunis: Ceres Productions, no date. p. 164;
p. 137: Mina Gregori. *Uffizien und Palazzo Pitti: Die
Gemäldesammlungen von Florenz.* Munich: Hirmer,
1994. p. 291.
ESSAY KLEMM p. 152: *Cy Twombly: A Retrospec-
tive,* exh. cat. (New York: The Museum of Modern
Art, 1994). p. 97; p. 155: ibid., p. 77; p. 168 top:
Cy Twombly: Skulpturen, exh. cat. (Krefeld:
Museum Haus Lange, 1981). p. 8; p. 169 bottom:
Karl Schefold, *Die Griechen und ihre Nachbarn*
(Propyläen Kunstgeschichte. Vol. 1). Berlin:
Propyläen Verlag, 1984. fig. 348a; p. 170 bottom:
Die Sammlung der Alberto Giacometti-Stiftung. ed.
Christian Klemm. Zurich: Zürcher Kunst-
gesellschaft, 1990. p. 93; p. 174: Heiner Bastian.
Cy Twombly: Catalogue Raisonné of the Paintings.
vol. 4, *1972–1995.* Munich: Schirmer/Mosel, 1995,
p. 81; p. 179: *Cy Twombly,* exh. cat. (Baden-Baden:
Staatliche Kunsthalle, 1984). p. 110.

Quotes

p. 45: Charles Olson. "Cy Twombly," *Olson: The
Journal of the Charles Olson Archives,* 8 (Autumn
1977): 14. p. 103/105: Giorgio Agamben. In *Cy
Twombly: 8 Sculptures.* exh. cat. (Rome: American
Academy, 1998), p. 5.

Dieses Katalogbuch erscheint
anläßlich der Ausstellung
Cy Twombly Die Skulptur
This book has been published
on the occasion of the exhibition
Cy Twombly The Sculpture

Öffentliche Kunstsammlung Basel / Kunstmuseum
15. April–30. Juli 2000
The Menil Collection, Houston
September 20, 2000–January 7, 2001

Konzeption der Ausstellung
Concept of the exhibition
Katharina Schmidt,
Öffentliche Kunstsammlung Basel
Paul Winkler, The Menil Collection, Houston

Organisation
Öffentliche Kunstsammlung Basel / Kunstmuseum
The Menil Collection, Houston

Wissenschaftliche Assistenz
Assistant Curator
Hartwig Fischer, Birgit Gudat, Kunstmuseum Basel

Dokumentation
Documentation
Barbara Kunz, Kunstmuseum Basel
Mary Kadish, The Menil Collection, Houston

Restaurierung
Conservation
Hanspeter Marty, Zürich, Peter Berkes, Basel;
Carol Mancusi-Ungaro, Pia Gottschaller, Brad
Epley, William Steen, Houston

Public Relations
Christian Selz, Basel; Vance Muse, Houston

Registrar
Charlotte Gutzwiller, Basel; Julie Bakke, Houston

Technischer Museumsdienst
Technical Services
Ernst Rieder, Dieter Marti, Markus Spinnler, Basel;
Buck Bakke, Gary Parham, Doug Laguarta,
Houston

Katalog
Catalogue

Herausgeber
Editor
Katharina Schmidt

Redaktion
Assistant Editor
Hartwig Fischer, Basel
Geraldine Aramanda, Houston

Lektorat deutsch
Copy Editor German
Hartwig Fischer, Birgit Gudat

Lektorat englisch
Copy Editor English
Hartwig Fischer, Basel;
Paul Winkler, Polly Koch, Houston

Verlagslektorat
Copy Editor Publisher
Christine Traber (deutsch · German),
Fiona Elliott (englisch · English)

Übersetzung
Translation
David Britt, London (Klemm; Vorwort · Preface);
Fiona Elliott, Eileen Walliser, Roger Harmon
(Schmidt)

Grafische Gestaltung
Graphic Design
Gabriele Sabolewski

Lithografie
Lithography
Repromayer, Reutlingen

Satz
Typeset
Weyhing digital, Ostfildern-Ruit

Gesamtherstellung
Printed by
Dr. Cantz'sche Druckerei, Ostfildern-Ruit

© 2000 Öffentliche Kunstsammlung Basel,
Hatje Cantz Verlag, Ostfildern-Ruit.
© für die Texte bei den Autoren · text by
the authors.
© für die abgebildeten Werke inklusive Fotografie
von Cy Twombly beim Künstler · artworks
and photographs by Cy Twombly by the artist.
© für die Fotografie · for photography: Tres
Camenzind, Zürich; Mimmo Capone, Roma;
Nicola Del Roscio, Roma; Plinio De Martiis,
Roma; Friedrich Rosenstiel, Köln; Kunsthaus
Zürich (Reto Klink); Ugo Mulas Estate, Milano;
Douglas M. Parker, Los Angeles; Werner
Schloske, Stuttgart.
© für · for Bruce Nauman und · and Robert
Rauschenberg, VG Bild-Kunst, Bonn 2000/
ProLitteris, Zürich; für · for Katharina Schmidt,
VG Bild-Kunst, Bonn 2000.

Erschienen im
Published by
Hatje Cantz Verlag
Senefelderstr. 12
D-73760 Ostfildern-Ruit
Tel. +49/711/44 05 0
Fax +49/711/44 05 22 0
Internet: www.hatjecantz.de

Distribution in the US
D.A.P., Distributed Art Publishers, Inc.
155 Avenue of the Americas, Second Floor
USA-New York, N.Y. 10013-1507
Tel. +1/2 12/6 27 19 99
Fax +1/2 12/6 27 94 84

ISBN 3-7757-0916-9 (Buchhandel · Trade)
ISBN 3-7204-0121-8 (Kunstmuseum Basel)

Printed in Germany

Umschlagabbildungen
Jacket Illustration
Cy Twombly, Untitled, 1955, Roma 1999
Photo Katharina Schmidt

Frontispiz
Frontispiece
Cy Twombly, Roma 1999
Photo Katharina Schmidt

Die Deutsche Bibliothek – CIP-Einheitsaufnahme
Ein Titeldatensatz für diese Publikation ist bei
Der Deutschen Bibliothek erhältlich

Die Deutsche Bibliothek – CIP Cataloguing-
in-Publication-Data
A catalogue record for this publication is
available from Die Deutsche Bibliothek

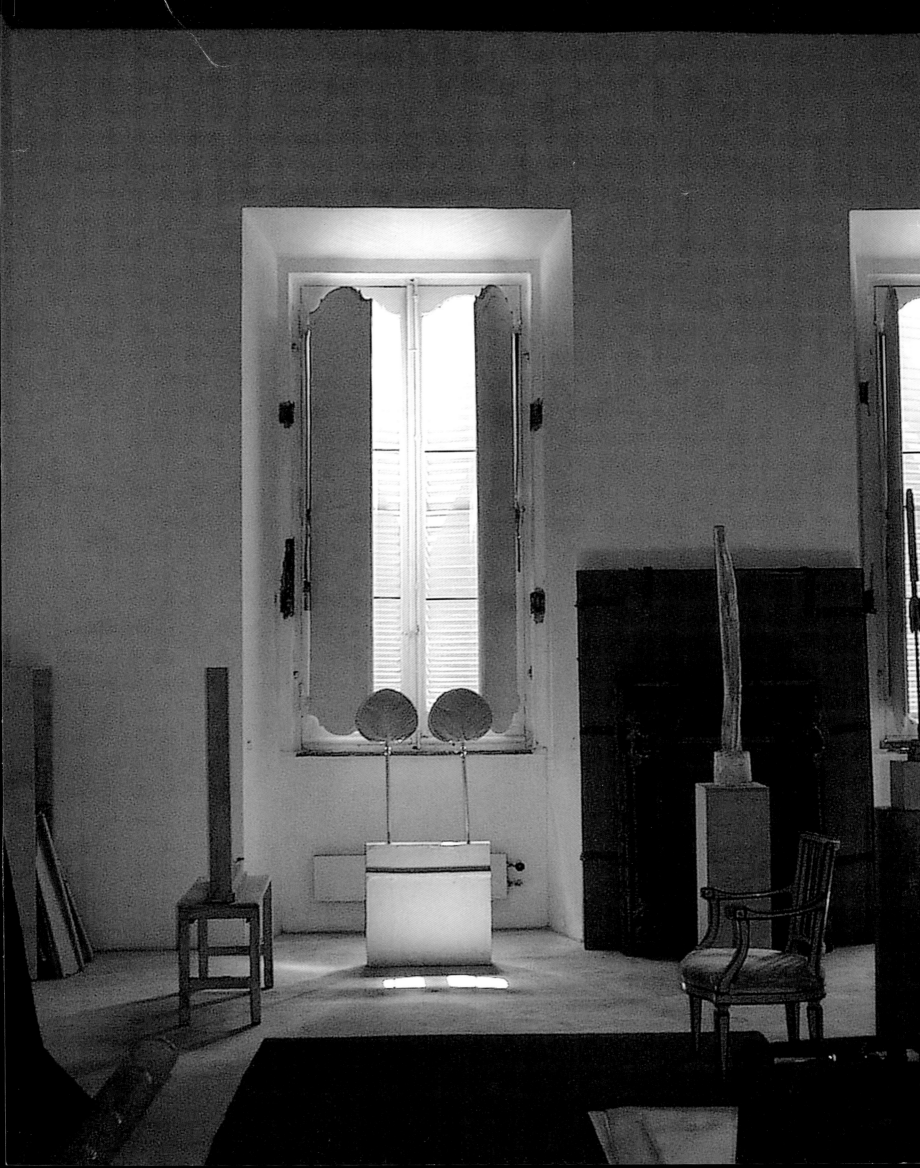